The Charles McCabe Reader

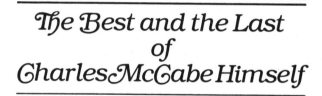

The Best and the Last of Charles McCabe Himself

Forewords by Gordon Pates and James P. Degnan

Chronicle Books • San Francisco

Printed in the United States of America.

Library of Congress Cataloging in Publishing Data

McCabe, Charles, 1915-1983
 The Charles McCabe Reader.

 Selection of his columns appearing originally in the San Francisco Chronicle.
 I. Title.
AC8.M1713 1984 081 84-17474
ISBN 0-87701-325-X

10 9 8 7 6 5 4 3 2 1

Chronicle Books
870 Market Street
San Francisco, CA 94102

Contents

12. Short and Sweet

13. Miscellany

Foreword

BY GORDON PATES

*E*d Lahey, one of Chicago's finest journalists, once compared writing a daily column to being married to a nymphomaniac. As soon as you get through, you have to start again. Charles McCabe understood and accepted this requirement gladly; as he said near the end of his career, "there was no job in the world I wished for more."

McCabe found the treadmill of column writing stimulating for the most part rather than exhausting; he had so many opinions that he wanted to get off his chest that he often wrote a dozen columns ahead of schedule. When events compelled a substitution so that he might remain current, the original column was filed away for later use. Nothing was ever wasted; to have done so would have violated one of the most sacred canons of column writing.

Charles arrived at his heart's desire by a circuitous route. He was already 44 years old and had never held a job that offered him the opportunity to exploit his talents properly. He had been born in New York's Hell's Kitchen in 1915, the first child of Irish immigrants. He had grown up in Harlem, attended New York Catholic schools and become a police reporter at the age of 20. Over the years he lived in Puerto Rico, Sun Valley, Idaho, Washington, D.C., and La Jolla, California.

San Francisco first saw him in 1955 when he drifted into town following the trauma of his second divorce. He held dull, dead-end reportorial jobs the monotony of which was infrequently broken by the chance to do the kind of writing he liked best—features in which he could spread his wings.

In 1959 his talents as a prose stylist won him the opportunity to write an iconoclastic sports column for the *Chronicle.* He reveled in it while the sports establishment writhed and the fans were goaded to the edge of apoplexy by his refusal to take seriously the grand passion of their lives. After five years of baiting them he quit, ostensibly to live in England with his third wife but probably also because he was bored with sports.

In a year or so, his marriage having exploded like a trick cigar, he was back in the *Chronicle's* employ, this time writing a general interest essay each day, which turned out to be his true vocation. He was over 50 years of age but finally going in the right direction. During his 22 column-writing years he turned out more than 3,000,000 words on a staggering variety of subjects.

His likes and dislikes were legion; here are some of them.

He loved raw garlic, Colman's mustard, California jug wine, Rainier Ale (The Green Death), Gucci loafers, red suspenders, Dewar's White Label whiskey and clothes from L.L. Bean (once he had worn out the Savile Row threads he had acquired during his residence in England).

McCabe's heroes included the French essayist Montaigne, Dr. Samuel Johnson, the Spanish novelist Cervantes, Justice Oliver Wendell Holmes, Jr., the British statesman Lord Melbourne (Victoria's tutor), Horace Walpole, George Bernard Shaw, Dean Swift, Oscar Wilde, James Joyce, Samuel Pepys, H.L. Mencken and Ambrose Bierce.

His personal rogues' gallery included Richard Nixon, Ronald Reagan, Jimmy Carter, Jerry Brown, Henry Kissinger, and just about every lawyer he ever met or had heard about. He despised believers in Zero Population Growth and Planned Parenthood, women's libbers, cancer quacks, gene splicers, bilingualists in the classroom or on the ballot, professional educators, IRA fanatics and their Irish-American supporters, Tahoe land developers, gun nuts, psychiatrists and their ilk, pornographers, vice crusaders and do-gooders of any stripe.

He was for gays coming out of the closet but against their acting up on the streets; he favored the decriminalization of prostitution and believed all crime should be divided into two categories—assault and theft; he was for legalizing marijuana and advocated heroin as a painkiller for the terminally ill; he hated tourism and denounced San Francisco's increasing reliance on it; he despised nearly all American beer and called it "hiss"—but only because his editors would not let him call it "piss" in his column, though God knows he tried often enough.

There were certain subjects of which McCabe never tired: his Irish heritage, his unhappy childhood, his early poverty, the opposite sex, his life-long addiction to liquor, his inability to give of himself or define love satisfactorily, his disdain of money but his enjoyment of what he called the "luxe" life.

He was convinced that a man is rich when judged by what he can do without (a notion acquired from Thoreau). He traveled light, threw away the nonessentials and strove not to acquire them in the first place.

Charles practiced small economies—rinsing out and reusing his coffee filters; shaving with the same blade until it disintegrated (all his life he searched for the perfect blade and, of course, never found it, though he was convinced that it existed and was locked away in a vault at Gillette headquarters); resoling the same shoes a dozen times; making liquid soap out of

slivers; saving toothpaste through regular use of toothpicks.

He was all for equal rights for women but violently opposed to feminism, which in his eyes consisted of little else than hatred of men. He believed the Good Book when it informed him that God had created two sexes as a means of propagating the species. Women, he felt, had best accept the Biblical role assigned them and get on with the job.

McCabe enjoyed the hospitality of his rich friends but, given their Neanderthal thinking, doubted that many of them would make it into the kingdom of heaven. Although he hated himself in the morning, he managed to smile when his hosts assured him that it was futile to give coal to the poor because they would just keep it in the bathtub.

He could be, and often was, rude, crude, quarrelsome, malicious, disputatious, contentious, and abusive. He could also, when the spirit moved him, exude the charm of a leprechaun though it was not given to everyone to be able to perceive it. Women especially seemed able to detect (or so they thought) the heart of gold under the rough exterior.

All these many things you knew about McCabe because he told you about them in his column. As he often quoted Horace Walpole, he did not know what he thought until he had written it down—so he put it down on paper in his column. His compulsive shriving moved Joseph Alioto to remark that Charles was the only Catholic he knew who went to confession in public and got paid for it.

His daily trips to the confessional began early in the morning in his Telegraph Hill apartment when he rose to type out the column which had been gestating in his head since the previous day. He then bathed, shaved, dressed and sallied forth to his favorite North Beach bar (for many years it was Gino & Carlo's on Green street).

His bar stool was his office. He read the papers and his mail and collected ideas for future columns all the while sipping at The Green Death with a chaser of ice water (five ales during the morning was his quota). Come lunchtime he was off to a favorite restaurant for his first real meal of the day, then home to read and ruminate about the next day's column.

At 6 feet 1 and 240 pounds, Charles verged upon the portly, and was one of the great freestyle drinkers of the town (beer, wine and whisky, each in its turn). He was not by his own standards either a drunk or an alcoholic; still his craggy face bore the inevitable stigmata of the serious drinker, and his devotion to the grape may have shortened his life.

Periodically he went through the purification ritual known

to all two-fisted drinkers as "drying out." He remained on the wagon until all traces of the crapulence that had afflicted him disappeared. Then the process would begin anew.

All his life, beginning with his mother, he was both fascinated and baffled by women and his relations with them were dicey at best. Try as he might, he was incapable of adapting to the demands of matrimony. On the record he was 0 for 4.

His first wife, Bridget, he met and married in Sun Valley, Idaho, where he was working as a press agent and she was seeking a divorce. Their union was both tempestuous and brief, setting a pattern for the future.

He stayed the longest (seven years) with number 2, publishing heiress Peggy Scripps, by whom he had four children before bailing out in 1955. In his late forties he married Lady Mary Campbell, daughter of the fifth Earl of Rosslyn, an intoxicating experience for one whose forebears had slept with the pigs in the grinding poverty of Ireland. Nonetheless, he sobered up and wriggled out of the bonds of matrimony after a few years.

Charles remained a bachelor for many years until shortly before his 68th birthday. In late 1982, demonstrating what his hero Dr. Samuel Johnson, I believe, called the triumph of hope over experience, he wed a charming woman he had met on an ocean voyage. Within a matter of weeks his marriage to Helen Sampson was on the rocks.

He had taken a three-month leave in order to house hunt with his new wife and recharge his batteries. He returned in April, alone once more, and resumed his column where he had left off and without comment on the latest debacle in his private life. Three weeks later, in his apartment, he died of a massive cerebral hemorrhage sometime during the weekend of April 30-May 1, 1983. He was six columns ahead at his death.

At the wake held for McCabe at Gino & Carlo's a red rose and a bottle of The Green Death were placed on the bar at his place. Many weeks later when friends aboard a cruise ship he had frequented prepared to commit his ashes to the deep along with a bottle of his beloved Rainier Ale they discovered there wasn't a bottle on board. They substituted a bottle of Heineken's Dutch beer, the glass of which, at least, was a lovely green.

I edited Charles McCabe's columns for nearly 20 years, from 1959 when he began writing them until 1979 when I retired. Our personal relationship was based on mutual respect coupled with mutual dislike, but we were both pros and recognized it in each other. I believe that I was good for Charles and I know he was good for the *Chronicle*.

When I was approached to undertake the job of winnowing

out the enduring columns from the several thousand he had written since his last book in the early seventies, I was told by my colleagues that I was the only editor who could do the job quickly and well. Having finished my labors I realize that, in the words of a favorite McCabe phrase, they were bang-on right. Here it is.

Gordon Pates

Foreword

BY JAMES P. DEGNAN

San Francisco Chronicle columnist Charles McCabe was, at once, one of the great originals of American journalism and a kind of walking cliché. "He was the consummate columnist down to how he looked and dressed, in a style known as 'Rumpled Columnist,'" says Chronicle writer Gerald Nachman, "a charming jumble of dandy and barfly. . .of Irish wag bucking for Oxford don." McCabe affected dark baggy English suits, suspenders, unpolished handmade English shoes, and a black shillelagh walking stick. He had a beer belly, white dishevled hair, brown merry eyes, and a huge magenta drinker's nose upon which perched a pair of half-moon glasses. His favorite sport was crawling the pubs of his beloved North Beach, and he could often be found on a stool in one of his favorite blue collar bars expatiating—to an audience made up typically of long-shoremen, garbage collectors, and short-order cooks—on everything from Sicilian hangover remedies to the influence of Copernicus on the metaphysical poets.

His past was colorful. He'd knocked about all over the world, hobnobbing with the rich and powerful and the down and out, marrying and divorcing newspaper heiresses and ladies to the manner born as he went. Born aboard ship to immigrant parents en route from County Cork to America and raised in New York's Hell's Kitchen, McCabe was in the tradition, to quote Nachman, "of tough, hard-drinking New York Irish newspapermen, a fearless breed from Jimmy Cannon to Jimmy Breslin."

But McCabe was not like Cannon or Breslin or any other columnist. Appearances are not reality, and behind the cliché, behind the stereotype, was the great original: the most unusual writer of his kind in America. He was, as his column was so perfectly named, "Himself."

At McCabe's gala Irish wake in the basement of his favorite saloon, Gino and Carlo's, a North Beach publican summed up McCabe's literary achievement by declaring: "The son of a bitch could write about anything." What the good publican meant was that McCabe could make almost anything he wrote about—and the range of his subject matter was vast—interesting, and interesting to an audience made up, in McCabe's not entirely facetious words, "mainly of unemployed house painters, car salesmen, barflies, retired cops, garbagemen and butchers who kite checks." For this audience, McCabe, using

prose liberally laced with words like *glabrous, quidnunc, archimandrites, callipygian, etiolated,* and *infundibulum,* wrote regularly about things that just aren't written about in American newspapers—about Virgil's *Georgics,* about the Senecan amble, about Horace Walpole's letters, about Swift and Montaigne and Dr. Johnson and Lady Mary Wortley Montague; about La Rochefoucauld, the Duc de Talleyrand, and the literary salon of Madame du Deffand; about the canticles of William Boyce; about the pronouncements of obscure desert fathers on the dangers of *accidie;* about eccentric Oxford dons of his acquaintance, about the pleasures of browsing the Bodleian; about being in Debrett; about having one's shoes made at Lobb, one's suits at Poole's; about Botticelli and Raphael and what Lord Melbourne said about Raphael's uncle, architect to the Pope.

McCabe also wrote, with vehemence, about America's criminal lack of decent razor blades or edible mustard or drinkable beer (most beer served in America was, for McCabe, "3.2 carbonated swill. . .something the Elizabethans would have reserved for traitors"); about the style of Jack Kennedy—"I was never sold on him until one day I saw him flip a coin and catch it palm down; after that I never doubted him"; about the vile-tasting glue on American postage stamps (when posting a letter McCabe always licked the envelope, not the stamp); about being raised a preecumenical Irish Roman Catholic—"If you enjoyed anything, it was bad. If you enjoyed it a great deal, it was sinful"; about the Irish, and especially about that formidable Irish creature, the Irish Mother: "The Irish Mother regards the pangs of birth as the price she pays for the possession forever and in fee simple, of the body, soul and gaiety of her children."

But McCabe was perhaps at his passionate best writing in defense and praise of his favorite pastime, an activity he called career drinking. In cranky, perverse, comical, and usually indefensible essays, McCabe, though he abhorred drunks and drunkeness, argued one of his favorite theses: drinking is good for you, abstinence bad. For McCabe, alcohol was not only the classic anodyne, "a snort or two of which makes the human condition bearable," but, he quotes philosopher William James, "the great exciter of the Yes function in man, the source for many, of the discovery of what is best in their natures I am certain," McCabe wrote, "that Winston Churchill's habit of guzzling a quart or two a day of good cognac is what saved civilization from the Luftwaffe, Hegelian logic, Wagnerian love-deaths and potato pancakes.

"Don't lecture me about the harm booze does," McCabe was fond of fuming, "I've heard all about that, and it's poppycock.

The folk wisdom of a hundred cultures over many thousands of years shows that beer and wine and spirits serve as a pleasant and useful counter to the irritant called life.

"Don't talk to me about the brilliant careers cut short by booze," McCabe huffed. "Don't talk to me about people like Dylan Thomas and Brendan Behan drinking themselves to death. I say, without booze as an ally, they would never have had brilliant careers to cut short. They'd probably have ended up a couple of ribbon clerks."

For McCabe, drinking was to be regarded as a career, "a dangerous career, to be sure," he writes, "but then so are other analogous callings, stalking the Indian tiger, for instance, or nipping up the Matterhorn or living with a woman."

A newspaperman and public relations man (in New York, Puerto Rico, and Sun Valley) for much of his career, McCabe, at age forty and with no job prospects, drifted into San Francisco in the mid-1950s. Here, Scott Newhall, a *Chronicle* editor of much ingenuity, gave McCabe a job writing a sports column, and, although McCabe hated most sports, most athletes, and all owners of sporting franchises, his column, "The Fearless Spectator," quickly became successful by attacking with regularity what McCabe regarded as the "insane religion of sports in America."

Later, McCabe began writing the column he was best known for, "Himself." Five-days-a-week "essays" (McCabe's literary and intellectual hero was Montaigne, father of the essay), McCabe's columns brilliantly demonstrate his rare talent for writing, regularly and with ease, about what is interesting to the writer and making it interesting to a wide readership; his talent for simplifying and popularizing the difficult and the obscure; his talent for being instructive, even didactic (McCabe was one of the best teachers I have ever read), yet entertaining.

A man of passionate opinions who loved controversy and debate, McCabe made enemies ranging from teetotalers; to proponents of sex education in the schools (McCabe thought such people little more than champions of promiscuity); to almost every politician he wrote about (e.g. Ronald Reagan, who, McCabe contended, "has made a career of pandering to the belief of the well-off that the poor somehow are both inhuman and expendable").

McCabe "fought with everybody about everything," recalls a North Beach restaurateur. "Most people either loved or hated him. No, hatred is too strong. We fought with him, but love prevailed.

On the whole the restaurateur's appraisal is not far from accurate. Perverse and curmudgeonly McCabe may have been;

but, finally, McCabe comes across—certainly in his work—as highly likable, if not lovable, and as a man of great compassion. Though he hobnobbed with the rich and the powerful in America and in Europe (he was, through two marriages, connected with British aristocracy and a member of the Scripps family), McCabe was most at home with the cops and firemen and cab drivers at his favorite rundown North Beach pubs, and his sympathies seemed always with the poor and the oppressed. He never forgot what he regarded as the purpose of journalism: "To comfort the afflicted and to afflict the comfortable; to humble the exalted and exalt the humble"; and this, as much as anything, I think, accounts for his great popularity.

A hater of hype, McCabe would probably hate being called one of the great originals in American journalism, but that he was. He was more than a great newspaper columnist. He was a man of letters, a magisterial stylist, a literary artist. His ambition was to be a kind of modern-day Montaigne, and in many ways he was. His best work belongs in the company of Lamb and Hazlitt and Mencken and Bierce. Publishing that work constitutes one of newspaper journalism's finest contributions to American letters, and one hopes that keeping that work alive will constitute a similar contribution on the part of American education, literary criticism, and book publishing.

McCabe on His Mother

The Eye

A team of American scientists, writing in a British magazine, has established that the enigmatic quality known as "female intuition" actually exists; and that, naturally, women have more of it than men.

Not that I have ever doubted it. Since an early age I have been a consistent victim of this curious feminine capability. Except that I have always called it The Eye. The Eye was my mother's, and it seemed that it was never off me.

The Eye knew more about me than I knew about myself. To this day, many decades after, I still occasionally feel The Eye on me, especially when I am engaged in some activity that shades slightly the laws of God or man. There is still a basilisk judgment in that motherly orb.

The scientists who reported their findings to *New Society* call the phenomenon neither "female intuition" nor The Eye. They call it nonverbal communication. Their tests show that women are more visually attentive to other people than men.

The tests, in which men and women were shown silent film clips representing various more or less complicated emotional situations, confirmed that women consistently scored higher than men 75 per cent of the time.

The researchers went so far as to speculate that "a mother's nonverbal sensitivity may, in our forebears, have substantially helped her child's survival chances. She may have been alert to signs of distress in the infants, or to signs of external danger or disorder within the group."

Another speculation is that women got this peculiar penetration because they are "socially oppressed" and must become skilled in reading the needs and demands of more powerful people—i.e. the men in their lives.

This is close, I think; but no cigar.

It is my feeling that women, by both training and inheritance, are more skillful spies than men. The reason for this is not hard to find. To fiddle with a Shavian aphorism: Those who can, do; those who cannot, spy.

Men have always had more interesting lives, and interesting jobs, than women—or at least that is what women have nearly always felt. That is why men have been subjected to such relentless scrutiny by their women. The lady is always on the lookout for clues as to what her mate is up to when he is out of sight.

She yearns to know just how the old boy conducts himself in his office or factory, and whether he may be playing pattycake with one of the hired hands on the distaff side. An extreme example of female intuition is the microscopic examination of shirt collars for microscopic traces of foreign cosmetic materials.

My mother was this sort of spy, par excellence. As I was her oldest son, and therefore the most available member of the enemy class, and the one least able to fight back, I became the *materia prima* in her endless studies in the duplicity of man.

Everything I did, when The Eye wasn't looking, was suspect. The lady boasted that she had eyes in the back of her head, and she wasn't far wrong. The only conduct of which she wholly approved was sitting bolt upright in a chair. And even then, The Eye was at work. "Stop thinking what you're thinking," she would command.

So baleful was this early exposure to The Eye that I have attributed the same almost insane prescience to almost every woman I've known since. I know of course that this is unjust; but there it is. You cannot easily erase anything so formidable as The Eye. I feel it on me this very minute, and wonder what it is I'm doing that is bad. Ah, yes, writing. The Eye put no store by that sort of thing.

cA Geltic View of Life

cA candid friend, by which I mean someone who tells you things that hurt you for your own good, once confided in me the disturbing information that life is not a standing ovation.

If you conclude that the candid friend was my sainted mother, you will not be far off the mark. She was a great one for administering strong doses of Epsom salts to both body and soul. I discovered quite late in life that she was quite right about the physical benefits of Epsom salts, apart from the one which immediately springs to mind; but that is another tale.

If, by chance, anyone was thinking of organizing a form of standing ovation for the youthful Charlie Mac, you may be certain that my mother would have aborted the project in no uncertain terms. She would have been quite right, in her own complex Celtic mind, in so doing.

The dear old girl truly believed that the slow drum, and not the fiddle or the flute, was the proper antiphonal accompaniment to the curious business of living. She met life gallantly, but with an undercurrent of sadness. Perhaps these are the same things, really.

My mother had had enormous vivacity, and considerable beauty, when young; but she suddenly gave up on life when she was in her 40s. She spend the next three decades mostly looking out of a window in her apartment in New York's Washington Heights, inspecting and speculating about the activities of her neighbors. These were found pointless in the extreme. Life didn't deserve her participation any more. She allowed herself to review it, harshly.

I have never lost that undercurrent of sadness, which she either implanted or uncovered. I think it was a bit of each. The sad view of life is typically Celtic. My mother was more Celtic than most.

Mary Kate's favorite saying was, "What you don't know, won't hurt you." Toward the end, she arranged not to know a helluva lot of things. She died pretty well reconciled to the narrow universe she had allotted herself.

But with that undercurrent of sadness there is something else present in her son. She never tired of telling me that you pay for what you get. This is a proposition I have never doubted; but I have added to it what seems to me a useful corollary: If you keep in mind constantly that you are going to pay, and imagine

just what you are going to have to pay, you can greatly add to the pleasure of what you get. This is true whether you buy it or it falls into your lap, as the best things seem to.

If you fix in mind the punishment that is always certain to follow your pleasure (if you follow the doctrine of compensation of the old Irish Calvinistic ethic), the pleasure can be at times almost excruciating. Love, as an example, can be a form of crucifixion, and ruddy good for it, too.

For is it not only the justice that is said to inhere in the natural law that ecstasy should be followed by crucifixion? In the symbolic sense, of course.

But is it not also the same kind of justice, as the pendulum must swing if it is to be a pendulum, that the crucifixion must again inevitably be followed by something like ecstasy? The pleasure, the greatest of all sensual pleasures in life, it may be, is the maintenance of this exotic equipoise.

Your eye is on the cost when you are enjoying. No matter how perverse it seems, this can add to the enjoyment. One of the most useful of the phrases of my Catholic tutors was "under the aspect of eternity." Pleasure is tempered by looking at things this way, and paradoxically intensified.

Pain is abated by the knowledge that it offends balance, and must be succeeded by some form of non-pain. To persist in pleasure, or in pain, is an act of will and a perversity. The latter deviance was well-caught by Freud in his phrase "the sexualization of pain." What a funny way to go!

Motherly Advice

When I was young, good little girls were told to wear clean underwear and wash their feet so they would look good in case they were knocked down by a bus and taken to a hospital.

Joyce Grenfell, the British actress, says she was always told to wear wool next to the skin, never to stand up in an open boat, and never, under any circs, get funny with a man wearing a peaked cap.

Another buck I knew back in the primal ooze said his mother told him never to buy anything that eats or needs repainting. I have, on the whole, stayed with my friend on that one, because I have seldom felt the need to buy anything that eats, or anything that is painted.

My mother wasn't a great one for giving advice. From time to time she would thump me, which was a pretty strong indication that she disapproved of what I had been doing just before the thump. These thumps followed just about everything I did.

I have found, through countless interviews with thumped former children, that my experience was not uncommon. At a certain age, just about anything you can think of is something your mother does not want you to do. There may even be a connection.

But my mother did give me one piece of advice that has never left me, though I cannot honestly say that I have followed it or not. This advice was directed against a notable weakness in my character.

I may as well confess that as a child I was a powerful verbal disputant. I might add, I did not lick this trait off the grass. My mother used to conclude heated debates on anything from theology to the price of butter with the conclusive phrase, "I never argue with people who are wrong."

Before I was of the age to join a debating team, I was a petulant and snarling debater. When I got to schools where they had debating teams, I not only joined the debating team, but as naturally as rain became its captain. Throughout a career that included contests with such formidable adversaries as Oxford, Harvard and Georgetown, no debating team with McCabe on it ever lost a judge's or audience verdict.

When you are captain of a debating team in a Catholic school, the line of your advance in the world is clearly marked. You go to law school, you work two or three years in district politics, you

join a decent, law-abiding Catholic-Jewish law firm and get a couple of Irish contractors as clients. Then you run for Congress. Unless you contract a serious social disease, or rob a bank, you are in like Flynn.

My mother saw the perils of this kind of life clearly. After one of my more striking forensic triumphs, like delivering the commencement address at my high school graduation, she took me to a Jewish restaurant on Second avenue, bought me a cup of coffee, and said to me quietly:

"Don't make your living with your mouth."

There ended my dreams of becoming a lawyer, and seducing juries, and maybe becoming president of something. I might add the dreams weren't all that serious. But there was such Celtic cogency in my mother's words, and in the unusually quiet way she delivered them, that I knew I had been given a strong and serious dose.

Far too many Irish have fallen victims to their own fluency. The gift of the gab can become the curse of creation. The capacity to talk yourself out of anything leads you into a lot of things that would never occur to you otherwise.

Most of the trouble I've gotten into in my life has been the result of my own power to convince myself and others of the great beauty of blind folly. Women, and some men too, have been caused periods of intense unhappiness because of my way with words.

Better I should have shut up.

The Gossoon

The other night I was talking to two pleasant old Irish biddies at the bar of the New Pisa on Green street. In the midst of a story one of the ladies mentioned a word I hadn't heard in 40 years—"gossoon."

The word brought back quick and vivid memories of that unusual woman whom I never have figured out—my mother. For I was her gossoon.

"Here he comes, the gossoon himself."

"Ah, the gossoon is back."

These, or some similar combination, were her greetings to me when I returned from school, or from play, or from the library. It was an assertion that I was still alive, and that she was rather glad of it; but no big thing, you understand. As far as I know she never used the term to either of my two younger brothers. I was the gossoon.

The word itself has a fascinating history, which I doubt my mother ever knew. It is directly related to the French word *garcon*. Garcon derives from a Teutonic word which originally had a meaning similar to "wretch."

In the oldest French texts, it means something like a varlet, a low fellow, a scoundrel. Its earliest-known occurrence is in the Chanson de Roland, where it is coupled with *esquier*.

The English think it is funny to pronounce the word in pseudo-French fashion, as garsong. The etymologist Ernest Weekley quotes a newspaper columnist who defined *garsong* as "a cry emitted at short intervals by Englishmen traveling abroad."

The word was completely taken from the French in Middle English as garsoon. According to Weekley, by the 17th century it had dropped out of use, but not before it had been adopted in Ireland as gossoon. Nowadays it represents nothing more than a young man, rather fondly.

The way my mother used the word to me was typical of our relationship. The biggest sin in her book, which was filled indeed with big sins, was to display emotion. When she was angry, she was coldly angry. She displayed affection by tentative little taps to your face, your head or your chin.

There was precious little kissing and hugging after the first year. I was thus set adrift at an early age, and remained always in a state of puzzlement about my mother's feelings towards me.

Whether it was this early giving me my own canoe, whether I wished to paddle it or not, life with mother soon turned into a conflict of wills that never stopped until I left the house. Of course it has never stopped internally, even to this day.

If I spent too much time at baseball, why wasn't I studying my books. If I spent too much time studying my books, why don't you go out and get a bit of air. There was nothing I could do right, or so I felt.

She wanted me to be a priest or a cop, since those were two forms of lifelong security she thoroughly understood, and they each wore the badge of authority, which was something she liked and respected.

I always wanted to be a newspaper reporter, or writer of some kind. My mother pretended not to understand this. What she really objected to was my attempt "to go above my station." Newspapering fitted into that classification.

But that other night, when those ladies mentioned the word "gossoon" a little spurt of delight went through me. I had been her gossoon, and nobody else had been, and all the *sturm und drang* that she had put me through for all those years was, as she would have it, for my own good. And maybe it was.

𝕿𝖍𝖊 𝕲𝖍𝖆𝖒𝖔𝖎𝖘

My friend Bill Lynn and I are about the same age, and have similar backgrounds—growing up in New York in a world of priests and mothers and Tammany Hall.

"If it wasn't for crooked Irish cops," said Bill, "I would have spent my entire childhood in the Catholic Reformatory." To which sentiment I could only give a spirited assent. The C.R. was a quasi-penal place where they kept boys who were incorrigible or close to it.

Another thing Bill and I had in common, along with thousands of other boys, was that we begged for cigaret and cigar coupons in front of the Whelan and United Cigar stores. The coupons were given out as a sales incentive. When you got a couple of hundred of them you could buy a Louisville Slugger, or a Frankie Frisch baseball glove, or some other useful article.

The coupons were our substitute for money, of which there was very little about, and practically none of it for us. Some of the customers kept the coupons. Most gave them to the little beggars gathered on the street outside the store.

Talking to Bill Lynn about these coupons reminded me of something I hadn't thought of for maybe a half century. I suppose I was about nine. I decided to do something good for my mother, who was at that time the sole support of three sons, of which I was the eldest.

Of all the household chores she did, the one she most disliked was washing the windows on our tenement flat on Columbus avenue. She did this once a month or so, using rags made of torn-up linen shirts or underwear. The job took a long time, and she was pretty hard to live with when it was finished.

I looked at the catalogue that contained colored pictures of the dandy things you could buy with cigar coupons. One item struck my eye and caught my heart. It was a chamois skin, maybe a yard square, and it was expensive, like maybe 50 coupons. It was the perfect thing to make window washing almost painless.

I went back to my coupon begging with a new vigor because I had a noble purpose in mind. I became more aggressive and spent more time at it.

At last the great day came. I had the wherewithal. I almost ran up to the warehouse on 125th street where they redeemed the coupons. The chamois was gift-wrapped, as were all the items. Going back to the house, I really ran most of the way.

I had never given my mother a present.

She was out on some errand when I got back. I had to wait, with all the impatience of the virtuous about to commit virtue. I placed the box on the kitchen table.

When my mother returned I steered her into the kitchen and pointed at the box. Puzzled, she took off the red ribbon and opened up the box.

It took her a minute to realize what the object was. Then she broke out into floods of tears. She took me to her breast. In between the tears she started to laugh. Then it would be tears again. I suppose that never before or since had I ever been so close to her.

Of course by now I realized the enormity of what I had done. I had committed the *gaffe* of making her a gift of something that reminded her that she was, really, nothing more than a domestic servant. And I had done it with the innocence and love of a child.

Always, after that, my mother cleaned the windows with the same old rags. The chamois stayed in its box, perhaps to her dying day for all I know, a reproof to a boy who had done the right thing in the wrong way.

Biddytalk

"Oh, isn't life a terrible thing, thank God."

Dylan Thomas

I don't know whether my sainted mother ever uttered the above words exactly, but I can hear them now in her accents. The words reek of her and her friends. They describe with total and deadly accuracy a good part of her life and that of her friends.

I call it biddytalk, because it is the idle roadside gossip of the Irish housewife. Since New York didn't have any countrysides, like the old country, this talk was limited to the airwells of the tenements we lived in. These were called areaways and the ladies eased themselves on their elbows and shouted out the windows of the well, to the neighboring ladies, who did the same.

The period lasted an hour or so in the morning, after the old man had gone to work and the kids shoved off to school and the young ones had been pacified by some milk or orange juice.

This was my mother's Happy Hour. The chief subjects were men, of course, and other calamities, like fires and arrests.

Arrests were big news. "Did you hear that Jimmy's son got pinched for goin' into Woolworth's and treatin' himself to a hammer and some nails?" This was a real bulletin, for Jimmy was the son of the Tammany district leader, and thus royalty.

My mother was everybody's rabbi since she was in good with old Jimmy the street captain of the organization. She opined "Ah, his father will have him out before you can say 'Shut up.'"

This was one of the few unkind things you might hear, because when anybody was in REAL trouble, the biddies all showed their essentially generous hearts. What infuriated them was gossip that could not be confirmed. Most of it centered around what happened to their men at Dan Ford's saloon, up the street on Columbus avenue. There, and at the men's club, the men could get away from the women and children after dinner.

"I hear Biddy Clancy has got ahold of a new possible. A fireman it is this time. The woman's a menace, wagging that black tongue around in Dan Ford's. A good man would shut her up, by the Grace of God."

The ladies hated that saloon, which they were only allowed to enter on weekends and holidays.

"I hear Tom Ryan is going to see Dr. Goldfarb." That meant that Ryan had the clap or something worse, for that's what

Goldfarb specialized in. And it meant that bad times were in for Mrs. Ryan for a couple of weeks. "Ah, she had it comin', with her nose higher than the roof of a church." Or, "I wonder what she did to deserve it."

This kind of black talk, and some of it was a lot blacker than this, served to pacify the ladies. When they went out to shop at Dan Reeves' or the German butcher shop after their session, they were sated but happy, and greeted each other as if they were members of some kind of Middle European court or something.

Before I went to my first grade of school, I used to hide myself behind a sofa or some other bit of furniture, and listen rapturously to this daily badmouthing. "Who's dead," was the way most of those sessions started. My mother, while making her neighborhood rounds, found out who had fallen off the hooks in the preceeding 24 hours.

After that, the form was: "Ah, he was a wonderful man, I wonder who will take care of the family now." And then came an airwell threnody on the deceased's faults, which would have had him whirling in his casket. If life wasn't a terrible thing, the biddies would have been bereft.

On Growing Up
in New York

The Citizen

*M*uch as I fight it, I always return to the knowledge that I'm just a poor city boy at heart. Return, as one of my friends says, like a dog to its vomit. The matter could be phrased more gracefully. He's one of these stalwart children of nature. I am spawn of the gutter. His young feet trod grass and soil, mine ran along concrete.

A city boy is almost as different from a country boy, as one biological class is from another. The shared experiences, the education in human relationships, are as distant each from the other, as the son of a cowpoke and of an old Etonian.

The New York boy, which is what I was, is as to other city boys another order. The ideal shared experience of American youth—rafts down the Mississippi, shooting birds and small animals with guns, catching fish with rod and reel, learning how to handle domestic beasts—these things are as unreal to the average city boy as chateau life in the Loire.

The games of the big city boy, in my youth, were mostly invented by him. The tools were discards of the industrial revolution—old bottles, garbage can covers, broomstick handles. We had spinning tops and checker boards, to be sure, but who in Salt Lake City ever heard of stickball? This is baseball adapted to busy city streets, using a rubber ball and a broomstick for a bat, with a manhole cover as home plate. Cheating traffic, you learned to move fast.

When we went into the armed forces during World War II, we began to realize how pitifully meager was the shared experience of the gutter-wise and the forest-shrewd. We had almost nothing to say to each other, except G.I. matters. What could a guy who learned his fundamental human attitudes, and not a little of his ethical values, from a Seventh avenue poolroom, say to someone of his age who grew up in a town dominated by an Elks Hall, Boy Scouting, and 4-H thinking? Result: The city guys shared their past and the country boys theirs.

In a quite real sense, a New Yorker is the most foreign of Americans. This applies especially to the first-generation Americans, of which I was one. We lived on an island, off the U.S. coast. It was our proud boast that none of us had ever crossed the Hudson river, even to take a look at fabled Hoboken. None of us ever would. That might still be true, had not the war changed things, and uprooted us to God knows where,

usually someplace where we began to take over like cocky missionaries, until we learned better.

What separates the New Yorker, and other big city kids, from his country contemporaries, is the way he relates to people. No matter how he smiles, no matter how readily he presses the flesh, no matter how great his charm, the first fact to remember about the born New Yorker is that he distrusts you. He distrusts you if you are from his neck of the pavement. He distrusts you mightily if you are from somewhere else. The asphalt jungle is no mere figure of speech.

If there are 5 million of you, as there were then, and not anything like enough to go around, as there was not then, you learned it was Number One or the end of the line. The other fellow was not someone to be helped. He was someone to be shouldered aside. If you didn't act on the principle that everyone had larceny in his heart, all the time, you ended up with a tin cup and a bunch of pencils, begging on the streets.

As for those other Americans we saw on stage and screen, who were always helping each other, giving away cups of sugar to people called neighbors, joining in waggery called community efforts, holding hands while they sang songs about something they called their country, I used to wonder, and so did the guys on my block: "Who's writing their crap?"

'Mickeys'

The other day a young chap who knew of my interest in slang asked me if I knew how the word "mickey" came to mean a half pint bottle of whiskey. I had known the usage on both the West and East coasts; but neither my dictionaries nor my raffish friends knew much about how the name got attached to the bottle.

The nearest I could come to it was that workmen liked that size bottle because it could be easily slipped into the rear pockets of work pants or overalls. And since the fondness of the Irish workman for distilled spirits is well-known or well-imagined, the term mickey got stuck on the bottle. Not really satisfactory, though.

While rummaging around the old brain, however, I did come up with another use of the word mickey that brought back rather fond memories to me. When I was a kid on the streets of New York, roasting mickeys was a social ritual almost as ubiquitous as street fighting and stickball.

The mickeys were potatoes, and their name came from the undoubted fondness of the Irish "micks" for the tuber, which is usually called the Irish potato. Nearly all of us were Mc something or other.

Mickeys began to be consumed when the weather began to get cold, which was about the time school opened those days, and did not stop until it got too cold, which was just before Christmas. (In those days we put on a topcoat on September 15 and changed to a heavy overcoat on November 15. Where has this custom gone, or has the weather really become more clement in the past half-century?)

The potatoes were roasted in garbage cans with holes drilled in the sides to give the fire some draft. As soon as darkness began to fall, which was about 5:30, a Swede who called himself Sly Fox would gather together all the kindling and coal he had been able to forage over the day. It was Sly Fox who started and tended the fire.

We all, that would have been six or eight of us, had our own mickeys and kept them in the pockets of our topcoats. The fire was started across from the firehouse on 102nd street near Columbus avenue. The garbage can was placed in the middle of the street where the firemen could keep an eye on it.

Before we actually got around to cooking the mickeys, we

warmed our icy hands around the growing fire. It was not until the fire was nearly gone, and only the embers left, that we threw in the mickeys.

You could not exactly say that the mickeys were cooked. More like carbonized they were: sooty black on the outside and medium soft within. You ate the whole thing, soot and all, and I can assure you it was delicious. Potatoes have never tasted as good to me since.

A great part of the charm of the institution of mickey roasting was that it was surreptitious. If our parents had known about it, they would have whaled us to death, what with spoiling a good dinner of meat and potatoes with that burned-up stuff.

The mickey roast was also a true social occasion. Who got beat up by Brother Charles that day compared notes with who got beat up by Sister Theresa in one of the lower grades.

If the sparks from the garbage can sometimes flew too high, one of the firemen would come over to caution us. We would give him an especially fine mickey on the end of a stick, and all was forgiven. The mickey was for me a part of growing up, and certainly one of the truly pleasant parts.

The Park

Central Park was a decided part of my growing up in New York. When I was not in school or at home, I was in the park, nearly always by myself.

The park was my home in a sense my home could never have been. You might say I lived at home, but my dreams, which were to me a much more important matter, were spelled out in the park.

This rectangle of greenery that started on 59th street and ended in lower Harlem at 110th street was my refuge from home and school. I spent nearly all my spare time there, with a book or several books.

Through some accident I discovered a volume of "Little Essays" of George Santayana, collected by Logan Pearsall Smith. This book was a revelation to me. I spent weeks alone reading it on the grass.

Santayana's ancestry was half New England and half Spanish. His first language was Spanish. His English was exotic. To me it was almost painfully beautiful.

That large red book taught me the power and pleasure of written English. Reading it totally changed the course of my life. I knew I wanted to be a writer, and have never had real cause to change my mind.

Of course I read other books, hundreds of them, in my Central Park eyrie. Nearly all of these came from the New York Public Library Branch in lower Harlem. Macaulay, Hazlitt, Shelley, Mark Twain—nearly all the apparatus of English culture as expressed in books.

My solitary life in the park was almost blissfully happy. I never talked to anyone unless he talked to me first, and that was seldom. I treasured my secret life as a miser.

I took my exercise there, running early each morning around the reservoir below 96th street. I practiced elocution there, mouthing grandiose periods from Macaulay and Cicero to the cold air of winter's night in The Meadows, as we called the playing fields around 100th street.

Above all, there it was I made my plans to conquer the world. These plans were made in solitude, and never conveyed to anyone. They were based on an amorphous, unfocused but wholly driving ambition.

Like those of almost any "dreamy" youth, my ambitions

could be put simply enough: I would run the world, somehow, and bring my enemies down. Friends did not play any part in these basically bitter dreams.

When I played games, they were solitary ones. Mostly, I was a refugee, pursued by all kind of evil forces. I knew the shortcuts that could bring me through the bushes from point A to point B with incredible and cunning swiftness, like a deerstalker.

My castle was an old locked-up blockhouse near 110th street, the upper limit of the park. It was about 20 feet high, and for most boys unsurmountable. I was an agile lad in those days, and I found a way to do it. There I was truly king of the mountain, among the rocks and rubble of the 19th century.

One place in the park that was romance incarnate to me was Cleopatra's Needle, down near the Metropolitan Museum. This landmark is a slender stone obelisk more than 3500 years old. It had been given to the United States by the Khedive of Egypt in 1877.

In the nearby Met I spent hours before a single picture. This was the gloomy magnificence of El Greco's "View of Toledo." The attenuated gloom of those buildings and of those clouds more or less comprised my world-view at the age of sixteen.

Do not think life in the park was all that gloomy. It was just that I was deep into the Romantic Poets, and the eccentricities of the "Yellow Book" crowd, and made a profession of viewing the world darkly. I was Don Juan and Oscar Wilde and Heathcliff from week to week. In the fastnesses of the park I could play all these roles, and be undetected.

It was as far away from the bustling city as I could get, and that was fine with me. I was the descendant of generations of Irish farmers. Something in me responded to the green of the grass and the brambles of the field. To this day, I regularly need doses of wood and trees to refresh me from the tensions of city life.

I often re-visit the scenes of my odd, private youth. It is saddening, of course. The degradation of this beautiful place is old hat now. Yet it is still the least-changed place in New York. The thing that has changed is me. I look back on the vitality and thrust of that dream-besotted boy. I can scarcely believe it was me. The park reminds me though, with a windy sigh of leaves.

Sinning

*E*very Saturday night, when I was a boy, I was thoroughly cleansed. This meant morally and physically. The moral cleaning was administered by an Irish priest who was available in the black confessional box of Ascension Church on 107th street. The physical cleaning was administered by my mother. It was my only bath of the week.

This ritual was performed in the two laundry tubs in the kitchen of our railroad flat. We only heard, distantly, of bathtubs. I guess my mother took her bath in the same two tubs when her sons were away at school.

I dreaded the two rituals. The one in the black box was worse than the one in the tub. You got in a long line of kids, most of whom you knew. You were supposed to be making an extensive examination of conscience, but mostly you were figuring out what Eddie Maher or Tommy Ahern were going to tell Father Murphy. Sometimes you knew the sins because you had participated in them; sometimes you only speculated. It killed time.

Eventually your time came. You entered the black box. "Bless me, father, for I have sinned . . ." Then you entered into your rigmarole. I don't know how the Father Murphys of the world stood it. The sins of Catholic boys in those days were as formalized as Japanese haiku.

They all involved sex and its various permutations. The most common of these sins was "having evil thoughts." This involved having dreams in which unspeakable acts were performed by you and Miss Juney Sheehan, or one of her classmates over at the other end of the school. There was no coed stuff for us Irish boys and girls.

When all was finished and you got absolution, you made an act of contrition and a "firm purpose of amendment." This courtly phrase is what I gagged on. It was your holy promise, given to a man of God in a sacred place, that you would not any longer commit the sins you had just confessed.

At least that was my interpretation of the phrase. It seemed crazy to me then, and it seems crazy now. What I was doing in the confessional was describing my own nature, or the dark side of it.

How could I have "firm purpose of amendment" about the way I was made and the habits I had, and I knew everyone else

had? How could the priests tell us about original sin in the classroom, and expect to erase that original sin after receiving absolution in the box?

I never figured that one out. I felt like an ignoble liar every time I made the promise and a hypocrite for hours after my encounter with the priest. I went my wicked ways in due time. Until next Saturday when the whole moral charade was repeated.

I suppose this ritual marked my first break with the church. Before I had had that pure faith which could believe anything, and was often asked to believe in what seemed patent absurdities. Mere faith in God, on which the whole system was based, was an absurdity if you lacked faith.

But I could not deny my nature just for a promise to a cassocked priest. I could not deny sexual feelings. I could not deny that they were often at their strongest in church, watching the virginal girls walk up to the altar to receive their Holy Communion. I often looked at their legs instead of keeping my head bowed in prayer.

The result of this was that I felt a terrible bad hat. I did not think that most of my male schoolmates felt quite the same. If I had I would have rejected the consolation. Being a bad hat can have its own, private pleasures.

Passions

The other night my pedantic friend asked me, "What are the transcendent passions in your life?"

The answer came, quick as lightning: "Books, women and baseball, though not necessarily in that order."

Later, I got to thinking how the answer was so quick and so certain. First, baseball, or, as it used to be called, "the national pastime."

My passion for baseball was possibly the most intense of any feeling I had about anything. Also, the briefest. It lasted three years, from age 6 to age 9.

This passion, like most, ended in tragedy, and my interest never really rekindled though fate put me in the position of writing about baseball in the pages of the Chronicle many years later.

I lived in New York City as a kid. I lived for the New York Giants under the management of John McGraw. In those days the Giants were arguably the best team in baseball.

My feeling for the Giants was so strong that I could recite the regular playing teams way back to the days of the great catcher Roger Bresnahan. That was about the beginning of the century. I got in arguments about this and other matters with men who had been Giants fans for 50 years. I usually won.

Then came the fatal World Series of 1924. The Giants under McGraw played against the Washington Senators under Bucky Harris. The series was even up, three to three, when they started the final and deciding game.

All through the series I had been as loony as a stamp collector. I couldn't eat, I couldn't sleep, and my mother would not talk to me. For the first time in my life I was caught in the grip of something bigger than myself, my family or anything.

I listened to that game on a crystal set I had made out of a quart cardboard container for beer. The Giants lost, due to a fluke I shall never forget.

An easy line drive to Freddie Lindstrom, the Giants' third baseman, hit a pebble on the field and flew over Freddie's head into the outfield, allowing the winning run of the game to be scored.

I was desolated, in tears or near tears for almost a week. I resolved I would never let anything move me so much again. I swore off baseball. For the next thirty-five years I saw maybe three games in which there was no involvement at all. So much

for baseball.

Women and books are other matters. I shall never get over these passions as long as I live.

The purest of the two is books. From Plutarch to Goethe to Scott Fitzgerald, I love unabashedly a good read. Early in life I learned that there were some bad books published, but I found it difficult to cope with them.

It is only recently that I learned to throw away a book that bored me, like much of William Faulkner and all of Agatha Christie.

On the whole, though, I have nothing to say against books. Those who write them are another matter, and will not be gone into at this point.

Women are another matter altogether. My best friends are men, for precisely the reason that my most intense involvements have been with women. For the most part my relations with women have been of the garden variety love-hate stuff.

The stronger my love for the last was, the more likely it was to fall like Samson's pillars at the end. Terrible scenes, passionate reconciliations—all leading to the final and bitter parting. Rather like baseball, in fact.

The Tootsie Roll

I was recently visited by a grandchild, an enchanting blonde sprite just entering her third year. When she departed after a visit of several days, she handed me a small brown object, wrapped in paraffin paper. This object proved to be a Tootsie Roll Midgee, a tiny version of the famous Tootsie Roll.

I do not eat candy, having dropped the habit about the time of my confirmation. After the midgee had lain about for a couple of days, I decided to chew it.

The effect was surprising. The candy tasted just as I remembered it, from my days on the streets of New York. The mere flavor began to act on me like that bit of madeleine which brought on the whole extraordinary saga of the Guermantes for Marcel Proust. The New York of the Twenties, when I was a boy, was vividly evoked for a few minutes as I chewed away on that tiny Tootsie Roll.

We used to buy our rolls, two for a penny, in a tiny Ma and Pa cellar store on 102nd street off Columbus avenue. The store was run by an elderly Jewish couple who were still learning English. They thought, quite rightly in many cases, that people only came into their store to steal the merchandise, and could be forced to pay only through the utmost vigilance.

On winter nights we would bring out our old garbage can, with holes for air around the lower sides. This can had served at least two generations of Irish kids in lower Harlem. Around six at night, when it was dark, we made a wood fire. When the fire was spanking, we cooked our mickeys, or potatoes.

I can remember when the high-spirited fire horses led the equipment to fires from the station house across the street. That was the equivalent of a kid seeing a plane take off, these days, or maybe even more dramatic. The firemen played handball, all day long, against the stone walls of the firehouse. This was my first spectator sport, and I followed the fortunes of one Big Red as though he was the greatest man in the world, as indeed he seemed.

The great men of New York in those days were the mayor, Jimmy Walker, and Babe Ruth, who hit home runs. Walker weighed about 90 pounds wet, but he was lightning quick on his feet, with an Irish wit that almost equalled Dan'l O'Connell himself. The mayor once defined smut-seekers as the kind of people "who like to go through a sewer in a glass-bottom boat."

The Babe was simply beyond explanation. He couldn't walk anywhere in the city without a hundred or more kids following him. Ruth was the living proof of what could be done by an Irish orphan from Baltimore who was thought by many to have a touch of the tarbrush. He once visited Doug Fairbanks and Mary Pickford, the great cinema idols of that time, and couldn't remember their names the next day.

The Irish ran New York in those days. You had to be a very bad hat indeed to get in trouble with the cops if you had an Irish name. Italian prizefighters became Kid Moran, or whatever, if they wanted to make it. If you were Irish, and made it through law school, it was almost impossible not to become a judge. An Irish cop was a minor deity, and an Irish priest was almost the Deity Himself.

We were taught to respect authority, to back the Giants and the Democratic party, which was Al Smith in those days, and never to leave our neighborhood, where we would be protected on all sides. It was pretty good to be an Irish kid in that place, though none of us knew it at the time.

cA Few Remembers

\mathcal{M}y seatmate on a recent flight was a little guy with the build of a jockey, about my age. The minute I heard his voice, talking to the stewardess, I made him.

He was from New York, and if I was not wrong he was from the West Side of Manhattan. The West and East sides are divided by nothing more exotic than Central Park; but they talk different, or at least used to, on each side of the park.

Turned out I was right. He was just my age, and came from the same neighborhood where I grew up. After introductions, we pranced into a couple of remembers.

"Remember the tar?" he asked. "Remember the horse manure?" I countered.

How could either of us forget the most memorable scents of the streets of New York in the early 1920s! They were always paving a street somewhere, not *re-paving* it, to accommodate Mr. Henry Ford's wonder.

There was some re-paving done, too. This was made necessary by the horses. There were a lot of horses on the streets then. I reckon I smelled as much horse manure as anybody brought up in the Blue Grass country. I still love the smell.

I lived around the corner from a firehouse on 102nd street. As the fire horses left and returned to the firehouse, they deposited their richly aromatic effluent on the streets outside.

My new friend remembered the tar. "Barrels of hard, shiny tar set out ahead of the pavers. Kids with grubby hands and broken fingernails chipped away at the tar with the accepted knowledge from their mothers that chewing it was good for your teeth . . ."

In later years my friend learned that this particular bit of hygiene was in the same class as the "fact" that wearing your rubbers made you blind, and masturbating turned your head into oatmeal, or worse.

One of his earliest memories. "A drayage horse in the street, dead, waiting for whoever it was that removed such calamities. While it seemed to be there for at least a week, it was probably taken away in a day or two. Millions, if not billions of flies attended the corpse."

Of course we both remembered the grocery stores of the day, piled 25 feet high with goods of all kinds. The grocers in those days were awe-inspiring guys. My new friend remembered:

"The skill those guys had with the pole and clamp to lift or tip things off the high shelves. Their beautifully written column of figures on the side of the bag, with a swooping line across the bottom, that they added with speed and undoubted accuracy."

In those days you bought butter out of a huge wooden barrel. The grocer scooped it out, with the skill of a good barman estimating just how much gin was needed to reach the top of a stand-up martini.

Unlike the aseptic supermarket of today, each store had its characteristic smell. The butcher shop smelled of meat, pungently and pleasantly. The grocery stores were a compost of smells, but they all came out the same way.

There were a lot of German pork stores in my neighborhood. They had things like blood sausages and other exotic Teutonic confections, which no good Irish family should touch, but which became staples in our house, partially because they were so cheap. The smell that prevailed in these shops was of sauerkraut. It was sold out of huge crocks, and was made on the premises. I've never been able to find kraut since that tasted so good.

First Glove

There may have been bigger days in my young life, but I cannot recall them. I must have been ten. It happened at a warehouse in 125th street in New York. That street is now central Harlem, but in those days it was still about half white, mostly German, and half black. It was the Main street and the Times Square of Upper Manhattan.

The period of preparation had been long and difficult. Hours had been spent outside United Cigar Stores, begging coupons from men who had just purchased their pack of Camels (15 cents) or their Roi-Tan cigar (10 cents).

I was one of a pack of kids who did this. Hungry little buggers that we were, we rushed the guys. Sometimes somebody bought a *box* of cigars. He had 10 or 15 coupons to give away (most of the men did give them away). He was J. P. Morgan in our eyes.

I was saving my coupons for what most of the other kids were saving them for—an infielder's glove. You needed something like 350 coupons for that glove. It took weeks of begging to get that much.

Buying a glove was out of the question, since it cost something like four or five dollars, and money of that kind was as inconceivable to us as owning a Rolls-Royce. You could go over to Central Park, in one of the fields where the rich kids from Trinity School played, and steal a glove. That was not only frowned upon. We just knew it was not right. Your glove had to be *your* glove.

The day came when I had enough coupons. The cigar store catalogue directed you to the warehouse where you traded in your coupons for a glove, or a coffee pot for your mother, or whatever.

The glove I wanted, and the glove I got, was a Frankie Frisch special. It was named after a gentleman who played second base for the New York Giants, and who was known as "the Fordham Flash," on account he had starred on that school's team before going up to the Polo Grounds. He was a great hero in the New York of those days.

They say that once you have fulfilled your heart's desire, there is a sense of anticlimax, and a long life has taught me that this is true. But it's not that way with a baseball glove.

A new glove is a shining and beautiful piece of leather,

usually produced by A. G. Spalding Brothers. But in those days it was hard, and a glove was nothing unless it was soft as a baby's cheek.

When you got your glove your affair with it was really only starting. You had to work it in. Each day after school I would go into what had once been the polo fields of Central Park (and where, long earlier, the Giants had played) and sit down with my glove and a bottle of lemon oil.

I sat on the grass with the glove on my left hand and the dime bottle of oil in my right. I poured the oil into the leather with the care of a great chef making a salad. Then I worked the oil into the glove. This would be done lovingly, and for hours.

I do not remember when I first used the glove in a game, or what happened to it in the end. But those days of making it soft and dark will always be with me. Baseball was the first thing I had ever allowed myself to love. If anyone had done anything to that glove, or tried to take it from me, I think I would have wanted to kill him.

Street Smarts

I know quite a lot about street fighters and street smarts because the streets of New York City were where I got my true education. I was born in Hell's Kitchen, and brought up in the upper West Side, just on the edge of Harlem. Arguably, this was the toughest school in the world at that time.

My contemporaries and I slept and ate at home, learned our lessons in a school building. The rest of our lives were lived in the streets. Our standards were those of the street, modified to some extent by the school and the church. The ways we treated people were the ways we learned on the corners and in the alleys. Our prejudices were sucked in like the air we breathed.

I got into more fights than almost anybody. Since I wore specs I was called "four eyes." Since I had a certain amount of Irish pride, this meant a fight. This meant one hell of a lot of fights—sometimes three a day.

These private fights were in addition to the organized ones that constituted our chief sport and amusement. These fights were usually staged—say for 5 p.m. Wednesday under the El station at 194th street and Columbus avenue.

Our sworn enemies as Irish protectors of the faith were the Italian boys, most of whom lived across Central Park on the upper East Side. The fights were strictly fist fights—no bottles or bats and certainly no knives. About 20 kids on each side would mix it up until somebody called a halt, usually somebody's mother or father.

Sometimes there would be a real brannigan. This would be held in the Meadow of Central Park, around 100th street. Maybe a hundred tiny battlers would be involved. In the vast emptiness of the Meadow nobody saw the fight and nobody could stop it. It ended when it ended.

I was born and grew up in the culture of street smarts. The people who grow up this way, whether in the East End of London, or in Lower Harlem, or in the middle of Chicago, are like the rich. They are different. And we recognize each other like a shot.

For centuries, the people of my parents had been tied to the bogs of Cavan and Longford. Their concerns and their culture were those of bog-trotters, and priest-ridden bog-trotters at that. Yet, within ten years, my parents had become as different from their forebears as a movie star is different from the ghetto

that may have produced her. That hard taskmaster, the streets of New York, had taught them things their ancestors had not reckoned on.

They passed this knowledge on to me, together with some ancestral wisdom and a lot of damned religious nonsense. The rest I learned on the streets myself. My view of life has been straitened, or broadened, by that street experience, and is to this day deeply informed by it.

The first thing you learned was that everybody was a thief. This was not just a phrase. It was an armory of wisdom. Whenever you dealt with anybody, the first thing was to put your guard up.

You were never to assume that the guy across from you was honest. That way led to peril most perilous. You were especially not to trust anybody who worked for the government, whether he was a cop or a clerk in court, or a bleeding alderman.

The only thing you could trust was your own capacity for escape. This involved being nearly as anonymous as possible. You never answered questions, no matter who asked them, no matter even if it was an old lady wanting to know the way to Houston street. Anything you gave, you were told, could be used against you. And you were told right.

The only people you could trust, in a limited way, were "your own kind." These were the Irish who came over from the old country the time your parents did, or a bit before. And you really couldn't trust them much, either, except when you were in trouble. Then the Irish were very good to each other.

Some of this bred-in paranoia left me as I moved about the world in my grown days. But I still cannot enter into a transaction with a fellow human, whether he be a waiter or a doctor or a judge, without the feeling that he is a thief, and wishes to take from me something I do not wish to part with, even if I cannot put a name to that thing.

The salient thing about this sort of wry gutter wisdom is that you are taught to be a survivor. But at what a cost! When I see people who are brought up gently among other gentle people, and who grow to be accepting and gentle adults, I realize the fierce price a street education costs.

To the kid off the street everybody is guilty until he proves his innocence. Everybody has a shiv hidden somewhere which he will gladly insert into your back when it is turned at the appropriate time. You think like this, you live longer; but there is a serious question whether you live better.

cA Whiff of Home

The last time I was in New York I made one of those melancholy pilgrimages to the scene of my childhood. I did not expect to see anything either inspiring or salutary there; nor did I. I had never been particularly happy in that childhood scene. But the attraction was irresistible if a bit morbid.

My neighborhood centered around the railroad flat my family occupied between 101st and 102nd streets on Columbus avenue. When I was born we lived in the Hell's Kitchen area. We moved uptown to Columbus when I was about 3, and lived there until I was 13. It was then almost 100 percent Irish immigrant stock, with a sprinkling of Germans and Italians.

I had not returned in over 40 years. The immediate neighborhood is now completely wiped out. It is replaced by a huge housing project of highrises between Columbus and Amsterdam avenues, connected by concrete pathways. Nothing remains. The colors are now black and tan. The usual truculent graffiti, in Spanish and English, speak the anger of the inhabitants.

I could not help thinking, not without the sentimental distortion of all who seek a whiff of early home, that the neighborhood had gone to hell. Doubtless the Puerto Ricans and the blacks living there now will think the same thing by 2010.

There was one definitely exotic thing on Columbus avenue in the 20s. This was the Chinese laundry. The guy who ran this one was Charlie. He drank water and then spat it out through his teeth on the dried shirts he was about to iron. The Sanitation Department would have a word to say about that, these days.

I heard about what happened to Charlie from another fellow who visited the old neighborhood, and who was about ten years younger than I:

"The laundry guy was the only Chinaman I ever knew who drank. Maybe it was the neighborhood. He was an old guy, all bent over from years of ironing. When he stood up straight to get you your shirts, he had to do it in stages.

"He had an awful temper with his load on. I'll never forget this one day, hot like today, he went wacky. The ironing and the boozing and the bad back and the heat must have all ganged up on him. He hollered and screamed and cursed and then he grabbed his shears and cut the sleeves off every shirt in the place. All the business guys in the neighborhood had to buy new

shirts for work."

I slept in the front room of the tenement, no more than twelve feet from the Ninth avenue elevated, which at nighttime roared noisily past us about every 14 minutes. I learned to sleep through the din, but I never got over my hatred of noise.

We were all poor in that neighborhood. Twenty bucks was a big salary for the breadwinner to bring home. But we never thought of ourselves as poor, so long as there was food on the table.

The only time we thought poor was when we saw the rich kids from West End avenue and Central Park West. These guys owned real baseballs. We used ones that had the hide knocked off and were covered with black friction tape. They had real bats. We had discarded broomsticks.

They wore wrist watches. If one of us ever wore a wrist watch, the others knew where it came from. It was loot from one of the periodic raids we pulled on the rich kids from Trinity School as they were walking home from their late afternoon baseball game in Central Park.

As I walked beneath the highrises I found myself saying things like "dispensa me" and "buenos tardes" and "eso es un gran barrio." Places like Columbus avenue are contemptuous of their past.

On His Early
Days
in Journalism

125th Street

One Hundred and Twenty-fifth street is the Main street of Harlem in New York City. Though I did not have a job on a newspaper at the time, which was 1935. I covered one of the biggest stories of my time on that street, and got paid for it—$100 from the New York Daily News.

Though I lived south of Harlem, this was the place where I spent most of my life, a solitary white boy among blacks and Puerto Ricans. I loved the colorful activity and sheer strangeness of the place. I also spent a good deal of time in the 115th street public library reading the strangeness of Joyce and Shaw and Ibsen and hundreds more.

On the night of March 19 I was walking along 125th street near Sixth avenue. I wanted to see what was the attraction at the Apollo Theater, where the great black bands of the time played—Jimmy Lunceford, Duke Ellington, Cab Calloway, et al.

I soon realized that something crazy was going on. A mob was forming down around Seventh avenue. It was all black and very angry about something. I knew the ways of Harlem pretty well, and kept to the middle of the street.

There was chaos all around. I was in the middle of the first great race riot in this country. I asked what started it all, and was told that a black child had been beaten to death for stealing something from the Woolworth's store near Seventh avenue. This turned out to be untrue. The boy had been reprimanded for stealing candy. He was released by the store manager after he had bitten two clerks.

But the rumor had gotten started and spread like a raging fire. The crowds started gathering about 6 p.m. All the resentment of the blacks of that day against the white merchants of Harlem erupted. Men and women, police said about 2000 of them, smashed windows, looted stores, and attacked pedestrians.

The crowds forcibly resisted the efforts of 250 policemen to disperse them. Order was not restored until the early morning hours after one man was killed and scores injured.

At midnight more than a dozen men and women were under arrest. Scores of suspects were being questioned in district police stations. Two policemen had been taken to the hospital, one in serious condition. Police said that more than 200 plate glass windows had been smashed. A dozen victims of rocks,

sticks, knives and revolvers were treated by ambulance surgeons.

Early in the commotion I went over to the police press room which was then situated on Seventh avenue in the Hotel Theresa. I called the city desk of the News and asked them if they wanted some color on the story. They said yes, and gave me a rewrite man to tell him what I had found out. Since I knew the News had a regular staff man and photographer in the press room I did not bother with the running story, but just gave little anecdotes.

When I finished the rewrite man told me to go back and get some more details. I covered the story until about 2 a.m. I never got a byline, but it was great seeing facts that I had dug up reported in the newspaper with the largest circulation in the city.

What brought all this rioting to mind was a story I read recently about an ambitious attempt by city, state, and federal governments to fund a revival of 125th street. The proposal, all on or near 125th street, consists of a shopping center, the Harlem Cultural Arts Center, the 125the Street Mart, a Studio Museum and an International Trade Center. To me the dowdy old street will always be where I first tasted blood as a big city news reporter.

Unipress

*"After catching his wife in bed eating
caviar with a local plumber, millionaire
Marvin Marvin shot her to death, and as an
afterthought shot her dog too."*

I wrote that lede just about as fast it came to me. If I believed the wisdom that prevailed in the United Press organization when I worked for it that lede and the story following would appear on the front page of every newspaper in this country that carried UP copy, and doubtless would be promptly stolen by the other wire services of the time, AP and INS.

The lede has the four ingredients that were guaranteed to get maximum attention of news editors just after the war. And I am certain, for hundreds of years before the war and it will never change. Sex, food, money and dogs—these are the ingredients of the perfect wire service story. That is, one that sold.

I don't know who first told me that one, but it works. I think my mentor was Freddie Othman, who wrote a fine column out of Washington. Freddie used to have the typewriter next to mine. He read recondite publications like Barron's and the Institute of Naval Proceedings and the Harvard Alumni Magazine to get ideas for his columns.

Freddie has a deathless lede to his credit. He was covering the famous Errol Flynn sex trial in Los Angeles just after the war. New York kept yammering for sub stories every half hour on the hour, on the hour, so great was the national interest in the story. Once there was absolutely nothing happening in the courtroom. Freddie filed a lede off the west wall, starting:

"Errol Flynn strode into court today, cocky as ever . . ."

Though at the time I didn't think so, in retrospect I had a hell of a good time working for the United Press (Unipress to us hirelings) in Washington for three or four years after the war. I used to meet David Brinkley at the Coke machine every morning. He was working for UP radio news and he was good even then.

Our star feature writer was the aforementioned Othman. Everybody was a good reporter or he wouldn't have been in the Washington bureau. We had Allen Drury, the now successful novelist, up on the hill covering Congress, and Merriman Smith at the White House. Smitty was the senior wire service reporter and he had the honor of saying "Thank you, Mr. President," thus ending press conferences with the leader.

Charlie Corddry, who took my job when I left, always wanted to work for the Baltimore Sun. He is now their defense correspondent and a public broadcasting celebrity as well. Graying but fractious as always.

Leaving the United Press was often a heart-rending experience for those who left, but never for those who were left. The boss would continue reading whatever he was reading when the announcement of his great loss was made. He nodded his head and said "Good luck," and shook your hand. That was it.

I left for the highly-principled, as I thought at the time, reason that I had married into the Scripps family who owned the outfit. Visions of accusations of favoritism danced in my mind. My fears proved totally groundless as I got to know the Scripps family. I never knew of anyone who quit UP who didn't get a much better job as a result.

Off the West Wall

I was reminded of Frank Bastable by a piece on old-time New York newspapermen written by John D. Tierney. Bastable was one of those elfin newspapermen who was never content with a story the way the reporter phoned it in. He often liked to add his own brushstroke. He was a rewriteman for the American when I was a reporter there, so I know.

Tierney tells a famous story about Bastable. In Tierney's words: "Once on a routine $40 candy store holdup, he (Bastable) invented a little child to whom, he told his paper, the escaping robbers had presented a raspberry all-day sucker as she skipped rope on a sidewalk in front of the store.

"Shortly every other reporter in the police headquarters group was charged by the city editor with mental deficiency for missing the little girl angle of the story. 'You want a little girl?' they all replied. 'You'll get a little girl.' They found one in the neighborhood, gave her a lollipop, and had her photographed in front of the candy store. As a result of the publicity the child had a brief career in vaudeville . . ."

Tierney calls this harmless form of fiction a "piped" story and infers the name came from the proximity of Chinatown to police headquarters in Center street. Using the opium connection is, I think, overelaboration. Even in those days pipe dreams were well known, and the pipers specialized in pipe dreams, especially on dull day.

In the United Press we had the same institution. It was called, with even more appropriateness, writing off the west wall. I was a great west wall artist in both the San Juan and the Washington bureaus. Say a dull day, like any Saturday, arrived in Washington. The following little conte might be filed to San Juan, after due consideration of the west wall.

"Informed sugar circles predicted a rise in the price of beet sugar after Franklin Roosevelt's recent political swing through the Midwest States, etc. etc."

Now there may have been some truth in this story; but if there was it was purely accidental. When it became fairly certain that Harry Truman was committed to the idea of a Puerto Rican to become the first native governor, I nominated, at one time or another, every Puerto Rican who had run for office since 1898. Some were nominated on no more substantial grounds than that they liked baseball, and therefore were

terribly pro-American. EVERYBODY in Puerto Rico liked baseball, whether he was pro-American or anarchist.

Damon Runyon also worked for the American. He was covering the trial after which Ruth Snyder and Judd Gray were executed for the murder of Mr. Snyder. After Gray's testimony, Runyon wrote one of the great newspaper ledes:

"A plain little man in a plain gray suit sat on the witness stand this afternoon and talked his life away."

The Lindbergh kidnapping story was probably the greatest newspaper yarn of the century and produced the greatest number of pipe dreams. Sometimes three of four ledes a day were required by the New York dailies and there weren't that many facts around.

In this emergency a creature by the name of Jafsie was practically invented by the press. Jafsie was a retired public school principal whose real name was John F. Condon. He had the Irish propensity for a good story. And no one that was ever suggested, did he turn down.

I had a weird interview with Jafsie once myself at the Bronx reservoir in the dark of night. This was a favorite rendezvous of Jafsie. I haven't the slightest remembrance of what he told me but I knew that it would make the line in the first edition of the American. Jafsie was hot that month with the authors of piped stories.

Police Reporting

Like most people in the reporting and writing end of the newspaper business, I got my first training hanging around police stations and telling anything that happened there to the City Desk, if I thought it was worth the attention of that august board.

This meant that my working day was spent with policemen and with the victims of crime, and with unknown people who fell dead in the streets, and with kids who were lost and wives who were beaten up. There were also murders, and safe-and-loft jobs, and stylish burglaries, and real rapes and fake rapes, and gang fights and gang jobs.

This contact with the underside of life was both educational and traumatic. It must have been both, to a tremendous degree, to the boys from Yale and Princeton and Columbia who came to work for the Times and Herald Tribune.

These boys had mostly been brought up in places like Westchester county and Fairfield county. Their first sight of the results of two Genovese carving each other up, or a black guy with his privates cut off, or their first trip through the morgue, must have shaken them up in ways that stayed with them forever.

I was not that far way from the material I saw and covered. The victims and the cops were people I grew up with and often people I went to school with. There was a saying around the Ascension parochial school that most of the graduates there became priests or cops or ended up in Sing Sing.

I was hardly ever surprised by the evil that men did to each other. That was in the book. But I was shocked, and sometimes to my heels, by the results. The *sight* of the results of violent crime is something that never leaves you.

I can never forget one gang killing. A guy from the old Owney Madden gang shot up a fellow from a downtown gang. The body was found near a meat plant on the East River. It was a machine-gun job. There was a vaguely circular pattern of bullet wounds around the torso.

I asked a guy in homicide why the art work? He explained that the modus of this particular assassin was to try to leave the fatal wounds in the pattern of a heart, just like the bleeding Sacred Hearts that hung over so many of the beds of the Irish and Italian families in the neighborhoods.

It is popular wisdom that seeing things like this, and

hundreds of other bits of pointless human cruelty, makes reporters cynical. They become the Hildy Johnson caricature of Hecht and MacArthur, smart-cracking mockers of real human feelings and aspirations.

That may be true of some reporters, but the truth for most of us, and certainly for me, was rather worse. We did not become cynical; we became apathetic. We got to feel the way doctors learn to feel about blood, and lawyers about passionate human quarrels.

We turned our faces away from the deepest wells of feeling in our own species. We did it because we thought we had to. After all, how much sleep can you lose because two likkered-up Irishmen used pistols on each other to compose differences about the Sinn Fein? Or because a Puerto Rican baby was bitten to death by rats, while the rest of the starving family looked on? There was just so much compassion you could expend on so much wild passion.

I've never really gotten away from that training. I don't want to help desperate people in the streets. I don't want to hear the tragedy-laden life story of a stranger. I know that the chances are only too good that I shall one day crumple in a doorway on a mean street, and the cops will be called only when my body becomes a nuisance. That's the way things are on the police beat. Why should they be different with me, even though I am white?

'Gimme Rewrite'

*O*h for those glorious days of the '30s talkies when Lee Tracy or Jimmy Cagney tore the earpiece off an upright black telephone in the press room and yelled at the operator, "Gimme rewrite I'm goin' to tear this town apart."

The rewrite man was the elderly alcoholic who took the exasperated gibberish of the star reporter and turned it into tidy, libel-proof prose. In those days it was as impossible to imagine a newspaper city room without rewritemen as a composing room without a linotype.

Today there are damned few linotypes, and the days of the great rewritemen are coming to an end. Today the reporter is also the rewrite man, and he may operate hundreds or thousands of miles away from the city room. His tool is a "portable word processor" that weighs about 28 pounds, which was about the weight of the Underwood portable I used to carry around on out-of-town assignments when I was a tad.

They tell me the working of these electronic devices is child's play; but I doubt it would be for me. In my days I mastered the typewriter, but it was heavy going. When I finished a story I gave it to a Western Union telegraph operator. These guys were marvels. They could punch my story, and I was and am a fast writer, in about half the time it took me to write it.

Now, thanks to the computer revolution that has hit the newspapers, the reporter just types his story on the "portable word processor" and ties it into his newspaper by telephone.

Connecting attachments known as "rabbit ears" allow the reporter-rewrite man to place a normal telephone receiver into two acoustically sensitive cup-shaped rubber couplers. The story is then sent from one terminal to another.

The reporter can also act as the copy desk. He can edit his story, transmit it, or receive printed instructions from the office, and do it more cheaply than using a Telex.

Naturally I grieve for the loss of the rewrite man. The greatest one I ever knew was a sports writer named Davis Walsh, who worked for International News Service. He was so good he became sports editor of the wire service.

The Walshs were an old Irish Philadelphia family. Dave was a boozer of prodigal proportions. His brother was a doctor who ran a famous "sanatorium" for drunks outside Philly.

Every once in a while Seymour Berkson told Dave to visit his brother's place or it was the sack. Dave would spend a month or so on the dry. When he came back he was put on sports and regular rewrite, for he could handle everything.

In these days Dave, who dressed as if his clothes had been hosed-down every week or so, would begin to sport a white carnation in his buttonhole "to celebrate his rehabilitation."

I watched Dave sit down for an eight-hour stretch, without even taking lunch, and turn out daily a string of faultless copy that often amounted to 10,000 words. He never took the earphones from his head.

He often, however, moved his head down to his chest. Everybody in the office knew he was sucking at a rubber attachment in his carnation that was attached to a bottle of Old Grandad inside his jacket. When he had done noble service on rewrite—he always walked away sober as Billy Sunday—he was made sports editor again. Life was tougher there, and Philly and his brother loomed again.

'Efforting Utmostly'

*O*nce upon a time I used to be what was called a foreign corre-spondent. This was a newspaperman who lived abroad and wrote cables. Cables, in those days, had to be written in a special lingo called cablese. This was a highly shortened method of communicating which eliminated most prepositions and con-nectives, and combined words in a most imaginative manner.

This was done, of course, to save money, as you paid for cables by the word. The organizations we worked for were in a perpetual economy wave, which was called, in cablese, down-hold. Cablese certainly trained you in concision of expression. The best rewrite men were usually former cable writers.

The New York cable desk might send you the following: "Need utmostly westwaller resugar." This meant that, since there was no hard news on sugar, it might be a good idea to send newspaper clients in sugar areas like the Caribbean and Hawaii and the Philippines, a lot of speculation about the economics of sugar, its production outlook—and, of course, its possible price.

If you could not produce this stuff immediately on demand, you sent back another cable: "Efforting utmostly sugar." Eventually you wrote your piece, studded with sentences like, "Cuba productionwise backfalling miltons biannually." You never used two words when you could use one, even it it wasn't altogether clear.

In fact, it was because inexperienced stateside rewrite men began to make too many mistakes that the Associated Press and the other wire services abandoned the use of cablese, and used all the buts and withs that were needed for total clarity and fewer libel suits.

We newsies used to collect examples of masterful tele-graphic concision. The best was an ancient wheeze about a college student and his father. "No mon, no fun, your son." To which his old man replied, "How sad, too bad, your dad."

My own favorite combined masterly concision with one of the best puns I've ever heard. It's a British story. Alastair, let us call him, had been to Eton and had just been graduated from the military college at Sandhurst. It was around the turn of the century. Empire was truly in flower, with Lord Curzon running his gaudy show as Viceroy of India.

Alastair had his commission, but no army, no objective, no nothing. The War Office put him on a P and O ship, headed for

India, with the simple order, "Take Sind." Sind, which figured much in recent dispatches from West Pakistan, was and is a province on the Arabian Sea.

Alastair, on landing, was given troops and supplies and interpreters, and sent on his way. He was not heard of for months, which was in no way surprising. He finally surfaced with a single word cable addressed to the War Office "Peccavi." This is Latin for "I have sinned."

Another stirring example of cablese was what is probably the shortest, and most certainly the worst, poem ever written by an English Poet Laureate. Again around the century's turn, Edwardian poet Alfred Austin wrote his lines "On the illness of the Prince of Wales, afterwards Edward VII."

Across the wire the electric message came,
He is not better. He is much the same.

It cannot be doubted that writing messages for Western Union and Mackay Wireless and All America Cables was an excellent school for aspiring authors. Many people say Hemingway's tersely loaded style came from his experience as a foreign correspondent for The Toronto Star. Certainly his stuff reads that way.

"To be brief," said Santayana, "is almost a condition of being inspired." The Lord's Prayer and the Gettysburg Address are the things kids should use as models of English prose, if anybody worries about that sort of thing any more. There is nothing which cannot be said briefly, if we would all effort utmostly.

My Days with 'My Day'

I recently read with great relish Joe Lash's book on Eleanor Roosevelt, wife of F.D.R. It recalled my brief but action-filled encounter with that remarkable woman during World War II.

Mrs. Roosevelt made the trip to the Caribbean in the days when German submarines made it a bit dicey down there. All kinds of elite Navy types were looking after the safety of the First Lady. It was not with the First Lady that I was concerned, but with a lady newspaperman who was a considerable financial asset to United Features Syndicate because of her daily column "My Day."

United Features was a sort of cousin to United Press, as both were part off the Scripps-Howard organization. I was a war correspondent, based in San Juan, for UP. Ergo, I was to keep an eye on Mrs. R. and edit and file her copy by cable. The filing, as I recall, was done through the Office of Naval Intelligence. This method was safe, and the price was right.

Mrs. R. tootled around San Juan and the interior of the island, making charming noises to everybody. Occasionally, she was a bit indiscreet. She offended the island's two Roman Catholic bishops with her outspoken advocacy of birth control for the tiny, overpopulated island. A naval aide gave me the copy of "My Day" promptly each evening at 6 o'clock and off it went.

After a bit Mrs. R. left for a tour of the other islands, and the military bases thereon—Cuba, Curacao, Aruba, etc. I was unable to leave San Juan, so the column was to be handled by an ensign from O.N.I.

Such was not to be, however. Some giant snafu developed. The column was not getting to New York. Frenzied cables to and fro. Mrs. R. meant a lot of loot for United Features. Something really had to be done. We knew Mrs. R. was alive, because the White House told us so; but her diary was going out into dead air, if indeed it was going out at all.

Somebody in New York made a statesmanlike decision. Charles McCabe was to become a nationally syndicated columnist, under the name of Eleanor Roosevelt.

Now, with deference to her many remarkable personal characteristics, Mrs. Roosevelt was no Jane Austen. Her column, which was about her daily doings, always read to me like an Irish biddy in a New York tenement regaling her friends over the clotheslines with what her husband Mike was doing. Or a

letter from a 14-year-old to her mother. But it was riveting stuff, since the lady was wife of the civilized world's top dog.

I wrote two of those columns, entirely off the west wall, as we say in the trade. I kept the Irish biddy in mind, and it worked well indeed, for I got a bonus from UP for the job. Bonuses weren't things UP gave out very often.

I can't for the world remember what I wrote; but I knew I included the hoariest and safest of all Caribbean anecdotes. Columbus is asked by Isabella what Cuba, or Santo Domingo or Puerto Rico looked like. The old navigator takes a piece of parchment, crumples it in his hand, and throws it on a desk. That, indeed, is what these island volcanic tips look like.

Mrs. R. got in touch with her public again, at about the same time I caught up with her in Aruba, a Dutch island. She was engaged in a characteristic task. There was a venereal disease section in one of the hospitals, and U.S. sailors lay there with a hairy collection of the ailments which result from love. Mrs. R. was shocked to her slippers.

She insisted that the Roman Catholic bishop of the Dutch islands make an inspection of the afflicted swabbies. The lady wanted to move that worthy's heart, at the plight of the boys, and maybe permit sale of prophylactics, or even set up pro stations. The white-haired bishop, accompanied by Mrs. R., inspected the boys and their eruptions. Mrs. R. awaited his reaction expectantly. "The wages of sin," said that man calmly, "is death."

Lady from Hastings

I have just looked at the back of the entrance door to my flat, and read for the hundredth time a text of Sir Willmott Lewis which is tacked there . . .

Extraordinary fellow, Sir Willmott Lewis. Now gone, of course. Was Washington correspondent for the Times of London in the days when that paper was called The Thunderer, and the words meant something. To us younger journalists, he was the Voice of Britain, even more than whoever the incumbent ambassador might be. When we wrote "London reaction" in our stories it was usually something Sir Bill, as he was always called, told us over a drink at the National Press Club. His evaluation of his country's position on a given issue was seldom wrong.

This is perhaps because he had been an actor in his youth—a barnstorming Shakespearean trouper in places like South Africa and Australia. His voice was magniloquent and stagey; his pauses were passionately pregnant, his periods involved and convoluted. Actors have empathy. The role he played was a sort of caricature of a British diplomatist. He played it well. He worked like a dog at his newspaper job, but never seemed to work at all. "I drifted into this sort of work in Manila," he said, "and just kept drifting."

Sir Bill was married to a lady from the Noyes family, which owned the Washington Star. The family also owned the largest silver martini shaker I ever saw—held a couple of gallons, if it held a gill. On Sunday mornings Sir Bill would be chauffeured down to the Press Club in his Rolls, with the huge filled icy martini shaker by his side. Then he would administer to all the hangovers in the Club. This couldn't be done otherwise at the Club as there were funny liquor laws in the District on the Sabbath in those days. Beer and wine, and you couldn't stand at the bar.

Sir Bill would have been a popular man even if he hadn't acted like a St. Bernard dog rescuing travelers with a keg of brandy about his neck. As it was, if he had told us Hitler was really an Old Etonian, we would have been strongly disposed to believe him. Anyway, back to the quote on the back of my door, Sir Bill's journalistic credo:

"I think it well," he said, "to remember that, when writing for the newspapers, we are all writing for an elderly lady in Hastings who has two cats of which she is passionately fond.

Unless our stuff can compete successfully for her interest with those cats, it's no good."

The whole ball of wax, of course. The job of a writer for newspapers is, above everything else, to grab the attention of the reader and, having grabbed it, not to let it go until the tale has been told.

This can be done, of course. If you have been around long enough, if you know the tricks, if you are a natural story teller, you can rivet attention with a seductive or a cannonading lede, and hold it with the pressure of your facts and the skill of your telling.

The real difficulty is not that it is impossible to please the lady from Hastings consistently. The real difficulty is when you think that pleasing yourself, as a writer, is more important than pleasing the lady from Hastings. This is the temptation we who write must always fight. We must make a decision, with almost each sentence we start, as to whether we wish to get read, or whether we wish to send messages. Sam Goldwyn was perfectly right when he told a screen writer, "If you want to send messages, try Western Union."

The sad truth is, when we oracles of print begin to get involved, when we start to enter serious enterprises, when we begin to belabor causes—we are alienating that old lady from Hastings. Those who like our causes will tell us in loudest terms how marvelous we are, because we will be magnifying THEIR voice; but we will be losing out to those damned cats.

There are days I know, and know damned well, that in my momentary passion for this and that, I'm losing out to those damned cats; yet so great is my perversity that I press on regardless. Sometimes I wish Sir Bill was around to edit me, in his graceful, heartless way. "The cats have won out," he would say, and drop the offending ms. in the waste basket.

The Checker Cab

There was a little throb in my heart when I read that the last of the Checker taxicabs had rolled off the assembly line in Kalamazoo, Mich. The phaseout of this huge piece of machinery reminded me of my youthful days as a copyboy and reporter in New York.

On the paper that I worked on, The American, when they called a cab from the head copyboy's desk, it was almost sure to be a Checker. I think the paper, owned by W. R. Hearst, had a contract with the Checker people.

The Checker was so high you could wear a top hat in it. It had jump seats, and five to a cab was not unusual. There have been tales of babies in strollers riding in a Checker.

For a while I had the job of calling the Checkers myself. It was something of a thrill to call one for MISTER Damon Runyon and the like. They came like a shot, for if reporters were not always in a hurry, they had to pretend they were.

Those were the days when there were six or seven papers in the city and competition was a very real thing. If a paper got a fact or a name that the other missed, it was sure to be included in the next edition of all the papers.

I did a lot of time and mileage in the Checkers, although the stories I covered were not of much consequence. Some of the older reporters had been city editors in places like Denver and Philly. It was mighty hard to break into their distinguished ranks.

I remember two particular Checker rides. Once I was sent to Staten Island to cover the funeral of some prominent Italian or other. The driver didn't bat an eyelid when I told him where I was going. This involved crossing from the Battery at the south end of Manhattan and taking the Staten Island ferry (for a nickel) over to the island itself.

The other ride was much more dramatic. As a copyboy I was sent to Lakehurst, N.J., where the dirigible Hindenburg was scheduled to moor. I was sent to pick up some copy from the reporter covering the arriving story.

The story was front-page material, but nothing sensational. It turned out to be one of the biggest stories of the century. More than a third of the passengers were killed when the ship burst into flames as it was about one hundred feet from the ground. The Checker waited for the reporter and a photographer, and

we went back to South street at breakneck speed. I even got to write a sidebar about the tragedy.

But mostly I covered Chinese baby beauty contests, ordinations of priests at St. Patrick's cathedral, and lots of funerals—Catholic, Jewish, Protestant.

The most rewarding thing about being a reporter in those days was the fact that you were one. Reporters were pretty important guys, and they knew it. They knew it and they knew the perks connected with the job. Some nightclubs gave you drinks at half price, or for nothing at all if you were important enough.

This was about the time the newspaper union, the American Newspaper Guild, was being organized by Heywood Broun. It was a mark of great distinction if you joined the picket line at the Long Island Press, where the Guild really got going. I marched in that picket line. I don't know how I got there, but I doubt it was in a Checker cab paid for by W. R. Hearst.

On Women

Belting

"A woman with a black eye usually deserves it." These are the words of Mrs. George Arvin, one of the waterfront sages who frequent my North Beach local.

There is much to be said for this point of view. There are, to be sure, ladies who get black eyes from causes other than manly. There are men who have never hit a woman in their life. These are lucky fellows who have obviously been going around with the right kind of ladies.

There are doubtless women who have never been belted in their lives. This is because they have been meeting the right kind of men, or have that rare and curious cast of character which consists in not asking for it.

We are not discussing, either, the proper brute. This is a man of strong sadistic cast who gets sexual pleasure from beating up on women. This kind of behavior is both criminal and deviant. It is the proper concern of the cops.

No, we are thinking of the middling sensitive man, who maybe strikes women four to six times in the course of his lifetime. It is in these cases, in my opinion, that the man is nearly always right and the woman nearly always wrong.

No ordinary man in his right mind would hit a woman. But there is the rub. When the ordinary man takes such an extraordinary course of action, he is almost never quite in his right mind.

He is not in his right mind, usually, because the woman to hand has arranged it. She has goaded and tantalized him quite out of his senses. Then a form of rough justice asserts itself. Pow!

The last time I hit a woman was about ten years ago, and I remember the occasion well. We were driving back on the Bayshore from a rather vinous party in Burlingame. The lady was feeling no pain. In the midst of an argument about something, she reached over to grab the wheel of the automobile from me.

I hit her, quite forcibly and sideways with my right hand. Otherwise, chances are that neither of us would have been around to tell this or any other story. She deserved it, as she had a few times before, for one reason or another.

The blow had landed on the bridge of her nose. The next morning she had two great shiners. These did not daunt the good lady, who went back to Burlingame that very noon to have lunch with three or four female friends. They all discussed with great relish the perfidy and cruelty of Brother McCabe.

There is no doubt in my mind that any woman who wants to get hit by a man can arrange it. The bad thing about all this is the number of women who truly seem to desire this ignoble fate. These ladies so orchestrate the lives of their current loved ones that violent and irrational male behavior is the result.

With some of these ladies, you suspect, this kind of provocation is a deliberate attempt to jazz up a relationship that is becoming moribund. By the time the deed is done, and the weeping ended, and the reconciliation joined, and the guilt worked out, the female has her hooks into the lad by just that much more.

It's the guilt that is really killing. There is nothing that can make the ordinary decent man as ashamed of himself as hitting a woman. For no matter how objectionable she might be just before impact, there is no doubt that she is usually weaker than he is physically, save in extraordinary cases.

Belting seems on the decline these days, if only because every other woman you bump into is working on her black belt in karate or something. It's not as easy to tell who can knock you on your back as it used to be. And it's probably just as well.

Women over 40

I was reading a gallant piece recently by a man who had just discovered the charms of ladies past 40.

I cannot resist adding a bit to his reflections, since I discovered their charms long before I was 40 myself.

In fact when I was in my teens my sexual ideal was a lady of 30, with two children, who wore tortoise-shell spectacles and was sensationally beautiful when she took them off before going to bed. When I was 30 I became interested in ladies over 40 and have never lost that interest.

I suppose in each of the cases above cited I was thinking of my own safety. I was frankly scared witless of those predators of my own age, who might take anything and everything from me and walk away in a simulated huff. I was convinced I could never win in a contest with a woman younger than myself. On the whole I have been proven right in this particular.

But there were other, not specifically sexual, reasons for my affection for older women. Older women have FORM. Men rather deteriorate after forty, women grow.

Though there have been one or two exceptions, the older women I have liked have all had children. The miracle of the creation of life is something men can never understand, but they can witness the results of it if they have any eyes in their heads. A woman who has created life is different from women who have not, and is of course wildly different from all men.

This is not to say that women under forty lack their charms. They, after all, are what women after forty are made of. But they are volatile and combustible at the same time, and that is a combination hard to deal with.

I have been with several women on their fortieth birthday, and think I have done a pretty good job of proselytizing them, that the really best years of their lives are ahead of them— if only they can put hands onto men who are aware of the value of a fully formed woman.

The author who started all this quotes a couple of paragraphs from a book called "The Velveteen Rabbit" by Margery Williams, that puts the whole thing beautifully:

"You become. It takes a long time. That's why it doesn't often happen to people who break easily, or have sharp edges, or who have to be carefully kept. Generally, by the time you are Real, most of your hair has been cloved off, and your eyes drop

out and you get loose in the joints and very shabby.

"But these things don't matter at all, because once you are Real you can't be ugly, except to people who don't understand."

My mind goes back, in its haphazard way, to a young American who was living in London (his mother was British) during World War II. He was drafted in due time. On his last night of freedom, he visited his favorite pub in an alley off Curzon street. He was wearing his white hat and all the rest of the regalia of a seaman second.

The pub was owned by a couple, well-born and friends of his mother. They were happily married, indeed. The woman was just 40 and strikingly beautiful. As she is to this day, as chatelaine of one of the most beautiful homes in Britain.

She saw and sensed the boy's utter loneliness. He was totally English except for his birth certificate, and frightened to death of what was ahead of him. She asked him if he would like to go to bed with her. He would, and they did. I have no doubt that her husband knew what had happened, and approved. Now where did that memory come from?

Gats, Hot Lids

At my age, and with my particular frame of experience, all sense would seem to say the hell with women. That they should be viewed as a delicious *creme caramel,* or as a stunning thoroughbred, or as the first cuckoo of spring. A pleasure, a benison, even a beatitude; but nothing to get tied up with, or to lose a week's pay over.

I am one of those men who never really got the hang of women. In this I do not know whether I am singular, or just one of the mob. Men are just as much liars about their relationships with women as vice versa.

Most men never even get as far as Freud with his famous question: What do women really want? Most of the men I know and have known know exactly what THEY want from women. For the most part it's as simple as a bit of tail.

Men will use any form of fakery to achieve this modest and earthy end. They will tear off a sonnet or two, if need be, to give credentials to the purity of their heart. They will hand out copies of the Rubaiyat or Kahlil Gibran, in the belief that these modest aphrodisiacs may make the lady a bit more complaisant in the clutch. Men will, in extremis, buy objects for the lady which they cannot imaginably afford.

It's not as simple as that with men of my age, unless they are dirty old men or pretending to be. I have had my successes with women, and some of them have been mighty succulent successes indeed. But since I now live alone it can be argued that most of these heavy attachments ended in failure. I cannot walk away from that hard impeachment. I either do not know how to get along with women on a permanent basis, or do not wish to know how to get along, etc. etc. I rather think the latter is closer to the truth.

The appalling fact remains that women are just as interesting to me as they ever have been. As throughout my life, I feel more at home with them, and enjoy talking with them, far more than I enjoy my own sex. I was brought up by an extremely feminine woman. She made a permanent mark on a nature that was already stuck with a strong feminine component.

The only thing that had ever turned me against women as a whole has been the iniquity of the most recent individual woman from whom I have parted. These partings have been mighty painful at times. And picking up the pieces has left huge arid

spaces in my life. Until the next charmer came along . . .

I got to thinking about these consummate denials, after consummate conjunctions, as I was reading Mark Twain the other night. The more I read of that old boy the more I think he was just about the smartest American we ever produced. In one of his more reflective collections of notes, "Pudd'nhead Wilson's Calendar," Twain touched on this very thing:

"We should be careful to get out of an experience only what wisdom that is in it—and stop there; lest we be like the cat that sits down on a hot stove-lid. She will never sit down on a hot stove-lid again—and that is well; but also she will never sit down on a cold one any more."

How I wish I had come upon this astringent bit of wisdom, and been able to act upon it, some forty years ago! When the Not Impossible She and I went thump, I always had the Celtic Twilight in my nature to contend with. Be miserable, and enjoy it. It is easy for an Irishman, and perhaps a man of any stripe, to sexualize groveling. If you're really good at it, the dark pleasure is almost as great as what you have lost.

I haven't had any big traumas along these lines for years, and perhaps more's the pity. Every time I meet a woman with a dancing eye and a quick tongue, no matter what the age, the old dream comes back. I think to those days when one woman or another had built up a huge bank of private jokes, which instantly defined each of us to the other. That's the best thing of all—those marvelous, unifying secret garden jokes. An intensely aloof lexicon of love, they made everything, the worst included, seem worth it all.

'Interesting Minds'

*My only books were women's books, and
folly's all they taught me.*

TOM MOORE

Women have interesting minds. I say this with a certain trepidation. At my age, and with the war of the sexes in a certain disarray, I no longer know whether I am complimenting a woman when I think I am, or insulting her when I think I am. With those ladies I least understand, the avant-garde who believe that two sexes are one too many, it is as if the numbers on all the bank notes had been changed. You just don't know what to expect for what you put out.

I long ago discovered that among the many dichotomies of man is the one between those men whose education has been had, and whose character has been formed, by men. And those who have been formed by women.

There are of course those who approximate a balance between the sheath and the sword. These are the fortunate ones, usually lumped together under the uninviting label of normal. Life does not shock them by its iniquities. They do not invent comfortable and comforting imaginary worlds where they can be at peace.

They are not, in the madly misused word, creative. And thus they avoid a helluva lot of trouble in their progress from womb to tomb. The British gent, with his female nanny in early childhood, and his sports-crazy instructors in public school, is a good example of a balanced emotional base.

I am one of those men whose emotional coloring has been almost wholly formed by female encounters. The most enduring was of course the first: My mother, Mary Kate, who for some reason has been on my mind in recent days.

She was a woman of great power and determination. I was her first, and I suppose her dearest. But it would be less than true if I did not characterize my entire lifetime with her as guerrilla warfare occasionally interrupted by open armed warfare.

Fundamentally, from about the time I first went to school, Mary Kate wanted me to stick by her side until the day she died. I had other ideas. I wanted to get away. This is a routine conflict with a single parent (my father was ineffectual when he was around, and after I went to school he was no longer around) but I will argue that in my case it was more.

For years I dueled with a clever woman with a devious Cel-

tic mind. It is the only game I have ever been truly proficient at, and the only one I have truly enjoyed. The metaphor of the duel must be continued. The object of the duel is to find weaknesses, to spar, and to lunge. To hurt, and if possible to destroy, all in the name of honor.

It is a dangerous game; but, as I say, a fascinating one. I find it quite as exhilarating as the Spaniard finds bullfighting, and requiring much the same skills.

It would be too easy to conclude from this that I dislike or even hate women. The matador certainly does not hate the bull. He might despise it if the animal is weak; but a skilled killer does not meet many weak animals. He admires the skills and strengths of his antagonists.

That is why I say I think women have interesting minds. And why I shall be almost wholly misunderstood because of some kind of cultural lag. Actually I think the worst things in the world—war and progress and disease—are almost wholly the work of men, and that most admirable of all things, the ability to understand and feel and carry on life itself, is almost wholly the province of women.

Had I the choice of wiping men or women from the face of the earth, and the choice was compelled, I would surely choose to off the men. But I would hope that the women left would allow one man to remain behind to fence and joust with them. My credentials are okay here.

Hit for the Fences

*It's better to love two too many than one
too few.*

SIR JOHN HARRINGTON

*I*n matters of the heart, I've always been one to hit for the fences. To those unfamiliar with the patois of baseball, this means trying for the home run every time you swing your bat. It means asserting your omnipotence or your macho, whichever term you prefer. It means trying to prove that you are Numero Uno every time you go to the plate.

That's the way I've always felt about women.

In almost every other realm of activity I can only be classified as a bunt man, or at best a sacrifice fly man. I settle for the level of achievement I feel most comfortable with, which is usually about four on a scale of ten.

I have never particularly wanted to make money, though I feel less antsy when I have it. Political power seems to me damned near indecent. There has got to be something seriously wrong with someone who likes to push his brothers around.

With women I have always wanted the best. Not merely the best according to my own opinion, but the best in the opinion of my fellows and my peers.

All I have really ever wanted from a woman is beauty, wealth, charm and servility. These are the things most men want from a woman, despite the emancipated howlings of Gloria Steinem, et. al.

Few men, however, pursue these ends with the tenacity they deserve. The fellow who settles for a childhood sweetheart, just because she was there, strikes me as decidedly lacking in venture. I like to go for the Everests and the Matterhorns, again just because they are there.

If I ever really wrote my memoirs of the chase, and believe me I never will, you would be astonished by the assiduity with which I pursued my chosen prey. (That's hardly the word to use these days, but it is the one that comes to mind.)

The technique of capture was quite as relentless, imaginative and single-minded as that of J. P. Morgan trying to get all the steel mills of America under his belt.

Once the object was clearly identified, and clearly desired, I became a new man. Torpor vanished. Desuetude disappeared. Purpose prevailed.

Letters of enormous length and passion were dispatched

from a man who usually writes about a dozen personal letters a year. Palgrave and the Oxford Book of Verse were pillaged for appropriately lofty sentiments. Sonnets, even, were written by my own tiny hand, with carbon copies kept in case they might be found useful in a later incarnation.

For in my heart I never believed that these great and greatly pursued seductions would be anything but temporary. They were a game, in the way highly successful businessmen call business a game. A brutal and single-minded pursuit of the Not Impossible She.

In retrospect, neither the seducer nor the one seduced was particularly admirable. It was simply a case of vanity colliding with vanity, in outer space. There was a temporary wild intimacy wherein each of us savored our success. Me savoring my blarney and she savoring having been blarneyed.

Admirable or not, it was great fun. It may happen again, before I have served out my mortal stretch. There is something highly zestful about lying like a banker to an attractive woman who knows you are lying to her like a banker. For one thing, it reminds us how much we are all like each other. For another, it tells us again that men are different from women. That's the real fun.

Takes Time

"Il faut du temps pour etre femme."

For those of you who do not enjoy the pleasures of the polyglot life, the above sentence was written by the famed French author Anon. and it means, "It takes time to be a woman."

Truer words were never spoken, mate.

Most women spend their entire lives trying to find out who the hell they are. A character in a French play puts it precisely this way: "I have been a woman for 50 years and I've never been able to discover precisely what it is that I am."

These ladies, unhappily, are the ones us here poor dear boys usually have to put up with. Having done a lot of such putting up, at one time or another, I can tell you that it's uphill work. What is so often called feminine intuition is only too often an inability to decide which side is up, or to recognize same if by chance the ability existed.

But a woman come to term—that is something else! The finished product. The marvelous patina. The woman who acts as a woman should, with the impulses coming from where they should come from in a finished woman—from the heart.

A lady dramatist a few years back wrote a book called "An Unfinished Woman." That was a good title, and it described an interesting condition. The lady had no heart, and I doubt she has acquired one by now. Thus unfinished.

The time it takes for a woman to become a woman varies with the woman. Because we are being so terribly Gallic, we may as well quote the views of the dressmaker Christian Dior, or of his ghost writer.

"Women are most fascinating between the age of 35 and 40, after they have won a few races and know how to pace themselves. Since few women ever pass 40, maximum fascination can continue indefinitely."

The gently touched upon metaphor of the race course is far from amiss. A finished woman is like a thoroughbred. The training is there, the heart is there, and that great little finishing gallop is there.

I do not consider myself an expert on women. What man could have the arrogance to make such a claim? But I have been a lifelong student of the creatures.

For more than two decades, day in and day out, I watched every move of one of the most finished women I ever met, my mother. I watched every move because I was convinced that the

next one was going to be directed against me, in the form of a poke in the eye or some devastating Irish *mot*. This training has stood me in fortunate stead. I flatter myself that, because of it, I can tell the women from the girls, and right quick too.

I don't think I have ever met a woman who boasted that she "had put her act together" who had ever done anything even remotely like that. It was merely a pious hope embedded in glib phrase.

But in fact that is just about what the finished woman does. In a tradition not generally in favor at the minute she spends her early years growing up and figuring out what kind of gent she would like to marry. Then she gives two decades, more or less, to the importunings of her husband and the care of her children.

Then, fortyish, and with her fundamental work done the real test comes. Does everything she has learned fall into place? Do the parts that have been floating about uneasily begin to fall neatly into place, as if this jig-saw puzzle had been waiting a long time to get finished?

If it all comes together, we have that rarest of things, a woman who looks into herself. And in looking, sees the person she was meant to be. This takes time, to be sure, but it is worth every minute of it.

Rosebery on Women

\mathcal{A}rchibald Philip Primrose, who became Lord Rosebery, was a dazzlingly handsome lad when he came down to London from Christ Church in the late 1860s.

At that time he is said to have expressed his ambition: to win the Derby, marry an heiress, and become Prime Minister.

That is just what Archibald Phillip did. He hated the story, however, and always denied that he had been so crass. He married a couple of centuries of Continental wealth in the form of Hannah Rothschild. He was Prime Minister for slightly more than a year 1894–95) and left the job with plain relief. He won the Derby not once, but thrice. He died in 1929.

Another remark has been attributed to Rosebery:

"No man ever knows true happiness until he has got a complete set of false teeth and lost all interest in the opposite sex."

I'm inclined to think this one is valid. Rosebery was, in his youth, decidedly a *poseur*, following the style later made popular by Oscar Wilde. His remark is in the style of epigrams tossed off by cultivated Victorian gents after dinner, often in Latin and modeled on the style of Martial.

There are still Englishmen who say this kind of thing. One gent I know is forever propounding the ancient wheeze that it's no use giving coal to the poor since they only put it in the bathtub.

Nonetheless Archibald Philip Primrose is correct in his remarks about false teeth and sex. Especially sex. It is a fact, lamentable or admirable, that there comes a time when the joys of sex are less gratifying than the absence of its aggravations.

Once women are no longer conceived as a source of erotic pleasure, a peace and quiet begins to descend on a man. For one thing, women begin to be viewed in the way that women traditionally say they wish to be viewed—as complete human beings, and not merely contestants in a race to secure the most prized specimen of male flesh.

Whether women prefer to be viewed as human beings or as sex objects is a matter on which I am not to this day entirely clear. The feminists of our time are far from the first women to raise this cry.

Whether a woman enjoys more the placid affection of a man unhorsed of lust, or the panting exertions of the stud himself, is

not a matter likely to be decided in my time. The argument that she can have both, and at more or less the same time, leaves me cold.

What is certain is that women as sex objects and women as human beings are both pleasures, and considerable pleasures. In fact, it is one of the great benisons of nature that a man who lives long enough can enjoy both these pleasures, albeit *seriatim.*

The woman as human being is most enjoyable if she has a past which includes the panting admiration of many men. Even after one has reached Rosebery's empyrean, the *game* of sex goes on. And the woman who has enjoyed what used to be called the pleasures of the chaise-longue is still likely to be a delight, because she still plays all the intricate steps of the oldest game in town.

It is the man who hasn't quite given up sex who is in trouble. He is caught between the Scylla of lust and the Charybdis of peace and quiet. He doesn't know whether he is coming or going. Instead of looking forward to the felicity of no longer being able to make it, he worries the problem.

Or so I'm told. My teeth are still my own, too.

On Love

'This Thing Called . . .'

*O*ur leg muscles tighten. We blush or grow pale. Our posture improves and we pull our stomachs in. Our eyes brighten. The bags around them and that ugly double chin miraculously disappear.

All this happens, Science now tells us, when we are beginning to fall in love. You can tell it by the way your muscle tone tightens. Science in this case is the team of sociologists Elaine and G. William Walster of the University of Wisconsin, who have written a book called, "A New Look at Love." Other scientific stigmata of love are:

Eye contact: Usually people talking look at one another only 30 to 60 percent of the time. The more two people are in love the more they sneak glances at each other. Posture: Persons in love visibly incline or slope together when sitting side by side, like at a dinner table. Standing distance: You're in love, you stand closer.

Unhappily, Science is everywhere and says just about everything, especially when the "science" is sociology. Sociology is based on the idea that you can measure and explain people, which is balderdash.

I do wish people would stop trying to explain love, at least erotic love. This thing, which, never quite leaves us, and which can be as rewarding in the memory as in fact, is just one big, fat, wonderful mystery, and should be left that way. Like the ways of God and His love, it is a matter best left to faith, or the lack of same.

One thing about erotic love is that it is democratic, in the exact sense. You do not have to be especially qualified, pass any exam, join any select caste, or have a certain credit rating, to be allowed into the company of those who enjoy good old sex. Society does not even ask that you be good or bad to play the game, so long as you observe some pretty loose boundaries.

I have reached the age when the fires are supposed to cool, but I know I have it within me to go tearing away after some female at the drop of. When I say this I don't know whether I'm boasting or making a confession, whether I'm being a dirty old man or a hopeless romantic, or a bit of each.

But the fact is there. And while I'm sort of between engagements at the minute, I do altogether hope to get entwined in the old devilment a few times more before I think of giving somebody my corneas.

Insofar as I have thought about what love was, during the times I was in the hands of this paradoxical fever (I say paradoxical because the fever is marvelous and the recovery quite awful) I have always regarded it as a mysterious gift, with accent on the mysterious.

I did not know what I did to deserve it. And, when I seemed able to arouse this same mysterious gift in another, I was similarly grateful. Love is one gift horse I was never tempted to look in the teeth. (Lest, among other reasons, I should start counting same.)

For one reason or another I haven't been one of those who stood up well when the scorching of sexual love abated. I did not have that talent of sublimating, or converting, or changing that feeling into something good and lasting and even sexual without the scorch. My most successful relations with women are those which have been platonic from the start; for in these there was no enmity, nothing to kill.

For the only thing certain about sexual love is that it is simultaneously a marvelous joining and a bitter war. We don't hear too much about the war of the sexes these days. I suspect that is because said war is just too close to the knuckle for us to face in these emancipated times.

I envy the guy who can enjoy the thesis of love, and cope with the accompanying antithesis of hatred, and come out with the synthesis of lifelong devotion. Me, I fear, I am arrested at the first stage.

Love Harder

*I*t was in the men's room at Portsmouth Square recently that my eye caught the message: "Love Harder." It was a graffito, of course—that form of gnomic expression which seems to appeal so greatly to the bright, gnomic young.

As a sentiment "Love Harder" is hard to beat, and as a personal discipline it might be the best moral rule of thumb around. It's a kind of instant Christianity. There's nothing wrong with that. Nothing wrong which I can see.

As a guy who thinks a fair amount about love, and its failures, and its beautiful growths, I should like though to throw in my two-penny bit of cautions for those who are adopting the motto or thinking thereon.

First of all, if you find love easy to find, or easy to give, you can be pretty sure it is not love. There's nothing easy about that redoubt. Love is to be stormed, not sneaked into. If it's easy, it is something else.

Nobody has ever really defined love; but the best tries at it are the same on one ingredient. Love is really about others, and not about you. A great deal of what is called love, perhaps the greatest part, is love of self which has to be ratified and echoed by something appropriately called a love object. This is the love of Narcissus and Echo. In the end Echo destroys Narcissus as Narcissus destroys Echo.

This kind of love is not love but a need, often desperate, for love. This kind of lover rages like a demented gorilla in his search for what he feels is rightfully his: The love he was denied in the long, long ago.

This kind of soi-disant love is so close to hatred as to make no difference. To urge this kind of lover to love harder is to compound a felony, and be guilty of disturbing the public peace in the process.

But even this kind of rapacious infant (they come in two sexes) can benefit if he just thinks about love, providing he admits it is something he may not have on tap, but a thing which he can strive for.

If you work at the idea of love, even if not very hard, and even if you fail, you will probably contribute to a lower general quotient of hatred.

"Love harder" is not the same as "Love thy neighbor as thyself." The one is an imperative and an injunction. The other

is in addition a limiting definition. To say you should love your neighbor as yourself is doubtless an impossible ideal. To say "Love harder" is an easy thing to do, if you are not too careful about the quality or nature of the "love" you are pursuing.

Yet "Love harder" has its poignance, its pith and its point. In a world where television has made a young man's span of attention about as great as that of a rabbit, brevity is more than the soul of wit. It is a ruddy necessity, if you are to get understood, or even listened to.

I am not sure that the man who preached the Sermon on the Mount would not approve of this punchy, right-on approach to the problems of the heart. He knew where it was at.

One of the paradoxes of the heart is that when love is well and truly given, it is as much yours as the person's to whom it is given. James Joyce, in one of his plays, had a male character say, "When you give a thing, it is yours forever." Joyce never said a truer word.

So in the end, true love gives the giver that same satisfaction the emotionally stunted Don Juan seeks for himself. If only out of selfishness of an enlightened kind, the spiritually sterile swinger should realize that giving without scoring has its point. A red rose a day to a beautiful woman you will never meet, because you choose not to, will make you a better man when you want to give love to someone outside yourself who needs it. Love starts with giving, and is killed by taking.

Dimple Love

*M*arriage is a most difficult skill, to open a hardly original line of inquiry. The business is all tied up with the sanctity of contract. Letting out contracts for such complex feelings as love and sexual attraction, and the inevitable human hostilities which accompany these matters on both sides, is perhaps not the finest way to bind humans.

This is especially confusing in that, while the final seal of the obligations of marriage is given by the state, the original commitments are thought to be made freely by free people. Some people, especially the young, seem to feel that the state should handle the matter all the way; or, much preferably, that the state keep entirely out of the mating racket.

Dr. Johnson felt the former persuasion. It was his view that some form of committee, like a Town Council, or a conclave of magistrates, should decide who shall marry whom. It is probable this system would work as well as any so far devised. The French come near it, with their carefully negotiated mating packages, which make a solid middle-class union seem more like a protracted bargaining session between entrenched management and entrenched labor, with the bride's dot as the prize.

Or else we could work things out entirely by chance, with no planning at all, on the possibly sound basis that human feelings are so dicey they elude all forms of categorization. Unions only work if they work period. This would be marriage by lottery. Such a scheme has much to recommend it. There would be no blather about supernatural sanctions, no guidance (i.e., interference) from patriarchs and matriarchs, no guilts about shabby choices. You hand in your ticket, you get your girl, and you're ruddy well on your own.

Meantime we are saddled with the system of union given us by Mosaic law, and perpetuated by people who labor under the notion that something is stable simply because it has been around a long time. Taking what we have, we might as well make the most of it. One throws out a small, fugitive suggestion . . .

The suggestion comes from that distinguished Canadian professor and humorist, the late Stephen Leacock. Leacock had a great way of saying wonderful things in passing. In the midst of some bit of wackiness, he would drop stunning obiter dicta. These hadn't much to do with the matter to hand, but often

illuminated greatly what Leacock called "the larger lunacy."

"Many a man in love with a dimple," he once said in passing, "makes the mistake of marrying the whole girl." There, in a neat little nutshell, is what goes awry with so many unions from the first gleam in the eye of the parties, or victims. The dimple can be merely a dimple. The dimple can be a million other things, literally—the color and hang of a head of hair, a way of walking, a seat on a horse, a good golf swing, etc., etc.

This is what the old-time theologians might have called marriage a posteriori, an argument by which principles are arrived at by deduction from facts, or sometimes a single fact.

Like all logic, a posteriori reasoning may be sound as a ruddy Tory, or fallacious as the next commercial. Dimple love is really lottery love. You can score, but you won't believe it when you do. You can reconstruct a prehistoric bovine from a bit of its knee joint. You can't build love from a dimple, no matter how grand the dimple is. Never? Well, hardly ever.

The fact is not the dimple. The fact is the whole girl. I'm not suggesting you forget the dimple, and concentrate on the whole girl. To do so would be to negate the foolish history of our kind. Such a course would effectively depopulate the species. I ask you to just admit, even if you have to force the admission, that there is SOMETHING to Miss Wonderful behind that dimple, and that you will have to cope with it for a solid portion of your life, if you embrace the good old vows. This may, just may, hold you.

No Love

*F*alling out of love, said the lady, "is so much like having the biggest room in one's house being completely cleared of all its furniture and clutter—neat and satisfying in a sterile sort of way."

And she added fiercely, "God, you could perish from the echo of your own footsteps!"

Yes, love is a clutter. How could it be anything else? Clutter will follow a feral windstorm. That too is what love is. And being out of love has everything, and nothing, to recommend it.

If you are a drinking man, out of love is not unlike going on the wagon. Clinically, I'm sure, the two states much resemble each other. There is that sense of virtue and purpose—that cleanness that comes from obeying every moral injunction that was ever hurled at you in your childhood.

"Oh, what a good boy am I!" There is delight in filing and classification, in shining of shoes, in tending to the long-overdue post, in doing those corporal works of mercy which got lost during the long foray into the illusory world.

You are composed, you have it all together. There is only one thing that is missing, and that turns out to be the only thing: the aforementioned world of illusion. Your friends are real, and they fall short. The world is terribly real, and falls terribly short. Your are more alive than you have ever been, and more dead. The leaf and its veins have never been more vivid to you, and never more bereft of meaning.

In your chaste chamber, you are pressed again and urgently with the insight that love is life. It is as simple as that. From your tower of control you desperately want once again to lose mandate over yourself, to breast vaingloriously the sweeping current of life. In short, to lose direction. Shorter, to be in love again.

When you are out of love, it seems to me, you neither hope nor fear. This is easy to understand. Hoping and fearing are, above all other things, the stuff of love. I am not talking of real love here, but of passionate love. Real love casteth out fear. But passionate love is a neurosis, with hope and fear so delicately in equipoise that intelligence and purpose seem beneath contempt.

This passionate love is neither high nor admirable; but it makes the spirit soar. In this passionate but loveless exercise, you are an organ on which the outside world, and especially the momentarily beloved, plays with devilish dexterity. The chords

can thrill to swooning, or turn into a stopped diapason.

This loveless love was defined with mastery by the greatest of our handbooks on the subject, the sonnets of Wm. Shakespeare. "Love is not love/Which alters when it alteration finds."

Love is like liberty and many another word, both above and beneath definition. But when you know what love is not, you are somehow along the way. When love rises or falls with changes in the nature of its object—the loss of looks, the loss of money, the afflictions of boredom, found inequities of the spirit, the mere savage passage of time—then you know you are not talking of love.

You are talking of passionate love, which is to love as night is to day. **That** thing involves you. Love is about somebody else, or a lot of somebodies else. Measure your feelings against this rule of thumb, and you will know whether you love or not. If you love, you will never be out of love. I think.

One Game Running

When did someone last come running lovingly to you at an airport? It happened to me recently, and was a warming thing indeed.

The true sign of growing old, it seems to me, is less a matter of failing physical faculties, or a rigidity at meeting new experiences; but in a certain incapacity to confide the heart. Trust seems so dangerous and *so unsafe.*

A lot of the trouble here, it again seems, is with that crazy word love, which we use in such peculiar and contradictory senses. Much waste would be eliminated if we could only find another word for the urgencies of physical possession, of which love is but a small part. We do not love someone or something simply because we *want* same. We love something or someone when we wish to add to he, she or it.

Sex is too ugly and twisted a word to use for the urgencies of physical possession. It is too flat a word to express the real poetry of the celestial lunacy. To describe the mating urge in terms of sex is like telling the exaltations of religion in terms of pews and poor boxes and objets d'art.

Temporary, passionate union would be more like it; but where's the word? To inject love or liking, or even plain affection, is to twist the thing away from reality. There is more hatred than love in high passion, but even this won't do. It's just a boy and a girl with the hots; but where's the word?

During this period of one's life, all the meetings, it seemed, were passionate encounters at airports, and in past days rail depots and piers. There was the quickening of the heart, and the running which could not be stopped, and the embrace which was the answer to everything. This was because we had joined again with The One and Only.

The One and Only was just that. All of the wild energies of our system had been channeled to and focussed on the single and perfect vision. In a triumphant anthropomorphic fallacy, all that was good in the universe was concentrated in that single person who made us run with delight and longing.

The load of such a deception is too great, always, as we have ample occasion to learn. There is NOBODY, and there never will be anybody, who is good enough for our dreams. We want the impossible in those we love. This is why the human race, as bad as it is, is as good as it is. There is something rather noble in

the desire to produce a perfect child from a perfect woman, which is what all this is about. I am well aware that this is an un-fashionable, and in some circles an almost treasonable, view.

You tell me the sex glands of man and woman were put there simply to produce pleasure, as might a superb ragout or a breath-taking view, and I will assure you that you're a bit of a nut.

But the other kind of love, the adding kind, is there all the time, often in spite of the passionate unions. In what is called a good marriage, this love has grown so heartily that it quite easily replaces the sexual fires when those have been banked.

The thing about this other love that is so curious is that it is free love. Not the promiscuity they talked of in the 1920s; but a love which is free to flow, not stunted by urgency. This love is not always returned; but it is still free to flow. When it flows both ways, it makes the sex department seem a bit puerile, which in no pejorative sense is exactly what it is.

The one who came running to me the other day, and to whom I would have run if I wasn't burdened with a typewriter and a heavy bag, was a person in whom there wasn't an ounce of sexual attraction. She was a good friend. In the car back to town, I began to think of those other, tumultuous encounters at airports, and even at post offices. I had a small twinge of triumph. Indeed, one may have grown a bit.

Love Is Fleet

\mathcal{A}n alert student of the human psyche, Professor F. B. Meeker of California State Poly at Pomona, has put The Grand Passion in its place. He made a survey, which seems to be what psychologists do. The survey revealed, at least to the professor, what some of us had suspected without any particular survey of our own: That big affairs of the heart, with all valves out, last about 15 months, or a little longer than the pro football season.

Within this period of "medium durability" there is a space of 90 days when things are, shall we say, intense. In the trade this is referred to as "being out of my mind."

But, warns the prof sourly, "It decays like radioactivity."

None of this scientific information actually amazes us here lay students of the human heart. That a grand physical passion should exhaust itself in slightly more than a year's time is not all that surprising.

What is surprising is that so many relationships, within the sacrament and without, survive the passionate period. Some of these relationships have been known to last a lifetime. They are sometimes called happy marriages.

What keeps marriages and long-time live-in arrangements going, as us laymen know, is not legs and arms and violet eyes. These are frequently the things that get the conjunction off the ground. They are not, and decidedly not, the glue that keeps people together and under the same roof.

When the bloom is off the rose, or the frost off the pumpkin, or whatever, the things that keep people in each other's pockets are more prosaic than passionate. Very high among these prosaic considerations I should put the fear, which may sometimes verge on terror, of living alone. People will take an uncommon lot from matey just because he happens to be around, even if the presence is no more than a butt affixed to a sofa in front of the tube with a bottle of Bud clutched in the left hand.

This kind of marriage cannot be characterized. It would be unfair to call it a good marriage, and an exaggeration to call it a bad one. It is just a wayward coupling, like a screw fixed in a wall.

Money may rank even higher as marital glue. Being married to money is heavy duty, as many a mate has discovered. Even work is often preferable to it. Still and all, mutually held

funds are a powerful incitement to conformity and passivity. With a hundred grand annually between you, the temptation to rock the boat is infinitesimal.

The family that reads The Wall Street Journal together damned well tends to stay together. Dun and Bradstreet and the Dow averages have a clarity and force for stability that exceed even the eloquence of the marital vows.

Another thing: There is no love quite like the love of two emotional cripples for each other. Even if this attachment more resembles black hatred to the outsider, to the neurotics who have found each other, the word is always love. These lucky folk are caught together by mutual fears, anxieties, and the conviction that they are headed for the bin, singly or together.

If you combine a neurotic coupling with money, and a lazy fear of being alone, you have a union that stands a much better chance of lasting a lifetime than one of those Montague-Capulet kinds of thing. The stuff that women call love and men call sex has only a peripheral bearing on how long a pair will stay unsundered. Even liking and hating are less important than the lasting verities, on which I have touched lightly.

If you want to pick up the reins after passion has thrown them down, I suggest you either have a lot of money or marry a lot of same; be sure that the subject of your choice is rather seedy or rather boring or both, and that you each go regularly to a shrink or an encounter group. But not the same shrink or group.

On Marriage

Misogamy

cA lady asked me the other night if I were a misogamist. Though I had never heard the word before, my small Latin and less Greek enabled me to figure out that the word meant a person who hated marriage.

There is also a misogynist, who hates women. And there is a misanthrope, who hates everybody. I am neither of these, thank the Lord, but misogamist comes pretty damned close to the knuckle.

I tend to agree with the gent who said the laws about marriage are far too lenient. For anybody who gets married, it should be a life sentence.

I don't really hate marriage. I just have a strong predisposition against it for myself. I have said more than once that I have no talent for matrimony, and I repeat it.

Yet there have been marriages I have enjoyed. All of them, in fact. When I no longer enjoyed them, I just got out of them one way or another. I suspect this is a sexist observation. So be it.

I feel about marriage the way some Swedes feel about Italy, Capri, Sardinia, Tunisia. It is a highly exotic state that I like to visit once in a while, enjoy to the full its pleasures, and then get back to the dour climate and country of my birth.

It is not that I am inexperienced in the institution. I almost said sacrament, but I have never been endowed with the sacrament because I've never been married in the church.

The sometimes eccentric theology of my church enables me, after three trips to three City Halls, to marry a virgin of 16 in St. Patrick's cathedral, if she chooses and I agree. Note the careful usage. I have in the past wanted to avoid that life sentence.

Being in and out of the institution several times, I have obviously given a certain amount of thought to it. I have known good and bad marriages, both temporary and lifetime, and some that were just bitches from the day they were born.

Marriage, someone said, is based on the notion that when a man finds a kind of beer that suits him to a T, it is his bounden duty to drop everything he is doing and nip over to the brewery and get a job there.

I suggest that the more you think of this notion, the more you will think of it.

Another gent, that witty dominie Sydney Smith, said a good marriage "resembles a pair of shears, so joined that they cannot be separated; often moving in opposite directions, yet always punishing anyone who comes between them."

For my part, I often think that the perfect wife is the woman who has the perfect husband. And the perfect husband is the lad who is so overwhelmed by his wife the first time he sees her that he never gets over it.

I've known several marriages like that. A friend of mine saw a lady playing tennis left-handed on a court in Burlingame and speaking fluent French at the same time. He never got over it. Until the lady's death a few years ago, it was a great marriage.

No, I don't really hate marriage. But if you talk to me about it for any length of time I'm liable to fuss at you, as they say down New Orleans way.

I think any sensible man should give marriage a go, or several goes.

For sure, it will teach you a damned sight more than four years at Harvard or Cal. Knowing how to handle a woman is as impossible a task as setting up a tea shop on Andromeda.

But it's worth learning to know that it can't be done. And some of the wicked little things are fun.

Kinds of Marriage

S ome lady whose name escapes me said that a woman marries the first time for love, the second time for companionship, the third time for support and the rest of the times just for the hell of it.

Now I assume that most of the ladies who read my column are not polygamous. I would guess that most were monogamous, and chafing at it, like most of the ladies I know. And I have the suspicion that a lot of them are just nongamous, having taken a scunner against the whole institution and living in what used to be called sin.

Whatever their state maritally, I think the generalzation applies equally to men, for men are humans too, and have feelings, you know. We, too, have equally been known to be nongamous.

By my count I have been married three times. There are other counts. One gent, who has known me for a long time, tells me I have been married six or seven times, he can't remember which. This chap also cheats at games.

For me, the first time was indisputably for love. There could have been no possible other reason, since otherwise we were chalk and cheese. She was beautiful, I was less than. She had some money, not much. I hadn't a boiled kidney bean, at the end, though I had a good salary, with two cases of scotch weekly thrown in as an entertainment allowance at the beginning.

We called it love, and I still call it love, but our relationship was that of two very insecure people in a wartime world. Until events drew us apart, we were never out of each other's presence for more than 15 minutes or a half an hour. That sort of passionate need for each other's company would have burned out such embers as remained anyhow.

The next five years I remained celibate, finding it sweet and fitting to act as a war correspondent. As near as you got to a girl in those days was a pinup of Rita Hayworth. Love was a thing of the past. Companionship loomed.

Companionship took the form of an attractive Puerto Rican girl educated at the Sacred Heart in Paris. She had good manners, was an excellent hostess, and had read just about everything in three languages. She was a widow and entirely experienced in the ruddy business of lovemaking. But she was just a mite crazy. I knew she would find a new favorite while walking

her dog, or playing bridge. I still regret the breakup, because I felt more myself in her company than anywhere else.

The second marriage was for companionship, and to change the world. For we were both young newspaper people (she owned them and I worked for them) and were going to use her family's newspapers to put the world straight after it had somehow gone awry.

We ended up by having four children, and precious little companionship. During our latter days "together" we were apart, through the then passionate fad of psychoanalysis. When I lived in La Jolla with my children, I used to sign my income tax form, "Housewife." I couldn't think of any other description that fit.

The companionship returned with the third wife. In the end I found it excessive. We lived in an English country house and the lady wouldn't allow any locks on the doors, because she had a terror of being alone. Even the library, where I worked, was always open to her interruptions. They were not few.

She was one of the most social persons I have ever met, and would go to dinner, or invite people to dinner, seven nights a week if I didn't put my little foot down. As love had destroyed the first marriage, and money the second, a surfeit of companionship destroyed the third. There's nothing worse than getting your heart's desire, etc.

Not Awfully Matey

As several ladies of charm and chic have had occasion to learn, I have no marked talent for matrimony.

One of them put it like this: "You aren't what I would call an awfully matey chap."

This is a fact, and one I have learned to live with. That I may get legally coupled again is a possibility; but a dim one. I am several times shy, having been several times burned.

Where did I go wrong? The question might more properly be: How did I get right? If any of the holy unions I went into had persisted, I doubt I would be walking around today. For me, the whole thing was a kind of sickness, like a low grade infection, which would eventually have done me in.

This has nothing to do with my feelings about women, whom I like and sometimes love and find compelling and endearing in their oddity and idiosyncrasy. But I agree with Byron that women are angels, but wedlock is the devil.

The institution is clearly archaic. About nine out of ten people marry at some time or other, the sociologists tell us, and half of those marriages, same lads say, are technical "failures."

I think the reason for this is clear, now that my marital fever is quenched. Most marriages don't work, at least in our American late 20th century, because the essential ingredient of the relationship is missing. And this is? Listen to that wisest of Frenchmen, Michel de Montaigne.

"A good marriage, if there is such a thing, rejects the company and conditions of love. It tries to imitate those of friendship."

This theme of friendship in marriage runs through the observations of the most clear-sighted observers of the institution.

Jourbert: "Only choose in marriage a woman you would choose as a friend if she were a man." Nietzsche: "It is not lack of love but lack of friendship that makes unhappy marriages." Alain: "If one wants marriage to be a refuge, friendship must gradually replace love."

That a majority of American husbands and wives are not friends is a proposition I find not at all difficult to entertain.

The reason for this is to be found in the words with which we invariably qualify love and friendship. We fall in love. We make a friend.

The love bit is a temporary lunacy induced by the full of the

moon, or the turn of an ankle, or a lingering look, or some other bit of fluff. It will pass. It always does. If something remains when it has passed, we continue to call it love. It is really friendship. Friendship that has somehow, and against all odds, sprung up during the uneasy course of the aberration, love.

Friendships are indeed made. They are made in leisure. They are the result of long and cautious, even suspicious, interaction. They are a personal decision of some magnitude and meaning. They are not repented in haste. The failure of a marriage is usually a fracture to your ego. The loss of a friendship is as tangible as the loss of a member.

The fact is, the worst people in the world to decide who should marry whom are the persons who generally do so: The husband and wife. The marriages that have the best chance of survival are those which are, to a great or small extent, influenced and even arranged by outsiders. The best marriages of all seem to be those French deals, which are mulled over for years by priests and lawyers and parents, and even the butcher and baker. These folk know more about what will keep Jean and Marie together than Jean and Marie will ever know.

Next to Montaigne the best thing said on the marital state came from that sober-sensible Englishman, Dr, Johnson: "I believe marriages would in general be as happy, and often more so, if they were all made by the Lord Chancellor, upon a due consideration of the characters and circumstances, without the parties having any choice in the matter."

On Ex-es

My wife made good soup, but I miss her just the same.

—Cannibal Chieftain

Casualties of even the most awful marriages must, I would think, still at times agree with the cannibal's little *pensee*. After all there must have been something, even if only such an ignoble consideration as self or pelf, that persuaded the couple to enter the contract in the first place. There must have been a moment of glory for each or both, however brief.

There are lady cannibal chieftains, too. They may, in fact, exceed the lads, in marriage and less formalized arrangements. Yet these lovely predators must have a memory, however fugitive, of some good, even if only bestial sex, that was once thought to inhere in the union.

For my part I've been lucky enough, on the whole, to have given the truly predatory lady cannibals a miss. This is not to say that in even the most demure of mates there is not just a smidgeon of the carnivore.

I am sure that each and every one of the ladies with whom I resided for any length of time were in agreement, when it was over, that I had been good soup. Nor do I doubt that there are times when they miss me.

As my old friend Jim Knox used to say, "They may not like us, kid, but they aren't about to forget us."

The thing I miss most as a bachelor is the talk, damn it. Those long, rhapsodic voyages into self that passed for passionate exploration of each other. These came at the beginning of the arrangement. You never forget them.

You meet a number. You *know*. Then, if you are like me, you embark on a conversation that lasts anywhere from ten hours to long months, occasionally interrupted by sleep. You are filled with the wonder of finding the Echo to your Narcissus. Except that your Echo has love returned. You think.

You discover that you use funny words in the same way. Ultimately you develop a private language. I know at least four of these tongues, into which I could easily relapse if one of my former affinities should heave into view.

Whenever I hear the word refined pronounced "rafeened" my heart still takes a slight bounce because it reminds me of someone once dear. She is now again very dear in memory.

I have always like women who walked well. Most of those I

liked best carried books or pipes on their heads when young. A fine carriage in a woman, on Montgomery street or Fifth avenue, brings back the good times, old boy. I think proud bearing in a woman is so seductive because it is a challenge.

In sexist terms, which I still happen to like and use, the well-borne woman is a citadel crying to be taken, a redoubt, and a test. When a woman slouches, and so many of them do nothing but in these liberated days, it is as if she had given away her spirit.

The favorite of my ex-es is still around, somewhere. I proposed to her in a ginmill about 75 yards from Claridge's hotel in London. I opened the joint at 11 a.m., ordered my first pint of the day, and stuck my head in the *Times*.

She arrived in a few minutes, said she was feeling ever so crapulent after a large party at the Mirabelle the night before. She ordered a pint, and asked that a double gin be put in it as a float. As we clinked mugs for the first sip of the day together I said, out of a clear sky, and out of my own head:

"I'm going to nail you, old girl."

She replied, in that staccato English voice I never tired of hearing, "I shouldn't be a bit surprised."

In the end, I'm sure, we both made good soup. And, speaking only for the party of the first part, I miss her just the same.

cA Real Nothing

The other night I met a handsome young lady at Perry's restaurant. She told me briefly the story of one marriage.

When the thing was clearly all over, the wife went to her attorney. She insisted on dictating the precise language of her complaint.

Her husband, she said, had "deprived me of my solitude and did not provide company."

How precisely, and with what bitter, honest pungency, has a bad marriage been described. And how many of them are still in existence, stymied in this kind of emotional inertia?

For the bitter truth is that you can almost destroy yourself as a person by getting tied up with another person. There are those of us who were not made to be coupled, people who simply cannot be joined.

There are people who, no matter how hard they try, simply cannot give themselves. For these people marriage is a form of ruination. Yet it takes such a long time to find it out, and at such a terrible cost all around.

It's no use for these unfortunate people to blame Jane, or Joe, for his or her lack of virtues held to be essential for the preservation of a union. It's no use even for a man to blame himself, for he is not truly to blame. He was just born with an incapacity to function in a rather important field, that of close human relationship. The condition is not unlike being born with a shriveled arm. It's not your fault. Your job is to adjust to your condition.

The really unforgivable sin, in these relations, is to persist in error. With the evidence spread out amply before you, to continue in an unhappy marriage, for the sake of the children, or the money, or any other consideration. No matter what some preachers may say, your loyalty in the end comes back to yourself. Maybe the other party is being ruined in a bad marriage. More important, you are being ruined.

Having said that, there is a need to insist on personal honesty in the severence of a bad relationship. Here, above all, we must beware of the psychological condition called projection, where we visit our faults on someone else.

With tedious regularity, the complaints of a person about his mate turn out to be stunningly accurate descriptions of his own shortcomings. If she is "unable to extend affection in times

when most needed," or any other familiar complaint, you are pretty likely to conclude that he is the one who is unable to produce.

It could even be that the woman who was deprived of her solitude and did not get company was the one who didn't give company and deprived one of solitude. The moral force of her position almost suggests it.

It is the bleakness of the words, to return to them, that stays with one. The words describe a real nothing, a conjunction where both persons have been deprived of nothing less than their souls. Married zombies.

One has seen them, people who exist together in a state of mutual catatonia. They share the same roof and practically never talk to each other. The name of the game is to Hang On, at all costs. Better to live with a failure than to confess to it.

A bad marriage is one of the cruelest inventions of nature. It is a case of two people floundering together endlessly. It is a case of stale and cold love. There is nothing more inhuman than that. Breaking it up is always tough; but it's no more important, really, than moving from one house to another. The deliverance is sweet. Some men were made to live alone.

Divorce Is Hard Work

*"Divorce always happens day by day, in
small increments."*

*T*he above bit of wisdom comes from an excellent book of
potted psychologizing called "People-Reading" by Dr. Ernst G.
Beier and journalist Evans G. Valens. The sentence hits the nail
on the head, as they say.

There is some early point in most marriages that end in
divorce when the actual process of divorcing occurs. At this
moment one or the other mate declares a war of the spirit on the
other. If they are unusually well-gaited in malignity, the couple
start this tedious process at the same time.

And the pair work at it. My, how they work at it! Divorcing
makes carrying the hod lightsome by comparison.

Day in and out, the redoubts of the mate's personality are
assaulted. As in war, destruction is the satisfaction sought.
When a man or woman goes to bed after a really good, hard day
of divorcing, the satisfaction is as real as when a captain of
infantry subdues a fort.

Destroy, destroy, destroy. That is the banner under which
the accomplished divorcer marches.

The objective is total, as is the objective in war. The
objective is the complete destruction of the ego of the partner.
Some few accomplished divorcers achieve this end. Their
quarry, to use a word, ends up in the bin, or behind the muzzle of
a fired gun.

Most divorcers, in the more or less egalitarian society we
live in, don't quite get that far. The destruction of the ego is
partial; albeit powerful aids, like lawyers and courts, have trad-
itionally been only too willing to aid in the process.

If one of the couple spots the fact that he/she is married to a
natural divorcer, she can try to cope with his tactics, which is
possible though difficult so long as she keeps in mind what he is
up to. Same vice versa of course. The better course is to get out
before the boom falls.

In civilized societies, where the wishes of the family and its
integrity are held superior to the frailties and itches of the indi-
vidual, these things are handled better. The husband and wife
get little friends, who live in little houses, and take care of their
more annoying physical needs. In this country we seem to
prefer the war, rather than this form of civilized retreat.

More to the point is a particular brand of divorcer. This is

the man or woman who starts the divorcing process even before the marriage is accomplished. This is the man or woman who actually marries for the purpose of getting divorced.

His or her end is nothing so tawdry as arranging the process to enrich himself or herself, though this is often an ancillary benefit. He just hates women, for one reason or another, and has found that the marital bed is an excellent substitute for the martial field.

There is nothing wrong in hating women. It's no more irrational a trait than disliking snakes, or horses, or association football. Women say, "But you *hate* women"—as if they were uttering a stinging indictment rather than stating a simple fact. Misogyny is a fact of life, just that and nothing more. It is intrinsically no more significant than a passion for pro football.

What does seem unfair is that a man who hates women (and, again, vice versa) should inflict his hatred on them. Single blessedness, which can be called lonely cussedness, is a good deal preferable, both morally and in terms of simple comfort, to systematically beleaguering a more or less innocent person of the opposite sex.

I once invented, or think I invented, an old Spanish proverb. I even put it in front of a book of little essays about women. *The fear of women is the basis of good health.* There is much to be said for this old Spanish proverb.

'Hobby: Matrimony'

I once filled out one of those impertinent quizzes people are forever sending you. The information requested was, as usual, nothing less than your entire curriculum vitae. In a moment of levity, I ended with the declaration that my hobby was matrimony.

That declaration bothered me for quite a while thereafter. These ill-considered trifles, as we have been taught by the psychological school of Vienna, usually have a rooted significance. They are crying out to tell us something, if we would but listen.

A hobby is something that one likes to do or study in his spare time. A rare meaning is a "subject that a person constantly talks about or returns to."

Both definitions are uncomfortably close to my personal attitude to both the institution of marriage and the sacrament of matrimony. The matter is both unimportant and an obsession. For a long portion of my life I couldn't live with it or without it, as we use to say about women.

I knew in my heart that I had no real talent for either the institution or the sacrament. Mine is not a nature which commits itself easily. Furthermore, I'm frightfully absentminded. These are not good qualities in the uxorious state.

All of which is too sad. I genuinely like the company of women, especially if they are bright and beautiful; but also if they are just plain homely/cozy. For some reason, when I say something to a woman, it just means more to me than when I say it to a man. The same, of course, goes for what women say to me.

Men are just sort of floating objects, which either boss me about or are bossed about by me. Their content is superficial, which is what makes them quite satisfactory in most of the passages of existence, like drinking or playing games or telling jokes. Life would be quite impossible without men, because most of our emotional needs are superficial.

Which brings us to the essential problem about marriage, and why a man of pith and moment cannot take it with appropriate seriousness. Women aren't like men, which is what makes them both desirable and impossible as mates.

Women are unlike men in that it is actually possible to communicate with them. A man who lives alone is a being in a state of profound imbalance. The truth usually follows the conjunction of a good male mind and a good female mind, with

appropriate sensibilities combined. The Supreme Court of the United States, as an instance, would hit more nails on more heads if there were four or five women among the body of nine.

All to the good, this matter of communication. The trouble is, the ladies wish to continue to communicate, and communicate, and communicate, and communicate some more. They always want to be in touch. They do not have the talent for triviality that the male among males has. They are never content to be just plain old floating objects, when that is what you happen most in the world to want in the room.

To people of my age and temperament, the sexual revolution is much of a puzzlement. On the good side of this revolution, ladies are undemanding to a fault. There are no preliminaries any more. Slam, bam, thank you, ma'am used to be a joke. Now it's damned near a way of life. Becoming physically intimate is often as easy as scratching pencil to paper.

Right-minded girls in their 20s look upon marriage with the paranoia of a retired admiral caught in a nest of longhairs. Though I shall probably never be able to find out, I suspicion that these girls are just the girls for me, and that if they had been around in the days when I was buddying up to the institution and sacrament, I might have been spared a spell of nonsense. Marriage could have been truly a hobby, and divorce something out of the dark ages.

On Money

That First Million

*I*t was once told me by someone who had plenty of them that "You must never ask a man how he made his first million." This was the speculator Bernard Baruch, self-styled "adviser to presidents." (I know at least two presidents who couldn't stand the adviser's guts.)

This same Baruch once said that any American of average intelligence could become a millionaire before he was 30 *"if he thought of NOTHING else."* That is apparently what Baruch did. He took up girls afterward.

His generalization about a man's first million was undoubtedly more true when he said it, in the '40s, than it is now; but it's still pretty valid. Today a guy down in Silicon Valley can invent some new kind of semiconductor, become a multimillionaire in a couple of years, and have nothing to be ashamed of and nothing you may not ask him about how he got rich.

In Baruch's day, however, you had to be a thief in the literal sense, and some other not very nice things thrown in, to achieve the beatitude of millionairehood. You had to be willing to walk over your mother, to bilk your siblings and other loved ones, cheat your employees, and lie incessantly to everyone from your banker to your priest, rabbi or minister.

You had to have a secret life. In this life you were ranged against the world. You had to be paranoid, suspicious of the motives of everyone set against you. They say the first million is the hardest. That is no idle metaphor.

Clarence Day put it gently: "A moderate addiction to money may not always be hurtful, but when taken in excess it is always bad for the health."

For those who have survived the tawdriness and humiliations that are needed to bring in the first million, life can be relatively sweet. But the rich man who earns his own wealth is permanently scarred by the sickness of his early devotion to accumulation.

When he gets enough money to give it away, and earn the title of philanthropist, which he most decidedly is not, I think his generosity is almost always dictated by the shabbiness of those early days of accumulation.

Some people are so silly as to feel guilt not only for their own peculations, but for those of their ancestors. This accounts for the presence of many a dandy collection in many a museum in

these 50 states.

It takes a particular kind of character to handle large sums of money without guilt. The great tycoons have this quality. The greatest of them all, J. P. Morgan the elder, had this quality in abundance.

He never let his money interfere with his yachting, his womanizing, his willingness to break a weak man. He was a sociopath on a large scale. He simply did not know good from bad, except that the possession and accumulation of money was good.

An old Yiddish proverb would have appealed to his baroque tastes. "With money in your pocket, you are wise, you are handsome and you sing well too."

This is, of course, after that shameful first million is acquired. That is the rite of passage for the money man. There are some who maintain that the difference between a little millionaire and a big one is slight.

I disagree. Money is addictive and the thorough and incurable addict shows the stigmata of his addiction. Maurice Baring, who came from a family of old-line British millionaire merchant bankers, once remarked: "If you want to know what the Good Lord thinks of money you have only to look at those to whom he gives it."

It's Only *Money*

I have an English friend who maintains that rich Americans don't really care about money. "All they want is what money can buy. That, chiefly, is the illusion of being rich."

No Americans, he maintains, have ever really lived as rich men, no matter how much money they had, or how many Ritzes they lived in, or how many German spas they wintered or summered at, or how many Tiffany or Van Cleef bijoux they awarded their loved ones, on which ever side of the bed. My friend, who knows this country well, claims this includes Back Bay Bostonians and the goateed gentlemen of the Virginia Tidewater. Status, in the solid old English, French, German and Italian senses, just doesn't exist in this country.

So what the American millionaire does with his money, according to this thesis, is buy status, and more status, and more status. It's fake status, manufactured mostly on Madison and Fifth avenues between 42nd and 57th streets.

For the poor, Madison avenue creates appetites. For the rich, it assures that their appetites are absolutely, but absolutely, wizard. You may not be the Duke of Devonshire, but you can use the same toothpaste. If you are truly in, you can go to his personal hairdresser on Curzon street if you happen to be in London. But there's no way, never, that you can have a house like his Chatsworth, or a garden like the heavenly one which surrounds it. No matter how much money you may have. The things that confer real status are older than this here Republic.

This leads into the disease of the best. People with money, and especially people with new money, collect the best. By the best, they mean the label with the maximum prestige. This is not on the whole a bad guide, since the people who have good labels know what they have, and tend to protect them. Labels can misguide, though, and they always cost too much

I once knew a chap in Mexico who came into a great deal of loot in a very short time by building a lot of hotels when and where they were needed. It was interesting to watch the way he spent his money, for he was a spender, like most Mexicans who have it. "What's the best?" he was always asking. He made lists, and he acted on them.

He knew the best tailor in the world was Knize, of Vienna, and he was suited by him. His ties came from Turnbull and Asser on Jermyn street in London and his shirts from Hodgkin-

son, on the same street. The shoes came from Peal, again of London. His automobile was an Aston-Martin. Etc.

The man lived in a succession of Ritzes, largely because he couldn't build and staff anything like them. The London Ritz, the Paris Ritz, the Barcelona Ritz. When he was in New York, it was New York's own Ritz, the Regency hotel, which still has astonishing service in an age when excellent service is no longer generally associated with a New York hotel.

This was all consumption, on a conspicuous and very grand scale. My Mexican friend was an astute businessman. He was aware that investing money for consumer goods was not good business, because his money did not grow. It was just spent, in the literal sense. But none of this mattered to him. He had, all the time, the feeling of being rich.

It all comes back to the most brilliant observation on the subject ever made by anyone, that anyone being the shrewdest combination of gauloiserie, bon sens, and panache recently put together by the French, Mme.Coco Chanel. "There are people who are rich," she said, "and people who have money."

And, one may add, never the twain shall meet. Those who have money may become rich but as I said, it usually takes longer than this country has been in existence. So the best the American millionaire can do in these times (and we seem to create at least one millionaire every day of the week) is to ape the rich. The apparatus for this entrancing game is around, and always will be. Even the ghettoes advertise gourmet hamburgers.

Meditation on a Dime

There I was, the other day, down in the bowels of the Co-Op on Bay street in North Beach, rummaging among the canned orange juice concentrate in the frozen food section. A dime had slipped out of my jacket pocket and disappeared from view among the cans.

I knew right away that I had a tiny moral problem before me. It has bothered me before and it will again. The question is about the value of money.

There is no question that it would have been easier for me to forget the whole thing than to recover the dime. I daresay four out of five people would settle the matter thus. But I'm not four out of five in this matter. I'm the unfortunate one.

I did not need the dime. I have plenty more where it came from. I am not a miser, despite the view of some uppity bartenders to the contrary.

I don't even like money, and do everything possible to avoid transacting in it. I even have someone else pay my bills. About the only regular cash transaction I have daily is the purchase of several bottles of ale in my local.

The learned part of me said, The hell with it. My teaching would not let me. My teacher about money was the Great Depression of the '30s, the years I attended high school and college. In those days a dime was the difference between having money and being broke.

As I continued to rummage through the tin cans in search of the dime, feeling more and more ludicrous by the minute, my mind turned to a news story of last year. A guy was being questioned for jury duty in the Albany County court in New York. The case involved three men accused of shoplifting $161 worth of clothes from Sears, Roebuck.

The potential juror made it clear that he was unhappy with his experience. He told a lawyer for one of the defendants that he considered it "stupid" to tie up a lot of people over what he called "a $250 larceny." About a third of his fellow panelists applauded his utterance.

The judge declared a mistrial. Seven jurors who had been seated were excused, including the disgruntled man. The 192 other jurors were told to return for another trial.

I'm certain the man meant what he said. Equally I am certain that his attitude turned on some strong resentment in his

fellow panelists. Money under the amount of $250 was nothing to get excited about.

I will never be able to feel that way. Money, though I dislike it in a way, is important. That is perhaps why I dislike it, being of what might be called an independent nature.

The freezer holding the orange juice was by now a shambles. I called one of the clerks to help me. He gave me a long look. However, he was a good soldier and burrowed all the way to the bottom for me.

The dime was gravely returned to its owner. The attendant and I had one of those silent, incomprehensible conversations with our eyes.

Usury

*T*oday we call it investment, or banking, and sometimes even investment banking. Our whole culture is based on it, and so is the culture of every "civilized" country in the world. Without it our economic system would collapse, for the reason that putting out money at interest IS our system.

Yet it was not always thus. The spiritual ancestors of the Western world—the ancient Greeks, the Jews and the medieval philosophers of the Catholic church—called lending money usury, and they said the hell with it. Today usury refers to Shylocking, putting out money at extravagant interest. The ancients used the expression for ANY payment of interest on money loaned.

By this stark measure, the difference between David Rockefeller of Chase Manhattan and your friendly ghetto banker's enforcer is one of degree but not of kind. What makes the one respectable and the other sleazy is chiefly the theological sanctions of the Protestant church. (Yet I seem to recall some bitter reflections of Martin Luther about people who sit comfortably behind stoves while their money works for them.)

The Talmud says, "He who lends without interest is more worthy than he who gives to charity, and he who invests money in the business of a poor man is the most worthy of all."

That, I may say, is an ideal pretty distant from the banker of modern times. This lad was aptly and famously limned by Mark Twain as "a fellow who lends his umbrella when the sun is shining and wants it back the minute it begins to rain."

What I am suggesting is that if three great civilizations rejected the idea of collecting interest on money, there may be something to it. Perhaps the greatest single turning we have made as a species was when we fell for this essentially meretricious idea.

For why should money, unrelated to work, become a source for money? Why should men be enabled to enslave other men economically simply because they have more money? Why, to come right down to it, are bankers as we know them necessary at all?

These are seditious suggestions, to be sure. I think they are worth at least a few seconds' speculation, especially by bankers and by investment bankers, and those greatest moneyholders of them all, insurance men.

There has always been something highly attractive to me in Henry Thoreau's theory of wages and costs. "The cost of a thing," he said, "is the amount of what I will call life which is required to be exchanged for it, immediately or in the long run."

There can be no admitting of usury into a system so defined. Money would be a reward for work expended. The idle man who lives on his investment (investment means putting clothes on your money) would no longer have any function. The citizen would be a worker.

If Moses and Aristotle and the Middle Age Christians were right, our whole system of life is based on one huge, gigantic sin. I am not an economist, and have very little understanding of, or capability of dealing with, money. I do not know when or where this giant turning took place in our history. But there is something inside me that says the turning was tragically mistaken, and that usury may be at the root of many of our maladjustments.

I do not expect anything will be done about it. Our dependence and the usufruct thereof are not only material but spiritual, and by now so deeply ingrained as to be irreversible.

But it is possible to live with a mistake while knowing it is a mistake. We do it all the time. If we were to recognize the shakiness of the assumptions which underlie our economic system, perhaps we could deal more intelligently with it.

A Baker's Dozen

Red Smith

*I*n the middle of January 1982 a gentleman and a scholar died. His name was Walter Wellesley Smith and he had always been called Red. He was a newspaperman who wrote about sports. He made me, and hundreds of other newspapermen, proud to be part of the racket.

When I was in the sportswriting biz, in the early '60s, I asked Red for some advice. "How do you write a column?"

"First you find a pediment," Red said. He also told me that there were only four sports that really interested people and to stick to them: horses, baseball, football and fighting. I took both pieces of advice and greatly profited by them.

Red was always free with advice. When a college student once sent him his columns for the undergraduate newspaper, Red replied:

"When I was a cub in Milwaukee I had a city editor who'd stroll over and read over a guy's shoulder when he was writing a lede. Sometimes he would approve and sometimes say gently, 'try again,' and walk away.

"My best advice is, try again. And then again. If you're for this racket, and not many really are, then you've got an eternity of sweat and tears ahead. I don't mean just you; I mean anybody."

Red was nearly always the last man to leave the press room. Like Westbrook Pegler, he was a bleeder. I well remember him at the Olympic Games in Squaw Valley in 1960. When everyone else left and was up at the bar, Red sat sweating, piles of rejected ledes surrounding him. He hadn't really even started his story yet. But when the lede came he wrote fluently and always met his deadline.

He was a generous, convivial man, who believed that his job was important and fulfilling. He once said: "Sports is not really a play world. I think it's the real world. The people we're writing about in professional sports, they're suffering and living and dying and loving and trying to make their way through life just as the bricklayers and politicians are.

"This may sound defensive—I don't think it is—but I'm aware that games are a part of every culture we know anything about. And often taken seriously. It's no accident that of all the monuments left of the Greco-Roman culture, the biggest is the ball park, the Colosseum, the Yankee Stadium of ancient times.

The man who reports on these games contributes his small bit to the history of his times."

But he insisted on being a newspaperman first and a sports-writer next. He said that if there were a half-dozen of the top sportswriters in America who hadn't served an apprenticeship in the city room, they did not come to mind.

I became acquainted with the work of Red when he wrote for the New York Herald Tribune, where Stanley Woodward had assembled perhaps the finest sports staff of our time, all men who wrote English with skill and love. After that paper's demise he worked for the New York Times.

As Red Smith said: "The English language, if handled with respect, scarcely ever poisoned the user."

Randolph G.

I was reading an English review of the recently published diaries of that malicious and gifted man, Evelyn Waugh. Quoting from the diaries, the reviewer made the worst possible case for Waugh's friend and companion-at-arms, Randolph Churchill, son of Winston.

Randolph's rudeness to servants was habitual, the man said. On once occasion during the war in Italy, Randolph stopped his jeep to pass water in front of some Italian women—"because," he explained, "I am a member of Parliament."

Drunk or sober, his conversation was intolerable. To keep him quiet, Waugh once bet him ten quid he could not read the Bible right through, whereupon Churchill set to work persistently exclaiming, "God, isn't God a shit?"

When Randolph entered a hospital to have a lung removed, and it was announced that the trouble was non-malignant, Waugh observed that it was characteristic of modern science to find the only unmalignant part of Randolph and remove it.

I have no doubt of the veracity of any of these tales: but there was rather more to Randolph Churchill than his worst, though there was plenty of that. Despite all this thorniness, he never lacked for a bed either in Britain or here, and his hosts were distinguished fellows indeed.

I knew him quite well in the years before he died in 1968, at age 57. His home was in the pretty Suffolk village of East Bergholt, where Constable was born. He had discovered gardening late in life, and pursued the elusive poinsettia with the passion that only an English gardener can.

It was at East Bergholt, with a team of young assistants, that he produced the first two volumes of the full-length biography of his father. This was hard and distinguished labor.

And it was a labor of love. Unlike many sons of great men, there was no hostility or alienation between father and son. Whatever his father's political fortunes (and there was a time, in the early 1930's when *his* political future looked brighter than Winston's) the son always believed the father was the greatest man in the world.

Randolph was a journalist of great pugnacity and talent. His comments on public affairs were in the first rank of British journalism. He was a skillful debater and public speaker. He also made quite a pile of money out of libel suits and other liti-

gation, often in defense of his father's good name.

There was a deep melancholy in him, which seemed to me to produce much of his recklessness. He had a strong suspicion that he was slightly mad. This madness he attributed to the syphilis that destroyed the career of his grandfather and namesake, Lord Randolph Churchill, and to some dark and mysterious "bad blood" that he found in his mother's family line.

For all his awful behavior, there were few who knew Randolph who did not love him, and forgive him again and again. When he died, his obit in the Times was a measured tribute to a superior if eccentric man.

He never fulfilled his early promise. At Oxford, he was one of the best-looking as well as the brightest of his generation. When he came down from Oxford, he was placed on the American lecture circuit at an exorbitant rate of pay. His tour was successful.

After his lecture tour Randolph and his father were both guests as Lord Beaverbrook's place in the south of France. At the moment Winston's future was as bleak as his son's was bright.

Elizabeth Bibesco, one of the guests, turned to Beaverbrook, motioned toward Winston, who was sitting in a corner reading a book: "What a pity," she said, "that Winston should have spent his youth in the shadow of one Randolph Churchill, and looks to spend his old age in the shadow of another."

'Co-HAN, If You Please'

Saw Joel Grey at the Fairmont recently. A very good turn he is too, having modeled himself in almost every particular after George Michael Cohan, who is a pretty good number to model yourself after.

I knew the great man in the days before he died. His turf, in the time I knew him, was a stretch of West 46th street in New York, between Sixth avenue and Broadway. Specifically it extended from a place called the Roxy Bar to the stage entrance of Loew's State Theatre, with the offices of the theatrical newspaper Variety right in the middle.

Cohan's trademark was his cocky walk, a sideward tilt of his head while he talked, always from the side of his mouth. If somebody mispronounced his last name he would firmly state "Co-HAN, if you please." He was as Irish as Paddy's pig, and proud of it. He knew that the Cohans were descended from some kings of Ireland or other, as all of us micks are.

Though he was born in Providence of a well-known theatrical family, Cohan became the greatest New Yorker of them all. He was the greatest chauvinist the city ever produced. "Give my regards to Broadway, remember me to Herald Square," always brought tears to HIS eyes.

His chauvinism about America was just as great. His biggest single success was a tear-jerker called "Over There," a ballad which practically fueled America through its first World War.

Cohan, when I used to see him, was in retirement. He had been bitter for years about the closed shop policies of Actor's Equity. It showed in his talk. He walked each day through Central Park from his apartment on the upper East side to his turf on 46th street. Here he would look at the bulletin board at the stage entrance of Loew's State, on which could be found the whereabouts of just about everybody in vaudeville, with messages from them.

Cohan was the greatest entertainer in our country's history. He once aptly called himself a "drama practitioner." In a career that spanned 40 years he was dancer, actor, dramatist, producer, manager, composer and lyricist. He was even a motion picture and talking picture star. He attended about 100 ball games a year and was a committed Giant fan, though he seldom admitted it. Being a national figure he said, "I'm always for the visi-

ting team."

He was a quiet man, an observer. He transacted most of his business from telephone booths. His office was in his hat. He wrote from midnight to dawn, a survival from the old barn-storming days when these were the only hours he could call his own.

Only three times in his long career did he ever utter lines on stage which had not been written by George M. Cohan. The first time was in a 1918 Hartley Manners production called "Out There." In 1933 he played Nat Miller in Eugene O'Neill's "Ah, Wilderness," a great personal triumph. And, in 1938, he was President Roosevelt in the Kaufman-Hart musical, "I'd Rather Be Right."

Cohan in World War I had the distinction of bringing in the largest box office gross in theatrical history. Characteristically, he also did it for his country. When "Yankee Doodle Dandy" opened on Broadway the tickets were War Savings Bonds, some of them selling for as much as $25,000. When the gross was added up there had been over $5.5 million in bonds sold.

"There aren't 20 people who really know the man," one reporter wrote, "but he knows more than 5000 intimately." He waved his hand to everyone who recognized him, which was just about everyone. This jaunty fellow could have had Tammany Hall for the asking, if he had liked the politician's trade.

Denis *B.*

I suppose Denis Brogan was the brightest man I ever knew. If the answer to anything had ever appeared in print, in English or in French, you could damned well bet that Denis had it and could produce it instantly, in his brisk impatient Glasgow-Irish accent.

In this he was like an earlier historian, Lord Macaulay. Macaulay could recall everything he had ever read, and had a masterly capacity for pithily regurgitating this information. Sir Denis W. Brogan, political science don at Cambridge University since 1939, had this same towering capacity over facts.

The first time I met Denis was at the bar of the National Press Club in 1949. We got into two subjects which I thought I knew quite a lot about: Horace Walpole, that great epicene observer of the British 18th century, and Tammany Hall. The British don's mastery of both subjects was to mine as Einstein might be to a math major.

Denis seemed to know everything about everything. He delighted in recondite scandalous bits about the great, of which he had a dandy collection. He knew more about the United States than almost any American, and more about modern France than almost any Frenchman. His 1933 book, "The American Political System," is the best thing I've ever read on the workings of our government.

The polymath intelligence of Denis Brogan was most usefully employed by Winston Churchill during the war. The canny P. M. planted two dons, one from Oxford and one from Cambridge, in the middle of wartime Washington to report to him privately and informally. The two men were a formidable combination, even then considered the cleverest pair of Academe. One was the Scottish-Irish Brogan, the other a gifted Jew named Isaiah Berlin.

(Churchill once told Scotland Yard, "Find this Berlin chap for me." The chap was located in Claridge's Hotel in London, and escorted down to Chequers for a weekend with the Prime Minister. The meeting went poorly, the two distinguished minds barely brushing. In due time it was found out that the Berlin chap was Irving B., of Tin Pan Alley. The story was first told me by Professor Brogan, who chuckled and chuckled.)

What Churchill and others who knew the Brogan mind well valued in it most was the Olympian disinterestedness. He never deluded himself about his fellow countrymen. One of his favor-

ite stories was about a period he spent on The London Times. His job was to cut out snippets of the kind American journalists call fillers, which are short items inserted between the news and the advertisements. His memorable snippet was sent by a Times correspondent in Monaco. It read:

"The funicular railways between La Turbie and Monte Carlo broke down yesterday. There were no casualties. Twelve Monacans were killed."

Sir Denis loved us Yanks, though he got a bit soured on the system when Senator Joe McCarthy began juggling espionage and homosexual balls over the head of the State Department in the early 1950s.

Brogan thought of Americans as "great short term optimists, always wanting things to go well. and when they turned out badly, totally forgetting the whole mess." He told me once he was a Glaswegian first, a human being second, and a Briton third. To me he was a good companion.

E. Waugh

The lucidity and elegance of Evelyn Waugh's English prose style was just about matched by the murkiness and untidiness of his life. His sentences were as chiseled as a Latin epigram, and he never wrote a bad one. His personal life, outside his family, was a chaos. Dr. Jekyll and Mr. Hyde were no more disparate than Waugh at home and Waugh abroad.

His rudeness was legendary. It was perhaps only equalled by his close friend and contemporary, Randolph Churchill, son of Winston. Waugh's own verdict on Randolph applies with perhaps equal force to Waugh himself:

"No one who knows Mr. Randolph Churchill and wishes to express distaste for him should ever be at a loss for words which would be both opprobrious and just."

It is usual to excuse rudeness in the British upper classes (which Churchill belonged to as certainly as Waugh did not, though the latter was obsessed by the rich and well born) on the grounds of something vaguely called eccentricity. In later years Waugh's *persona* was that of an English country squire, with a good seat both in the shires and on a horse. Yet his habitual attire was that of a bookie, dreadful houndstooth suit and all. This was eccentric.

He was a Catholic, by conversion, but hardly a Christian. You never knew when he was going to savage you, verbally. He blotted his book constantly at dinner parties. He once put down an American lady who praised one of his novels. "I rather liked it myself, but since I hear it praised by a vulgar, underbred American woman, I am no longer so sure."

There is something more than eccentricity in a remark like this. Christopher Sykes, in his book, "Evelyn Waugh: A Biography," tells the most revealing anecdote I've heard about Evelyn. Waugh once was brought to meet Hilaire Belloc, the great Catholic writer, for whom he had great respect. Evelyn was deferential, says Sykes: "He spoke very little, being clearly somewhat awed."

Belloc was later asked what he thought of his young visitor. He replied, "He is possessed."

That seems to have been the truth. When the English use the word possessed they usually mean "dominated by a spirit that has entered one, or other irresistible influence." He clearly had a devil within him, and might easily have been put to the

stake at an earlier time.

Randolph Churchill was always haunted by a fear that there was lunacy in his family, and said his father had the same fear because of the syphilis Lord Randolph Churchill, Winston's father, had contracted. In Randolph's case the fear was compounded because he thought his mother had the blood of "the mad Mitfords" in her veins.

Waugh, too, had serious breakdowns in his life. He was well aware of his incipient, if not intermittent, madness. The best bit of writing about Waugh has been done by himself, in the first chapter of "The Ordeal of Gilbert Pinfold." This chapter is one of the great bits of autobiographical writing in our language, though it is presented as fiction. Waugh's madness, and his terror of it, are nakedly there.

I recommend Sykes' book thoroughly, if only for his anecdotes. A priceless one concerns Waugh's lunch with an R. C. bishop at the London Ritz. The occasion of the lunch was a marital annulment, which Waugh was seeking for his first marriage, and the fact that such matters were within the bishop's provenance.

After the pair had picked up their menus, and the waiter came for the order, Evelyn said solicitiously: "Well, what would you like to start with? Oysters? Smoked salmon? Caviar?" The bishop said that would be very nice, and had all three, for starters.

Gene Tunney

James Joseph Tunney, known as Gene, was a remarkable man, in the ring and out. His passion was self-improvement, and I've never met anyone who was better at it. From a start in the poorest section of Greenwich Village, he made himself into heavyweight champion, a millionaire many times over, the father of a U.S. Senator, and a cultivated man at home with the great on easy terms. There are few men I have admired more, one way and another.

I've told the story of my first meeting with him. He was a Navy commander in charge of physical fitness for the fleet. He was visiting San Juan, P.R., where I was working. It was late in 1942. The aide to the admiral commanding the Ninth Naval District informed me that Commander Tunney would like to have dinner with me.

I couldn't imagine why. We met at La Mallorquina, a good restaurant in old San Juan. After introductions the Champ put a huge paw around my shoulders and uttered the following astonishing sentence:

"Three nights ago in New York your wife Bridget was sitting on my knee in Mabel Dodge's apartment on Fifth avenue where my friend Thornton Wilder was reading passages from 'Finnegan's Wake.' She asked me to say hello."

We soon discovered we had quite a few things in common. We both came from poor New York neighborhoods; we had gone to the same high school, La Salle Academy; we both liked rich and rather fancy girls, and I was a great fight fan.

Mostly, we both loved books. This was partly because of our common passion for self-improvement. Books were the easiest way for a mick to become an Irishman. But there was genuine love for the printed word on both sides.

The Commander, as I have always called him, had an astonishing memory. I remember a night on the beach where he recited page after page of Carlyle's "Heroes and Hero-Worship" as if he were reading a page before him by moonlight. He knew the main body of English literature quite as well as most college profs.

He was, with his ruddy cheeks and great height, the healthiest looking man I had ever seen. He was then in his early 40s and still looked as if he could lick every male on the planet. The force of his confident physical presence was almost overwhelming.

There was, to be sure, something mildly ridiculous about

such a man speculating at length about the private life of Swinburne, or whether Gertrude Stein wasn't just a wee bit overrated. The older he got, the better he carried it off, and when he became a proper tycoon, a millionaire many times over, he almost grew into the image of the fox-hunting squire who collected editions of the poetry of Lord Rochester. The Commander was something.

Once we took a trip on a sub chaser from Corinto, Nicaragua to the Galapagos islands. While fishing off the ship he read Bulfinch's Mythology on the way out and Darwin's "Voyage of the Beagle" on the way back. And doubtless remembered every word of each.

The Commander could be silly at times, as when he addressed a group of sailors at a Caribbean air base with the daunting opening lines, "A few days ago, in the Pacific, Bull Halsey, Chet Nimitz and I were discussing Plato."

The Commander was reluctant to discuss his career as a fighter ("Boxer, please," in pained tones) unless urged by a pretty girl. In those circumstances he was always willing to answer the question: "Who was the greatest of them all?"

The Commander would review them all, from Jem Mace and his great hero John Gulley, to Joe Louis, Rocky Marciano, and Muhammad Ali. The GOTA, the Commander insisted to the end, was Jack Dempsey. "Vital, deceptive, clean, speedy, and with better coordination than any of the other champions. Unquestionably tops."

WE know who beat Jack Dempsey. Twice.

ʾKoestler

When I was living in England in the '60s, I knew the late Arthur Koestler fairly well. When I came up to London with my wife we visited one of her friends, who lived across Montpelier Square from the Koestlers. She would bring us over, for she was a great friend of the writer. There would be drinks and lots of talk, for Koestler was a great talker. Nearly always the talk would be about new ideas.

I am convinced that Koestler will be remembered as a great figure in this century. I was deeply influenced by his "Darkness at Noon," his best known book, when it first came out in 1940. This was the first book to set me truly against Communism.

The book has been described as "an account of the moral struggles of an idealistic revolutionary who is persuaded by his superiors to confess to crimes against the state which he did not commit." It is that, and much more than that. It is a passionate examination of modern Communism in which that theory's bones are laid bare. It is a book that can properly be called frightening.

Koestler was a true exile. He was born in Hungary in 1905. He started his writing career as a journalist. When he was 21 he left for Palestine. Also he wrote, in German, articles on science.

In 1932 he became a member of the Communist Party. While covering the Spanish Civil War for an English newspaper he was captured by the Franco forces and spent several months in jail and was released only by British intervention.

At the outbreak of World War II he suffered another term in prison in France as a refugee. He was released and served two years in the French Foreign Legion. After the war he became a British subject. He wrote many essays and novels in his lifetime but his *magnum opus* was "Darkness at Noon."

I was not surprised by the joint suicide of Koestler and his wife Cynthia. Accounts of the suicide in the London papers said the Koestlers gave no indication of their plans, but few of their friends were surprised by the action.

No wonder. When I knew him self-slaughter, and the circumstances under which it is defensible, was a subject about which he talked incessantly. His endless propaganda for "death rights" has put the subject on the late 20th century agenda. Koestler, 77, had Parkinson's Disease which was progressively worsening. A friend, author Brian Inglis, said he thought the drugs used to stem the disease made him miserable and depressed.

His editor, Harold Harris, saw the couple about a week before they took their lives. "He found himself becoming helpless," said Harris, "and plainly decided the time had come."

I have said he was a true exile. Several years back, at the Austrian alpine village of Alpbach, where he had a small cottage, he met with a cultural attache from his native Hungary. "What would happen if I came back for a visit?" Koestler asked.

"We would welcome you with pride," said the official, "but we could not guarantee your safety.

"You are on a very short list of those whom the Soviet Union cannot come to terms with. 'Darkness at Noon' is as dangerous today as it was a generation ago. They might try and come for you. It is a very tiny list, but you are on it." That was worth the Nobel Prize he never got.

Mabel and David

With all her husbands' names included, her name was Mabel Ganson Evans Dodge Sterne Luhan. She was best known as Mabel Dodge, who had once had a boiling affair with John Reed, the American journalist who is buried in the Kremlin. She died in Taos, N. M., on August 14, 1962, at age 83.

She was the great artistic groupie of this country in the 20th Century. She had a brilliant salon at 23 Fifth avenue before World War I. Reed and Walter Lippmann would speak on Socialism Night. Margaret Sanger was chief speaker on Birth Control Night. Top labor leaders spoke on Trade Union Night. Max Eastman, Lincoln Steffens, Carl Van Vechten and sculptor Jo Davidson hung about.

Her most notorious relationship was with D.H. Lawrence, the British novelist. In the early 1920s she and Lawrence's wife engaged in a lively struggle for his creative personality.

Of this struggle with Mrs. Lawrence, the former Baroness Frieda von Richthofen, Mrs. Luhan wrote: "I wanted to seduce his spirit so that I could make him carry out certain things. . .I did not want, particularly, to touch him."

Mabel's literary friends discussed this affair in books numerous enough to fill a small library. Mabel quoted Mrs. Lawrence as having said that "I could have him if I could get him." She never got him.

I got to know Mabel quite well in the early 1950s, when we both lived in Cuernavaca. She then told me a delicious, and malicious story about the Lawrences that I do not think has ever seen print.

In the middle 1920s, Lawrence was very sick of tuberculosis, the disease that carried him away in 1930. He was in Florence, for his health. He was bed-ridden, and deep into writing "Lady Chatterley's Lover." He was also, according to his wife, sexually impotent at the time.

Frieda Lawrence was a woman of sturdy sexual appetite. She was in the habit of taking long walks around Florence late in the afternoon. Her usual route took her daily across the entrance to a large military barracks.

The barracks entrance was guarded by an Italian sergeant. Each day he greedily took in the Germanic good looks of this formidable woman: Frieda Lawrence, for her part, liked the little sergeant, who was also a painter and ceramicist.

What with one thing and another, a tearing affair got under-way. When the sergeant, whose name was Angelino, got off duty there would be a spirited *cinq a sept* session in a cottage Frieda rented for the purpose.

Mabel Dodge was visiting the Lawrences at this time. She knew what was going on, though Lawrence presumably did not.

It was Lawrence's habit to write page after page of manu-script and throw them from his bed to the floor. When Frieda came home, usually at the onset of the evening, it was her prac-tice to pick up the written pages, get them into proper order, and then read David's daily production to the author himself.

It did not take Frieda long to figure out that something pretty funny was going on. A few days after she began her affair with the sergeant, the tone of the manuscript became more and more sexually explicit. The scenes between her ladyship and the gamekeeper Mellors began to resemble nothing so much as a recapitulation of what Mrs. Lawrence and the sergeant had been doing earlier in the afternoon.

As Lawrence did not leave his bed, and was in fact unable to, Frieda never figured out either how he knew or if he knew. She was a dauntless woman, and continued reading the manu-script, totally without expression.

Lawrence's insight remained a mystery to his death, for both Frieda and Mabel. Many years later Frieda and the former sergeant were married in Taos. Witness to the marriage was Mabel Dodge, who was by this time married to a taciturn Navajo Indian chieftain, Tony Luhan.

Joe McGarthy

I confess I always had a soft spot in my heart for Joe McCarthy. I mean the private Joe, the guy who told funny stories about his colleagues in the Senate in a little apartment he had behind the Capitol in Washington.

I knew Joe before he became the famous Communist hunter who accused the Department of State of "harboring 205 prominent Communists"—a charge he was never able to prove. I saw him besmirch the reputations of scores of blameless men, and still I liked him personally. I was working for the United Press at the time. I declined to cover stories involving Joe and his phantom Commies, and the UP went along with my wishes.

That I liked Joe is probably due to a defect in my own character, or in the nature of the U.S. in the '50s, which made Joe and his depredations possible. Or, closer to the knuckle perhaps, to the curiously ambivalent nature of Washington, where political enemies are only too often personal friends.

Undaunted at being unable to produce his 205 Commies, Joe kept up the fight during the late Truman and early Eisenhower days. He accused the Truman administration of being "soft on communism" and the Democratic Party of a record of "twenty years of teason."

As chairman of the permanent committee on investigations of the Senate, a job he got after Eisenhower was elected, he specialized in "hectoring cross-examination, damaging innuendo, and 'guilt by association.'" He hurt a lot of people. Whether he did any permanent damage to the country I shall never know.

Joe just wanted to be famous, or notorious, or just talked about—and he succeeded by his lights. He finally had his comeuppance, when he openly attacked Eisenhower and the Army, which he accused of "coddling Communists." There Joe clearly overreached himself. He died (in 1957), and I am convinced that the cause of his death is that he finally achieved inattention. He that lives by the headline dies by the headline.

These moody thoughts are brought up by a biography of Joe by Thomas C. Reeves called "The Life and Times of Joe McCarthy."

Reeves tries to give a level view of McCarthy. He pictures a man who was no more corrupt than most guys who make it to the Hill, a genial host, a man who held no rancor after the battle.

Then why did he become the best known politician in the

U.S.? The Economist, in a review of the book, theorizes that Joe's power came from "the coalition of all the forces which found McCarthyism a very present help in time of trouble.

"It was the incorruptible Senator Robert Taft, concerned for his Ohio seat and the GOP which he led. It was General Eisenhower, wanting the fruits of McCarthyism without being caught in the act of picking them.

"It was the Kennedy clan, from the old man down, always ready with material and ideological aid and comfort. It was the leadership of the Roman Catholic Church. It was J. Edgar Hoover and the FBI, without whose constant leaks McCarthy could not possibly have stayed in business."

These manipulators were the cause of Joe's rise, but when he took on the Army, his backers found they liked the Army more than they liked Joe. They turned against him, with all their real power. The media were silenced. The powerful men who backed him didn't want somebody who flew out of control doing their work for them.

In one small corner of this great country neither Joe or his ideas are dead. To this day, an annual service of remembrance is held on May 2, the anniversary of Joe's death, in New York's St. Patrick's cathedral. The totally committed have long memories.

'Uncle Arthur'

The first man to give me a job on a newspaper was a great figure of his time, Arthur Brisbane. I talked to him for about three minutes, and never again had any social intercourse with him, though I often saw him in the corridors of the building.

At that time he was editor of the Hearst morning newspaper in New York, the American. He wrote a column called "Today" that ran on the left hand column of the front page and, if I am not mistaken, on the front pages of every Hearst morning paper in the country.

He was a small red-faced fellow. He looked like a well-fed Presbyterian dominie. He thought like one too. He had been a great reporter in his youth; but his famous column was mostly a collage of silliness from the top of the editor's head.

He got his first reporter's job on the New York Sun on his 19th birthday in 1883. Later he became London correspondent for the Sun and at age 23 became the newspaper's managing editor at a salary of $15,000 a year, a huge salary for a newsman in those days.

Brisbane really became famous when he went to work for William Randolph Hearst. His new boss owned a faltering New York paper called the Journal. Young Arthur had previously left the Sun for a job on Joseph Pulitzer's World and he agreed to take the same salary he was getting on the World, with the proviso that he would get part of the profits if the Journal's circulation increased.

His first move was to hire an editorial writer. The man was late in arriving. Brisbane wrote the editorials himself. They caught on immediately. The readers read and clamored for more. In four months the circulation of the Journal had climbed to unprecedented heights.

Whatever came into his head went into those editorials and later the "Today" column. His comments were determinedly lowbrow. He meant what he said when he adopted his motto: "Don't tell them what you think; tell them what they think." He was never guilty of overestimating the intelligence of the American people. This was easy for Brisbane. He had a mediocre mind and never had an original idea in his life, or if he did, he concealed it well.

He had a way with money, which he relished above all things. "To Hell with fame and power," he once said to a friend,

"I intend to be rich! That's all there is to this life!" He was known to introduce himself: "My name is Arthur Brisbane and I make $260,000 a year."

There are none of these journalistic potentates any more, and it's just as well. Brisbane and his boss, Mr. Hearst, came to wield great power in New York and it was used primarily for their own well-being. If they were alive today, and in their prime, they would probably control television.

I thought of him the other day when I read a remark he wrote for the Chicago Record Herald in 1913. "Motion pictures," said Arthur Brisbane, "are just a passing fancy and aren't worth comment in this newspaper."

But he was a pretty wily old boy in his later business dealings. His passionate and unceasing editorial backing of the East River Drive project was widely rumored to be not unrelated to immense real estate holdings he had acquired along the route. He died a very rich man.

There was one small business deal in which he was bested, and it is my favorite Brisbane story.

When he was editing Hearst's Journal, the brightest star on the paper was the San Francisco cartoonist T.A. Dorgan, called TAD. TAD was also the highest-paid employee of the Hearst organization, with the possible exception of Brisbane.

But TAD threw money about like a bar owner patronizing his rivals. He arranged for a meeting with Brisbane and mentioned a raise that almost brought tears to the editor's eyes. Brisbane was a great one for telling people illustrative stories when he didn't want to give them money, so he told one to the cartoonist.

"TAD," he said, "I want to tell you a story about a great artist, an artist even greater than you. He was an Italian named Michelangelo. In the 16th century he was ordered by the pope, Julius II, to decorate the ceilings of the Sistine Chapel with his paintings.

"Michelangelo didn't want the job, as he considered himself a sculptor, but he was loyal to the pope. And do you know that for four years, between 1508 and 1512, that poor painter worked on these paintings, all the time flat on his back.

"And," he continued with great emphasis, "do you know what he got paid for that great work? Thirty-five dollars a week."

Dorgan got up and wordlessly left the room. About a week later a series of TAD cartoons reached Brisbane's hands. They were called "If Michelangelo Worked on the Journal." He got his raise.

John McClain

$c\mathcal{A}$ now forgotten part of the business of gathering news was ship news reporting. Before the jet-age the only way you could get to New York from Europe was by the big ocean liners—the United States, the Queens, the Normandie, the Europa, the Ile de France, the Conte di Savoia, and scores more.

Ship news reporters, and every young reporter got the duty at some time or other, got up before dawn (or didn't go to sleep at all) and boarded a Coast Guard cutter that took them out to where the ship was clearing immigration.

The line's press agent would have alerted us to who on board qualified as a celebrity, and also would have set up an interview on board. You met a lot of interesting people at these sessions. I recall interviewing Lord Beaverbrook once, and being offered a job by the great press baron. I would have taken him up on it if I had thought he would remember.

The most interesting person I met as a ship news reporter was not a celebrity at all; but another ship news reporter, John McClain. McClain was everything I was not. I don't think I ever envied another man so. He was handsome, urbane, wildly successful with women, witty and an excellent reporter and writer to boot.

McClain was sometimes called Johnny by his friends, who numbered among them Jock Whitney, Jim Forrestal, and hundreds of other rich and stylish chaps and ladies. I cannot remember anybody ever calling him Jack. It was plain John. I remember one of his lady friends whom he later married. She was Rosie Clyde, and more beautiful than her name. She had been a marchioness of something in a previous incarnation.

Although he became a New Yorker to the teeth, John was actually a hick. He came to New York from Kenyon College in 1927, as a self-described "beamish boy, fresh from a fresh-water college." He was born in Marion, Ohio.

He threw in his chips when the Journal-American, for which he had been working, merged with the Herald Tribune in the mid-'60s. He hastened to assure his readers that he had no regrets about being a newspaperman and would never have done anything else.

"I think," he said, "one of the greatest things in the world is to wake up every morning and be able to say, 'If I had my choice of what to do to earn a living, I would be doing exactly what I am

about to do today."

"I have been able to say this every day since I started out as a cub reporter on the old New York Sun in 1928, and that is a large order. How many men can match it?"

When I knew him he was living at the Hotel Pierre with a rapscallion named Randy Burke. I was living there, too. We were both guests, on a due bill, of J. Paul Getty, who owned the place.

John had lived in 22 other places in New York in his time. Perhaps his favorite place was a Brownstone on East 55th street where he shared ground-floor apartments with John O'Hara, who was flush from his earnings from the recently published "Appointment in Samarra." McClain was everything O'Hara aspired to be but could never become, largely because he was a bad and boisterous drunk. McClain drank like a gent, as he did everything else.

When ship news reporting declined, McClain became a drama critic. He retired as drama critic in 1966. He said that after 15 years "it would be nice to have an evening life of one's own." He died in London in 1967, reportedly of a liver ailment. Rosie Clyde was with him.

Don Luis

\mathcal{A} bit of light went out of my life when I read of the death of Luis Munoz Marin, in San Juan, Puerto Rico, at the age of 82. He was governor of that island for 16 years, and before that had been president of the Senate for eight years.

His father, Luis Munoz Rivera, was often called "the George Washington of Puerto Rico." What his son, a far greater man, will be called I cannot even conjecture.

When I first knew Don Luis he was not famous. He was, if anything, rather infamous. He was editor of a small Socialist newspaper, "La Democracia," and had a vaguely scandalous reputation both personally and politically.

Don Luis had been brought up in America, where his father served in Washington as resident commissioner—a congressman without vote. Luis was a Bohemian to the core. He went to a succession of schools, briefly to Georgetown Law School. Before he came back to edit the family newspaper, he had been a poet and journalist.

He was a free-lance, naturally, because he could never work for anybody but himself and his idea of "the people." He wrote for the American Mercury, the Baltimore Sun, the New York Herald Tribune, and Smart Set. He was a friend, in Greenwich Village, of Vachel Lindsay, Carl Sandburg, Robert Frost and Edgar Lee Masters. He led the tumultous, hard-drinking life of a Village Villon.

Munoz comes back to me most vividly as a talker. If I had to count the hours I spent listening to and talking with Don Luis, they would go into the hundreds. He had an immense effect on my young life.

Don Luis was so completely bilingual that there were arguments among his bilingual friends as to whether he spoke more brilliantly in English or Spanish. It must have been tragic to him that in his last years the magnificent instrument of his voice was impeded by a series of strokes.

Had he been born a Britisher and made the House of Commons, he certainly would have ranked as a talker and political orator with Churchill. On his smaller stage, he was a combination of Talleyrand and William Jennings Bryan.

The private man mocked the public man. When he was with his cronies, of which I was one for a while, he mocked his colleagues endlessly and pitilessly. An especial butt of his

humor was the last American governor of Puerto Rico —Rexford G. Tugwell, a humorless former Columbia professor and member of FDR's "brain trust." Tugwell and Munoz were chalk and cheese.

Don Luis used to tell his followers, "You must live like saints and work like the devil." This was strange advice coming from a man who did neither—at least in the days I knew him. He was lazy but given to spurts of energy. He was untidy. When on political forays to Washington, he would buy a dozen white shirts at a time, throw each in a closet when dirty, and then abandon the lot.

He had founded the Popular Democratic Party in 1936. This party was nothing when I met him in 1939. He was out of office, thought by many to be a burnt-out case.

As press agent for the island, it was part of my job to lead around visiting journalists and introduce them to people I thought sufficiently interesting to write about. One day an Associated Press man named John Lear turned up. Lear wrote Sunday features that were used by practically every newspaper in the mainland.

We went down to Munoz's office on Calle Tetuan (as I remember) and found the editor in the back. He was tall, burly, intense and handsome in the Gilbert Roland style. Big moustache, chain smoker, bottle of Ron Rico rum in front of him, proofs strewn all over the desk.

Munoz was at the top of his form. He delivered to Lear what was essentially the same speech he had been giving to the peasants of the islands, called jibaros, for the past two years. The theme of his talk, as was the slogan of the party, was "Pan, Tierra, Libertad"—bread, land, and liberty.

Don Luis explained how he had traveled to just about every one of the 77 towns in the island, telling the jibaros not to sell their vote for two dollars to the sugar growers, as had been the custom. "Lend your vote to me instead of selling it, and if I don't do right by you, take it back at the end of four years."

Lear was entranced by this articulate and magnetic man. He wrote a series of Sunday pieces that made the name of Munoz Marin known in many mainland places, especially in the Interior Department, which ran the affairs of the island.

To the surprise of everyone, even including admirers like myself, the Popular Democrats won control of the island Senate in the 1940 election. The bohemian was in power at last. He never looked back.

'S for Nothing

I see that most people in this country, if we can believe one of those polls, would choose among our dead presidents John F. Kennedy to lead the country. Behind him came Harry Truman and FDR.

I disagree with most of the country on this as on a great many other matters. My vote goes to Harry Truman, who sometimes signed his name Harry S. Truman and explained that the "S" was for nothing.

The reason for my choice is a simple one. He was the most recognizable *human being* to hold the office during my lifetime. On a scale of ten, I'd put Harry Truman at nine. He had the human faults, the human crankiness. He had a chance to make great mistakes, and he made them.

Actually the "S" in Harry's name did stand for something, a family dispute. When the time came to give him a middle name neither the Shippes, who were his paternal grandparents, nor the Solomons, who were his maternal grandparents, could agree on the name. So they compromised on "S."

This was one of the few major compromises in HST's life, and it was not made by him. When he made up his mind about anything, he was the Missouri mule enmarbled.

Truman almost went to West Point, and remained through his life a student of military history. He won a scholarship to West Point but was rejected for weak eyes. He was 12 years a farmer before he went into the haberdashery business and then into politics.

One of the reasons for my fondness for Truman is a personal one. He is the only President who knew me well enough to call me by my second name, and my first one, too.

I was something of a monomaniacal pest at White House press conferences. These press conferences were always concluded by the senior man on the beat, who was Merriman Smith of United Press in those days. Smitty never concluded a conference without giving me the high sign, so I could ask MY question. It was a good thing we worked for the same organization. My invariable question was:

"Mr. President, can you say anything about your promise to appoint a Puerto Rican as governor of the island?"

The answer was always courteous but never committal. The Interior Department was studying it, or something. One

day I saw him in the subway going from the Senate to the House. He walked over and whispered, "The Resident Commissioner."

That would be Jesus T. Pinero, and his appointment was indeed soon announced. That was a mighty scoop indeed if you were covering Puerto Rican affairs, which was the chief part of my job with UP.

Truman took office two weeks before the San Francisco Conference that resulted in the United Nations. It was the most unpropitious time in history for a man to take over office, but Truman rose to the occasion.

He had not wished to be President, and said so often. "Sometimes I forget I'm President," he said, and the remark was used both for and against him. Perhaps he was best summed up by his fellow Missourian, Roy Roberts of the Kansas City Star:

"Humility probably would be the first characterization; then loyalty, perhaps excessive loyalties that sometimes get high officials into trouble; common sense; deep patriotism; and above all an abiding faith in his country and in its democratic system. Harry Truman didn't go in for personal government under any circumstances. He doesn't believe in it and wouldn't know how to operate it."

Advice

Go with the Flow

I was much impressed the other day with a little booklet put out by the British Medical Association, and written by Prof. Henry Wallace, head of psychiatry at Edinburgh University. The prof comes as close as anyone to giving a definition of the normal, or completely sane, man as I've seen.

The normal person, says the prof, "never over-estimates or belittles himself. He accepts life as it comes and makes the best of it. He manages his own affairs, escaping exploitation or domination by others. He never blinkers himself to awkward facts or daydreams of better things. He always finds the proper outlets for his skills and secures suitable recognition for his talents."

Though the fellow sounds like a paragon, especially to the neurotic, who may almost be defined as a person who worries about happiness, there are a lot of such good ones around. While the definition may not make it in court; it makes it with me.

The most interesting part of the definition to me is, "He accepts life as it comes and makes the best of it." It would seem man is the only creature of nature who constantly fights nature, and who constantly resists the impulses which come to him from nature. This he does at tremendous cost to his life and his happiness. As one who had learned it the hard way can tell you: The only way to go is with the flow.

This idea of accepting life in its natural enfoldment has been known to the best and the wisest for centuries in many cultures. Epictetus knew it well when he said: "No great thing is created suddenly, any more than a bunch of grapes or a fig. I answer that there must be time. Let it first blossom, then bear fruit, then ripen.

"Since, then, the fruit of a fig tree is not brought to perfection suddenly, or in one hour, do not you think to possess instantaneously and easily the fruit of the human mind."

In other words, force things not. To hurry is not to increase the flow, but to slow it down. You accept the fact that you are a part of a great whole, and that the whole, if fully accepted, will bring you to a kind of perfection, like the grape or the fig, because that is what this great whole is for. All the popular cults which obsess us, which promise a hothouse growth of happiness, a road to Heaven in a golden Cadillac, simply offer us those things which disappoint us when we have achieved them.

Nearer to our time, Emerson was into this same wise bag of

hanging loose, of going with the flow. He said that "There is a principle which is the basis of things, which all speech aims to say, and all action to evolve, a simple quiet, undescribed, undescribable presence, dwelling very peacefully in us, our rightful lord: we are not to do, but to let do; not to work, but to be worked upon; and to this homage there is a consent of all thoughtful and just men in all ages and conditions."

Consent is the key, as Newton Dillaway had said, in a remarkable book of that title. I came to this notion of consent rather late in life, and almost without trying. A certain stoicism is perhaps the result of living beyond the years when you are needed by nature to produce and raise a family.

All I know is that when I stopped fighting things, which had been a lifelong habit, I felt like a man who had given up a dangerous addiction such as smoking or drinking. There was a great relief. I began to hear the birds sing. I saw the beauty in the faces of the old, and the sadness in the beauty of the young, which must be transformed.

While intellectually and politically I've never learned to conform, and hope I never do, I think I've learned to conform my life to things as they are. Only to a degree, of course. One of the ways I do this is by avoiding occasions of resistance, people and places which I know from experience put my back up, to use an eloquent expression. Why erect barriers to the greatest of our experiences, life itself?

Exercise

*I*t was the view of one of the wisest doctors I ever met, Logan Clendening, that four people out of five are more in need of rest than of exercise.

And we must not forget, either, the celebrated dictum of the famous New York lawyer of the '90s, Chauncey M. Depew: "I get my exercise acting as pallbearer to my friends who exercised like mad."

None of this is likely to get anywhere when you are talking to the biceps nut, that odd and increasingly growing species. Exercise, the more violent the better, is in. Running about with a stick in your hand is fashionable. When I argue that more lives have been lost than lengthened by playing tennis after 40, I am looked on as if I had just spat on the door of the temple.

Yet, as a fact, in the last decade three fairly close acquaintances of mine dropped dead in the middle of a tennis game. I think doctors who recommend tennis, or anything remotely as strenuous, to persons over 40, or maybe even 35, ought to be stripped of their decorations. If the patients have been playing tennis all their lives they might perhaps be permitted to continue until they are 45. And don't bother throwing Kings of Sweden at me, or similar aberrations.

It is possible to apply common sense to the matter of bodily exertion, though not easy. Violent games have an important and useful function in our lives. When the juices are flowing freely, there is joy in playing games and in winning them. Need, even.

When there is no money involved, as in amateur sports, this kind of exercise does indeed promote certain useful traits of character, and handles the violent element of our young nature in a way that usually does not hurt anyone. Though I still don't want to think of the scores of men I've met whose entire life has been bedeviled by a back injury gained in school sports.

After 25, this need to play games, as a purely physical need, is usually done with. I know of no doctor who would not readily admit that, after age 25, walking or swimming will provide all the exercise the human body needs to function at its best.

Men who take up tennis after age 40 seem to me like women who get their faces lifted. They wish to preserve an illusion of youth, instead of gracefully settling into the role that nature has cut out for them. The difference between middle-aged tennis and middle-aged face lifting is that tennis is decidedly danger-

ous. In a sedentary society, which our affluent middle class is, it is unnatural to be carrying on physically like a teenager. Unnatural, unwise, and unhealthy.

Much more important to the aging human body than activity is inactivity, as Dr. Clendening noted. A lot of people play tennis to "relax." Actually they play tennis to get tired. There is a huge difference between being relaxed and being tired.

Time spent in a bed with a good book or a good girl is, in my view, of far greater importance to the mature adult than traipsing about the greensward with a golf club in hand. If there is anything which can contribute to intelligent aging it is moderation in all things, and the place to be moderate best is in bed.

The bed is where wisdom lies. This is where you can collect your soul, which is a lot better than expending your body. If you want to grow old gracefully, learn the art of laziness.

Don't *Analyze*

*O*ne of the happiest men I know, or perhaps one should say one of the least discontented men I know, carries around within him an emblem which he will probably have put on his tombstone. "Don't analyze," is what he says.

He says it to everybody—his children, his friends, and even occasionally to the grousing counterman in the supermarket. The way he says it is neither chiding nor righteous. The words are so much a part of his character, and so completely ingrained into it, that they sound like "Good morning" or "How're things?"

Whenever I think of his words, and this is fairly often, it is a sure sign that I am either unhappy or teetering on the edge. It is almost a definition of happiness to say that it precludes analysis, the heavy brood, the incisive sorting out of motives, the rigorous allocation of blame and guilt.

In fact, a character in one of Luigi Pirandello's plays puts it in almost those words. "When a man is happy," the character says, "he takes his happiness as it comes, and doesn't analyze it, as if happiness were his right."

The most famous character produced by the English-speaking theater was also one of the most miserable, and his misery took the outward form of self-analysis. Hamlet made the definitive diagnosis of his kind in his famous soliloquy:

> *Thus conscience does make cowards of us all;*
> *And thus the native hue of resolution*
> *Is sicklied o'er with the pale cast of thought,*
> *And enterprises of great pith and moment*
> *With this regard their currents turn awry,*
> *And lose the name of action.*

If this view is accepted, and I see no great reason why it should not be, then the whole profession of shrinkery is sullied by a gigantic fallacy. That more people have been made unhappy by prolonged Freudian analysis than the reverse is a proposition which is self evident, in the light of my own experience and that of my friends who have suffered under this fantastic discipline.

Those of my friends who felt better after this kind of therapy are less inclined to credit the therapy itself than mere spontaneous remission or the simple healing passage of time.

There is really nothing more tedious than the man who tells

you he can't get properly off his arse, and address himself to the cause at hand, because he was severed from his potty at far too early an age, or was exposed to a teacher who secretly wished to ravish him sexually. All you want is that he do the thing or not.

If you are a compassionate person, you recognize that these verbose and complex uncertainties are merely catalogues of a sickness, a quite common and by no means trivial sickness. You think of Buridan's ass, equally pressed by hunger and thirst and placed between a bundle of hay and a pail of water, with no motive strong enough to push him one way or the other. Or the Arab who became an infidel during a prolonged hesitation between two mosques.

Though much of this tedious self-analysis, and the resultant masterly inactivity, is a serious and even compulsive sickness, there is a helluva lot of it which is mere self-indulgence. The self-indulgent part is amenable to treatment. And there is no better treatment than the forceful utterance of my old friend's motif:

"Don't analyze."

This is not to say that you should *never* analyze. As with all sound rules, this rule is upheld by its exceptions. It was our own great American folk humorist, James Thurber, who noted that he who hesitates is sometimes saved. But take your Thurber in small doses.

Never Love a Writer

Someone said it to me a long time ago and I've never forgotten it:

"What no wife of a writer can ever understand, no matter if she lives with him for 20 years, is that a writer is working when he's staring out of the window."

I've had a fair amount of experience with ladies who have never been able to grasp this proposition.

If you are a businessman, say a stockbroker, the line is clearly drawn between the time you must devote to your work and the time which you may devote to your family. This arrangement is sanctified and respectable.

If you are a seaman or a traveling salesman, and must be away from home for prolonged periods, this too is fully understood if not fully liked by the lady in the arrangement. This is the way life is, and this is the accommodation that must be made. Even a painter, once he goes into his atelier, is clearly understood to be working.

But a writer, especially if he has the bad taste to work under the roof where his wife lives, has no such luck. He can be sitting by the breakfast table, sipping amiably at his coffee, and be as distant from his surroundings as if he were in Murmansk.

What the man is doing is musing. He is absent-mindedly meditating. It may be on a column he is writing for the next day, or the interstices of some heavily-weighted plot, or the cadences of a particularly lovely line. Whatever, he simply isn't THERE.

This is why writers are particularly difficult fellows to live with, and why a wise woman would do better to opt for a stockbroker or a plumber. With such a fellow, when he isn't there, she knows it.

Writers are particularly difficult for women who require attention, and lots of it. For a while the writer can fake it. He becomes a kind of lip-reader. While some notion or other, connected with his work, is rolling about in his noggin, he can still manage the ritual appreciative responses to whatever his old lady is saying.

But in time the old lady catches on. It is a sorrowing moment. She learns that for a considerable part of her day she is dealing with about one-tenth of a man. The rest is off wrestling with demons that he doesn't even name for her, since most writers do not talk about work in progress.

If he decides to let the steel enter his veins, things get even worse. He gets a room and locks himself in, and studiously attends to the business that brings home the bacon. He works uninterruptedly.

This decisive action can indeed be the beginning of the end. There are ladies, and they are numerous, who interpret such a sensible procedure as a prodigious rejection.

The only answer for the writer is a limbo. He has to get a place away from home where he can work. Although the arrangement is essentially the same as the insurance man or stockbroker enjoys or suffers, the wife, especially if she is the possessive kind (and is there any other?) will never really forgive him for his defection.

If this leads to the conclusion that writers should not marry or set up permanent arrangements with ladies to whom they are unwed, you are indeed welcome. When a woman becomes aware that for a long time she doesn't really exist as a person, the emotional attrition becomes dreadful.

The writer, on his side, is not unaware of his neglect, and gets wound up in a circle of guilt. Once this happens, there is nothing, really, left on either side.

There are women, to be sure, who like to be married to writers and who do well at it. But there is something about these devoted celebrants that puts me off. They give up so much that they have a perfect right to retain. For me at least, it is better to burn than marry.

The Fifth Rule

*I*t's an old story, but it fits the mood of the day. (Then, too, old stories are frequently new stories for the young, and what is there wrong with repeating an old good tale, anyway?)

A veteran British diplomat called in a junior in his department. The purpose of the meeting was to give this rather pushy and self-centered fellow a haircut. In a terribly urbane way, of course. Get it said, but don't let the Whitehall side down. He got to the point, as he had before with many junior diplomats who needed to be slowed to a canter.

"Young man," he said, "you have broken the Fifth Rule. You are taking yourself too seriously."

Dismissed, the young man moved to the door. As always happened, he stopped and asked: "But what, Sir, are the other rules." To which the old fox, with an ironic smile, replied:

"There are no other rules."

Anybody who is in the business of peddling sagacity to the public would be well to have a futures file where this little homily turns up every month or so.

For reasons that are imperfectly clear to me, the temptations toward excessive seriousness are great for those who give out personal opinions. No matter how modest the opinion-giver may be of his opinions, he is always, and to someone, an opinion-maker.

The difference between "I think" and "This is the way it is" is immense, but it is all too easily bridged by the license allowed a commentator on public events or morals. Just seeing yourself in print at regular intervals does its bit to point you in the direction of becoming a public figure, which I define as a person who makes pronouncements.

Readers, who are much quicker about these things than they sometimes recognize, can tell when a writer or any performer is losing his sense of humor. When this happens it is money out of the bank for the performer.

One of the reasons I like to travel is that new and preferably remote places get you away from the physical presence of your work. When I cannot get to a newsstand of a weekday morning to pick up the newspaper, I find my feeling about what I write is a good deal ventilated.

And when I am in San Francisco I do my best to observe the Fifth Rule by keeping away, as much as possible, from people

who constantly flout it. Unless I am seeking specific information, I do not hang out with mayors or supervisors or other public figures except on a purely social basis.

It is so easy, and so natural, to give into the temptation of thinking you are more important than you are. There are people who are willing to pump your self-opinion remorselessly, simply because you are a print journalist.

I have learned several times in my life that I was just as important, to most people, as the medium I operated in. Deprived of that, whether it be a newspaper beat, or a column, or a supervisory job, you are just another lad making noises in the street.

But enough of modesty. Having a public forum is a privilege as well as a responsibility. If there are things you feel seriously about, you would be a damned fool, and dishonest to boot, if you did not treat of these things with the seriousness they deserve.

I feel strongly about the moral defaults of a great many lawyers, about the unthinking arrogance of scientists who make things like atom bombs and new forms of life, and about other priesthoods that get between people and their lives.

By the nature of the game, I am perhaps the worst person to judge when seriousness crosses the line and becomes excessive seriousness. I could ask of my readers this favor: When they see that line has been crossed, please bring it to my attention. I want to be good, really.

Don't

When fate gets nasty, and piles a litter of weighty alternatives before me, and I am advised on all sides that it's time to get off the pot, I call up the magical incantation of that most civilized of all British Prime Ministers, Lord Melbourne.

"When in doubt," he said, "don't."

Some of my happiest moments have been those serene intervals after I've said No. This taking time by the forelock, this rushing into the breach, this cutting the Gordian knot, this Grow-Up-and-Be-a-Man stuff—it can all be very enervating.

The nicest thing about the postlude to one of these negative triumphs is that you no longer have to wait to find out what good you've done, if any. Nor do you have to face that melancholy consequence of most decisive action, that you've done more harm than good. No, all you have to do is look back at the harm you have averted by simply doing nothing. There can be a powerful lot of virtue there.

Another man of notable sensibility, the late novelist and essayist E. M. Forster, spoke in 1939 of these negative triumphs.

"What the world needs most today," he said, "are the negative virtues—not minding people, not being huffy, touchy, irritable or revengeful.

"Positive ideals are becoming a curse, for they can seldom be achieved without someone being killed, or maimed or interned."

The highest achievement of the civil man has been reached when he learns to mind his own business; or, if you will, to cultivate his own garden.

Three decades and a couple or three wars after Mr. Forster's nicely put words, we are surrounded by salvationists. In private and in public, busybodies who call themselves committed or concerned citizens or good old Pro Bono Publico, are telling us how to avoid our imminent destruction.

We are told how and for what reason to make love: No more than a litter of two, and better no litter at all. Practice yoga, get into alpha waves, get an analyst who smokes weed, learn the all too scrutable wisdom of yin and yang, get stoned on whatever this week's fashionable intoxicant is. All this is put out in a rhetoric that is never too far from frenzy.

I'm so tired of being saved by my contemporaries that I could scream. The business of merely handling your own life is more than sufficient to sustain the most physically and spiritu-

ally energetic of men. Handling your life is really a process of editing, and in editing, as in everything else, the keystone to excellence is the principle of exclusion.

Figure out all the things you are not interested in, and add to that the things you should not be interested in. You will find you still have quite a lot of room to swing. Rid your mind of intellectual impedimenta. I do not think, as an instance, that anyone would be permanently impoverished if he should be deprived, from this morning on, of his copy of The Wall Street Journal.

We could do without the exertions of our more public salvationists, those apotheosized busybodies of whom the most visible for some years has been the implausible Messiah, Mr. Ralph Nader. Mr. Nader reached the apogee of salvationism when he was reported as proposing "that corporations that abuse the public interest should be transferred to public trusteeship and their officers sent to jail."

A man who says that kind of thing is a symptom of a deranged society. These are the people who set up violent groups which are seats of judgment, and whose shibboleth is, "Off with their heads." Why can't people just be good fellows, cut their wood and ride their bike, love their children, go to a movie once a week, read the newspaper and nod their heads sadly, and leave the saving of other people's souls to those who find it kicky?

Love Thyself

Love thyself as you would have your neighbor love you.

This is not the law of the prophets; but I suggest it's a pretty good set of marching orders.

It is by now a cliche of modern psychology that you can't love others until you love yourself.

The absence of love is visible everywhere, as it always is to those who have a cold eye for this sort of thing. The worst part of this absence of love is that it is throttled at the start. That first step needed for the 10,000 mile journey just isn't getting made.

"Self-hatred," I keep telling both of my friends, "will get you nowhere."

Nor will it. The worst and most dangerous of all haters is the whiner, the lad who cannot accept himself, and thus gives out almost clangingly bad vibes. "Love me not," is his shibboleth.

Were I asked, as in fact I have been asked, what is wrong with the American male, I would answer, and have answered: "He has lost, or is losing, his self-respect."

Keeping your self-respect is not really all that big a thing. Being buddy-buddy with yourself is a matter that can be arranged, even if you are in a sea of troubles and gasping for oxygen. Every one of us has this in common: We are all human beings. Our humanity is something we can respect. Man is a marvel, both of good and evil. His variety and his capacities sometimes can hardly bear witnessing. As the boozy old philosopher, Mr. W. C. Fields used to say, "What man has done, man can do."

Self-esteem then, which is really what we are talking about, is a matter within our control. Self-esteem is that high estimate which we place upon ourselves, on our work, on our opinions, on our relations with others. The way we value ourselves is, to a large degree, our own business. We cannot say that of too many things.

People who do not think too highly of themselves in fact, often do so in fantasy. They dream constantly of being crowned for acts of impossible valor, of exigent maidens throwing themselves at their feet, of tape-measure home runs and unassisted triple plays.

At risk of sounding like Dale Carnegie, the problem is to turn those fantasies within, and legitimize them. It is the cruel way of the world to accept you at your own valuation, since life

is too short for exhaustive research into everybody who shakes your hand. You pull a forelock, you await a kick.

By these standards, and they are accepted ones, the big phony flesh-presser is far more adapted to survival than the Hamlet of the inner city, sicklied o'er with the pale cast of thought intent on finding out exactly what was WRONG with the last thing he did. Others will respect you just as much as you respect yourself, and not a damn bit more.

Merely to have gotten as old as you are, and to have moved as far as you have in the tricky pageant of life, is reason for satisfaction—and thus respect. Just think of all the things you aren't, and are glad you aren't, and you have another solid ground for satisfaction, and respect of self.

The Golden Rule is all well and dandy. You should indeed do even so unto men what ye would that they should do to you. But the pump must be primed before this exercise can usefully be carried out. Number One has to be sure he's okay before he can do very much about Number Two. You must have strength to be generous.

It might be a bit too much to go along with Walt Whitman and "dote on myself, there is that lot of me and all so luscious," yet that is the direction of health. As a starter you might even read Whitman's "Song of Myself." You will find no great difficulty, I think, in agreeing with Mr. Whitman in this: "I find no sweeter fat than sticks to my own bones."

'Tell It Like It Is'

I've never read a newspaper story that told it as it is, and in truth I never expect to. The kind of objectivity that most newspapers boast about is just a nice journalistic illusion. I suggest both the newspapers themselves and the readers would be considerably better off if this illusion were abandoned.

Yet the idea that you can tell the cool truth about a subject in a newspaper story is instilled into us from our first newspaper assignment; or, if we are one of that lot, from our first class in journalism school.

"Find the facts and tell them," is the way they used to put it. One of the best textbooks for young journalists, Herbert Brucker's *The Journalist* puts it this way:

"Reporting can of course help or hurt a cause. But under the American journalistic tradition, reporting is not concerned with whether it helps or hinders anything. It consists simply of getting and telling the facts, be they pleasant, nasty or in-between."

Most of us have had the experience, at one time or another, of reading in a newspaper about something we really know something about. Such as our personal life, or our business, or our family. How often have you heard the complaint, usually justified, "Everytime The Blat has written about something I know something about, they've been wildly off-base?"

"News," I was told, "is something that happens." I was not told that by a great editor, but by a great press agent, Steve Hannagan. It was Steve's business, and great talent, to make things happen, and thus make news.

The things that Steve made happen were of no great intrinsic value to anyone save the publicity client in whose behalf they were staged—the Coca-Cola Company, glass bricks, the 500-mile Indy, or Miami Beach.

Steve's definition (and the one usually accepted by editors) was shrewd enough so far as it went, but it didn't go far enough. The things that Steve made happen would never have become news if the wire services and newspapers and newsreels had not been *alerted* to the fact that they were happening.

Otherwise they were like the famous tree that fell down in the wilderness, but did not really fall down because there was no one to hear it. News is what is printed in the newspapers. That's all there is to it. What is not printed in a newspaper is not news,

no matter how important it is, or how vividly it affects our lives.

In 1958 when Fidel Castro was already at the head of a massive guerrilla force hiding in the Sierra Maestra Mountains and about to overthrow the Batista government, his forces kidnaped a group of Americans from the naval base at Guantanamo.

Castro promised to release the Americans if The New York Times would send a reporter to cover his revolution, which of course did not exist because it had not been duly reported.

The Times obliged, almost excessively, by sending its star war correspondent, Herbert Matthews, who had covered the Spanish Civil War on the anti-Franco side, and who was not unfriendly to leftist causes.

Matthews did indeed discover a revolution, and covered it brilliantly. The Castro revolution really existed because the leading newspaper of this country, in response to blackmail, said it did. The attack was launched, Batista was forced to flee, and Castro became prime minister in February, 1959. By confirming the existence of the revolution, Matthews added to its power. It is said that Castro thought the Matthews stories were worth at least three battles to him.

In the end, as anyone who has been in the business for any length of time knows, the greatest manipulator of news is the reporter himself. Every question he asks in an interview, and every reply he selects among those he has been given, is determined by his own entirely fallible personality.

Unless a story is simply rewritten from a handout, which is pre-manipulation, the color and texture of a story by an Irishman who drinks, a German who doesn't, a chap who went to Harvard and another who went to Beloit, one who is a snob and one who is a mucker, will be different in handling from one to the other. Sometimes the actual content of the story will be affected. No one, for sure, will "tell it like it is."

'... Let Them Move'

A friend, who is an aging ski instructor, has a little motto which has helped him well through the vicissitudes of an unusually busy life.

"Don't move," he says, "let them move."

This is a philosophy which has, as you might say, implications. It is rather like the old army injunction which says, Never Volunteer. It is also rather like the stoic, "Take 'em as they come."

Yet it is not quite these. Nor is it inertia. I have another friend, of whom I have written, who makes inertia such a ruling thing that he will never associate with a girl unless SHE picks him up, and who will only move from his appointed bivouac at the bar under force of a catastrophe or a call of nature.

Rather I think my ski instructor is simply a true follower of Zeno, who taught under a stoa or colonnade in Athens a philosophy which came to be called Stoicism—the belief that all happenings are the result of divine will and that therefore man should be always calmly accepting and free from passion, grief or joy.

This is and has been proved to be through the course of history, a splendid way to go. You just look at your fellow-man, or -men, and observe their moves carefully. When and if they affect you, react in the manner which is best calculated to advance your interests.

In statecraft, this is called diplomacy. It is not a bad policy to extend to your personal life. But your blood must run a trifle thin. This leaves the purest kind of stoicism out in the cold for the likes of me, who tend to throw punches when they should be calmly evaluating the situation.

The Stoic approach doesn't work too well, either, in matters of the heart. If you decide to wait for a woman, rather than be slightly on the chase, you are likely to find that you have been overrun by a woman rather than mated to her. Men are more often called chasers than women. They are in fact far less chasers than what used to be called the gentle sex.

Yet there is much to be said for the art of doing nothing, which is integral to the Stoic creed. Charles Lamb said it as well as anybody:

"A man can never have too much time to himself, nor too little to do. Had I a little son, I would christen him 'Nothing to

do'; he should do nothing. Man, I verily believe, is out of his element as long as he is operative."

The evidence of this is everywhere, from here to the rice fields of Cambodia. The more civilized a man is the less he actually does. The English country gentleman of the 18th Century, perhaps the *beau ideal* of Western culture, spent most of his time fooling about with animals and flowers, with an occasional foray into the House of Lords, where opportunities for doing nothing were considerable even in those days.

An aristocracy is precisely the product of a society that throws up an elect who are enabled by fortune to do less and less. One of the more incongruous of English aristocrats was the late Earl of Lonsdale, who was a *boxer*. It must be added that Lord Byron was a boxer also. He too was a decidedly odd bird.

The perfect man, say the ancient Chinese, was the sage who took no action. To do is to almost certainly do bad, one way or another. To do nothing is almost certainly to do good.

One of those sagacious Chinese fellows, Chang Ch'ao, said: "Only those who take leisurely what the people of the world are busy about can be busy about what the people of the world take leisurely."

Don't Give Up

\mathcal{A}s I near the end of middle life and look forward to the final days of the trek, the temptation to drop out gains an insidious interest. By "drop out" I mean drop out; not the cant phrase for what a person does when he gives up his job and opts for what he sees as a freer life. I mean just forget the whole thing, become a recluse.

In this I have a solid example. My mother was a woman of rich appetites, chief of which was for life itself. There was precious little that went on about her that she was not a part, and usually moving part, of. Her zest, it seemed, could never die.

Yet die it did. At some time in her 40s, for reasons that never became clear to me, she gave up on life. In her last years she barely left her flat. She sat by the front window and watched the progress of her neighbors into and out of their homes, and speculated, in that vein of sarcasm with which she was so richly endowed, on what devilment these neighbors might be up to. She became a recluse. It took a funeral to budge her to any form of sociability.

Having gone through this age myself, how well I understand the impulse that led my mother away from life, with an almost Swiftian disgust. Most people, and especially the ones you read about in newspapers, are pretty terrible advertisements for mankind. Just excluding them from your consideration, you would think would work toward that peace of mind that is the best reward of a well-spent life.

When I begin to think like that, I draw myself up short. Also I think of old Horace Walpole, who knew as well as anybody the secret places of the heart. On Dec. 16, 1764 we find him chiding his friend George Montagu, who had seemingly given up on the world.

"You come to town for two months," he wrote, "grow tired in six weeks, hurry away, and then one hears no more of you till next winter.

"I don't want you to like the world; I like it no more than you do; but I stay a while in it, because while one sees it one laughs at it, but when one gives it up, one grows angry with it; and I hold it much wiser to laugh than to be out of humor."

There is nothing that comes more easily to me than anger. There is likewise nothing in myself that I more deplore than this tendency to rail at things that I cannot do much about.

So if there were only a single motive involved, the avoidance of anger, I would find myself justified in taking Walpole's advice to accept the world, no matter how difficult it is at times to do. A sour old man is not one of the embellishments of nature.

The good Walpole was also the author of the celebrated statement that life was a comedy to those who think and a tragedy to those who feel. The older one gets the more this seems to be true.

To survive you must curb feeling. You must learn, when you see a friend's name in the obituary pages, to burke reminiscences of golden days, and to look sternly at the work that is at hand.

If you are lucky enough, as Walpole was, that to see the world is to laugh at it, then your final days may go in grace. Then you will read the pages of your daily newspaper for laughs, not for proof of essential folly. You will see your friends and their strivings as light comedy, rather than be made miserable with a sad cast of thought.

You get the suspicion, finally, that to be in the midst of life is really what it's all about. The cenobite has his place in the scheme of things; but for most of us life is not a convent. More importantly, it must not be allowed to become one. There is a thin line between the end of privacy and the beginning of reclusiveness. It must be observed, strictly and well, if we are not to end in anger.

Answers
to Questions

What's 'Class'?

Soon or late the sporting crowd in and about North Beach will engage in a lively and largely incoherent discussion of something called "class."

Us here sporting types are always interested in class: in women, in horses, in pool players, in pedro games, in beers, bosses and servants—in guys, even. "He's a class bum," is a high compliment.

Just as nobody ever denies he has a sense of humor, nobody ever cares to rap what he calls class. The difficulty is defining this *ignis fatuus.* It's sort of like that Supreme Court Justice, Potter Stewart, on pornography: we cannot define it, but we know it when we see it.

I have a friend in New York, a publicity man and former journalist named Tex McCrary, who is positively obsessed by this matter of class. He regularly sends out releases to friends and clients giving so-and-so's definition of this rare and fevered quality. In return, Tex asks you to send along your particular definition.

I regret that, the last time I got one of Tex's mailings, I never got around to answering. For I do know what class is, and so do a lot of other people, though these people do not appear to be numbered among McCrary's correspondents.

In my belief the term derives from British track circles. It is so understood also in American racing. In these places the word "class" has a distinct and specific meaning.

Class is a quality to be found in the great thoroughbreds. Class is the ability of a horse to go one and a half miles really well on the flat, plus the ability to produce, when the finishing pole is in sight, an almost unbelievable final burst of speed.

This is, as someone has said, the quality "that grabs the heart and sets the stands roaring." The horse with class is usually a winner, but he can place or show or even be in the field and qualify as "class" if he shows these salient characteristics.

If you remember that, you will know all you have to know about class, whether in an animal or a human. The person who has class is the person who is really good, and can manage that marvelous finishing spurt.

Class is that something extra which, when added to genuine skill, puts the champion in front of the merely excellent.

Beautiful women have it. You can pick one up at her hotel

room, or flat or mansion in the country, and bring her to a dinner party where her mettle will be tried against women of her quality and men prepared to admire it.

She will be just a beautiful woman until she enters the room, where she is expected. Once over the threshold, that damned secret little bulb she has inside her goes on to its fullest wattage. She is nothing that she was not in transit to the party, except for that added power that the need to excel brings out in her.

I've seen it in tournament pool, where class is likely to be dismissed as playing over your head. I've even seen it with card sharps, for, incredibly, it is possible to cheat with class.

They say Arnold Rothstein, the guy who fixed the 1919 World Series, could cheat with class. They also say Arnold was the prototype for Jay Gatsby, in Fitzgerald's marvelous short novel. That novel, incidentally, had all the class that its hero longed for and never quite achieved.

Your best moments were, or will be, little clots in an otherwise undistinguished life—marrying the girl who was far too good for you; making the right outrageous pitch to your boss at the right time; *knowing* you're going to make five sevens before you crap out; catching that fly that looks four feet gone. These are the times you will be showing class. Treasure them.

Is Life a Ball?

William Ewart Gladstone was a remarkable man. He was four times Prime Minister of Britain, the greatest orator and parliamentarian in his country's history (Churchill included) and a profoundly moral man. He resigned from office several times during his lifetime over matters of principle. He was religious almost to the point of religiosity.

He was speaking to a group of school children in 1877. He said, "Be inspired with the belief that life is a great and noble calling; not a mean and groveling thing that we are to shuffle through as we can, but an elevated and lofty destiny."

Here, Christianity has never been better put. This vision, it might not be too much to say, is why Christianity exists. It is a call against one of the greatest of our weaknesses, spiritual sloth—the *accidia* of the Middle Ages.

The visible evidence is all on the side of the view that life is ignoble rather than noble. All you have to do to know it is ignoble is to wake up of a morning. Evidence of meanness is on every hand, from the legislative halls to the grocery stores. To get through your ordinary day requires a stout faith that "life is a great and noble calling."

Yet who could survive, and respect himself, without such a faith? We all have it. The problem is to augment and protect that faith. This requires something called moral courage, a thing that is not much spoken about.

Life is weakness and frailty, except when it is viewed with faith. Faith is the speculum that redeems it all, that gives us the vision of what man can be against what he all too frequently is.

That vision in fact may be false. Perhaps man will end with a whimper. Perhaps his glories will be extinguished by his follies. Perhaps his thrust towards greatness will be blown up in one vast, lewd explosion. Perhaps man has not met his measure, and never will.

None the less, the vision that life is a generous, and even noble, undertaking, is necessary if we are to live with dignity, and a sense of our powers. It is like a piece of equipment necessary to our existence, like a slide rule to an engineer.

Like everything that makes life worth living, the vision is a gift. It is a gift from Whoever, or Whatever, presides over this fortuitous concourse of atoms.

People say that they like to be able to look at themselves in

the morning. This is more than a hearty colloquialism. It is a profound truth.

Man has a very deep need to approve of himself. For even the tawdriest of traders, there is a limit to the extent to which he will bend his conception of himself. That limit might be murder, or it might be voting no when he should have voted yes, but there is always the limit.

But one grows sententious. Gladstone was talking about something simpler. About something I heard a tipsy girl say the other night. "Life's a ball," she said.

It really is. I've been around more decades than I care to count, and I don't think there has ever really been a time when I wished to opt out, no matter how bad the going was—and I can tell you it has been pretty bad at times. There was always something that kept me rooted in place.

That something was a faith that however badly things were going at the moment, they would go better later on. Life is unfair, but it is not unkind. Think only of the curative power of memory, which edits pain into sadness, and sadness into poignancy. I have experienced calamities, and will experience them again. I hope that when the next one comes, I will have the strength not to shuffle through it.

Spare the Rod?

I see where the U.S. Supreme Court has ruled that the Constitution does not bar spanking, even severe spanking, of pupils by school officials and does not require even an informal prior hearing to determine whether spanking is justified. The ruling was five to four.

Those five to four decisions kind of throw me. They mean we are being offered but five-ninths of the wisdom of the highest court in our land. If one of the justices should wake of a morning with a gippy tummy, or something, the accumulated wisdom of our highest court could readily end up on the opposite side of a given question. So tenuous is our hold on wisdom!

Yet five to four is in general the way I feel about corporal punishment in schools. And that five to four could, in any case, easily tip from day to day. You might say I have decidedly mixed feelings on the subject.

When I grew up, corporal punishment was very much a way of life. My teachers were burly Irish peasants who most decidedly felt that wisdom grew out of the end of a stick.

I have been hit by everything from the leg of a chair to a thin, elegant switch. The latter was favored by a thin, elegant chap from Boston named brother Charles Austin. He was anything but a peasant, that one. His switch got to you much more effectively than the leg of the chair, or the thick yardsticks favored by the other brothers.

Sometimes the punishment was administered during class, when someone was caught chewing gum or when his eyes were wandering out the window. I was most frequently punished for the formidable crime of "not paying attention."

This was the worst offense you could possibly commit towards a teacher. He asked you to quote what he had just been saying about algebra or the Christian faith. If you did not know you were rewarded with a couple of thwacks, usually on the spot.

More often, and more seriously, the punishment was administered after class, or even after the school day ended. Here you pulled down the blue serge trousers, exposed both cheeks, and gritted the old teeth.

I was seldom absent from these punishment sessions. At times it almost seemed as if I were included among the offenders on principle. For I was guilty of that most serious offense—having a "bad attitude."

I seemed to have conveyed to my betters the idea that I thought their efforts were a distortion of the whole educational process. This would get their dander up, and they would flail away with the utmost gusto. I learned to keep back tears so well that I have seldom cried at anything in my adult life.

Whether I am better off for these constant chastisements I honestly do not know.

I do know that they have produced in me a strong confusion in the face of authority. I recognize that authority exists and should be respected. At the same time I fear authority so greatly that I constantly, and often foolishly, resist it fiercely.

When I see a cop or any other officer of the law, I see behind him an image of Brother Charles with his switch, or Brother Norbert with his yardstick.

It is with interest that I have noted that teachers as a whole now seem to share this ambivalent attitude toward switching or spanking pupils. One poll showed that 45 percent of them favored its use in secondary schools, while 67 percent were for its use in elementary schools.

In practice, and with my own children, I have been of the hands off persuasion. And again, I do not know if the children are better or not for my having favored that policy, and having sent them to schools that did the same.

Truth Is Silence?

*H*ave you ever felt that every word you said in your life was a lie? I mean every word?

Words are such extraordinary and tricky things. Every word, even at the beck of a Shakespeare or a Goethe, is an approximation. Every person who reads each such word invests in it a very different set of feelings.

Communication is, in the end, difficult if not impossible. Edmund Wilson once said that no two persons ever read the same book. The same can be said of every exchange, from conversation to biblical.

When we say what we mean, or what we think we mean, we are saying something that will never be quite thought of in the way we are thinking when we have said it, by anybody else.

I am not talking of writing, or of formal communication. I am talking of talking, the ordinary intercourse of people from day to day and time to time. "I don't know what you're talking about" is true of everything we hear, much as we are unwilling to admit it. This applies to whether we are talking about a mathematical theorem, or the virtues of a public servant.

Most of all, it is true of our personal relations. It can be argued that no two people know and understand each other less than man and wife. They may indeed have that emotional sympathy that transcends words, and that keeps marriages together, but when they speak words to each other they are often just engaging in a lifetime of lies.

This conviction that words are lies is the base of the genius of that great Irishman, Samuel Beckett. This man, who comes from Dublin, that town of talk, views life as empty because people cannot talk to each other.

Beckett, who was once "secretary" to James Joyce, views this failure of people to talk to each other as a mirror of the pointlessness of life.

His heroes, who feel they are born and bred liars, long for the silence of truth. But truth always eludes them. They continue to talk, and to torture themselves and those about them. They may talk themselves into telling the truth.

But they know they cannot. They know the struggle is futile. But, in Beckett's piercing words, "one must go on." The characters in his plays and novels hope always for death, where they can escape the tyranny of words, and achieve the heaven of

silence.

How well I know these feelings. In the midst of the most passionate declarations of love, or of hate, I get the feeling that what I am saying is just words. And just words are just nothing. The feeling can be real to the point of murder, but the words are just words.

These somber reflections come from a lover of language. Perhaps they could not come from anybody who did not love language so well, and so despair of its possibilities.

The idea that to voice is to falsify is not a pleasant one to contemplate; but contemplate it we should. These desperate little exercises in honesty, called encounter groups, do incalculable harm, precisely because everybody is telling everybody else lies, and often harmful and hurting lies, in the delusion that they are telling the truth.

The best we can do is to try to express what we are feeling, unless we are to take a Trappist vow of silence, and "go on." We can refuse to tell the lies we know to be lies, and admit that most of the truths we so firmly believe in are in themselves lies. And we can try to be silent in the presence of the great truths—the sea, the sky, the hills, the trees—and life itself. We must learn to be humble before the fact that we cannot really tell the truth about anything.

'Anyone Has His Price?'

The two worst advertisements for money in my lifetime were Howard Hughes and J. Paul Getty, classic examples of the spiritual sterility brought on by the single-minded pursuit of loot. Their lives were as empty as their bank accounts were full. They should have been a lesson to us all; but of course they weren't.

Howard Hughes' right-hand man for 32 years was Noah Dietrich. More than anyone else, Dietrich knew how the twisted mind of his longtime master worked. "Howard," says Dietrich, "had three principles: one, anyone can be bought, so find out the price; two, use other people's money; three, any trouble, fire the sonofabitch."

It is not hard to believe that these hardboiled aphorisms were the Hughes way of handling almost any business situation. They certainly appear to have worked, in terms of Hughes' aspirations, if not of his character.

But we may well doubt that everyone has his price. More precisely, that every person has a money tag attached to his integrity. There are some people who are quite prickly about giving away their favors for money. Can you imagine William Marcy Tweed buying Henry David Thoreau with a little political pourboire?

There are people whose traits and talents can be had for almost anything BUT money. They can be quite tough about this. In the course of my mostly uneventful life I've been offered money, on one occasion rather a large amount, to do something that ran counter to my ideas of what I would allow myself to do. The pleasure I had in turning down these offers was almost lustful. I positively glowed with self-righteousness for the better part of a week.

My refusal in these matters springs less from the loftiness of my principles, which aren't all that grand, than from the low value I place on money. There is a part of me, believe it or not, that actually dislikes the stuff. I don't even like to carry it around.

Most people who won't do things for money will do the same things for some other reason, like sexual favors, a hi-fi set, or just a little bit of stroking. I imagine I could have gotten around even the formidable Thoreau by stating my whole hearted admiration for, and thorough accord with, everything he said and did.

Yet there are literally people around who have no price, or at least no price that I have been able to discover. They know what they stand for in life, and have made a resolution to stick with their conclusions.

As a counterpoise to the bitter wisdom of Howard Hughes I would put a statement made a couple of years ago in that grand but relatively unknown novel "A Fine and Private Place" by Peter S. Beagle. "There are honest men in the world only because the devil considers their asking price ridiculous."

These are the boys who sweeten a man's day. There aren't so many of them around as to constitute a distraction, but they do exist. If I can say it without sounding starchy, these men have a kind of moral splendor. You can entrust a good idea to their hands, which is a much riskier busines than trusting a man with a lot of money. You can be sure than when they are 70 they will be just as fervent in their view of the right as when they were 30—except that as they grow older they will be called, and invariably, cranky.

And when these old boys go, as go they must, they will leave behind a warm cloud, an afterglow. A moral presence will survive the body. Nothing survives the passing of the likes of Hughes and Getty, except pinchbeck benefactions to cheat Uncle Sam out of his tax money, and a memory of lonely eccentricity.

Do We Ever Learn?

*I*t is an epigram that has gotten so much currency that it has almost been elevated to proverbial status. It came from the pen of George Santayana, who wrote English with the gingerly reverence of one whose native language it was not. He said:

"Those who cannot remember the past are condemned to repeat it."

This is absolutely true. But, like many an epigram and also many a proverb, it is by no means the whole truth. It is almost mathematically a half-truth. Those who cannot remember the past are, truly, condemned to repeat it. Also, and equally truly, those who do remember the past are also condemned to repeat it.

Making mistakes and then making them all over again is one of the things that really distinguishes man from the animals. A cat will get burned by a hot pipe. He will learn forever to keep away from that hot pipe.

The human is both more and less astute about hot pipes. He touches one. He is burned. The lesson lasts for a while. Then the uncontrollable curiosity of the species intervenes. Will it hurt the next time? Is there some fortuitous combination of circumstances which may evolve that will make either the pipe cold or the hand heat-resistant? The curiosity must be satisfied again and again, in spite of the patent lessons and the squalid histories of compulsive pipe feelers.

A really bad marriage is somewhere between a kick in the head by a horse and the loss of a couple of limbs. There is no human situation where the evidence is more naked and more cogent. One or both of the victims of their folly clearly lacks a talent for the Holy Rite. Usually it is both.

Yet, with the evidence barking back at you with agonizing insistence, who among the untalented is not willing to give it another go, to twist the evidence from an inhibition into a spur, to enter fearlessly into the quest for the cold pipe—as you watch the steam curling up from it?

The one thing that excellent moral lessons never do is to teach excellent morals. The English essayist, Robert Lynd, recognized this fully.

"It is universally admitted," wrote Lynd, "that in the years before the Flood what the human race needed was a lesson, and the Flood certainly taught it a lesson. It may be objected that the human race did not learn the lesson, but then the human race never does learn the lesson that is taught it. At the same time,

everybody recognizes the importance of going on with the teaching.

"What is the Old Testament but the story of a great race that was taught more lessons than have been taught by all the schoolmasters since the beginning of time and never learnt a single one of them? What is all history but a repetition of the same story with variations?"

The simplest of all lessons, and the hardest one to grasp, is not that two and two are four, or that black is not white, but that what goes up must come down, and vice versa. It did not take Newton to tell us this, though he formulated the law admirably. We have seen it happen, over and over again, but we can never believe it.

We cannot accept that happiness will be followed by unhappiness, and the other way round, that inflation will be followed by deflation, that love will be followed by hatred, that ecstasy will be followed by ennui, and that there is nothing new under the sun.

Nor can we accept that of all the poems that have ever been written in all the languages of men, the greatest of all these is the book once attributed to Solomon, "Ecclesiastes." Not only is it the greatest of poems, it is the most useful guide to conduct. And its essential lesson is that we never learn. The book concludes, as it begins: "Vanity of vanities, saith the Lord: all is vanity."

So Who's Happy?

*H*appiness, a subject of some concern to nearly all of us for quite a while now, "has only recently come under scientific study." That is what The New York Times told me recently.

Virtually all the people quoted in the piece were profs of "psychology" at some place or other. So much for "science." I stick to my view that any discipline that tries to reduce human behavior to a science, whether it be called sociology or psychology, is barking up the wrong tree.

Since you cannot logically cope with that which you cannot define, asking people if they are happy is like asking them how much they were frightened by a dream or how they feel about the pigmentation of their skin.

Stabs at defining happiness have not been lacking. To Dr. Johnson it was "the multiplicity of agreeable consciousness." To Freud it is "the (preferably sudden) satisfaction of needs which have been dammed up to a high degree." To La Rochefoucauld happiness "is in the taste, and not in the things."

All these get on the dartboard, one way or another, but nobody hits the bulls-eye. (This is unusual, it might be pointed out, in the case of Dr. Johnson, whose bulls-eye average was remarkable.) There is more, and there is less, to happiness than meets the eye of those who pontificate about it.

There seems to be an idea abroad that happiness is something that can be "attained." The piece I was reading even suggests "that the attainment of happiness requires a lifelong quest." This, I suggest, is overblown nonsense.

It is always useful in these matters to find out what the word meant when it was first used by men. My dictionary says it comes from the word "hap" which means "by chance or by luck." The happy man is, then, the man to whom a long series of lucky accidents has occurred. It lies, not in tables or disciplines or lists of reading, but in the luck of the draw or the fall of the dice.

Some people are happier than others for exactly the same reason that some people are luckier than others, which is at base no reason at all. None the less, there are some people to whom good things seem to happen with greater frequency and even regularity than others. Which suggests that there is some sort of elusive constant in the happy person that the less fortunate of us do not have.

I suggest, and this is from my own experience only, that this constant is that a man is engaged in work that he likes and finds rewarding of itself. I have heard people say that they would do what they do for a living for absolutely nothing, and I believe them. I spent more than half my life rooting about at things that occupied a minimal amount of my energies, and had no rewards I could ever ascertain beyond a weekly paycheck.

I think that generalization can be widened beyond my experience. In fact one of the psychological studies of happiness mentioned by the Times stated that "70 percent of the people who were happy in their jobs were also happy with their life generally, but only 14 percent of those unhappy with their jobs said they were happy."

Love and sex and health and money are the usual desiderata of those who are asked about what makes happiness. I think they are all inferior, in the long run, to personal fulfillment in work. This satisfaction with work is the pediment that gives the other satisfactions that are built on it their meaning.

Beyond that, and even beyond sex and love, etc., is the most exquisite satisfaction of all. This is the noblest of satisfactions, the one Vergil gave in tribute to Lucretius: "Happy he who could learn the causes of things and who put beneath his feet all fears." This is the joy of just finding out what the hell it's all about.

Know Your Enemy?

"*O*ur enemy's opinion of us comes closer to the truth than our own," wrote Montaigne.

Now that's a bit of wisdom to conjure with. Like nearly all aphoristic or epigrammatic or proverbial statements it had a stiff core of truth. And like them, it is a bit loose around the edges, sacrifices thrust to grace of expression, and has the thrill of surprise.

Try, with as much disinterest as you can, to take a poll of your enemies. Put down those qualities you are aware they disapprove in you. Be brutal. After all, these people are only your enemies. Nothing they can say can, in the end, penetrate your careful defenses.

I begin my list confidently. Selfishness, seclusiveness, coldness of heart, bigotry, lack of charity, indifference to nature and to animals. To these I can plead guilty with various degrees of emendation and clarification.

Like most people there are some faults that I find it difficult if not impossible to plead guilty to. I've never met anyone who would admit he lacked a sense of humor. The thing I cannot admit is that I am a monster, though I doubt not that some of my more fervent detractors have found a stone to throw at that particular glass house.

For if you are not a monster, you can admit to selfishness, seclusiveness, coldness of heart, etc., etc. All of these qualities are ensigns of humanity. You can even give your faults different names. For seclusiveness and selfishness you can say solitude, having a place to lurk secure, as Montaigne had it.

Another thing about enemies that makes them less than wholly reliable as a glass to read you by is that they are often manufactured by yourself. A host of enemies, you could say, is a form of unconscious autobiography.

You often appoint as enemies people who have conspicuously those qualities you find least attractive. This is often because you have a disturbing affinity to them, and more than your quotient of those same unattractive qualities lurks in your innards, waiting to burst out.

I know one ass who is selfish, unscrupulous, kicks cruelly the head of the guy on the lower rung of the ladder as he affixes his lips to the rear of the one on the upper rung, is a ruthless social climber and gate-crasher into parties where he is not wel-

come, and slanders unmercifully those who have been kind to him. He also earns more money than is good for him.

I hate his flaming intestines; but, if I am honest, I wonder. . .

And what goes for me, goes for my enemies too. They read into me qualities and impulses that they cannot acknowledge in themselves. (This line of thought could make you wonder about the whole validity of the idea of enemies.)

More than any man I have ever met in the world of books, I admire the above Montaigne. It has been said of him that he knew that life is full of bitters, and he held it wisdom that a man should console himself, as far as possible, with its sweets. The principal of these, for the one-time mayor of Bordeaux, were peace, travel, leisure, and the writing of essays.

As a prescription for a pacific and amiable existence, especially in later life, I cannot much improve on this prescription and I do not. My additions to the list would be the company of attractive women, and drily bitter men, and whiskey, which Dr. William Osler called the mother's milk of the elderly.

Yet these aspirations and preoccupations, in the hands of someone who did not like you, could be made into a catalogue of corruption. You could start with, "A selfish, drunken dirty old man. . ."

Better you define yourself and keep making enemies than take the salesman's route of friendliness at any price. As for those French aphorisms, many are best savored and spat out rather than swallowed.

Innate Good Will?

"People need to be reminded more often
than they need to be instructed."

—SAMUEL JOHNSON

*D*uring the 1940 presidential campaign when Wendell Willkie
ran unsuccessfully against FDR some bright lad thought up a
marvelous compliment for the American people. "That vast res-
ervoir of good will," he called it.

That same line of chalk was being used by Jimmy Carter
when he was hustling our votes by promising a government "as
good as the American people." The troops appear to stuff it down.

In 1940 I was young and vinegary. I didn't go for that good
will stuff. In a not terribly clever inversion I could be found talk-
ing about "a vast reservoir of ill-will." That phrase more closely
described my world-view of the time. Everybody was a crook,
etc. etc.

Now I'm not so sure. The proposition that there is such a
thing as innate good will seems to me at least debatable. A life-
time of examining evidence on the proposition has certainly
weakened my early view that original sin was nearer the
knuckle than salvation by planned good works.

One person who weakened my faith in the hopelessness of
man was my friend, mentor, political rabbi and spiritual adviser,
the above-mentioned Dr. Johnson. In his 74th year the great
man said to a friend:

"I look upon myself to be a man very much misunderstood. I
am not an uncandid, nor am I a severe man. I sometimes say
more than I mean, in jest; and people are apt to believe me seri-
ous; however, I am more candid than when I was younger.

"As I now know more of mankind I expect less of them, and
am ready now to call a man *a good man* upon easier terms than I
was formerly."

It is wonderful, as the doctor might have added, how a bit of
seasoning through the passage of years, clears the mind. People
are not different from what they were in 1940. My view of them,
on the whole, is more charitable. Whether this be due to erosion
of principle or accretion of it I cannot say.

The idea that people need merely to be reminded of good to
do good has considerable justification in the history of the spe-
cies. All the morality that people need to live together in civility
and comity is, as Christ insisted, contained in one principle:
That we should do as we would be done by. That is the Golden

Rule.

This rule was by no means a Christian invention. Six centuries before Christ, Confucius put it thus in the "Analects." "What you do not want done to yourself, do not do to others."

Whether we live by the Golden Rule or not, even the most villainous among us distinguishes a certain moral resonance in the words, "As you would that men should do to you, do ye also to them likewise." There is something in us that KNOWS these words are right, and timeless, and above dispute.

While the skeptic in me wars with the idea that there can be any intrinsic good in a species that practices, and glories in practicing, the killing off of its neighbors, too much evidence has entered my life of acts of quite spontaneous benevolence.

It's easy to say that everything good is caused by something bad, and that the bad is the real wellspring of conduct. Charity, thus, is prompted by guilt. Love is the hope of future favors. Decency is a form of pride, the worst of all our sins. Hope is but fear turned inside out.

These notions are all gravid with plausibility. But how can you explain a man as hard-headed as Johnson, at the end of a bitter life and entitled to the solaces of bitterness, going soft on the idea of what constitutes a good man?

Who Needs Security?

*F*rankly, I don't know what I would do without my insecurities. If it weren't for those little tics and terrors that lurk in the sink of the unconscious, this would indeed be a bland and boring world.

When I think along these lines I am often reminded of my friend Fred. For 45 years he led what might be called the most secure of lives. He had a good job and a neurosis. The job provided for his physical needs, and even enabled him to be a collector of paintings, in a small way.

His neurosis kept his emotional life safe, which is what neuroses are for, of course. He had an abnormal fear of open spaces. It was torture for him to go to his office. He often arrived there in a sweat. His fear made him a recluse. He had almost no social life. He only felt safe in his own beautifully furnished apartment.

An attractive woman literally forced herself into his life. She liked him; but also knew that what she liked was a secure corpse. The lady persuaded him to go to a shrink. This was one of those cases where the patient was truly ready for the shrink. The therapy worked.

He began to live a strange life. He quit his job and lived on his savings, which were modest at best. Fred began to live as if there were no tomorrow. He gave dinner parties twice a week for people he barely knew. He seemed to get a positive pleasure from seeing his bankroll diminish.

"The only thing I'm afraid of these days," he began to say, "is getting sick and secure again." He has made it in the oddest of ways, by selling to a good restaurant his talent as a cook. He is rotten with friends, and travels all over the world, with ease and pleasure.

Fred traded one big fear for a lot of little fears. It worked for him beautifully. I mention Fred because his experience is terribly similar to my own.

Early in my 30s I was effectively incapacitated by an abnormal fear of heights. This fear rendered me damned near unemployable for a number of years. In due time I too went to a shrink, here in San Francisco. Shrinkery, like making beautiful benches or writing snappy novels, is less a discipline or a profession than it is a knack. The lad I went to, who no longer practices, had this knack.

I never really understood what caused my phobia, but it be-

came clear that it was somehow related to a fear of success, a fear of fulfilling my full human potential. The factors contributing to this fear were numerous and boring and not at all unusual.

The important thing is that after about a year of weekly treatment, the fear just evaporated. That was the time when life, for the first time, began to seem dangerous. By getting rid of the one big fear, the nature of which I was unable to acknowledge, I became aware of a lot of little fears, and their role in my life.

Their role was to make me do things, to break away from a crippling passivity. Overcoming these small fears was like finishing the 220-yard hurdles every day. Tension became the conscious motive of life instead of the unconscious crippler of it.

Each day I put paper into typewriter to get a column done is my personal life *in parvo*. The first sentence is usually in my head, or written down. The rest is pure risk, the fighting of the many little fears that inhibit a man from talking about himself or about his ideas.

When I come to the end of each day's job, as I am doing now, there is the satisfaction of a race finished, without too many hurdles having been knocked down in the process. I still do not realize my full personal potential. So few people do. But I have made friends with my fears. There may well be a time when these fears abandon me. That will be a most unhappy day, if it comes.

How's Your Heart?

Remarks are not literature, as I think Gertrude Stein said to Hemingway. Information is not intelligence, as I seem to recall C. McCabe having said. Perhaps even more important, style is not literature. Thornton Wilder said that.

In that small perfection of a book, "The Bridge of San Luis Rey," Wilder speaks of the cultivated Count who lived in Spain and so vividly appreciated the letters from Peru of his half-mad mother-in-law, which were destined to become part of Hispanic literature.

The Count, said Wilder, "delighted in her letters but he thought when he enjoyed the style he had extracted all their richness and intention, missing (as most writers do) the whole purport of literature which is the notation of the heart. Style is but the faintly contemptible vessel in which the bitter liquid is offered to the world."

The notations of the heart! How exactly Wilder puts a finger into, if one may so so, the heart of the matter. Style without blood, a matter too often met in all literatures, can be elegant and pleasing indeed; but it is rather like a human figure that is so elegant and attenuated that you can count the bones, and descry too clearly the rivers of the veins.

"How's your heart?" This is the way my mother greeted her friends. It is the way many Irish peasants still greet their friends. The phrase is the most graceful and felt of all hailings. It asks the most important of questions in a way that makes it easy to answer. For surely you cannot be ashamed of what is in your heart?

Great or good writing is that precise inquiry carried on with more skill or intensity. The writer, or any other artist for that matter, asks the content of his heart, using the word as the source of his emotions. When the feelings are felt they are put on paper—that is, annotated.

Style, in the sturdy and admirable sense of the proper words in the proper places, is an almost necessary by-product of this knowledge of the heart. Style is almost a discharge accompanying a wound. If you know what you feel, and you let it pour out, you will be producing an art form, whether you are an Irishman in a pub on the ingratitude of his sons, or Cervantes spinning out his epic of appearance and reality.

If you are true to your feelings, it is difficult indeed to write

poorly. Those who choke when writing, whether professionals or love-struck adolescents, should look to their feelings for the trouble, not to the mysteries of the language. I have maintained for years that a person who knows exactly what he wants to say can hardly avoid saying it well.

The problem is: How many people know exactly what they want to say? Which is another way of saying, How deeply are they willing to probe the source of their feelings? Honesty is both a brutality and a luxury. There are those of us who haven't the hardness of integument to stand either.

There are people who write like a boot and yet produce literature. The most notable to come to mind is Theodore Dreiser, who was as flat as Baedeker and not nearly so clear. His genius was that he quite literally wrote from the heart, never losing sight of the flailings of that gently powered mechanism.

Most of the literary style of the great Russian novelists is lost in translation; but we are carried on resistlessly by an Orinoco of feeling. The writer finds style as the mystic finds God, by the pitiless contemplation of his heart. The two realities may, in fact, be one.

Who Needs It?

What I am going to preach today is wicked un-American nonsense, and I don't want you to forget it. Not for a minute.

If the advice I am to give you were seriously followed the American economy would be changed and diminished overnight. We might become a truly second-class power. Our material affluence would no longer be a towering marvel facing an envious world.

And, as a consequence, I'm sure we would all be wiser and more contented people. The only reason that I shall proffer this revolutionary advice is the certain knowledge that almost nobody will accept it, despite its *prima facie* verity.

My advice is simply this: Before you next buy *anything,* ask yourself this question: Do I need this? And put the burden of proof on yourself. If your answer is yes, re-examine it, and examine it once more. The question must be asked of everything, even of giving away money to charities. Especially it must be asked of services designed simply for your own well-being, such as shrinkery, and lawyering and doctoring.

I know someone who puts the matter somewhat more bluntly in a phrase he started using about two years ago. He conjures it up whenever a potential purchase rears in front of him: "You don't need that crap." "And I really don't," he says. "There is a real satisfaction in making do without all the impedimenta we have been conditioned to accept as necessary to the good life. You don't need that crap."

You will never know what you can do without until you try. I know hardly a man alive who could not with profit throw away at least two-thirds of the bottles in his bathroom; and for women I suspect that percentage would be considerably higher. Would women really be less attractive if they never again used a drop of perfume? And what man really needs after-shave lotion?

The other day I went downtown to buy some jockey shorts for the essential reason that I was out of them and am not yet prepared to take the step of doing without undergarments entirely. I suddenly realized that this was the first time in about three years that I had been in a clothing store in downtown San Francisco, with the exception of the occasional necktie bought at a Sulka sale.

In ten years I havn't been inside a department store. There has been no real sense of loss. The nearest thing I have to a

gadget in my apartment is a 15-year-old Waring mixer. My pots and pans, my fodder and my meat are bought in North Beach.

It is entirely possible I shall not go into a large department store anywhere, for the rest of my life, with the possible exceptions of Fortnum and Mason and Harrod's in London, which are to me as exotic as a Turkish bazaar and for the same reason. They are great theatre.

People who collect automobiles and fur coats, and more than one of anything, really, are becoming increasingly difficult for me to understand on a rational basis. What to do automobiles do that one cannot? Really. And who needs to shell out five bucks to see a vulgar and noisy movie? Who needs the next thing you are reaching for money to buy?

The proverbial wisdom is full of stuff about how possessions are bad things; but proverbial wisdom is not all bad. A man truly is rich in proportion to what he can do without, even if Thoreau said it. The tycoon, I am sure, will have a tougher time wiggling through the needle's eye than entering the gates of Heaven. There *is* real sensual pleasure in doing without. Right now there's only one thing I can think of that I really want. A helicopter.

Love Is Here to Stay?

*U*nless I discern incorrectly, there is a growing view that love is here to stay. The era of sex as rec is dying a slow and painful death.

Of course, love was here all the time. There were always people out there in the boonies who did not practice sex like jogging. A physical skill utterly unconnected with joy, in the good old joyous sense of that word.

The boonies are way ahead of us on sex. They believe it is tied up with having bairns, for good or bad. They believe that people who think otherwise are fair to daft. These people made good marriages and bad ones, good love affairs and bad ones; but they never questioned the fundamental proposition, denied by such authorities as Studio 54 and the Snow Set, that love and sex and children are all manifestations of the same thing, keeping the human race, as bad as it is, intact.

While the number of homosexuals increases, and partners become increasingly hard to find, old-fashioned romantic love, even in the fleshpots of Chicago, New York and San Francisco, seems more valuable than ever. I began to suspect some of this was in the wind when a boy I knew who was going to Princeton about five years ago started taking waltzing lessons with other kids in his class and asked his Pa for a set of tails for a birthday present.

Is romantic love, which has always existed and always will, finding its way back to the swill pots of the city? I think there is strong evidence for this belief, apart from Newton's idea that every action has its equal and opposite reaction.

Says a lady who had been brooding on this precise subject: "A few years ago people spoke in terms of being 'mutually supportive,' 'sharing,' and 'developing their sexual potential' and it seemed uncool (or even reactionary) to run around declaring yourself to the other sex. Now it appears to be all right, even good. The late John Lennon and his lady emerged as the ultimate couple: Unafraid to be totally devoted and to say so.

". . . If sex doesn't bring us closer, it does define our distance from each other, and if you don't meet some ultimate other person in bed, you do, at least, crash head-on into yourself. While times, techniques and technology change, human need remains the same. If passion's back, it's back because we want it to be, and because it never went away."

One of the wonderful things about nature is that it is self-correcting. The mad idea that sex is for pleasure only, which originated when certain devices and chemicals could displace what was the real purpose of sex, the perpetuation of the human race, is hardly two decades long, and it is already being perceived as an unhappy fallacy.

Promiscuity aside, and I do admit that it performs a function in lonely societies, sex follows love, and babies follow sex. It has been so since Adam and Eve, with temporary aberrations like Sodom and Gomorrah, and it will continue to be so as long as people are born and die with the same needs.

The lunacy that sex could be detached from personal feeling, as on one-night stands, which are really a caricature of feeling, can largely be attributed to the general idea that yields the quasi-profession of sexual therapists. These are essential unemployables who have invented a new profession: Telling people who know they are acting in a way morally unacceptable to themselves, that they are doing just dandy and keep it up and see you Tuesday next at the regular time.

Herpes simplex has done much to remove the glamor from the quickie and the shower and the taxi at two in the morning and not knowing what Herb's last name was. Nature, in other ways than subtle and incurable venereal diseases, is forcing people back to the truth: Boy meets girl.

cAre Women Saner?

Just because a woman is a feminist does not make her a cretin. The same applies to all extreme doctrinaires, from anarchists to people who believe that eating carrots can save humanity. There is a core of truth in all fanaticisms. Otherwise they would simply be dismissed as lunacy.

Take the case of Sonia Johnson, who ran for president of the National Organization for Women. Because of her view that women have more rights than they have been granted, she had earlier been expelled from the Mormon church, a hotbed of MALE rights.

Johnson said that male leadership of the world is pushing us all the way to planetary extinction.

"There is no way to stop this destruction except for woman's leadership," she said. "Women are the voice of sanity and survival." She added that "patriarchal thinking" is harmful and destructive.

"I don't think men are morally inferior. I just think there is something wrong with male leadership. . . . Women hunger for justice the way men do. Men still go to extremes for human rights. No one thinks they are hysterical."

I agree, all the way. In the essential quality of civilization— respect for life—I have always thought that women have men beaten to a frazzle. There are obvious and indisputable reasons for this. No man would exist without a woman to give birth to him. Nor would any woman, for that matter. Except maybe Eve.

Women who bear children—and that is why they are put on this earth (despite the views of the more extreme feminists) —are the custodians of life. They know what life is about, even if the child is a deformed bastard.

Women know the value of life far better than men. There was doubtless a time in the growth of the species when men performed a useful function, with bow and arrow and with how- itzers and now nuclear bombs, in protecting women and children from predators. He developed an instinct for killing and taking the risks involved in such an enterprise.

The condition of being sane is defined in my dictionary as having "soundness of judgment." In this sense, I think, the women of the late 20th century are far superior to the men.

The human race is in peril as it never has been before. This is because we have the means to destroy it in the The Bomb.

The Bomb is in the custody of men. There are crazy men and sane men, just as there are crazy and sane women. It is the crazy men, however, who threaten the survival of us all.

It will never happen, of course; but I would like to see a woman share the job of head of state with a man, and this woman should have the veto power when the man decides to push the fateful button. This is the best way I know to guarantee the survival of the human species.

We will, of course, have to assume that the women chosen for this fateful job would be sane, as we assume that most heads of state of the male persuasion are.

The Spaniards say that women and calendars are good for only a year. In a cynical and a sexual sense, a case can be made for this bitter epigram. But in a larger sense, a woman who has borne and raised children is far better equipped, morally and sensibly, for the custody of the human race. I hope, against hope, that the day comes when this benison arrives.

Men are good for a lot of things apart from killing. They can build useful and even beautiful things. They are still equipped to protect their families. Yet I really do not trust them to protect the life of the human race as much as I would women. If this be treason, make the most of it.

Ugly Is Beautiful?

I was reading a piece recently that mooted the odd question of why ugly men are often heavily attractive to women.

This is not a new thesis. It has been labored over by men, ugly and handsome, for centuries, and even by certain suscep- tible ladies.

No man ever really knows what makes other men attractive to women. Only the most naive of us assumes that the ugly man walks away with the brightest and the best because of some extraordinary endowment in the way of sexual equipment.

It's a lot more than that, as lovers since Casanova can point out. You may not have liked the guy, but there is no disputing that the late Aristotle Onassis had it with the ladies, and would have had it if he had been a ribbon clerk.

The classic statement on the issue was made by John Wilkes, the 18th century English politician. In looks, he was notably unfavored by his Creator. Yet he could say, "Give me a half hour alone with a beautiful woman and I will overcome the handsomest man in Europe." Wilkes was noted as one of the great womanizers of his time.

While I recognize the validity of Wilkes' thesis—that a glib tongue can coax a lady onto a chaise lounge—I think there is something to be said for its precise opposite: That a good lis- tener is the world's greatest seducer, whether he looks like Robert Redford or the bandy-legged little runt at the end of the bar.

The ladies, dear things that they are, dearly love to talk, and the subject they most dearly love to talk about is Numero Uno. If you can but give ear to the delightful one, throwing in the sympathetic cluck from time to time, in no time at all you will be in the sack or at the altar, whichever your preference. What you look like will in the end be irrelevant.

Another thing in a man that draws women like flies is sheer animal energy. That, I daresay, was Ari Onassis' little secret, as much as anything else. One of the most successful operators I have ever met is a guy who simply overwhelms women by his energy and his confidence. He invites them to his perfumed couch within ten minutes of meeting them. His batting average is spectacular.

The real truth about the ugly man as successful lover is that he, like Avis, tries harder. He studies the prey (or the prize, if

you will) with the detached and scientific curiosity of an anthro-pologist.

It's just like keeping your eye on the ball, which is said to be the secret of success in so many sports. The ugly and aspiring lover never lets his attention wander. He has his eyes out for every sign of approval or disapproval that comes into his lady's face, and notes what he has been doing or saying at the time he got the signal.

Most big tycoons are quick to tell you that it isn't all that tough to make your first million dollars. All you have to do is think of nothing else. The same is true of the wizards of the boudoir. Keep your eye unremittingly on the old sphere and you can score with Bardot or that young one with the double-barreled name.

The only and hardest problem, really, is getting to meet these ravishing numbers. Being a doctor or a lawyer or a theatrical agent helps; but then these chaps also have their business to attend to, and this tends to attenuate the finer skills of seduction.

Having arranged the matter of an introduction, I revert to my earlier statement. A pair of pearly ears are the quickest way to a woman's heart. It won't be very long before she is actually *pouring* out said heart. From that point on, you're in like Flynn.

Chastity Is In?

\mathcal{M}y youngest daughter recently returned from a year of wandering in that Babylon-by-the-Hudson, New York City. This place, as you may know, is where things are decided for the rest of us. What clothes we shall wear, and what movies we shall see, what books we shall read—all these things are in the hands of arbiters who live on the avenues between First and Fifth and the streets between 42nd and 59th.

In talking to the young lady I discovered many interesting things, but nothing that interested me more, or surprised me less, than that sex is becoming a bore among young women of her age and general background, and that abstention from same is becoming the chic thing.

If there is anything that is stronger than sex among enlightened womanhood, it is fashion. There was bound to come the time when the sexual revolution, so-called, would reach the point of diminshing returns.

My daughter tells me that among some of her contemporaries the reaction has become so extreme that good words are heard about so besmirched an institution as marriage. This is happening at a time when the bloods up at New Haven are learning to waltz, and have reverted to white tie and tails as a form of attire.

"The free-form flop has just become too much of a hassle," my cultural reporter says. This is too easy to believe. Our newspapers from coast to coast are filled with toothsome headlines about how to cure your dry vagina, and revelation that poor old Charles Laughton was queer as Dick's hatband, that when young men go to the showers it's not like what it used to be, and similar sexual information that we could all usefully do without.

I don't know for a fact which is more objectionable: Never to talk about masturbation, and thus enormously to exaggerate its importance and its consequences; or to blather about it all the time, and thus fail to realize its importance and its consequences —of which there are both, and in plenty.

The same goes about sex in general. Freud had a core truth when he traced much nervousness to repression of the sexual feelings. The wheel of fashion, which works in scientific circles as in others, took hold of this truth and, with fashion's irresponsibility, decided that a small truth, if magnified in quantum fashion, became the whole truth.

If sex had not been talked about before, *it must be talked of now.* In the past ten years I've heard more ignorant palavering about sex than about any subject that has been current in my lifetime.

Sex, like everything human, resists rules and categories. Everybody drinks in his own way, dopes in his own way, and makes love in his own way. To make charts and tables about sex, as Kinsey and Masters and Johnson do, is to fight the inerrable proposition that what goes up, comes down, and that the "sophisticated statistics" of 1950 are the lies of today.

That people change their individual and even tribal sexual habits surely should be known to the Kinseyites, for they indeed changed them tremendously for Americans. If Yanks think other people are doing it, no matter what it is, they tend to give it a go. And our media, in recent years, has been in a sweat to prove that "other people" are doing just about everything, to the point where even the sheep are not safe.

If, in fact, I had invented the mild thesis on which this column is founded—that some girls in their 20s have had it up to here with the sexual revolution—there still would be a helluva lot of people who would take me seriously, and go out of the house of their beloved for the legendary beer. Such is the passionate need for approval felt by the insecure emancipated.

Is Marriage Negotiable?

I have a couple of with-it young friends who have decided to shore up the creaking institution of marriage. Or, as they rather cynically put it, "to beat the rap." Marriage is in such bad repute among some of the young that they can view it as a penal sentence.

This couple could readily live in what used to be called sin, of course. There would be no condemnation and scarcely any comment among their peers if they did so. But these are the kind of kids who would climb up the north face of the Bank of America building simply because it is there.

Their idea is to sign up for marriage, as you would sign up for a year or two playing right field for the Red Sox. They have entered into a marriage contract. They tell me this is the wave of the future.

In ten years or so, they believe, the institution of marriage will be like an agreement under the Wagner Act between the steel workers and U.S. Steel, or something. It will include, as does their contract, features like meditation and arbitration.

All of this rises because women think they are getting a putrid deal in marriage as it stands. A lot of men agree with the women, and more men are being forced to agree. The liberation movement has a lot to do with it, to be sure, but there is a felt need (again, mostly by women) to define the values they will share in marriage, and to nail down their rights and duties.

Well, I give to doubt about the whole thing. There is no doubt that industrial and labor disputes are complex things, involving complex and bitter feelings, and that arbitration and mediation have worked wonders in their solution. But when you have said everything about the differences between capital and labor it all comes down to one thing: Money.

Money is negotiable, whether it is called wages, sick leave or holiday pay. And labor-capital strife wounds are not all that deep these days, since both sides know the costs will be passed on to old John P. Consumer.

Marriage, however, is the most intricate arrangement humans can enter into. It is maybe more intricate now than in the past, because the guidelines of tradition are absent. By traditional standards, one of the parties to a marriage may be mildly miserable for half a lifetime, and the marriage could still be technically a "success." Now a good hardy spat can be the

signal for abandoning the premises.

My real objection to marriage contracts and such, though, is my profound feeling that you can't make rules about human feelings. This is the basis for my severe distrust of such disciplines as shrinkery and sociology.

The way a person feels about anything is the most private part of his nature. The person does not know WHY he or she feels as she does; but knows HOW, for a certainty. Feelings are as distinct as people are, which is one of the reasons why people who fail in marriage remain puzzled to their dying day, as to where it all went wrong.

The answer is, nobody knows; neither the people involved, nor the experts, laical or clerical, whom they may consult. The mysteries of the feelings are as inscrutable as the mysteries of creation. We would do well to remember this, especially when we dismiss the feelings of others, and most especially when we dismiss the feelings of those closest to us.

Successful marriages do exist, have existed, and will continue to occur. How come? The answer is much like the problem of creation, in a way. We cope with it by invoking those intensely real but impalpable things called love and faith and hope. Otherwise we could not cope with either our existence on earth, or those we choose to utter as our sigh at immortality, our mates and children. And faith and hope and love cannot be written into a contract, nor are they anywhere or at any time negotiable.

Marriage?

"*Boswell: Pray, Sir, do you suppose that there are fifty women in the world, with any one of whom a man may be as happy, as with any one woman in particular? Johnson: Ay, Sir, fifty thousand. Boswell: Then, Sir, you are not of opinion with some who imagine that certain men and certain women are made for each other; and that they cannot be happy if they miss their counterparts?*

"*Johnson: To be sure not, Sir, I believe marriages in general would be as happy, and often more so, if they were all made by the Lord Chancellor, upon a due consideration of characters and circumstances, without the parties having any choice in the matter.*"

No sounder words have ever been said on marriage. It is not likely, however, that they will deter those who continue to marry, or to couple informally, from affection rather than from interest.

The French are admirable in this direction. In general they marry for interest and indulge their affections, generously, outside of marriage. Among the Bretons, and other more primitive societies, there is a custom of forbidding marriage until the lady is pregnant. This, too, makes a kind of sense.

One cannot but speculate what the good Dr. Johnson would say of marriage as it exists today in the United States. To say that it is in a state of disarray would be putting it mildly, since more than 1.3 million people live with members of the opposite sex without marriage papers.

What would the good Doctor have thought of a bill recently introduced into the Arkansas legislature? If you are living in sin, as we used to say, this bill would require that you apply for a $1500 "cohabitational license" and register with the local sheriff. Under the proposal, violators could be arrested and fined $2000. Happily, the measure doesn't seem to have much chance of passing.

Unmarried love still presents problems. Laws against living together without marriage are still on the books in 20 states. In the business world, employees want benefits that are commonly granted to spouses to be extended to their unwed housemates. This trend hasn't gotten very far, however.

The widespread suspicion of marriage by the young is an interesting phenomenon. Part of it is unquestionably due to the rise of feminism, and the feeling on the part of many women that marriage is a political act that is loaded against them.

But I detect among the unmarried young I meet a strong suspicion of marriage based on affections, or on the affections themselves. In this they are with Dr. Johnson, but are unwilling to take the further step of submitting their destiny to a court of chancery.

These young have seen too many great loves deteriorate into rotten marriages to leap into matrimony simply because somebody startles them into emotional sentience. They wish to be free to get from one affection to another without the exertions of lawyers, and the terrible perturbations of dissolving a legal marriage.

My own two daughters represent polar extremes in this matter. The older is square as a bear, married and liking it, with two children and probably expecting more. She is aware of all the arguments for liberation, and is in intellectual sympathy with them. Trouble is, she is a born wife and mother, and no argument can change it.

The other is free as a grasshopper. She intends to remain free, though not necessarily uncoupled, for quite a while longer.

Me, I'm caught in the middle. I like each of their choices. There are, as I think somebody has said, different strokes for different folks.

Why Drink?

I sometimes tell people that I drink to drown my happiness. This is supposed to be a joke, but the older I get the nearer I think it is to the truth.

The reasons why people take to alcohol, and have done so throughout the history of mankind, are fascinating. There is an old rime which says:

"Good wine / A friend / Because I'm dry / Or any other reason why."

Good reasons all, but it's the last one that interests me most. The celebrated cliche is that people drink because they are unhappy.

After a lifetime of observing both species I would say that, en masse, teetotalers and drunks are about equally unhappy, though perhaps the drunks talk more about it. Unhappiness is the lot of man, drunk or sober.

I'm talking of your ordinary everyday drunk, not the chap in the last stages of cirrhosis, who is often more unhappy because he cannot drink than because he has a terminal disease.

I am certain that when I was young I drank for reasons other than what makes me drink now. Much of my youth was bitterly frustrated because I could not get published the kind of writing I wished to do.

This caused great pain, and The Stuff eased the pain, though on the whole it did not improve the position greatly because it prevented me from working harder and better.

Contrariwise I have known eminently successful writers, and even great ones, who have told me the reason for THEIR drinking was precisely this success. They were afraid that if they stopped drinking the well would go dry, and the bank account be reduced considerably.

Some of these writers felt this fear of drying up so greatly that they spent years with psychiatrists trying to exorcise it. I've never known one who was affected by this sort of treatment one way or another.

Several years back in The Atlantic, writer Richard Hugo had some interesting speculations on this very point.

"One reason many poets drink so much may be that they dread the possibility of a self they can no longer reject. Alcohol keeps alive a self deserving of rejection.

"If the self as given threatens to become acceptable, as it

often does after years of writing, it must be resisted or the possibility that the poet will not write again becomes a monstrous threat.

"When Faulkner, replying to the question. Why do you drink so much? answered for the pain, he may not have meant to cure the pain. He may have meant to keep it alive."

I sometimes get this latter feeling strongly when I am writing personal as distinct from general columns. The pain felt by the young and frustrated McCabe remains the real motive force, and the grudge I held against the world in those days has been retained because I wish to retain it.

If the facts are honestly faced I do not have a bad life. I work at something I personally like, and get paid a good salary for it. My personal life is a good deal less passionate than it used to be, but a lot more satisfying.

Perhaps, like the putative Faulkner, I do not wish to accept the fact that my life is no longer a continuous pain, as I liked to think, and is not something I have to use to rail against a world that is lined up against me.

I think there's something in that, how much I do not know. I must also remind myself of the mundane fact that drink is a habit, and that habits are hard to break, no matter how recondite the psychological reason behind them.

Truths?

*What is true is what I can't
help believing.*

—O.W. HOLMES JR.

*I*n my opinion, the author of the above sentence had the keenest mind in public life in our country, with the possible exception of Abraham Lincoln. Holmes has got me to thinking of some of the few things I can't help believing. Here are a few:

• Honesty is the best policy. I know it causes you to lose friends and sympathy, but I still believe it. On the obverse side guilt is among the worst policies—whether partly expunged by a prison term or, worse, rotting in the sink of the unconscious. I am not setting myself up as a paragon of honesty. This is just one of the things I can't help believing.

• Baseball is honest, despite the Series thrown in 1919, and pro basketball and football aren't.

• A belief in life after death is no more absurd than some of the wonders we take for granted here below, such as the human body, the airplane, the computer and the works of Shakespeare.

• By and large, the world as it exists today would fare better being governed by able women than by able men. This especially applies to the "advanced" countries. I say this despite Margaret Thatcher's bellicosity in the Falklands.

• I think the educational system in this country should be devoted to the cultivation of the brain through a rigorous liberal arts program. The software and scientific stuff can come easily to a good brain after graduation from college.

• I think the Catholic church is the most rational of the religious systems with which I am familiar. This is because of the stunning realism of the doctrine of original sin. The idea that we are all born bad boys and have to redeem ourselves is a splendid challenge, which is what a religion ought to be.

• I do not believe we can ever prevent the detonation of a nuclear bomb by a lunatic or a temporarily deranged "normal" type. Anything that man can do, man will do, somehow. This is perhaps the most cynical of my "truths" and I hope I am wrong about it.

• Man is more good than bad. This is a close one. Its main support is that man, with all his wars and all his perfidiousness, has managed to live together in some form of orderly society.

• I believe that quite a few men enter political life as honest men, but very few remain that way long unless they are multi-

millionaires and traitors to their class, a combination that is as rare as a virgin in show business.

• I think Leonardo da Vinci was the greatest man who ever lived, excluding Jesus Christ, of course.

• I believe passionately in the family, perhaps because I never really had one. I know there are bad families as well as good; but the good ones give an emotional strength to their members that fills me with admiration and envy.

• I think Fred Allen was the wittiest man of my time. I also think California is great if you're an orange. Excepting the circulation area of The Chronicle, of course.

• The two books I would like to have on a desert isle are the King James Version of the Bible and the essays of Montaigne. The life of the spirit is covered by both books, but I think Montaigne has the edge in his comprehension of man in all his weaknesses and strengths. Don Quixote would be a close third.

Essays

On Being a Has-Been

*I*t was with a small sigh, almost, that I read recently the news that Watergate conspirator John Ehrlichman had obtained a New Mexico divorce from his wife of 29 years.

This was the fellow we saw lecturing uppity congressmen on the tube a few years back. This was the man who, from all available evidence, ran the country. His sidekick, H.R. Haldeman, was too busy running Richard Nixon to take on the affairs of the country. Nixon himself was just sitting around, being famous and important.

And now Ehrlichman is a has-been. Despite a modest career as a writer, he is a person of no importance in the world's eyes after having been a person of great importance indeed.

I know the feeling. I have been a has-been, on a modest scale, several times in my life. I have had several situations where there seemed to be no way but Up for me. In each case my circumstances, my luck and my character mixed to make me blow the whole thing.

While in my 20s I had a job at the very top of the then-young racket of public relations. I had two handsome salaries, one from my boss and one from the client, Union Pacific. I had an expense account so generous that I banked both my salaries without touching them. In addition the UP threw in two cases of scotch a week for entertainment purposes.

I blew the whole thing for what I called love. I fell head-over-heels with a marvelous girl who had come to Sun Valley to get a divorce. I married her, knowing the move would deeply offend the strait-laced Catholics who were my bosses both in Sun Valley and in the UP, which owned the resort. So they were, and so I went.

Being a former success and a lad of great promise gone to seed is a curious bit. If you went into a restaurant where some of your peers were sitting, you could almost read the speech the guys were forming with their lips when they saw you. "McCabe . . . had it made . . . damned fool. . ."

No matter how tough your integument, this is a hard thing to take. In time, of course, the cruel judgments will wear off, and you will be accepted again, though at several rungs lower on the ladder. But the interval before your acceptance on a lower level can be hellish indeed.

Unless you give up human society altogether, which is de-

cidedly not healthy, your ego is subjected to daily battering. The work of building up your defenses against those assaults can be as difficult as carrying a hod of mortar all day long. My heart goes out to anyone who wants to work and can't find work. Even more so, it goes out to the man whose soul has been battered by the brutality of his fellows.

It is not merely that you lose power, which is a very nice thing to exercise, no matter what the moral philosophers say. You also lose confidence, without which it is almost impossible to do anything.

The way I got over that particular crisis was not particularly courageous but it worked. I went back to Puerto Rico, where I had lived before, to help edit an English-language newspaper that had been set up in the early days of the war, and to work as a correspondent for another UP, the United Press.

It took years, though, to get back that sense of triumphant identity that I had as the No. 2 man at Sun Valley. Had I stayed doggedly at the job I would probably have today a cushy job doing public relations for Mobil or Exxon, with a big fat house in Scarsdale.

But the truth is that I did what I did because I wanted to. It meant an admission of failure, but it also got me out of a way of life I knew I could not stand for long. I was a has-been, to be sure, but I had turned off a wrong road before it was too late. I was willing to pay the price, and I did.

On Being Yourself

cAll my life I've been playing a game called "Be Yourself." This is a perilous game, fraught with troubles; but in the end a rewarding game, or I reckon I would have stopped playing it years ago.

The thing I call selfhood is a hard little core within me. It has always been there. I cannot say I know where it came from. What I do know is that I have always guarded it as carefully as any maiden ever guarded her virginity.

I have been brutally beaten by people in an effort to break down what was called my stubbornness and my obstinacy, what I always saw as my essential selfhood, a thing more important than anything that has yet happened to assail it. Certain kinds of torture, I am sure, would break it down. I reckon myself lucky that I have not had to face these tests.

I have remained, for good or ill, my own man. And I honestly do not know whether this insistence on being what I see as myself has been a good or a bad thing. I know that I would not be able to look at myself in the morning had I not fought for this black, beautiful thing.

I do not know how strongly other people feel about this core of self. I know that protecting it has been a ruling passion of my life. That other people feel the same way I could believe; but I had not heard the feeling so well expressed as in two sentences I read the other day, written by Edmund Gosse.

Edmund Gosse was an English man of letters who wrote a wonderful book about his relations with his father, Philip Henry Gosse. "Father and Son" was published in 1907. The father had become a professional naturalist in Jamaica, and virtually invented the new science of marine biology.

The son, speaking of himself, says: "Through thick and thin I clung to a hard nut of individuality, deep down in my childish nature. To the pressure from without, I resigned everything else, my thoughts, my words, my anticipations, my assurances, but there was something which I never resigned, my innate and persistent self."

In those words, as I read them, was the story of my life, the essential story. There have been at least three or four times when I have technically had it made. In each case I rejected what the world would have accounted very good fortune indeed. I rejected it for the good and sufficient reason that the role

assigned me by fortune was not *me*.

That this is arrogance, that it reeks of the Greek failing called *hubris*, that it is a kind of railing against the gods—none of this I can deny. That it is selfish and self-righteous I also cannot deny. I so acted because there was no other way I could act and retain the respect for my nature that I deem necessary to keep on going with myself.

I have hurt lots of people, and even a few pretty decent causes, because I deemed that hard little nut of selfhood more important than other people and other things. I have gained the reproaches that such conduct calls for.

The hard little nut, held so long, for a lifetime, has cost me greatly, but I've never failed to pay the price. I still consider the whole negotiation a bargain. It is rather like that other dubious blessing, or blessed curse, the gift of gab. There are times when I cannot tell whether it has helped me or hurt me.

But you must believe in something you fight so hard to protect. I once gave up a great job with fine salary and really unlimited future, plus an extortionate expense account, with the words "This ain't me." I've never regretted it, though it was a long time before I got another job, of any kind. The reward or punishment? These days I often feel that I am myself, that a bitter fight has been won.

On Watching Fires

\mathcal{A}s it happens on many evenings when I am alone at home, I begin to think of whether I should turn the television on, or light a fire. As nearly always happens, I ignore the tube and amuse myself with a fire.

The reason is simple. I derive more pleasure from the play of flames than from what passes for entertainment on the box. The sight of flames and the crackle of wood sets alive the world of the imagination for me. They produce in me a reverie that has almost no content.

I could never tell you exactly what goes through my mind as I watch the wood and coal being consumed; but it is always pleasurable. I am lucky enough to have two fireplaces in my flat, and there are times when I have both of them roaring, and move upstairs to one and down to another.

It is as if all the bitterness, remorse and sorrow of my life were wiped out when I gaze into those flames. I cannot say why this should be so, but so it is. There is all the comfort of three good blankets in one good fire.

In the most precise sense, fire-watching is an escape. Some ancient association of fire and comfort must exist in all of us. Fire equals warm equals safe.

Even if you are with someone you love, firewatching is not so good as when you are alone. The whole process is a stirring of the spirit which can only really be done in deep solitude. In the odor of privacy, as it were.

I know that, for many reasons clear and unclear, I am an odd bird. In some matters I have always marched to a different drummer. This is related to the matter of fires and television programs.

One day on a downtown street of a big city I saw a group of people staring at a dark young girl. Eventually they gathered around her, and some shoved papers and books at her for her autograph.

I asked who she was and somebody said she was a television star named Cher. I had never heard of Cher in my life. I did not know what she did. There is a whole world of celebrities that do not exist for me.

My acquaintance with the tube consists of ten minutes each day with the news, and an occasional fling at something on Channel Nine.

Thus, I am almost completely untouched by the greatest cultural and educational fact of my time. The decision has been a deliberate one on my part. I do not want to get hooked on TV as entertainment because what I have seen of it is shoddy and largely a waste of time.

Yet it also means a sacrifice as a journalist. As a writer for newspapers you are supposed to be with it, to know what is going on, to be able to gauge accurately the temper of your audience. The obvious way to do this is to share the entertainment of the people who read your product.

Yet I think I shall stay with my decision. At least, I hope so. If one thinks the chief purpose of life is to learn about yourself, and this I certainly do think, there is more to be learned from fireplaces than from the tube.

And yet, and yet . . . I do not wish to be estranged from the people I meet because what goes into my system is so different from what goes into theirs. I do not wish to become monkish.

But, as the man says, you can't have everything. And as the other man says, win a few, lose a few. I guess I think, truly, that what is inside me is more important than what is outside me, and that I can encourage and let grow that inner thing better with some logs and flames that with what the networks choose to show me of the world.

On Not Licking Stamps

The world can be divided into those people who take baths and those who take showers, those who are Nominalists and those who are Realists, those who function best in the morning and those who do so in the evening, those who like television and those who can't abide it. There is one other broad human distinction of which I have been reminded recently; there are those who lick the stamp and those who lick the envelope.

It must be admitted that the envelope-lickers, though clearly in the right, are also clearly in a minority. In fact, the only high carat envelope-licker that I can rightly call to mind at the minute is myself.

Others addicted to this practice may give me a jingle, as a result of this publicity. We might even work up a modest federation. It is not good that the elect should live in ignorance of each other.

I cannot remember a time when I was not an envelope-licker. It just seemed the clean, natural and even American thing to do. I came by it naturally, you might say.

You might also say that I hate the taste of the glue they put on Uncle Sam's stamps. The French ones taste better, the Spanish decidedly worse. How do I know? Why should I taste stamps, domestic or foreign, when I prefer to lick the envelope and avoid the taste of the stamp? Just plain contrariness, madam.

Envelopes, on the whole, have no taste at all—if they are white. If they are manila envelopes, the ones I favor for most forms of communication, there is a rather strong flavor. To this I have become decidedly partial.

My unwillingness to lick stamps is known to some few of my friends. Most of them take it as a deliberately perverse form of behavior, a desire to draw attention to my own idiosyncrasy, even an ego trip.

"It's just unnatural," my friend Charlie claims. And yet, to me, the modus operandi seems eminently natural. Perhaps I didn't know any better, at the start. My mother and father were rather sparing correspondents. I cannot recall either of them ever sealing a letter. I do remember that when they opened one, both allowed the envelope to drop to the floor before going into the contents of the letter.

This seems to me, now that I think on it, rather unnatural

behavior. Envelopes have their proper place in the nature of things, and it is not a humble one. I know people who would rather keep the envelope than its contents any day.

When it comes down to it, the whole thing, as so many other things, is a question of texture. Do you wish to go through an entire day with the memory of an encounter with a slippery, slimy stamp early in the morning? Not for me, thank you.

The texture of a good manila envelope is not unlike that of the skin of a raw potato. You are going against something. The result is abrasive. It carries with it a sense of accomplishment. The stamp-licking maneuver, on the contrary, is filled with images of loss, of retreat, of decadence, of (the word is inescapable) slipperiness.

I am certain that some Viennese-trained theoretician of the soul would have a ready explanation for my *recherche* preoccupation. It could indicate either latent homosexuality or latent heterosexuality, depending on the agility of the theoretician. It could mean I have a deep unconscious desire to send my mother to the knackers, or my father—again depending.

My conscience is clear. I think my way of going is as American as apple pie. Until they produce a stamp which is clearly redolent of garlic, I shall follow my unreconstructed path. There is a lot at stake here, as I am beginning to perceive.

On Getting Older

I'm awfully glad I've lived as long as I have. Had I died when I was 20 I would have missed three or four interesting persons, the persons a rather miserable 20-year-old evolved into.

Had I departed at that age the number of persons who would have missed me would have been almost nil, myself included. I was unhappy, contentious and confused. It can be argued that most 20-year-olds are in the same boat. I can only say that I was worse than most, and knew it.

I wasn't suicidal, but certainly indifferent to life. Were I victim of a serious illness in which death could be averted by a conscious act of the will, I am not certain I would have made this conscious choice.

What kept me going, in addition to an inherited peasant constitution, was mostly damned curiosity. I wanted to know how the whole crazy plot would turn out. Would I end up as a villain in the end, or some kind of hero, or, worst fate of all, a mere spear carrier? Was I to be part of the problem or part of the solution?

Ecclesiastes assures us that there is a time to die. I've always thought that John F. Kennedy died at just the right time, in terms of the fulfillment of his own life and purposes. Poor Mr. Nixon had no such luck.

I wouldn't have missed the past decades of my life for anything. The chief use of my life has been that I have grown, or think I have grown. My chief pleasure in the later part of my life has been the observation of that growth.

Except for the not unusual love/hate relationship of an eldest son with a domineering mother, I doubt that I felt anything but basic hatred for most human beings until my late twenties.

Then, in a brief, tempestuous and doomed first marriage I found it was possible to love more than I hated. The weakness of that marriage was that the margin of love over hate was not what you'd call great.

But I had made a start. I had glimpsed the truth that you could give without being destroyed. From that time forward I knew things were possible. The struggle was make the love creep up on that great wasteland of hatred, my legacy from childhood.

For most people the birthdays of 30, 40, 50, etc. seemed to

be melancholy affairs. What is gone is mourned. The gaiety and pleasures and marvel of the past decade is exaggerated. Youth, that flaming thing, is grieved over.

This has never been the way with me. At 30 I looked forward to being 40. At 40 I looked forward to being 50. When I reached 60 I began looking forward to being 70. *Deo volente.*

I view having got through a decade as a kind of triumph, not with any sense of loss at all. I made it, and I think I'm the better for it.

I am wholly fascinated by the people named Charles McCabe that I have met and studied in the past 40 years. My satisfaction with myself, to put it bluntly, has increased with the years. I'm less a pain to myself, and to others. I recognize that the object on the other side of the bed is not a thing made for my delight, but a person who can delight me.

I can hardly wait to see the man who awaits me at the end of the tunnel of the next decade, if l last it out. I would like to be kinder, to love myself less, to wish to help people more. I would like to keep clear in mind and in memory. I would like my faults to be blunted by the kind arm of time. I would like to continue to wake up in the morning with the feeling that I have useful work to do.

On Being Happy

cAbraham Lincoln, that wise man and distinguished writer, once said: "Most people are as happy as they make up their minds to be."

Those words hit me with particular force. They are almost the story of my life.

As I have intimated in this space more than once over the years, I had a quite unhappy childhood. The only good thing about it is that I didn't know it. I felt that all my peers felt the same way about things as I did. It was only when I reached late adolescence that I knew there was something different from the rest about me. I discovered that I was a very unhappy boy.

Then it was that I made my decision, which I have followed with a certain success for the remainder of my life. To paraphrase Lincoln, I made up my mind not to be unhappy. Though I have had moments of happiness and even joy in my life, I never really made up my mind to be happy. I thought it beyond my capacity.

I have known many people who have decided to be unhappy. Being sicklied o'er by the pale cast of thought is their idea of fun. They relish gloomy poetry, gloomy talk and gloomy people. They find expression in cultivating the dark side of their nature.

Though by nature ambitious, I strove to curb that impulse by staying away from things that had the capacity to disappoint me. I became non-competitive because I didn't want to lose, and losing would certainly cause me unhappiness. The only thing I competed in was something I was pretty certain to win at. One particular talent I inherited from each of my parents was the ability to argue. In high school and in college I was a brilliant debater, if I say so myself. No team that I debated on ever lost a contest, and that included such formidable opponents as Harvard, Oxford and City College of New York, and the best debaters of them all, the Jesuit schools like Georgetown, Loyola, Fordham and Holy Cross.

Like other good debaters, I seemed destined for the law. I was even offered a scholarship to law school by one of the sachems of Tammany Hall, Jimmy Hines. But I knew I would be unhappy practicing law, and not only declined the scholarship but gave up debating entirely.

Working as a newspaperman has probably been the most sensible choice I made in my life. As a reporter, you mostly

covered other people's troubles. You had an opportunity to forget your own difficulties. You were not allowed much time to be unhappy. I lived according to the sensible (for me) advice of Schopenhauer: "It is advisable to reduce one's claims to enjoyment, possession, rank, honors, etc., to a very modest size, because it is just the striving and struggling for happiness, glory and enjoyment that brings about the great catastrophe."

For me "the great catastrophe," the thing that kept intruding on my desire to avoid unhappiness, was sex. From my mother, my first great educator, and the various priests, nuns and brothers who taught me in school, I learned the ugly lesson that sex outside marriage, and often within, brings nothing but misery. But I had a normal and very strong sexual drive; so this, like many another thing, turned out to be a self-fulfilling prophecy. The best women friendships in my life have been those in which there was no sexual component.

It was not until I approached middle age that I allowed myself to think I might be happy. Saying what I want to say to a half million readers each day SHOULD make a journalist happy, as my publisher once reminded me. And, in the course of nature, the beast sex has been tamed.

In truth, I should classify myself these days as a moderately happy man. And, I can tell you, it comes as a mighty great surprise.

On Being Fat

\mathcal{B}y the standards of today, I am fat. I do not accept these standards, or attempt to meet them. There are times for being fat (or stout). This is not one of them. There are times when heft has been considered "bottom," and thought to be a very good thing.

I am six feet one and my weight varies between 235 and 240 pounds. By the standards of the Metropolitan Life Insurance Company, I am obese. My flippant answer is "The Lord meant me to weigh this much." But I don't think it's so flippant at all. I feel okay most of the time, which is all I can expect at my age.

The only form of diet I ever go on is to forswear the drink temporarily. This only increases my appetite, after the first few days, and my weight stays steadily where it has been. Through college, when I was a track man, my weight ran about 140 pounds. Autre temps, autre weight.

But one thing I find maddening. This is the prejudice toward people who are obese or heavy or bulky or portly or whatever. A century ago, such is the power of fashion, I would have been considered a fine figure of a man. These were the days of Gladstone, of Palmerston, of the Marquis of Salisbury, and of our own Grover Cleveland and Teddy Roosevelt.

I recently discovered that there is an organization called the National Assocation to Aid Fat Americans Inc. It makes a lot of sense to me. Hear the executive secretary of NAAFA, Lisbeth Fisher:

"Our culture's attitude towards obesity is so degrading and humiliating that fat people are allowing their bodies to be cut open by the surgeon's scalpel; having their jaws wired shut; spending billions of dollars a year on diet gimmicks, pills and books; literally losing their lives on dangerous fad diets—ANYTHING to lose weight and satisfy society's demands.

"Day after day I become more and more horrified by how fat people are allowing themselves to be used as guinea pigs— something that thin people would never dream of allowing!"

Fisher waxes even wrother: "Fat people are the butt of countless cruel jokes, social prejudices, employment discrimination, medical and life insurance bias, attacks by the media and advertising, excruciatingly uncomfortable public seating, denial of entrance into higher education institutions and, until recently, almost completely ignored by the fashion industry."

This is all brutally true. Fat people are just as much the

victims of bigotry as blacks and homosexuals and people in wheelchairs. Mostly it is not their fault that they are fat. They go on diets, as I have gone on diets, and there is absolutely no permanent effect once the diets are abandoned. I for one would rather be fat than spend my entire life in a state of chronic mal-nourishment.

It is now medically established that hormonal and chemical differences, and age, and where one lives, can be responsible for excessive weight. There are compulsive eaters who go to their graves via their mouths. There equally are compulsive eaters AND drinkers who weigh the same at 60 as the day they got out of high school. The knowledge of the causes of faulty metabo-lism is still very much in its infancy. I like to think I have more or less stabilized my weight by taking a couple of thyroid pills a day.

Maintaining one's weight, even if it displeases the Metro-politan, is much healthier than constantly losing and gaining weight, which is the fate of nearly all dieters. (I have heard the figure of 98 percent).

The NAAFA is fighting for a federal law that will ban dis-crimination against fat people in every sector of society. Being fat is not more peculiar than being a Marxist or a lesbian. The public obsession with it must be brought within reason.

On (Not) Keeping

*I*t takes a man with a great sense of his worth to keep memorabilia of his life. He is a mortal waiting for a biographer. The biographer (if found) will extend his mortality by that small amount, and all that record-keeping and diary-hatching will seem to have been of importance. In the end, though, even Thucydides and Boswell will die.

I do not squirrel things away for posterity. Letters I receive, some with rather formidable signatures, go promptly into the circular file after they have been answered. I can hardly think of a human being whose letter and signature I would frame and hang. The last time I did this was with two letters from JFK. They are now lost, and I find I do not miss the loss one whit.

There are people whose lives are actually preparations for their biographer. Gladstone, I often think, edited much of his public life with John Morley in mind. The most researched literary man of his time, F. Scott Fitzgerald, led an appallingly empty life but he did store away enough stuff to continue to occupy his various biographers.

There is at the moment considerable fuss in the literary world about another literary figure and contemporary of Fitzgerald, D.H. Lawrence. This is the 50th anniversary of Lawrence's death. Appropriate garlands are being laid. The whole thing is being organized rather like Babe Ruth's final appearance at the plate, though lacking the entrepreneurial virtuosity of baseball's nabobs. Poetry, after all, is a minority taste, like drinking herbal wines.

Lawrence would have hated it. He was one of the great non-keepers of all time. (Though this cannot be said of those he wrote letters to.) His hatred of keeping things was linked to his love of the Etruscan people, who left no great literature, no magnificent buildings, no glorious military history.

Lawrence wrote: "Give us things that are alive and flexible, which won't last too long and become an obstruction and a weariness."

I possess nothing tangible that can call up the Charles McCabe of age 20, or 30 or 40, except maybe a fistful of byline stories in the libraries of news organizations I have worked for.

I allow things, mostly newspapers and magazines and letters that for some reason I find it difficult to answer, to accumulate in piles in my living room which is also my working

room. At intervals, usually when I am about to go on a longish trip, I take the lot and burn it in my fireplace.

I never fail to feel a small glow of gratification as I do this. During one such interval I burned a sizable number of traveler's checks. I've no doubt I've thrown away things more instrinsically useful.

I think mortality should be respected for what it is, an end. What's past is prelude is hopeful and perhaps even true to a degree. What's past is past is indisputable. I can understand why some people can pore over love letters they wrote or received in their youth. I hope they can understand people who would find such reading uncomfortable, simply because the whole thing is passed.

Freud, or someone of his persuasion, made a jolly distinction between people who are anal-retentive and those who are anal-expulsive. The former wouldn't give away their dung; the latter can't get rid of it too soon. The former tend to be bookkeepers and immortality-scroungers. The latter tend to be what is properly called wastrels—of their talents, of their friendships, of their accomplishments.

Count me among the latter. I will be remembered after my death by my children and some few friends. I may figure as a footnote in a book or two. So be it. Mortality is The Great Fact. Let us respect it as such.

On Being Interesting

There are few bits of advice I care to hand out to my young friends; but one is about being interesting, which usually comes down to letting other people know you are interested in them.

This interest can be either malevolent, as in absent gossip; or benevolent, as in open flattery, or generalized concern, as in the salvationist. The distinction among these three groups may be considerable. What they have in common is that they are interesting. They care about people, even if negatively in some cases.

If a man at a party asks you about some girl you are taking out, and what you think about Cambodia, and whatever happened to that great horse Nijinsky at Longchamps, you are pretty sure the guy is interested in you. You are likely to infer that he is interesting.

I once worked for a newspaper which had a big sign in its city room reading, "Is It Interesting?" This could be a little chilling when you came in off the street with a story and sat down to write. How could you ever know what was interesting?

Soon, of course, the answer occurred to me: Was I interested? That I could tell from the scalp of my head. If I was interested, I really wrote. If not, three paragraphs with the essential facts would do.

This is still the lodestone by which I work. Each week I read and hear hundreds of good stories. They are good for someone else. I am not interested.

I knew an English lady who had been a nurse and became an enormously successful author of historical novels. When asked how she came to be a writer, she would reply cryptically:

"There is a passage in 'The Prisoner of Zenda' in which Rupert of Hentzau has just shot the king on impulse. He goes to see one of his close friends and associates with the momentous news.

"The henchman is disconcerted. 'Why did you come here?' 'Why did you tell me?' "

"And Rupert replies, 'I told you because it was interesting.' "

There, in brief, is the secret of all writing. That you should cause discomfort to someone is an inferior consideration to that of generating interest. If you can be interesting without causing discomfort, so much the better; but it isn't that easy.

Which is why gossip remains the most permanently interesting form of social intercourse. The opinions of people about other people are a truly addicting commodity, especially when

the tincture of malice is present. Gossip, like journalism, is basically an assurance that we are better than the other fellow. This accounts for the great popularity of both art forms.

Saki said it, with a slight twist. "Scandal is merely the compassionate allowance which the gay make to the humdrum. Think how many blameless lives are brightened by the blazing indiscretions of other people."

To be interesting, then, is to discover the interest of other people, and to appeal to it. A great English statesman said, "What you make it to the interest of men to do, that will they do."

I once wrote sports, a field wherein it is almost impossible to be uninteresting, though it can be managed. The sports section is geared to a single interest, and over the years the section has learned how to appeal to that interest.

It is impossible to learn anything, or to succeed at anything, without strong interest. With it, learning and success are usually proportionate to the strength of the interest, or drive. Chesterton wrapped it all up when he said, "There are no uninteresting things, there are only uninterested people."

On Book Burning

There are few things in this world more beautiful than a spanking wood fire. I've spent perhaps the happiest days of my life before big fireplaces, watching elm or eucalyptus being consumed in their flames, while my mind went off on wondrous journeys.

A wood fire is good of and in itself. But I confess to a curious weakness. There are few things beneath the sun which please me so much as burning in a big and beautiful stone fireplace the complete works of, say, Harold Bell Wright.

You might say I drifted into my career as a book burner. About 30 years ago I was living on a ranch outside San Diego. The ranch house had a huge and strangely ill-chosen library. Beautifully bound Florio translations of Montaigne perched side-by-jowl with the standout productions of Miss Elinor Glyn. Bacon was bounded on the left by Dick Merriwell, etc.

The lady of the house asked me to thin out the books. She gave me carte-blanche, since our taste in these matters more or less coincided. I agreed to do the job while she was visiting New York, so there should be no disputes about what was to be thrown out.

It was winter. Each night after dinner it was the custom of the place to have a huge fire of eucalyptus logs from the ranch. The smell was delicious. The logs were just dry enough. The San Diego Union, possibly the worst large city newspaper in the country, was used as a starter.

As I began my thinning, it occurred to me that the best method of disposal was incineration in the living-room fireplace, near where most of the books were stored anyhow. I began the daunting task. My first sacrifice was the collected works of Gene Stratton Porter. This author's work consisted of an endless repetition of the same book which was about A Man and His Dog. Then I moved on to the works of Zane Grey and the aforementioned Harold Bell Wright. The only Westerns I ever liked were written by Mark Twain, and maybe Walter Van Tilburg Clark.

The job was pure sadism and totally pleasurable. There were far too many books in the world, and I was doing something about it. Not to speak of the oceans of bad taste, sentimentality, and false values represented by the trash I was ridding one corner of the world of. The fact that I was a frustrated and

largely unpublished writer at the time did not detract from my almost orgiastic pleasure in getting rid of books which had nearly all been best-sellers at one time. I was really playing God.

In due time the indisputable junk was consumed. I found that books burn easily if you have a real bed of coals. The ones I burned were powder fine each morning. Dust to dust.

I was reaching the stage where important decisions had to be made. Galsworthy was the first real border-line case. Here I found myself engaged in literary criticism on, if I may say so, the gut level. To burn or not to burn the "Forsyte Saga"? In the end, Galsworthy went, and half of H. G. Wells too. My standard was basic. If the books had bored me, into the flames.

I was getting into the grip of a mild obsession, and I knew it. The pure joy of watching a book burn, and of reflecting brutally on the amount of work that went into it, and the perverse joy the reading of it may have given thousands, was affecting my own set of literary values. If this kept up, I realized, the day could come when I would burn my beloved Montaigne or Charles Lamb and rejoice in the doing. Time to stop.

I've been burning books off and on, for myself and others, through the years. I thinned out two libraries in Great Britain, to the satisfaction of one and all. Further, my obsession was understood and given sympathy.

Now I burn books to make room for other books, as the shelf space in my small flat is limited. This minute my eye lights on six or seven wooly-minded books on the subject of marijuana, its history and legalization, etc. They'll get it before the week is out.

On Walking Alone

There was a time when a great pleasure of my life was going on long, lonely walks. During these the shards of the soul were re-assembled, the tidying-up of a not very orderly life arranged.

I remember walking on the Wiltshire downs, on the fort-resses of old San Juan, on the beaches of La Jolla, on the shores of Lake Tahoe; and, most of all, on the unyielding sidewalks of New York.

Another man who likes to walk alone, and who has won my admiration, is Edward Lawson. Lawson, a black man who lives in San Francisco, is a minor hero in my eyes. He has been arrested at least 15 times in recent years because the cops in California claim long, lonely walks are a crime.

Lawson says his troubles are a result of nothing more sinister than walking, at any hour of the day or night. "I don't smoke; I don't drink; I don't do dope," he says. "I am a vege-tarian and at any particular moment day or night that you run across me, I am probably much more lucid and sober than most people."

What Lawson is up against is the California penal code, which says a person is guilty of a misdemeanor if he "loiters or wanders upon the streets or from place to place without appar-ent reason or business and . . . refuses to identify himself and to account for his presence when requested by any officer to do so if the public safety demands such identification."

Peace officers say they need this statute to prevent and deter crime, by halting suspicious people before they mug and murder. The law says two conditions must be met for any arrest. Cops must see "circumstances of criminality" and the suspect must identify himself. As one district attorney put it, "Most violators have something to hide."

Lawson insists he has nothing to hide. He carries always a valid U.S. passport, a California driver's license, and other identification papers, but will not produce them until the officer involved explains why he is being stopped.

If Lawson sounds like some kind of crank, he's the kind of crank that I'm on the side of. I have been stopped by cops for the crime of walking alone in Beverly Hills.

I was walking along the street to the Beverly Hills Hotel, to keep a dinner engagement with Cecil Beaton, the British pho-tographer and stage designer.

A police car stopped, and two cops got out and started talking to me. What was my business? Where was I going? Where was I staying during my visit to Beverly Hills?

I wasn't altogether surprised. I had recently been told of the experience of another friend, the writer and journalist Patrick Balfour, who had been picked up for doing precisely what I was doing, walking alone in Beverly Hills. Balfour was British, and he was arrested as a vagrant because he didn't have $20 in his pocket. He spent an uncomfortable hour or two in a police station before friends came to his aid.

I had $20 and was very polite. Nonetheless, the cops asked me to get in the back of their car. I was driven to the hotel. The officers smiled when I left. I had almost, but not quite, violated the Beverly Hills loitering law.

Edward Lawson and the rest of us lonely walkers can take considerable heart from a recent unanimous U.S. Supreme Court decision that police may not stop a person on the street and ask him to identify himself unless they have a specific reason to suspect he may be engaged in criminal activity.

The justices decided that loitering laws like California's violate the Fourth Amendment's ban on unreasonable seizures whenever the laws are applied to persons not suspected of any misconduct.

Police power over law-abiding individuals should be resisted vigorously by a democratic citizenry. If a man cannot mind his own business, on foot or in his car, without identifying himself to a cop, we are all in a parlous state.

On Living Alone

\mathcal{T}he Bureau of Census people told us a while back that the number of adults living alone had more than doubled since 1970, despite an uncertain economy.

This is an extraordinary fact. It is bound to affect the lives of all of us in all kinds of ways. One thing is for sure, public entertainment is certain to be a good investment. While these young people like living alone, they also get lonely, and go outside to patronize restaurants, coffee houses, bars and theaters.

In interviews with 50 of these loners all over the country the *New York Times* found the dominant reason for living alone to be freedom and independence.

"There was an almost self-indulgent preoccupation among them with wanting the luxury of coming home, turning up the stereo, dropping their clothes on the floor and lighting up a joint. Or to go camping or skiing with whomever they wanted whenever they wanted."

I am all for this trend. I've always found living with other people uphill work. If someone is under the same roof with me long enough I cease to regard him/her as a companion and begin to think of them as a suspect.

A suspect? I hardly know what the suspicion is about. It is a kind of generalized thing, like free-floating anxiety. I really suspect the other people are up to something really monstrous, like kidnapping my soul. Anyhow, continued intercourse with other humans, no matter how agreeable, becomes in the end intolerable to me.

The question of why I like to live alone is interesting, I am sure. More interesting to me is the question: Have I ever lived otherwise?

As long as I can remember I have lived in a private world. As a young child I was estranged from my parents, and from my brothers. When I was in grammar school my closest contact with my peers was fighting with them, which I did often and badly.

The fights were caused largely by the fact that I wore specs, and was called "Four Eyes." Lads with this handicap found no trouble at all getting into fights.

Teachers were constantly reproaching me for a lack of either "school spirit" or "team spirit." They could not have been

more correct. I thought both ideas were nonsense, and pursued my private dreams. This got me into trouble with teachers but did not harm me or anyone else very much.

Later on, being a solitary did begin to hurt other people. This was largely because of an institution called marriage, in which I have dabbled. Being lonely while in the married state can be taxing on the person you are married to.

I don't know what the chief cause of marital breakdown is, but the determination to be your own man or your own woman must rank high. To be married to a person who simply isn't there most of the time requires a kind of emotional heroism that not many of us possess.

Why do such people get married? The answer is, happily, that not too many of them do nowadays. The tendency is to crash together until the old boredom betokens an end.

In my younger days the pressures to get married were both visible and invisible and terribly strong. You were somehow less than the rounded man if you did not have a wife and kids. The hardened bachelor was a figure, slightly, of fun.

Now there is a new wariness about marriage among the young, and this contributes to the living alone thing. The census people also tell us that divorce among the young has doubled in recent years. Too many kids have seen others broken into shards because their marriages went bust. They want to wait, on the chance that it might be permanent.

Yet I have never regretted being a loner. I should just have left the institution of matrimony to those who were able to handle it. Since I know no other way to live than by myself, I just jolly well grin and bear it.

On Being Poor

The other day some flipping sociologist or other came out with some flipping survey or other which concluded that the poor aren't popular in this country. The elaboration of the obvious is almost the name of the sociologists' game. They set out to prove that black is black, and there is always a grant, somewhere, to endow this dauntless quest.

I spent my life growing up poor, and I can tell you it is no fun. There was no welfare and no food stamps when my family was poor, save the occasional and shaming handout from the St. Vincent de Paul Society.

Our poverty wasn't grinding poverty, because none of us had ever known any better. My parents came from the bogs of Cavan and Longford, where their parents had often slept in bins with the pigs. I knew nothing about any world other than my own except occasionally from rumors in the tabloids about the lives of people like Daddy Browning and John D. Rockefeller. I really didn't believe there were any rich people. Your wisdom is your experience.

None the less, I knew I was poor and this was in the fabulously affluent 1920s. I knew it and I know it still, and there is nothing on God's acre that angers me more than people who get angry with people because they don't have money.

I know all about the shiftless poor, some of whom aren't poor at all, who collect welfare in three or four counties, and are more or less a criminal elite. But the welfare system cannot be blamed on the poor, worthy or shiftless, crooked or honest. The kind of people who seem most to deplore the abuses of welfare are the children for whom the system began to be created, in the Depression days of FDR. Ronald Reagan was a poor kid, and he has turned into a holy horror on the subject of the poor.

The survey mentioned above said Americans associate poverty with "moral failure." Poor people are not loved by their non-poor contemporaries because they cost money and threaten the work ethic.

I have a firm and old-fashioned belief in free will, but there is damned little free will about who is rich and who is poor. A lot of Mexicans and Puerto Ricans and Nicaraguans are poor not because of any inherent incapability of being rich but because they do not possess adequately the language of this country, and because they look funny. A lot of blacks are poor just because

they are black.

Someone said to someone else that the rich are different from us because they have money. The poor, and those who have been poor, are a helluva lot more different from us than that. The next worst thing to being destitute is being compelled to live off charity. If you have ever undergone the experience, and I did so for years as a child, you are never going to forget it.

Even to this day, one of the greatest sins in the world for me is throwing away money. If there are any people in the world I loathe, it is the lavish tipper, the big spender, the guy who puts hundred dollar bills in the hands of head waiters so that he can feel secure for an hour or two. I even get mad at people who leave food on their plates; even when the person is, as occasionally happens, myself.

Being smug and righteous about the "moral failure" of the poor is something I hope I have never been, and do indeed hope I shall never be. I've been there, and I don't want to go there again. Being outside looking in is not the greatest fun in this damned world.

Being non-poor is mostly luck, as practically everything else is. My luck has run well in the adult years of my life. My children and grandchildren almost certainly never will know poverty, and that is something. But I knew it, and shall never forget it, and I daresay the reason I am writing these words is to assure that I shall never forget it. The poor are our brothers.

On Being Inert

I have this friend, whom we shall call Mike, who holds that everything he needs in life will come to him so long as he stands for a sufficient time at a certain place in a certain bar on Union street. He has yet to be proved wrong.

His love life is a relatively easy matter. He does not pick up girls. Girls pick him up, this being a permissive society, and Mike is nothing if not permissive. He is there. When one girl gets tired of him, another picks him up. Simple as that.

He has no office, no typewriter, yet he has a business of a kind. He is a public relations man for bars, including his favorite one, which until recently had his name on a gold plate by his battle station. So many people kept stealing the name plate that it is no longer there.

Mike watches what happens at the bars he inhabits, smiles, and then makes a little notation with his Mark Cross gold pencil, which is just about his only personal possession. He sends this pressing intelligence to local and national columnists. For this he gets paid just about enough to support his drinking habit, which runs about 40 bucks a day.

Who pays him is the saloons where he makes these interesting observations. Thus he admirably combines business with pleasure, while remaining at his fixed observation post. This is a kind of obsessive-compulsive life, in the language of shrinkery; but it seems to work.

For Mike is truly inert, in the sense of being without power to move or to resist an opposing force. There are many people like him, but nobody quite like him. To do next to nothing, and still survive, and survive quite comfortably, and without robbing a bank, is no small feat.

The other day Mike came up to me at one his favored haunts, which I too happened to be haunting at the minute. He had his usual Cheshire cat smile on his round, moony face. He gave me a small press clipping which he had meticulously cut from the Chicago Sun-Times or one of the other 40 newspapers he seems to read daily. He cuts these things out with his tiny Swiss army knife. The knife is a present from an admirer of his inert life, namely Mr. McCabe.

The cutting was a quote from Franz Kafka, and it goes like this: "You do not need to leave your room. Remain sitting at your table and listen. Do not even listen, simply wait. Do not

even wait, be quite still and solitary. The world will freely offer itself to you to be unmasked. It has no choice; it will roll in ecstasy at your feet."

His smile was even wider as I returned the snippet to him. This was it, the intellectual justification for inertia which he had been waiting for so long a time. And what more respectable source could he have than Kafka, that sensitive man of Jewish parentage who, although overwhelmed by a desire to write, spent most of his life as an official in the accident prevention department of the Austrian government-sponsored Worker's Accident Insurance Institution. This was about as close to inertia as you could get, without starving, in Austria.

Mike's life and times are an illustration of one of my own firm beliefs: Any system works, as long as it works. He defies all the treasured American verities, yet he persists and remains honest. The world will continue to beat a path to his door because he has invented some kind of mousetrap. Because this mousetrap happens to be invisible, does not in the least mean it is not real and highly effective.

There is much to be said for doing nothing. Kafka has said it eloquently. Mike says it eloquently. He says, "Don't pay any attention to what I say, pay attention to what I DON'T do." A man is rich, as Thoreau said, in proportion to the number of things he can do without.

On Being Nice

There can be no more chilling self-portrait in modern English literature than the one Evelyn Waugh offered the world in 1957 under the title "The Ordeal of Gilbert Pinfold."

The "ordeal" was a massive nervous breakdown Waugh had recently recovered from, with the aid of a long sea voyage, and a certain amount of therapeutic writing, of which "Pinfold" was a large part.

The first chapter of this book, especially, is a very model of telling the bitter truth about yourself. Like most satirists, Waugh was at base a bitter and misanthropic man. Even his religious faith—he was a convert to Roman Catholicism and almost comic in the sturdiness of his ultramontane beliefs—didn't help him with the central problem of man's life, his ability to love.

In that first chapter of "Pinfold" there is a famous sentence. It is one of the saddest in our language. I've never forgotten it, and never shall. He said:

"Why does everybody except me find it so easy to be nice?"

There speaks, out of profoundest sorrow, a man who has suffered a failure of the heart. Nobody knows quite how it happened to Waugh, who seemed a quite sunny fellow when an undergraduate at Oxford. It is thought by most of his friends that an unhappy first marriage turned him around, and led him from his marvelously comic early novels, which were much influenced by the work of P.G. Wodehouse, to the sere and gloomy Roman Catholicism, the increasing seriousness of his later work, and his profoundly anti-social tendencies.

To keep people at bay, he even pretended he was deaf. He put them off by producing from his pocket a huge ancient ear trumpet. This his son Auberon had gotten for him through an ad in the agony column of the Times of London.

I met Waugh a few times before his death. I remember particularly a long vinous lunch at White's Club in London with Waugh and Randolph Churchill, an old friend with whom he had served in the Commandos, under the legendary Bob Laycock.

We were a well-met group. Randolph found it impossible to be nice to people, too. He was consciously and loudly rude, in the manner of a mad Duke from a Victorian novel. Evelyn was just plain rude, except when in the presence of a Marquess or up, when his manner tended to change somewhat.

When Evelyn was rude, he was not forgiven. When Randolph was rude, people forgave him soon and utterly, God knows why. His obituary in the Times was a model of generosity. The other difference was that Evelyn could be quite marvelous to people, sometimes. This could seldom be said of Randolph, who used to love leaving emotional litter behind him wherever he lighted.

The third member of the lunch group, myself, was in the midst of one his blackest periods, and had too suffered a congealing of the heart. There were times I could have hit a beggar, or robbed a poor-box.

The lunch went well enough, with a lot of Randolph's port at the end. But I could not help the feeling that we were three people living behind a barricade. The barricade was that we all felt the utmost difficulty being nice, even to the other members of the club in the room. The talk was funny and wholly denigratory of the species, ourselves included.

We were outcasts of the feelings. I had seldom felt so much so in my life, aided by these skillful and liquor-merry haters of mankind. I have moved a considerable distance from that day, thanks to God, and to some measure to the Catholic Church, which seems to have helped me more than it helped poor Waugh. These days, it is a bit easier to be nice.

On Serving Others

S ince quite a young dog I've been told by one priestly figure or another that I have been placed on earth to serve others. When very green indeed, I viewed this proposition with skepticism. There is little that has happened since to make me stray from that early conviction.

The sentiment is holy, it sounds good, and above all it is not likely to throw anybody off base. The last is a proper sin, in case nobody told you.

The gospel of serving others is something like another pious injunction, "early to bed, early to rise, etc. etc." What would capitalism do without these cozy slogans? Early to bed is indeed a good policy for the lad with the iron heel who hires you. He stands to profit from the use of your sweat, which flows the more profusely after a good night's sleep.

Since first being assured my destiny was to act as my brother's butler, I must have heard scores of emollient commencement addresses directed to this heartening theme. To my eternal shame, I've delivered a few of these numbers in my time. I must indeed have been hard up for a spot of affection when I succumbed to the temptation.

For all the millions of devout hours spent by this and that noble fellow in serving others, it must be confessed it's a bit hard to see what you might call great results. Service to others is a used-car salesman's expression, and a used-car salesman's concept. Leave it lie, right there.

I don't think any man of worth ever gave a dime's worth of thought to serving others. He did, and he does, what at the time gives him satisfaction. That is all. That is enough. If, in passing, his work has been a service to others, that's a spot of lagniappe which can be greeted with polite applause all around, and as politely forgotten.

The craftsman, it has been pointed out, gets his hire as he goes. Whether he builds a bridge, or covers first base with agility, or finds something new to ginger the old glands, the good man is working at a job HE likes. His reward and his solace, his escape and his wonderland, his purpose and his destiny, are found in the optimum functioning of the collection of cells called himself.

I can hardly think of a more pathetic fate than a young man who is "filled with a sense of mission" by his preceptors. He is

saved at an early age, which means he is lost. There is nothing you can do about the saved.

He brings the one, the true vision, to Africa or the Malayan country, or the board room of IBM. He wastes his spirit in the sterile conviction that he is serving others, when he is usually assuring himself with quiet desperation that he doesn't need salvation himself.

This is not to say anything against those who honestly have a sense of mission. These saintly folk are few and far between, however. These men do their thing, only to be sold out by their acolytes. It is these acolytes who are to be watched. They create a set of demi-prophets out of pliant and innocent children, and send them off into the world with The Message and a stout collection box. If you want to find a sure way to stunt a man, this is it.

Think of serving others long enough and you will denied the heartfelt pleasure of using your own skills and self control to bring to order the bits of a perplexity.

Whether this is called creativity, or just a bit of work well done, there is no satisfaction like watching the wildly alien elements of anything being hammered into something rich and strange by the nerve and craft of a single man. You will never serve anyone well until you serve your self well. That's a shivering fact.

Short and Sweet

Dope

*I*f there is any essential difference between your cup of coffee, my shot of whisky, and the other chap's sleeping pills, snort of cocaine or deck of heroin, I simply fail to see it. Most other people see tremendous differences among these drugs which heighten sensibility, or are thought to by their users.

Dope makes people feel better, or makes them think they feel better, which is perhaps the same thing. That is why dope is so popular, and has been throughout the recorded history of man.

Of course there is a tremendous *real* difference between participating in a coffee break and in a pot party or a cocaine high. People who habitually take sleeping pills, or who are addicted to the grape or tobacco, do not think of themselves as taking drugs. Yet that is precisely what they are doing.

The only thing which distinguishes these drug takers from pot and coke freaks is a series of legislative enactments that make the latter activities the concern of the cops and the courts. Why people legislate against one consciousness-changing drug and not against another is a thing which would make us the most interesting to the Martians, if there were any.

We know that smoking the leaves of the tobacco plant is deadly, but we have no law against it. We know, as of now, that smoking the leaves of the cannabis plant is not deadly, but we have laws against it.

In some countries tobacco smoking was once punished with brutal severity. In ancient Russia and Iran, smoking tobacco could be punished by pouring molten lead down the offender's throat, public whipping and even the death penalty. In the early days of our own Republic, there were severe laws against tobacco smoking.

There seems to be something of the fear of the unknown in our choice of drugs whose use is punished by the police. If the habit is one shared by all our friends and peers, we are not likely to take action against it. It is when the outsider and the infidel are reported to use a drug that we are prepared to act.

Take the case of marijuana. Hemp has been grown in this country since its earliest days. George Washington farmed cannabis, and could have smoked it. Yet nothing much was heard about the drug until the early 1930s, by which time black jazz musicians had begun to make their mark on the white culture.

More than black musicians used muggles, as the stuff was then called. A large number of Harlem non-musician residents used it. And a large number of white sophisticates from downtown joined them. Because the drug gave pleasure to a tiny alien sub-culture, it began to threaten the majority.

To legitimize the resentment against the users of marijuana (and not the drug itself, which nobody much had experienced) the drug began to be called "the killer weed." This derived from an absurd story, still widely believed, and even incorporated into dictionaries, that fanatical Moslem sects fed hashish to "assassins" who murdered the leaders of their enemies. Thus the word assassination, from the Arabic word for hashish.

The truth, as I get it, is that the killers were given hashish *after* they had committed their horrendous deeds, as a reward—a pleasure and an abatement of their conscience.

In the late '30s that leading organ of American piety, the Reader's Digest, swallowed the killer drug myth fully and exploited it endlessly with the help of a publicity-seeking one-time head of U.S. narcotics forces, Harry J. Anslinger. Thus the ball got rolling on pot. Existing laws against it were enforced to the hilt. New ones came into being. All to prohibit the smoking of a grass which we now know to be less harmful than the coffin nail.

Beds

The bed is, on the whole, a neglected and underrated amenity.

The old Puritan ethic, the propellant of our society, would have it that use of the bed, for any purpose other than sleeping, is immoral; and, even worse, offensive. The idea is to get an honest day's work out of the filthy brutes. Doing nothing, for the Founding Fathers, was the sin that cried out to Heaven for vengeance. And there is nothing like lolling in bed. (The word loll, is of course pejorative in our society.)

There was old Ben Franklin telling one and all that, He that riseth late must trot all day, and similar balls. Early birds, that awful lot, are said to get the worm. Who needs worms?

It is my conviction that the more time a man spends in bed, the more civil he becomes, and that our unruly country would be in far better shape for a little more mindless staring at ceilings. For an American, doing nothing is the hardest of tasks. Like most things hard, it can be rewarding.

For those caught in the prison of nine-to-five, with the daily Armageddon on the freeway thrown in, it is still possible to sandwich a little nothingness into your lives. Just set the alarm an hour earlier than usual. You won't miss the sleep. And let the old noodle float like a butterfly, lighting on whatever leaf turns up handy.

If you are out of the rat race, as I through good fortune happen to be, then spend all the time you can in bed. Chairs look rather foolish, if you but give it a thought.

I do most of my reading in bed, and my watching of television, and listening to the radio, and thinking vengefully of how cold it is outside. Apart from the mechanics of typing, most of my writing is done in bed, either while asleep or during the free-floating period just after I have awakened.

It has taken me decades to get over the feeling that my affection for the sack is not a form of perfidy. But I made it. Now I'm an unreconstructed slugabed. Proud of it, too.

Not all nations and people are uptight about being horizontal on a Beautyrest. The Chinese philosopher, Lin Yutang, spoke out loud and clear for all us bed-lovers when he said:

"It is amazing how few people are conscious of the importance of the art of lying in bed, although actually in my opinion nine-tenths of the world's most important discoveries, both scientific and philosophical, are come upon when the scientist or

philosopher is curled up in bed at 2 or 5 in the morning.

"I find that those people who agree with me in believing that lying in bed is one of the greatest pleasures of life are the honest men, while those who do not believe in lying in bed are liars and actually lie a lot in the daytime, morally and physically."

It's the Chinese sage's view that those frenzied tycoons who use four phones in their obsessive pursuit of the buck, would not only feel better, but would make a great deal more money, if they gave themselves a daily allowance of "one hour's solitude awake in bed."

Purpose can be the great enemy of enjoyment. Making up little moral syllogisms which all end up with "I have to do this, that or the other," is a fine way to extract the joy from life. The pleasures of goofing off, like the pleasures of playing hooky, are among the greenest of memories.

Staying awake in bed, finally, is a way of looking at things under the aspect of eternity, which the ancients said was the only way to look. After the old brain has been cantering endlessly for an hour or so, sorting out the dregs of existence, you will find that you have to arise from the sack to do something. Whatever it is, I can assure you it will be important.

Boredom

Boredom, and her big brother Death, are among those subjects that are shrouded because we find them too unpleasant to think about. Fortunately there are those about who are trying to let some rational light in on each of these matters.

One authority on boredom defines it thusly: "An incomplete striving for meaning. It is the desire for meaning coupled with the inability to get it." By this definition boredom is the "tension" of striving for meaning. It is not apathy, where we accept the lack of meaning.

My desk dictionary calls boredom "the condition of being bored. . .as in a person or thing that wearies by being dull, monotonous, uninteresting, etc."

Neither of these definitions does much for me. I would say boredom is simply another word for fear, especially a fear of giving yourself.

Boredom was known in the Middle Ages as accidia, and it was then called the sickness of monks. It is really a religious malaise, whether it is suffered by monks or tearing agnostics. One monk asked one of his Elders among the Desert Fathers:

"What shall I do, Father, for I work none of the works of a monk but here I am in torpor eating and drinking and sleeping and in bad thoughts and plenty of trouble, going from one struggle to another and from thoughts to thoughts."

The most beautiful expression of spiritual boredom I know is Francis Thompson's great lyric, "The Hound of Heaven." Here is the terror of the man who fears to give himself to the greatest thing of all, his God. "Lo, all things fly thee, for thou fleest Me!/Strange, piteous, futile thing!"

It is fear of being ourselves, of living up to our fullest potential, of using the strength of our identity, that causes us to choose boredom as a defense. Another form of boredom is sleeping away the challenges of life. This sleepiness has the same roots as boredom.

Creative people know and recognize boredom as their fate and their greatest challenge. Performers call it stage fright, those terrible moments before the work actually begins, when all our instincts cry out against doing that thing we have so carefully prepared ourselves to do.

Writers, likewise. The critical moment in writing is usually that period just before you hit the typewriter or take up the pen

or pencil for the irreversible commitment. You feel just awful. You want to run. You are about to be caught out.

You have, as one writer justly observed, a complex of fears—"the fear that one will not realize the inner vision, fear of self-exposure, fear of sterility—but in general the fear of the creative artist adds up to one big overriding fear, the fear of giving himself."

Of course he wants to give himself. He is like the tale of Buridan's ass, which is the very definition of a neurotic: The poor beast died because of inability to choose between the water to his left and the food to his right. Boredom is just that profitless state.

Who among us has not been bored? And who among us has given much thought to the causes of that boredom? It is, at base, fear of something so strong within ourselves, and thus so difficult to live with, that we dare not face it.

The funny thing is that when you do this thing you so fear to do, the results are marvelous. You feel unified by the experience, as the actor and the writer feel unified when they have made their leap from fear.

The Siesta

I see by the papers that the Spanish siesta is yet another victim of the oil shortage. Civil servants in Madrid and Barcelona, who traditionally took several hours off at midday, now are instructed to hold it down to one hour for lunch. This will permit their offices to close at 6 p.m. instead of running on into the night.

This is melancholy news to all those folks, like me, who have found the siesta to be an integral and most pleasurable part of life.

I encountered this pleasant institution in my youth in Puerto Rico. The siesta has been part of my day ever since, save in the days when I worked eight-hour shifts on a newspaper. In those days, I can tell you, the siesta was sorely missed.

I cannot say I immediately embraced the siesta. My Irish Puritan training and upbringing rebelled at what seemed to me positively voluptuary conduct. That is, stopping the important matter of work right in its middle for a snooze, and then resuming it afterward. The whole thing seemed close to a mortal sin to me.

The rationale for the siesta, which has been for centuries traditional in Spain and most Latin-American countries, is that the sixth hour, or siesta, is the hottest time of the day, and it is therefore better to be behind your adobe or concrete than out in the rays of the sun.

In Puerto Rico this was quite true. At midday it was boiling. It was the practice of most shops to close at one and open again at four or four-thirty. During those hours the streets of downtown San Juan were effectively emptied. It was also said that during those hours most of the children on the island were conceived.

Most of the big American companies, like General Motors and Swift, insisted that their Yankee representatives show the flag and uphold the Puritan ethic at the same time. It was a point of perverse pride with these boys that they worked the same hours as they had on the mainland, just as it was a point of pride for the F.B.I. guys, of which there were lots, to wear fedora hats in a climate notably unsuited to them.

What finally converted me to paganism was the fact that my boss, one Basil Gallagher, and an Irish Catholic of the most pronounced stripe, did not hesitate to stay away from the office for three or four hours in the afternoon. I never did know whether he in fact took a siesta; but he kept siesta hours.

After a long vinous lunch at La Mallorquina, I would repair

to my home on Calle Miramar in surburban Santurce, and crawl under the mosquito netting of my bed for a couple of hours snooze. I would get back to work about five and work until seven, more or less.

I soon made the interesting discovery that I was living two days instead of one, which suited my psychic gait most properly. As one convivial friend used to say, "I can get drunk twice a day instead of once if I take my siesta."

I have been taking my siesta steadily for more than 20 years now, or since the time I was liberated from the city room by being awarded my own column. On the days when, for one reason or another, I have to forego the afternoon sleep, my life is seriously discombobulated, and my temper far from improved.

There are people who find this mode of life mildly amusing. To them I can only say they do not know what they are missing.

I actually sleep for only an hour or so; but remain in bed for an hour or two longer. The siesta seems to refresh me completely, body and mind. I spend the rest of the time in bed, just reading, usually light stuff like periodicals or the occasional mystery story. The Latins say the siesta, with its systematic withdrawal of the old libido, adds years to their lives. I believe it.

Buttons

We bachelors are at the mercy of so many damned THINGS. Take buttons.

There was a time when, if you were not lucky enough to reside with a woman who was a fool with a thimble, the learned Oriental gentleman who ironed your shirts replaced buttons for you—and unfailingly. Now the learned Oriental gentlemen are willing to accept your shirts, and give them back to you; but that is all. Usually, they have nothing to do with the washing of finished laundry, or of its ironing. The ironing seems to be done by some sort of Iron Maiden, which does not have the power to detect the missing button on your right sleeve. The right sleeve always goes first.

This is rough on us bachelors, who are no good in the needle dept. Even the substitute measure of using a safety pin is not open to you, if you are a rightie and the flopping sleeve is on the right elbow. You end up by putting on another shirt, which is time-consuming and like-wise wasteful, or you show up at a dinner party showing an elegant quarter-inch of linen beneath the left arm of your blue serge. The right arm is naked below the elbow, to which the cuffs have been rolled up. Very putting off, for both guests and host.

And what can you do when your suspenders go bust, after seven years of faithful service, just as you are getting out of a taxi to pick up a lady for dinner? This happened to me recently. Not even the most formidably equipped household in Pacific Heights is likely to be able to produce a spare pair at short notice.

To ask a lady to patch up your suspenders while you are leaning into a martini, is neither an easy thing to do, or a graceful thing to ask. The result: a rather unsettled evening, due not to any basic weakness of my character but to a weakness of that small army of bits and pieces which hold our clothes up and together.

Why should buttons exist at all on clothes? They hardly seem to for women. I know ladies with fat closets of frocks and such. Not a single one of them boasts a button, except for purposes of decoration.

But men continue to be tyrannized by them. Tradition, you know. British tailors are terribly fond of buttons. Zippers are thought of as some kind of Yank barbarism. British tailors can also be terribly persuasive, when they want THEIR way rather

than yours. "Are you quite certain, Sir, that you will rule out buttons on the trousers this time?"

This bit has brought a certain confusion into my life. On my American trousers, I zip my fly. On my English ones, I button it up. There are times, in a busy life, when you don't know which is which, fast enough. It might be added that each system—zipper and button—has its drawback, which I won't go into.

On the whole, though, I will opt for the zipper, or the metal snap, over the button. Apart from my own vicissitudes with the beasts, I can remember when my father had to button his SHOES each morning. That was truly dedicated dressing, and hardly in the spirit of these stirring and fast-moving times. High-button shoes are seemingly as unsuited to our needs as Jeffersonian Democracy.

I should think it high time some form of grand committee of suffering males were set up for the purpose of urging those glorious Frenchmen and Italians and Bill Blasses who control our male couture to consider the simple merits of zipped-up shirts and snapped-on cuffs. Since our libbers wouldn't sew a button if they could, the market for this long-awaited reform is expanding outward from the bachelor. The button has caused almost as much tedium and fret as the mutations of the feminine hemline.

Character

*C*haracter is old-fashioned. Take it from me. It died sometime in the '60s, though there were signs of its demise sometime earlier. The refrain that signaled its demise was, "I'm doing my own thing." This swinging shibboleth is almost the exact obverse of what has been considered character since the days of the Greeks and Romans.

What do I mean by character? I accept the simple dictionary definition of "moral strength, self-discipline, fortitude, etc." I don't know what the etc. means, but I can guess.

Character was a great thing when I was being educated at home and at school. The worst imprecation that could be thrown at a boy or girl was, "You've no character" or "You're a weak character." This for behavior that would be deemed admirable in the hot tub culture of today.

Put another way, character means being tough with yourself. It shows in almost every action of a person, and in the whole pattern of his life. As the Spanish proverb beautifully puts it, "Every cask smells of the wine it contains."

The people who impart character are the people who have it. Aristotle called these people "men of practical wisdom." They are mentioned in his account of what virtue is:

". . .A settled disposition of the mind determining choice, and it consists in observing the mean relative to us, a mean which is determined by reason, as a person of practical wisdom would determine it."

I am one of those people who believe that something which was thought excellent 2000 years ago is excellent today. That there are, in short, enduring values, which will probably be held excellent for another 2000 years, with occasional and lamentable lapses.

We are in the midst of one of these lapses right now. A thing called "values" is now taught in schools by teachers who can't teach reading and writing. Another Aristotelian, philosophy professor Jon Moline, has views on this sort of teaching:

". . .When we are trying to teach students about moral issues—and much learning involves such matters—we are troubled as to what tactic will assure that they (the students) arrive at the 'right' answers.

"But the approach suggested by Aristotle leads us to take a different tack. His prescription is: It is more important that we

teach our students to be judicious—making allowances for their development—than to be right."

Lord Acton said that a man is seldom better than his word. You can trust the word of a person of character. The mere fact that you can trust is it is proof of the man's character.

Character, like any other virtue, is taught, first and most importantly, by the mother who bore you and shaped your first view of life. Blessed is the person who had a mother who possessed "practical wisdom."

But it is developed in the school of hard knocks, the very stream of life itself—in play, in love, in business, and in marriage. Character results in integrity, that state which exists when the deeds and words of a man are consistent. Character is not a bad thing to have. It will come back into style one of these days.

Style

\mathcal{G}.B. Shaw once said that "effectiveness of assertion is the alpha and omega of style." For Shaw this was certainly true. He was one of the most effective writers of English. A characteristic Shavian utterance: "So long as you come here honestly as a self-respecting, thorough, convinced scoundrel, justifying your scoundrelism and proud of it, you are welcome."

There is a whole school or writing, extending from Henry James to Samuel Beckett, with hundreds in between, who style themselves stylists, who do not even attempt effectiveness of assertion. These have their followers and apologists; but I think they are on the wrong track.

Newspaper writing is not literature, but you can't get anywhere in this business without effectiveness of assertion. In fact, Shaw started as a journalist, writing music and dramatic criticism.

"Style is the man himself," is the famous assertion of Buffon. This is true as only a truth can be. If you accept the view of Shaw on style, as I do, you must cultivate in yourself the qualities that lead to effectiveness of utterance. Some people are born with the qualities; but most of us have to learn them.

Curiously, to be truly effective, you have to sacrifice the exact truth at times. As Dr. Johnson put it, "In all pointed sentences some degree of accuracy must be sacrificed to conciseness."

Shaw and Mencken, two of the great journalists of our time, were so given to exaggeration that people really did not believe what they wrote. Nor, I expect, did the writers expect them to. They were interested in getting a point across, and found exaggeration a useful tool.

If this line of reasoning is accepted, it is almost impossible to write truly without being dull. One of the few people who achieved this empyrean state was Ernest Hemingway in his early short stories.

As in most valid generalizations, at least in such a matter as style, the opposite can have much to be said for it. In the matter of clothes is it better to be dressed to kill, or simply not to be noticed at all?

There is the art that conceals the art, and this was the last thing either Mencken or Shaw cared to practice. This kind of style had been defined by Tacitus as early as 81 A.D. He said, "Style, like the human body, is specially beautiful when the

veins are not prominent and the bones cannot be counted."

The prime example of this kind of writer in our language is Dean Swift. You can read Swift for hours and not be conscious that you are reading *writing*. This is a great gift.

"A Tale of a Tub," "A Modest Proposal," "Gulliver's Travels," says Richard Quintana, "have endured through all the climates of opinion which have come and gone since Swift wrote. There is infinite wit here—wit in the sense of comic energy and ceaseless imagination. But we are made to feel the passion that informs this wit, and it is the passion that we remember. Against all history, Swift asserted the integrity of the intellect and the dignity of the human spirit."

So we get back to Buffon's dictum. Swift was a man of passion, and our two other examples, Shaw and Mencken, were men of reason. And the lesson that passion outlives reason is demonstrated by the fact that the reputations of both modern writers have suffered since their comparatively recent deaths, and Swift is vividly with us.

What is the point of these contradictory dicta? It would seem, from one point of view, that there is writing for the moment, which is journalism, and writing for all time, which is literature. And most of us who write fall somewhere between these two categories.

Gents

\mathcal{A} gentleman has been defined as a man who does not do things himself. This is of course a British definition, because Britons of all classes take the gentry very seriously, even under socialist governments. The only people who take it more seriously are the Germans, especially the Prussians, who will fight a duel if someone improperly uses the prefix "von" before his name.

Bertie Wooster and Jeeves are comic versions of the British gent and the man who does things for him. There exists the real article, and he is not without his comic aspects.

Take the gent going a-hunting. He is waked very early in the morning by his man. His hunting pinks are all laid out. The gent is aided in putting on each and every garment, including his boots. This is accomplished by a yard-long boot horn, an extended shoe horn.

When he gets to the taking-off place, and meets with his pals, each is served a stirrup cup by yet another man. That can be a huge dollop of cognac, or a couple of bottles of Dr. Browne's Chlorodyne, a universal remedy. In any case, the object is to screw up the gent's courage before he embarks on the chase of the fox. The horse does the rest, aided by some dogs in the end. The gent has done nothing except exercise his liver, as he is quick to point out.

A gent never carries anything in his pockets, which have been made by Huntsman or some other fancy tailor around Cork Street and Savile Row. He never queues up. If he wants money he does not go to a bank. He goes to a tailor. He does not repay the tailor. He has a man to do that.

There are, to this day, gents who have their jackets broken in by people of the lower orders, butlers or cowmen. These chaps wear the master's new coat until it has just the right hang. There are an awful lot of well-dressed cowmen in the West Country. Sometimes the master's son breaks in the jacket, if he is burly enough. When he parts with it, there can be a bit of difficulty.

The gent does not even furl his own umbrella, of which he has a complete set. He sends one of his men to Swaine's, a store on Piccadilly, which specializes in brolly-furling. When they finish with the brolly, it is as tight as a cane. The gent does not unfurl it, unless something like a cloudburst falls from the heavens.

Some flashy gents drive Aston-Martins, but for the true gent

it is all chauffeurs and taxis. One of the few things he does for himself is walk, and he does a lot of that. He also eats unaided.

The gent has been brought up this way. He regards doing things as a venial sin. If he wants to hang a painting, which is surely no great thing, he calls in a decorator to do it for him.

The road to genthood is not as easy as it sounds. There was a time in his life when, by golly, he DID things. In fact, he did so many of them and in such a humiliating way, that he never wishes to do them again.

This busy period is when he is at Eton or some other equally classy school. The first thing he discovers at school is that he is a servant. The most important task of his life is not the pursuit of classical studies, but doing menial tasks for the boys in the upper forms. He runs errands, the more unnecessary the better. And the boys in the upper forms are extremely imaginative in inventing fantastic errands.

The servant dreams of having a servant, or a series of servants. In due time, if he is not sent down for one reason or another, he gets his servant. When he does, he becomes a gent, and does nothing substantive the rest of his life except maybe chase girls. And there are some gents who do not do this by themselves. They have a man.

Pockets

*O*n occasion I like to celebrate small pleasures. Today let us look at a really small one; but none the less real for being really small. These are the pockets in men's clothes, and especially the pockets in the trousers.

The first time I ever remember consciously masquerading as a man—that is, a real grown up man—was when I was about six. I knew I would not be as big as a man for years, or as smart, or as able to take care of myself. There was, though, something that I could do that could make me feel I was all these things.

I could walk with a slouch and stick my hands so deep into my trousers pockets as to threaten the stitching. This is the way I saw what a MAN was. Actually, what I was impersonating were boys somewhat older than I who were impersonating men, who were usually too busy at their work to put their hands in their pockets. But let me be grateful for small favors; impersonating swaggering adolescents impersonating real men had its decided points.

To this day a feeling of quick security comes when I stick my hands into trouser pockets or those of a jacket. When one is dressed for outdoors, the hands and face are the only parts of the body left uncovered and thus unprotected. There's nothing much you can do about the face, since you must see and talk and listen. You can add a little warmth to your hands by encapsulating them in pockets.

I once led a virtually pocketless existence for a short time, and I can tell you it did not exalt me. I was taken in hand by a British lady who decided I should dress like a gent. The first lesson in gentryhood is that pockets are out. Hiding your hands was as vulgar as drinking scotch and Coke.

The tailor (dear old Mr. Dingle of Grafton street) was duly instructed. There were to be no pockets in my trousers and none save one in my jacket. Where the two or three outer pockets should be in the jacket, there was merely a flap with nothing below.

The only pocket allowed was inside, on the right. A gent was allowed to carry a cigaret case and a wallet. Sometimes the cigaret case also carried the fivers, though this seemed a mite unsanitary to a Yank. Nothing else was to be given portage. The lines of your suit and your manly figure were to be plain to all. Otherwise, why call on Mr. Dingle at all? Made sense, of a kind.

The lady who took me in hand had a close friend who was married to another Yank, Howard Dietz, a rather raffish Hollywood type. This lady was even rougher on poor Dietz than my lady was on me. From the report I heard, she had Dietz fitted out with a totally pocketless set of rags. He had to wear one of those handbags around his shoulders for his cigs, et. al. The kind that are so popular these days with some of our more liberated young males.

It must have been hell for Dietz. I know it was for me. I wished, within all rational bounds, to please the lady who, I knew, had nothing but the best intentions toward me. There was no way.

I became conscious of my hands the way one becomes conscious of a flaw in a portrait. Once perceived, the flaw grows day by day until it becomes an obsession. I could think of nothing but pockets. They became a kind of King Charles head to me.

I could hardly wait to get back to the farm in Wiltshire where I lived. And I could hardly wait to get into a pair of Levi's I had brought from California. There is one thing to be said for Levi-Strauss. They know pockets. They are not stuck awkwardly down on the side of the trousers, whre you have to deform yourself slightly to get to them. They are right at the top, where God and nature intended them to be. You plunge your fists down with one natural movement. God's in his heaven, and all's right with the world.

Prayer

I don't know whether it still goes on, but some time ago there was an odd ceremony carried out once a year at the Church of St. Katherine Cree.

This is the annual Lion Sermon. It is endowed from the will of Sir John Gayre, who was Lord Mayor of London some 300 years ago.

Sir John had been a missionary in what is now Rhodesia. He had been shipwrecked. As he knelt in prayer a lion approached him, sniffed all around, and then made off.

Nothing quite as dramatic as that has ever happened to me when I was engaged in my orisons; but I too have a pretty high idea of the power of prayer. I'm not one of those lads who nearly wear out their knees in the severity of their devotion to the idea of prayer.

I do go into church to pray, and often pray while walking along the streets. I have even been known to pray in saloons, which I am sure Jesus would not have found to be offensive.

For most people prayer is just a form of begging. Life pushes them into a corner and they call upon God to get them out of it, quick, please. This is not the worthiest form of prayer, to be sure.

If the pressures on me are great enough, I do indeed engage in this ignoble form of negotiation. But I long ago figured out that trouble just has a way of going away, prayer or no prayer.

There is this to be said for prayer, however: it is decidedly relieving. The trouble you are praying to go away may not be in the least affected, but you will feel better when you have finished your silent or audible communion with Whoever or Whatever you are praying to.

I tend to pray to Jesus of Nazareth, rather than those large and frightening entities like God and the Holy Trinity, or the Holy Ghost Himself. Jesus is a man I can understand and feel at home with. Even His mother, Mary, has never been clear enough to me to petition her.

It is a cliche to say that prayer is therapy, but that does not make it less true. Simply thinking about your troubles in the presence of a comforting spirit has value of a high kind. As the meditation engineers have discovered, merely keeping quiet for a given time has spiritual benefits of importance.

Yet, as I say, this sort of begging is prayer of a rather low

order. The highest kind of prayer is the kind most difficult to set yourself to, as might be expected. This is the prayer of thanks, where instead of being a mendicant before the higher powers, you give thanks for some good that has happened to you.

Begging has always been easier than saying thanks. To say thanks, and to mean it, is mighty difficult for some people, and I am one of those.

So I make it a practice, almost a small discipline, to go into my local church once in a while and thank God that I have my health, that I do not lack for friends, that my children are okay. Even, in somewhat more frivolous moments, I have been known to be thankful that I still have my hair, that Joe DiMaggio is still alive and kicking, or that you can still get good dinners at a moderate price in this town.

There are all kinds of things, great and small, to be thankful for. There are men of character, and women of goodness everywhere, if you only take the time to seek them out. Thank God for them.

I don't know what got me off on this holy kick. Prayer is not a dominant part of my personality, as I shall demonstrate when I go to Mass in an hour or two; but it is a real part. Just as real as the irreverence, the skepticism and the plain obscenity that is also a part of me.

'Faultlets'

*M*y friend James Vince has added a most useful word to my vocabulary. It is "faultlets." He has them. You have them. I have a million of 'em.

By faultlets I take it James means little deficiencies of your character that you are prepared to admit, and maybe even to boast about. Faultlets are especially useful in that you can admit you are wrong while at the same time boasting that you are not.

My chief faultlet, and one that has been called to my attention more times than one, is that I am absent-minded—to a faultlet. I am sometimes so absent-minded that I will drive through a red light without the slightest knowledge of having done so.

This is not good for me. It is not good for the rest of the people on the road. It is not good for the common weal. It is not good, period, but it is so.

I almost never get telephone numbers right. There is one digit that turns out wrong, so that even if I actually *want* to talk to the person involved, it is not possible. Unless I put social invitations in a little book I almost always forget them, unless the Queen of Siam or Muhammad Ali is involved. Further, I have a disconcerting habit of forgetting the book that I carry with me to prevent me from forgetting these arrangements.

I am so absent-minded that I make lists to compel me to buy coffee, and toilet soap, and buttermilk, and pick up the laundry, and be sure to call that delicious creature in Larkspur—and promptly and surely forget the lists.

All of which may suggest to you, quick-witted reader that you are, that my absent-mindedness isn't all that absent-minded at all. It is simply a device for permitting me to lead a wholly anarchical life, which is the kind of life that I am most suited to.

If you don't *have* to remember anything, you are a completely free man. Everything you should remember is some kind of damned link with the human race, a reminder that somehow people and things are of some importance to you. This reminder is an insult to the man who would be free.

It is a distressing thing to have to admit but if you say that you have forgotten an invitation to a dinner party, you are really saying that you did not want to go to that dinner party, that in fact you preferred the company of your own sweet self to the distinguished *galere* which you had been invited to join.

As you get older you appreciate, with an especial savor, that old maxim that tells us that less is more. Most things, even exciting things like skiing, lose their essential point after you have done them the first time.

Again, it is a terrible thing to admit it, but no woman is as interesting as the first time. And none is as truly interesting as when it is the first time for her. Taking a virgin is like first glimpsing the Pacific, or discovering the bounding beauty of Gerard Manley Hopkins. But a woman is only a virgin once.

So I am prepared to acknowledge that my absent-mindedness is a defense against a life I find far too frequently boring. Against this I put the fact that, on base, I do not find life boring at all.

This is because of something called people. Persons sometimes bore me, people never do. I can spend hours on a New York city subway, even in these disarranged times, and look with fascination at the faces of the ladies and gents and children who sit across from me. If a single person interests me sufficiently, I can spend months and even years trying to pluck out the heart of his mystery. I never forget a face, if it interests me.

cAsperity

*I*t was something like the hat trick plus one for me. The hat trick, for those who are not keen cricketers, is a wild triumph when three wickets are taken by consecutive balls.

Graham Greene was talking on the BBC about the work of his contemporary and friend Evelyn Waugh. In speaking of Waugh's personal character Greene quoted Dr. Samuel Johnson on Dean Swift. That's what I mean by the hat trick plus one—four of the most fascinating, to me, characters who ever wrote the English language.

The message was even more personally to the point, for me. "His (Swift's) asperity continually increasing, condemned him to solitude, and his resentment of solitude sharpened his asperity."

This is certainly a telling criticism of Waugh, who toward the end of his life went out of his way to alienate everybody he knew. His rudeness was legendary around White's Club and the Hyde Park Hotel, which were the only two places in London he could abide.

He died about as alone as a man can be, on his john in the country. On Easter Sunday, 1966, having earlier participated in a mass of the Roman Catholic Church, to which he had been converted in 1930.

Asperity is roughness of mind and manner that I am not a stranger to. Both in my personal life and in print I carry the plain blunt man bit about as far as it can go, and more than occasionally even farther.

Those who like and indulge me sometimes speak of diamonds in the rough. Those who don't say I'm a rude S.O.B.

There are quite a few people in this world I consider fraudulent and pretentious. I do not hesitate to communicate this view to them from time to time. The result is that I have fewer pretentious phonies among my acquaintances than most people.

But the predicted concommitant, loneliness, has not so far crept up on me. I like people who are what they are and who are well aware of it. Since there are more of such people in the world, though they never make the gossip columns, the spectre of loneliness doesn't often get through my personal gates.

I flatter myself that I choose my enemies more often than they choose me. I used to worry about this. I figured my asperity, which is defined as "harshness of the feelings, rigor, severity," was some kind of mortal sin. I even used to bring it up

in the confessional box when I visited that fearsome cage more frequently than I do now.

I don't bother any longer. My asperity is an undeniable part of me, just as my hair is white and my belly expansive. By inheritance and by training severity was to me, if not quite a beau ideal, at least nothing to be ashamed of as a way of life.

Nobody ever measured up to either my mother, or to the other great influence on my early life, the Christian Brothers. And of those who didn't measure up, pre-eminent was Himself. I grew up in the chill air of a remote and inarticulate love. That it was love at all, you could hardly tell. You only knew that these people were trying to make a good man of you, and such a direction can only come from love.

How true all this was, and not at all an editing of my early life from the vantage point of a relatively untroubled maturing, was brought home to me last Christmas when I got a letter from my only surviving brother. He remarked, in passing, that it had taken him over 50 years to use the word love to another person. "Flippin' Irish," he added.

I suppose Johnson's judgment on Swift needs a gloss: Is solitude a bad thing? For me, it is far more friend than foe.

Truth

Sir Francis Bacon has Pontius Pilate say "What is truth?" He adds Pilate "would not stay for an answer."

Poor Pilate cannot be blamed. People who wrestle with truth, which my dictionary confidently defines as "the quality or state of being true," invariably find themselves on the mat looking at the sky and wondering what went wrong with their own precious hypothesis.

I am in my small way a lover of wisdom, or philosophy if you will, and I am not like Pilate, who ran from truth, or the philosophers like Schopenhauer, who gobble it up and spew it out for the benefit of mankind. I sort of believed in total truth, sanctified good and evil.

Recently I decided I was all wrong. That I have known the answer for a long time and have not recognized it. I was reading the letters between Oliver Wendell Holmes, Jr., and the great British jurist Sir Frederick Pollock. In a discussion of William James' "philosophy" of pragmatism, which Holmes called "an amusing humbug," he characterized such speculations:

"They all of them seem to me like his answer to prayer in the subliminal consciousness—the old-time spiritualist's promise of a miracle if you will turn down the gas. As I have said so often, all I mean by truth is what I can't help thinking." He had no faith in the existence of what we call absolute truth.

I translate these utterances into what is true is what you are. This simplifies life greatly. The formulation makes you more humble and more confident at the same time.

But there is a condition. When we say the truth, the whole truth and nothing but the truth, we must transfer the formula to me, the whole me, and nothing but the me. And the one who comes closest to that latter knowledge is me, myself, and I, no matter how miniscule. I sometimes think we come on Earth to find out who we are, and hence who our truth is, which is as good or better than any other truth.

Doing this in public, as a writer or a painter, is like walking a tightrope. When I say something that people disagree with who have lived different lives than I, and therefore are in possession of different truths, the answer is quite often that I was brainwashed by the Jesuits, whose boast it once was that if the order were given a child at age 7 he would think as the Jesuits wished him to for the rest of his life.

It is this using of your truth to impeach the truth of others that is decidedly unjust because it is usually wrong. I was never educated by the Jesuits, and I never knew how I got the reputation of marching behind their shibboleth.

Undeniably I was educated, at home and at school, as an Irish Catholic. Undeniably, it has colored many of my beliefs in matters of faith and morals—things "I can't help thinking."

But my religious upbringing was a war between me and my teachers, and anything but an indoctrination. When I wasn't forced to go to Mass, I stayed away voluntarily for some 30 years.

A lot happened in those 30 years and damned little connected with faith and morals in the Catholic sense. But the fact that what I called my hatred of my childhood was poked into the unconscious may have influenced me more than if I passed the collection plate at each Sunday Mass.

Yet there were other things. I could be living in New York City today. But I spent five years in Puerto Rico, where I learned what the poor were like. I spent my time in the war as a correspondent. I spent some years as a press agent at Sun Valley, Ida., where I learned that the rich were quite as good as the poor. These things and a million cellular experiences with my fellows add up to McCabe's Truth. And the same could be said of you, and you.

Sins

*T*hat fountain of trivia, People magazine, had a little note about the religious life of the actress Doris Day. She revealed that she had stopped being a Catholic in 1948 and had turned to Christian Science. The reason for her conversion was interesting if not unique.

"Somehow it (Catholicism) wasn't enough for me. I used to go to confession and make up sins because I didn't want to waste the priest's time."

I think I understand Day's problem. More and more, I am becoming confused on the subject of sin. More and more, on those increasingly infrequent occasions when I venture into the confessional to recite my sins, I find it difficult to conjure them up. I feel like a kid who went to a ball game only to find out the team was playing out-of-town and there was nobody in the stadium.

It's not entirely a question that the definition of sin seems to have changed almost as much as the manner of the priesthood. It's just that sin doesn't seem to exist when there is not a professor of sin around. To really think you are committing a sin you have to have a lad around who is constantly reminding you of the fact.

It is hard to believe that lying, for instance, is a sin, or much of a sin, when we have a society that is based on it, not to speak of a president who practiced it almost daily after having informed us (as a campaign promise, no less) that "I will never lie to you." Ditto to most of the other things we used to be told were sins.

In the days of my youth, Lord knows, there was no lack of counsellors to tell me right from wrong. Wrong was just about anything I was doing at the time. Right was seemingly that which it was impossible to perform. Engaging in "evil thoughts" was a sin, but I'll be damned if I ever figured out a way to refrain from this terrible sin. "Evil thoughts" were thoughts about female breasts and that sort of thing.

Going to confession was no trouble at all. You brought in a moral laundry list about as long as your arm, nearly all about venereal thoughts and activities, were informed you were the scum of the earth and a disgrace to your poor mother and father, and were given five Our Fathers and five Hail Marys, and upward.

It was all simple then. You knew what sin was because you

were told what it was. In fact, a definition of sin might be any more or less natural act of which your moral dictators disapproved. With the absence of these men from my life for the past three or four decades (where are the hellfire sermons of yesterday?) the knowledge of sin has become nebulous.

Quite the opposite has happened to my notions about evil. Evil, if the idea is not too simplistic, is a sin that is premeditated, which comes out of the depths of your own nature, and for which you are responsible. There has to be somebody to tell you what a sin is. Evil needs no telling. It has a pungent existence of its own.

There is evil on all sides of us, and we share in it, each and every one of us. It is evil, in my view, to let men of science dictate our moral values. It is even worse to let men of science murder large numbers of our fellow humans with pollutants they have invented in their unholy alliance with industry.

To an extent, while sin is something that is told to you and evil is something that is done to you, I repeat that we share in this evil. We can sit up on our hind legs and object to it. It is even within the power of our infirm nature to eliminate much of the evil in the world. Why don't we? Next question.

Politeness

*T*he politeness to strangers of the average well-bred Englishman is a peculiar thing.

During the time of my life that I lived in England I encountered this strange form of public address just about daily. I thought it just about the most alien thing I knew about the English. Until one day it suddenly came to me: The whole thing was so strange because precisely it was so like me.

This may take a little explaining. About the only time an Englishman talks to strangers is when he is in his pub. The pub is, of course, short for public house. It is public and it is a house, and for those reasons imposes almost contradictory standards of behavior.

The public politeness of the English is defensive. It is not open and embracing, the sharing of loneliness that you find among, say, Latin peoples. The Englishman is polite so that he may be left alone. His tentativeness ("I rather think, etc. etc.") is more putting off than it is tolerant.

A Dutch observer, Godfried Bomans, caught this thing well. "The aim of Anglo-Saxon politeness is to be left alone," he says. "It creates distance. It is fascinating to hear these people converse. Each speaker at the bar begins with the statement that what he is going to say is only a supposition, a way of looking at the subject which could easily be replaced by a different point of view.

" 'I suppose,' he says, 'I may be wrong, but I think,' and then follows what he thinks, frequently interrupted by new assurances that it is only a personal opinion.

"At first one thinks that this is based on modesty until one gradually begins to notice that it is based on a need for isolation. These kinds of statements create room around the speaker so that he cannot be identified with his opinion. He distances himself from it and he nods in sympathy and listens to the rebuttals of his neighbor, completely in agreement because of his non-involvement."

The trait can be infuriating. It is almost impossible to get in an argument with this kind of person. He is impregnable because he is always in retreat. And retreat can be a very effective weapon, both strategically and tactically.

There is this other thing, which I understand more fully: The need to be alone in public. I can sit for hours in a public

place, reading newspapers or a book. I hear scraps of conversation almost subliminally. I know pretty much what is going on around me, and am at the same time almost totally absorbed in the words I read which someone else has written.

Why read in public? you say, when it can so much more effectively be done in private, at home in a library or in a study. I cannot really give an answer to that, save that this combination of privacy and being in public is important to my nature. Withholding and participating at the same time may seem a curious form of intercourse; but I like it.

There comes a time, to be sure, when you do join in the general rowdy talk of the bar, as a full participant. This is the way most Americans act in public. They make noise to get away from being lonely.

Gradually, this English trait became known to me for what it is. It is a way of keeping away from erosion of himself, by getting involved in viewpoints that would unsettle his own convictions. The Englishman, and some people who resemble him in this trait while being almost wholly different in others, surrounds himself with a magic circle of privacy, a kind of moat to protect his emotional castle. It is one of the nicest things about the Englishman (the women are something else again) and a thing I look forward to meeting up with again soon.

'Eligible Bachelors'

\mathcal{A} couple of enterprising young ladies have sent me a letter which says in part: "We are analysts developing research concerning the single male of today, and we are gathering material for a book . . .

"You were listed as one of the 100 most eligible men in the Bay Area and it is our feeling that your experiences would be beneficial in our research.

"We are interested in knowing how you were selected as one of the most eligible, and how (if at all) your life has been affected since the article was printed. Your feelings on the changing morals of society, and woman's changing attitude toward marriage and family life would be of great value to our research."

I doubt I can contribute greatly to the work of the ladies. That 100 most eligible thing is an annual promotional stunt of a rather dumb local magazine called San Francisco. How I got, and continue to get, on their list is absolutely beyond me. So far as I know, my life has not been changed by this distinction one jot. Or even a tittle.

I am, however, interested in the phenomenon of bachelorhood. The word itself has an interesting derivation. It originally meant a young knight holding a farm or farms in vassalage, who served under another's banner. The second meaning is one who has received a bachelor's degree from a college or university. The third and last meaning is "an unmarried man."

Since the end of my last marriage, I have lived the life of a bachelor. On the felicities of this state I take mild difference with St. Paul. He said it was better to marry than to burn. I say it's better to stay single than to get burned.

Each time I took the matrimonial vows I honestly believed I was becoming a married man, and would act in the manner prescribed for men of that state. Love, honor, obey, provide, cherish, etc. Something, however, always went awry with these unions.

I have always suspected what that was, but the suspicion was too vague to take form enough for me to act on it. In the long period of time since my last venture into this form of legal binding, I have had time to put a finger on the thing.

Truth is, I am not only a confirmed bachelor, but a lifelong one. The truth is, and I can see it clearly now, that I went through three marriages as a bachelor.

And there is no way a born bachelor can become a good husband, by any definition that a modern woman would accept. Half the time you're just not there. This is not lost on a woman.

The percentage of born bachelors who get married is especially high among the Irish and Irish-Americans, for reasons too complex for me to understand. In the old country where a man was truly king of the roost, you could get away with this monstrous deception for a lifetime. A woman's lot was not a happy one, nor was her mother's or her mother's mother's.

The modern lady, Irish or otherwise, has seen all through this facade, where the lad takes on a woman so he can have a couple of vassals for his farm and fine life at the local. You are expected to let a woman have a life of her own, especially when the child-raising is over.

I have had the occasional nibble from wholly acceptable ladies in recent years. I have just replied that I am a bachelor at heart, and that she would not care to be married to a bachelor, no matter how fond she was of the brute.

So here I am of a sunny morning, feeling slightly sorry for myself, and looking forward to the pub where I will find Willie and Frank and Reggie and the rest. But at least I will not be running away from a woman to go there.

Heels

*N*early every woman has had a couple or three in her life. A lot of these ladies marry them. Whether they are cads, bounders or heels they are what the dictionary calls "contemptible or despicable people."

Yet there is no denying their fascination for the ladies. I am talking about the blatant, fully out-of-the-closet heel, the one who almost proclaims he is an s.o.b. We have heels that come like dominies, or masquerade as the salt of the earth until they are fully and finally exposed.

We can forget these hypocrites. It is the pure heel who fascinates me quite as much as he does the ladies. I wonder about his secret. What is it that makes perfectly sensible women, fully conscious and in their right mind, fall for such obvious bad news?

Of the many theories advanced on this pregnant matter I favor the Salvation Nell syndrome. The bum brings out some kind of twisted maternal instinct. She is going to make this junkie or con man over. By doing so she will, as the shrinks say, increase her own feeling of worth. It will also increase her sense of power, of which ladies have at least as much as men.

Of course, this kind of therapy never works, either for the bum or for his savior. The bum has his sense of worthlessness, which he is unwilling to part with as is Salvation Nell with her missionary zeal.

Bums like to remain bums, as ladies who are fascinated by them learn too soon or too late, but certainly. Yet this feeling of feminine worthlessness is at the basis of much of the attraction to the male tramp, at least according to one shrink who has gone into the matter.

Dr. Jewitt Goldsmith touches on this in his "Medical Aspects of Human Sexuality."

". . . the worthless feelings are seen in women who, while growing up, seldom if ever are praised but rather are consistently criticized, ridiculed or compared unfavorably with peers seen as prettier, brighter or more competent."

The Argentines without means appear on the scene and, Voila! The worthless lady finds a profound satisfaction in being mistreated by someone she perceives to be as worthless as herself.

This feeling of worthlessness is not confined to ladies. This accounts for the presence of lady heels. These predators of the

opposite sex are just as fully armed in the battle of the sexes as the heels, and exercise a similar function.

I have known quite a few of these reckless wastrels in my time, and have been deeply taken by more than one of them. In my youth I was hectored by my mother for wanting "to rise above my station." That is, to meet a better class of folk, as I thought, than was available in the purlieus of southern Harlem.

I am quite sure that my lifelong fascination with ladies of breeding and title and quite often with more money than they could handle began with a defiance of the maternal injunctions about remaining 'Umble 'Arry for the rest of my life.

In totting up the books I have never been able to decide whether rising above my station on fairly numerous occasions has been a plus or a minus. I got a good education in the ways of the world, but I paid for it with rue aplenty. I have even, believe it or not, been called a heel by some parties.

The Pill

*D*uring the 25th year of the use of the birth control pill it has been pointed out that the consequences of this invention have been immense, and that society will never be the same again.

The pill has affected me somewhat in that I have known, and known well, some women who have used it. Mostly, though, it has not meant much in my life. I have a family of four children and three grandchildren, which is pretty much the same as I would have had if Dr. Min-Chueh Chang had never invented the thing.

For others the effects have been terrific. A recent Census Bureau study revealed the proportion of women between 25 and 29 who have never been married rose from 10.5 percent to 18 percent in less than 20 years, up 70 percent. The figures for men showed an increase of one-third.

The study linked this trend to "an increasing desire among young adults to pursue nonfamilial interests, such as advanced education and labor-force careers before marrying."

The Census Bureau also reported that the number of unmarried couples living together has more than doubled in the first eight years of the '70s, and increased more than eight-fold among people under 25.

These facts are changing the face of the country. Their economic and social consequences are already with us. One result has been the stunning number of people living alone. Since the 1970 census the figure has more than tripled for men under 34 and has nearly tripled for women in the same age bracket.

While these pill-connected statistics are fascinating to everyone from wholesale grocers to people running for office, my mind keeps dwelling on an altogether different matter: How a chemical tablet can revolutionize the moral attitudes of a people.

With the "fear" of pregnancy removed, and the responsibilities of a family a thing that can be totally removed from a marriage, or other kind of union, women have become what they call liberated. The results have been anything but an unmixed blessing, as anyone with eyes in his head can descry, and as many of the pioneers of the feminist movement are publicly acknowledging.

In the days before the pill, virginity had an almost palpable value in respectable circles. Those luscious ladies from Manhattanville and Mt. St. Vincent that I longed for in my youth believed, for the most part, that virginity was part of the pact

called marriage.

What the daughters of these ladies believe is a much different thing. Far from being soiled by premarital sex, they have convinced themselves they are being enriched by it.

They may be right or they may be wrong. What is certain is that the pill is what wrought this change of moral values.

So the question becomes: How stable were these high morals we had, in the first place? Was it merely fear of pregnancy that caused respectable women to eschew the final pleasures of sexual union? Was the virtue we all so much valued in a woman so frail a growth that control over pregnancy could shatter it? Was the fact of sons and daughters, and the responsibility for rearing them, more a matter of accident than responsible choice?

It makes you wonder. The one true thing we have learned from the pill is that American women like casual and irresponsible sex. And they have learned, and oh, so easily, to dissociate copulation from its primary biological and moral purpose, the creation of children. Few of us, I think, realize the psychological consequences, to both men and women, of this misguided dissociation.

Lolling

*H*ow I love the sound of that word—lolling! This is perhaps because there is no word in this language that my mother more delighted in using. Not that she liked it. She detested the word and what it connoted.

My mother had a formidable lexicon of contempt, most of it rooted in the Puritan ethic. Simply put, it went something like this: If you weren't working with your hands, you were doing the work of the Devil. I was usually doing the work of the Devil.

"Is it all you can do, loll about?" she would demand. When that good lady's patience was at a total end, she would heighten the accusation, "Ah, there he is, lolling about with a book!" Lolling about with a book wasn't quite as bad as having lascivious relations with girls; but it ranked right up there with breaking and entering.

The dictionary before me says the word loll perhaps comes from the Dutch, meaning to sit over the fire. It is defined as "to lie lazily about, to lounge, sprawl, to dangle . . . to let hang out."

I should say a major part of my life has been spent lolling, or hanging out. I truly understood the moral background of my mother's opposition to this sort of thing, since I was brought up on the word bum. A bum was what my father was, and what I was destined to be. My mother's life was given her to save me from bumhood, with the cooperation of various dour clerics. To this day I cannot tell the difference between saving somebody from being a bum, and steering him toward glorious bumhood. If you want non-bums, forget the word bums, or something like that.

I knew that I was made to loll, as other people were made to fuss, and fidget, and build bridges and that sort of stuff. As I've grown older, I've managed to get over the feeling that lolling is somehow wrong. Lolling is the way that I live, the way that I was made to live, and there's an end to it.

One of those tediously sagacious Chinese remarked, in some dynasty or other: "Only those who take leisurely what the people of the world are busy about can be busy about what the people of the world take leisurely."

We are really just on the brink of the Age of Leisure. Us lollers have something to tell the future. We are closer to the nature of things than the movers and shakers, who tend to move and shake in ways that beat the hell out of the world around us.

Our first lesson is a simple one: Practically nothing ever comes out of trying. I cannot think of anything in my life worth preserving which came from what is called sustained effort. A lot of things, including a couple of marriages, were ruined by the application of this boring principle. Hanging loose in situations where social pressures dictated strenuous effort would have mightily mitigated the old vicissitudes.

Every good idea I have had in my life has come to me when I was both mentally and physically lolling. Thinking about absolutely nothing, walking through the park, or putting away a morning ale—suddenly, out of the ancient and empty air, a notion came. Unbidden, almost unsought; but usually most welcome.

Being undisciplined, like everything else, requires a discipline. You have got to figure out the conditions under which your lolling is productive.

I have several procedures. One is staring blankly at a page of The Times, whether of London, or New York, or Los Angeles, with a bottle of ale in front of me. If this is continued long enough, everything you want to know comes to you.

This is usually nothing more than the lede for the piece you are going to write tomorrow; but it may involve such transcendent ideas as what you are going to do with your money, or how you are going to get out of your current high passion. If you do nothing long enough, everything somehow gets done. This is what lolling is all about.

Sauntering

I suppose sauntering can be defined as moving about aimlessly. I love the word and I love the thing it defines. The great Thoreau loved it too. He once said, "It is a great art to saunter."

Some people, lucky souls, saunter through most of their life. They leave their dwelling with stick in hand, or they pick up a convenient twig, and they walk off to—nowhere. Or at least nowhere they are conscious of. Maybe deep within themselves there is a desire to go to the Palace of Fine Arts; but they are genuinely surprised when they find themselves there.

This is sometimes called creeping, crawling, lagging, loitering, lumbering or dawdling. I find none of these words demeaning. I am of the Thoreauvian school, but I find it more difficult these days to walk pointlessly, and appear to be walking pointlessly, without getting into trouble.

The law says that any loiterer can be detained by police. He must then identify himself, prove where he lives and show that he can support himself. If he refuses, he can be arrested. The cop does not need to suspect him of a crime to put him through this rigmarole.

Sauntering encourages uninhibited thought. My life has often been changed by notions that spring, seemingly unbidden, into my head while I am roaming through Washington Square Park or around the streets of Chinatown.

As many columnists have pointed out, publicly and privately, it is sometimes hard to pick up ideas for columns.

On the not infrequent occasions when I go dry, I walk down Union street to Washington Square Park, the capital of North Beach, and just set off pointlessly. Sometimes a purpose forms and I buy a pound of coffee or a book.

But i regard purpose as an occasion of sin. It is much more profitable to improvise, and improvise continuously. Looking at the varied faces of this varied city is a good way to keep you from purpose.

Sometimes I count telephone booths, which is about as aimless an occupation as you can find. I haven't got as far as Dr. Johnson, who used his stick to count the number of iron railings in front of houses between the Cheshire Cheese and his home.

This form of aimlessness, besides being a mild physical exercise, enables you to edit your life. There are a lot of ideas within you which are dying to get out; but the organization of

American life in this century makes loitering unrespectable.

The great enemy to sauntering or aimless activity is the automobile. When you reach a cross street, the activity is no longer aimless. It is often a matter of life and death. This is no condition for the dedicated saunterer.

It is duller, but better for the soul, to settle on a street out on the avenues, in a fairly safe district, and just walk around the block continuously. It gets to be a little boring, but you get away from the damned automobile, and its arrogant interruptions.

The only safe place to saunter, and the locus of Thoreau's idea that it was a great art, is the country. I would like to see Henry David trying to saunter along among the Chinese shopping on Grant avenue or Stockton street at high noon.

In the country there are no interruptions but the birds and the frogs and the occasional neighing of horses. Far from interfering with the process of ratiocination, they seem to encourage it. That is, I think, because they were all around long before we were. They are part of the mise-en-scene while we are the interlopers. But I think the beasties take no offense at a really quiet saunterer. We have things in common.

Secrets

The other morning I was taking on my first mug of ale in the North Beach purlieu that I call my home away from home when up came an old acquaintance with a knowing look and a confidential smile.

"Old boy, I'm gonna tell you a secret you won't believe."

I replied, in a voice so emphatic it rather surprised me, "Pal, I don't want to hear any damned secrets."

That was true. It has been true in the past, and is becoming much more true each day of my life. Secrets are a prison and a pain. Secrets are one of those trifles that are not trifling. The way you look at secrets is something of a key to the way you look at other, far more important, things.

There are people, and I am becoming one of them, who find a secret not only an intolerable burden but a decidedly demanding transaction. There are people of whom it is said that money burns a hole in their pocket. Secrets bore a hole in my head. They are an irritant I must get rid of.

And in that getting rid of everybody looks bad—me, the person I tell the secret to, and the person who told me the secret. Who needs this kind of nonsense?

I have not always had such a prudent view of the matter. Like most everyone else, I have trafficked in secrets, and delighted in doing so. Being in on a secret gives us a factitious importance.

William Hazlitt, that brightest of English essayists, hit the nail precisely when he wrote, "Those who cannot miss an opportunity of saying a good thing . . . are not to be trusted with the management of any great question."

This undoubtedly helps explain why no matter of great pith or moment has ever been confided to me by the authorities. It is my tendency, when I hear a good thing, which is all too frequently a cruel thing, to become immediately a kind of town crier.

If somebody tells me that a noted macho type is queer as Dick's hatband, I consider it almost a civic duty to let the intelligence leak into each and every nook and cranny. This does not inspire trust.

Knowing this deplorable tendency is one of the reasons why I shy away from secrets, either personal or professional, in my capacity as a journalist.

But so wretched is this commerce in confidences that I often get more secrets by saying I don't want any, thank you.

When we tell a secret to someone else, we have already given away the game. How can we expect him to keep the secret which we ourselves have been unable to keep? As La Rochefoucauld, or someone of his cynical stripe, once observed.

Equally, when someone tells you a secret HE is breaking a secret pact, with either himself or someone else. Whichever the source of his knowledge, he is acting dishonorably.

The one creditable thing about most people's dealings with secrets is that the *really big* secret is usually kept.

I know several instances of people who were born on the wrong side of the bed, to the knowledge of a handful of people. In years, that knowledge has not been communicated to more than this handful. Sometimes, in fact, the secret has been kept too long from the child, who at some time in his growth deserved to be told.

Most people who tell secrets want them to be told. This is a true and sorry thing. Too, there is an old Spanish proverb that states love and pain and money cannot be kept secret: They soon betray themselves.

From the contagion of the secret there is no reasonable refuge. The safest thing is to make clear you don't want to traffic with the damned things. Then you can deal with what comes your way with a bit lighter conscience.

'Bustle'

There can be few more personal books in our language than the Dictionary of Dr. Samuel Johnson. You can almost read the entire life of the great lexicographer by skimming through the definitions. His prejudices, against the Scots, cheap politicians and cant, are written large in his word entries.

One of the doctor's favorite words was "bustle." He felt quite strongly about this form of activity. His definition indicates that bustling indicated foolish and ill-directed activity carried on for no other purpose than to relieve tedium and "to fill up the vacuities of life."

Another time, and even more picturesquely, he defined this irritating activity as "getting on horseback in a ship."

Do not we all know what he meant? Life would be empty for a lot of people if they weren't constantly hustling and bustling, assuring themselves that their vagrant movements have some planned and deliberate meaning.

What Johnson called bustling I call dithering. These are not quite the same thing, but close enough for purposes of meditation.

Ditherers and bustlers are basically people who cannot stand silence or stillness. Motion for motion's sake is thought to endow the motion with meaning. Furniture that is constantly rearranged, an inch or so at a time, is regarded as inherently better each time it is moved. Only the next day or the next hour to be found somewhat inadequate.

Bustlers are totally unaware that their bustling, far from seeming meaningful to some non-bustlers, actually irritates them no end. And, regrettably, the longer you hang around this life the more bustling people get on the old nerves.

The worst of all bustling is the verbal kind. A silence lasting no more than a few seconds seems to threaten some people in some way. There is a necessity to fill that silence, fill it with anything that comes to mind, lest some unnamed calamity befall them.

There are bustlers who talk because they want an audience, or maybe even need one. These are bad enough. The worst of the species are the kind who don't really know they have an audience. These just want somebody parked in front of them as an excuse to talk.

To be on the receiving end of this kind of chatter is almost

invariably annoying. Sometimes it is positively unnerving. But sometimes, too, it can be pathetic—an affliction that can only bring forth your sympathy.

There is actually an ailment called logorrhea. This is a compulsive flow of talk, and it apparently springs from some neurotic source. The flow cannot be helped, even when the speaker realizes that it is pointless.

I knew such a man once, and knew him well. He was a sterling fellow in almost every respect. He was able. He was dutiful. He was helpful to people he could help. The salt of the earth is what he was. But he couldn't stop talking.

He went to psychiatrists for the ailment. Nothing seemed to help. He continued to be made miserable by his unwanted loquacity. Last I heard he was somewhere in Malaysia, presumably still unable to stanch the flow. When he didn't have somebody to talk to, he talked to himself.

Such a fate I would not wish on an enemy. You cannot begin to address yourself to such a bizarre problem. You can, however, address yourself to the matter of those who talk too much, and are in a position NOT to do so.

The treatment is brutal, but it often works. You just stare at the person for a minute and say, "You talk too much." As is said of another form of proposition, you get quite a few punches in the nose, but you also get quite a lot of much-desired silence.

'Gay'

The people who publish the American Heritage Dictionary have what they call a "Usage Panel." This is a group of 150 writers and editors who are asked their opinion on words that have newly entered the language, or are about to. Among the questions asked the panel via mailed ballot recently was:

Is "gay" (homosexual) as an adjective and as a noun appropriate to formal speech and writing? How about "gays" as in "The gays were among small groups of protesters?"

The published answers to this question were mixed; but the weight of the evidence seemed to go with the No's. " 'Gay' used to be one of the most agreeable words in the language,' " said Arthur Schlesinger Jr. "Its appropriation by a notably morose group is an act of piracy."

Said Gilbert Highet, not altogether relevantly: "Auden was a very amusing man when slightly drunk, but one look at that seamed and haggard face would keep anyone from calling him GAY."

And Isaac Asimov weighed in with: "I bitterly resent the manner in which 'gay' has been forced out of speech. I can no longer say, 'I feel gay' or speak of a 'gay spirit.' "

I fear I must join the side of those who feel "gay" is a regrettable usage. I do not see why a homosexual should object to being called a homosexual, especially since the pejorative connotations of that word have largely been lost in the change of public attitudes toward the matter.

Another word that would seem to do the job, and which seems to be increasing in currency, is homophile. This means a person who loves people of his own sex, and applies to either men or women.

The word "gay" has a curious history. Nobody seems to know exactly who used it first. It is certain, however, that it was an adjective in the 1950s. It referred to places and things that were patronized by homosexuals, as a gay bar or a gay restaurant, or a gay bath house.

It was not until the '60s, when the Gay Liberation Movement got up full steam and waged a marvelously successful propaganda war, that the word began to be used as a noun. It became, and I think unfortunately, the homosexual's word for homosexual.

In an adjectival sense, I think its use can still be justified. As

a noun, I find it annoying, distracting and slightly offensive.

Homosexuals are not gay. They are human beings like the rest of us—sad and gay, funny and rotten, good and bad.

They have little reason to be gay. Their life is no bed of roses, nor will it ever be. They are a minority, although an increasingly respected one. They are viewed by most straight people, even those who are friendly with them as a group, as people with an emotional problem.

Despite the success the homosexual class has had with the media in gaining acceptance of their way of life, I do not think this feeling that they are different, in some distinct way, will ever evaporate.

Even more seriously, there will always be a large segment of the straight community that will feel sexually threatened by homosexuals and their sexual practices.

The acceptance of the homosexual is, actually, skin deep. Among the educated and the affluent, the social acceptance of the homosexual is almost complete. But the farther down the social scale you get, the stronger is the prejudice against him. When you get to the rednecks and the ethnics, the feeling against the homosexual is still so great that you can taste it.

All of which makes "gay" as a synonym for a homosexual that much more inappropriate. As a class the gays have damned little to be gay about. A flippant friend has suggested the answer might be gay spelt backwards. Yag is not good; but it is better than gay.

Miscellany

The Shown Heart

The business of the poet, it has been said, "is to move the reader's heart by showing his own."

I do not know who said this; but it sticks in the mind like a burr. All kinds of things have been said about the poet and his function, from Aristotle and Longinus to Eliot and Pound. None beats this no-nonsense job description. The poet can be one whose concern is openly with the heart, often bruised, as in Christina Rossetti or Elinor Wylie. Or it can be a bitter rage of the mind, as in the late Yeats and the early Eliot, which gives upon that most terrible of visions: That the world is heartless, and the artist heartbroken.

The showing of the heart is not a thing American men do with any ease. They have difficulty in weeping, too. Yet both things have been widespread, if not popular, at various times in the history of the English-speaking. In my adult life I can recall weeping but once. That was in the presence of a doctor. It was convulsive; and once started, lasted the better part of an hour. An ancient wound had been opened. This heaving response was my comment.

I was not ashamed of this weeping. The relief was too immense. My only guilt was that I could not have spread that giant fit of tears over the years, into convulsive relieving little spasms. But no: I was brought up in a culture where brave little men did not cry, under any circumstances. Anything which can be tied up with manhood has a great power of moving. Those critics of machismo, the advanced lady libbers, can and will tell you.

Crying is for sissies; as, for that matter, are all those things we call the tender feelings. When in hot pursuit of some morsel, we will stoop to such mean stratagems as buying roses or orchids, or sending bijoux and even cribbing a few lines from Browning to accompany them. Since folly is permitted in our sexual mores, we may even go so far as to say we will kill ourselves if the lady does not yield her favors. This is lover's license. Usually it is recognized as such, by all parties.

In the ordinary intercourse of life, though, we fear to acknowledge feelings of love and like. The young have put into our lexicon the useful word, "vibes," short for vibrations. These exist. You can sit next to a person. You feel bad vibes, as clearly as you can discern he is wearing an unsuitable jacket. And luck can throw you a person who is vibrant in the exact right way. You

will not, of course, be able to conceal from such a person that you like him or her, and your manner will exceed what politeness requires: but will you explicitly say: I like you, or love you, and whatever that might lead to?

I knew a fellow in Europe who was widely regarded as the perfect dinner companion. He was an artist at this sort of thing. Like such artists, he was more than a bit disingenuous; but it worked. Before the soup was over, he would inquire earnestly of his companion, in one of several languages, "Just why is it I like you so much?" It was a rare time that calculated remark didn't take care of the rest of the evening. It is no imposition on a person to force him to talk quite seriously of his immense charm and how it came about.

In the world of published discourse, whether it be about our political leaders or the doings in the social section, the heart is seldom shown. Perhaps this is one of the reasons for the popularity of the sporting pages, where all is naked emotion for failing or fulfilling heroes. Even the agate, those tiny printed results of high school basketball games in far-off places, can be filled with passion.

The most riveting of literary forms to many readers are diaries and published correspondence, where the divested heart is shown.

We tend to believe a person when he has suffered, and has admitted it. Or when he has lost deeply, and acknowledges it. Winners satisfy us; but they are dull, usually. Who was duller than Ike Eisenhower? But the losers, the ones whose hearts are forever publicly drifting and getting broken and damned! We feel for them and love them because they are one of our own kind.

'Cherished Ill-Will'

Not the least of the pleasures of growing old is that the great grudges of your heart tend to erode and die. This is, as they say, all a part of growing up.

Don't go around saying you haven't harbored grudges. There is not one of us who hasn't. And a few of us can calculate the utter waste in spirit that such harboring has brought to us. Grudges are the most poisonous of things. They wither the spirit. They dry the juices. They harden the heart. They are despicable.

Webster is especially eloquent on the subject. The noun grudge, the dictionary informs us magisterially, means "sullen malice, cherished ill-will." Can you think of anyone who would clutch to his breast sullen malice, cherished ill-will? Yet there are those who do so, even in old age.

Tom Ferril, the Denver bard, has put it well. "I've known people who would grow old bearing a grudge; usually it betokens lack of a sense of humor. I think of them as mosquitoes trying to sting the past."

What a devastating image that is! An old man trying to live off ancient wounds and harrowing memories! Could a life be poorer? An expense of spirit in a waste of shame, as the Stratford bard put it.

While we are at the business of quoting good men, we find the admirable Dr. Johnson is useful, too, in this general area: "It would add much to human happiness, if an art could be taught of forgetting all of which the remembrance is at once useless and afflictive . . . that the mind might perform its functions without incumbrance and the past might no longer encroach upon the present."

That is the real trouble with grudges. They are a weight and an encumbrance. The memory of what your father did to you when you were four, or how you were cheated out of your heart's desire when you were 12, or the girl you didn't get when you were 20, can deeply impoverish a later life. And don't you believe those confident fellows who speak of defeat as a spur. If it is a spur, it is usually in the wrong direction.

I have to work to remember my grudges, these days. Not that I didn't have them, and giant ones. Few people in the world were as unappreciated, in their earlier days, as one Charles McCabe. Few diamonds were rougher. More light was never hidden in a barrel. No more deserving nominations than mine

were passed by in the nominations for the Hall of Fame. There was a time when I described myself, quite accurately, as a reservoir of ill will.

Yet it all seems to have gone up in smoke, this dreadful baggage of defeat, despair and frustration. As I think back on the man I hated most, in the days when I hated best, all I can remember is a powerful and unhappy person, who dressed funny, and spoke funny, and was funny. So kindly is the editing of the mind that the people most easily evoked from the past are the pleasing bums, who asked nothing from anyone, and who had the natural courtesy of the lost.

I guess it all comes down to what Tom Ferril says, the sense of humor. A sense of humor is another way of saying a sense of proportion. Laughter is a way of seeing things in scale.

To quarrel with your past, to wrestle with ancient hatreds, is to deny the existence and urgencies of the present. The sense of humor has a way of diminishing you, benevolently. It reminds you that you are one of several billion people on this planet, all of them coping with the same problems you are. None of them, when the dust envelops, is of any greater consequence than you.

The wretched past has no right to encroach on the present. In fact, the sensible man has a positive duty to prevent this. Fortunately, this isn't hard for most of us. Just growing older does the trick. Here's hoping you will be able to say, as the Abbe Sieyes replied when asked what he did during the French Revolution: "I survived."

Me People

You know several of them, and not at all to your advantage. There is, for instance, the chap who is interrupted in his account of his latest exploits, (which are considerable), by a couple of minutes of the badinage of his companions. During the interruption, if you happened to be watching him, you saw glazed eyes and a polite strained smile.

In due time, he kidnaps a lull in the talk. Without so much as an, "As I was saying," he resumes full tilt. "Now that I have enough seed money, and have thought through the plans for the installation at Greenbrae . . ."

This chap is one of those I call the Me People. They have a single string to their bow. That is themselves. They have a passion for this subject that never abates. It is not enough to say that the world about them exists merely as a stage on which they perform. The true Me Person thinks neither of the world, nor of stages.

The Me People are a funny sub-phylum of the human species. You cannot say they are selfish. That does not begin to tell the story. Neither is it really true. They are suffering from a minor if irritating emotional disorder. The Me Person is literally obsessed by himself, by his virtues, by the villainy of his opponents, and by his achievements.

Ah! Those achievements. If there is one thing the Me Person has been intimately involved with, it is the changing of history. In his chosen field, and sometimes that includes just about everything under the sun, the grass grows infinitely greener where he treads, the lives he touches have uniformly been enriched, the riches he has conferred are always five figures and over.

I know one such whose special consuming interest is baseball. He doesn't quite insist that he gave Major Doubleday the idea for the game; but you have no doubt that he was present at the creation. Whatever latest move the Yankees made is related to a conversation he had with the owner over drinks at a party for Cecil Beaton. The latest inter-league transaction could not have been carried on without his active counseling, the details of which are a bit sensitive to discuss at this time. There is nothing, no how, about the world of baseball in which this fellow's fine Florentine hand is not to be descried. In private life, he is a painting contractor.

When Me People really get going, it's time for the rest of us to leave. In a public place like a bar this is quite easy to do. An audience is not absolutely needed for the Me Person disquisition. If everyone should disappear, the cartography of self would be continued, either audibly or silently.

When our man imprisons a dinner party, and must be listened to because of his seniority, or his place in some government pecking order, a guest can feel poorly used indeed. You feel about as needed as a butler at a hot dog stand. Under these circumstances it is literally impossible to stop a Me Person in full throat.

The psychiatrist Erich Fromm frequently makes the point that a selfish person is not able to love other people; but he is likewise not able to love himself. And that is what must be at the bottom of the pathology of the Me Person. His need for approval is so great that he cannot wait to get it from others. He must furnish approval himself, and in copious doses. He literally has to remind himself that he is alive, and okay.

All this is a bit rough on the rest of us. For myself, I once made the discovery that I was unable to love every damned human being I came in touch with. If I disliked someone I resolved never to speak to him again if it could possibly be done. The decision has cost me little, and given me much comfort. This has been especially so with the Me People. There's little to be gained from hanging around with people who don't even know you're there.

The Awful Present

*I*t can be argued that all life, for the civilized man, is a strategy of evasion of the present. In fact it has been so argued by the eminent Dr. Samuel Johnson.

"No mind is much employed upon the present," said Johnson. "Recollection and anticipation fill up almost all our moments."

What are you thinking of now, if you are not engaged in some immediate task like adding up a column of figures, or operating a computer? Your immediate task or the lady you took out last night, or the one you hope to take out in a week or so?

It is a useful thing, on the whole, that God or nature allowed us this faculty of running away from the present. To have to concentrate continuously on what is happening in the world from minute to minute would be a debilitating and perhaps deadly course.

I am living by Lake Tahoe at the minute, in a very pleasant little cabin that is familiar to me, and what am I thinking about in the back of my head? Of a friend who is coming to see me tonight, of whom I am fond. And of getting this column finished. And of having a glass of ale thereafter. And of two of my grandchildren who are coming to see me at the end of the month, and of their mother, who is my daughter.

What is this awful present that I am avoiding? That large portions of the world outside can be destroyed in seconds? That there is treachery among friends? That you never know what those who are close to you really think of you?

Of course I do not know. The present lacks solidity. It is vaporous. It is far less real, as a stimulus to the imagination, than what has gone before and what is to come.

The great event of my future is my death. I should be thinking of, and preparing for it. But I am one of those persons who do not think much of that great dark scythe. I do not terribly fear it, as of this minute. The only word I can associate with it is magic. The only people I know who share this feeling, or lack of feeling, are certain Irish and certain Mexicans whom I have known well.

When I think of the future, as far as I know, I think Elysian thoughts. I think of the beautiful places I hope to live in, and the peace I am going to enjoy. I also think of thinking, of arranging my life into some inwardly coherent pattern. Outwardly, I fear, I

shall always be a roustabout.

Each day I hope I shall meet a new and interesting person, or a beautiful one. By beauty I do not mean that sort of woman who parades upon boardwalks, or the world's most highly coordinated hockey player. I mean what Plato called the other half, that person who when added to me will make me a complete human being.

That is a worthy dream; but it is a dream. The best you can do is to hurt least the smallest number of people with whom you come in contact. This is by no means easy. It is a quality that takes a lifetime of experience.

I pray that the strength within me endures. I know that my outer strength—partially due to my own choice—is helpless before the buffetings of the outside world. That is, the awful present.

Recollection and anticipation, if we listen to the learned doctor, is our portion in life. They both provide satisfaction. They help make life bearable.

It would, I think, be a kind of dementia to be imprisoned in the present. The wickedness of man, what religious people call original sin, is a kind of hell in prelude. When the good man prays, he prays for the past and for the future. The present, if we dwell on it, is mostly a punishment.

Humor and Wit

*I*t is a good thing to remember that there is a difference between wit and humor, and that it is not a small difference.

The kind of people who enjoy wit and the kind of people who enjoy humor are usually very differing kinds of people. The kinds of people who ARE witty and the ones who are humorous are distinctly different kinds of people.

The salient difference between wit and humor, I think, may be found in that useful four-letter word, love. Humor is informed and suffused by love; wit is heartless.

As one observer has noted: "Humorous persons have pleasant mouths turned up at the corners . . . But the mouth of the merely witty man is hard and sour until the moment of its discharge."

The supreme wit of the English language, Oscar Wilde, was almost devoid of humanity. Wilde's epigrams betray much knowledge of life, but precious little suspicion of love. "Woman begins by resisting a man's advances and ends by blocking his retreat." Clever, yes; but harsh and putting off.

I admire Wilde, as I admire all truly witty men; but it is hard to feel affection for him or for wit itself. Perhaps this is because I have so often been the butt of another man's wit.

A collection of celebrated wits can be an intimidating thing. I recall having been invited as a guest to one such group which met in New York. It was modeled after the Algonquin Hotel Round Table—a you-scratch-my-back-and-I'll-scratch-yours organization which is much better in the telling than it was in fact.

It is significant that I was told before lunch that I was not expected to make any contribution, just to sit there and watch those mousetrap minds at work. Each of the members present had done his homework, and decidedly.

The question was how to get those well-rehearsed mots, stolen from everybody from La Rochefoucauld to Fred Allen, on the floor in the face of the competition of some of the most formidable egotists of the city.

The occasion reminded me vaguely of a cockfight. Nobody really listened to anyone, save perhaps the two guests. Everybody who wasn't talking looked thoroughly miserable. The guy who was talking was proceeding like a pile-driver in order to keep the floor. A most disagreeable performance by a lot of non-nice guys, who had perhaps been forced into their roles by the

whole silly format.

It is not a hard and fast rule; but we tend to associate humor with the fat man, the person who has given up the ceaseless striving of his youth, when he was perhaps a thin and witty man, for the comforts of the flesh.

G.K. Chesterton and his friend, Hilaire Belloc, were fat men with a genuine flavor of humor. I should rate Chesterton the more humorous of the two. In fact, I would say that gifted fellow was one of those rare ones who defeat my generalization: He had both wit and humor, and in quantity.

Chesterton's humor came out in the Father Brown books and his other novels. The wit came out in the marvelous essays: "An adventure is only an inconvenience, rightly considered." "The only way of catching a train I ever discovered is to miss the train before." "I hate a quarrel because it interrupts an argument."

The antithesis of the fat men, Belloc and Chesterton, was that great wit and misanthrope, G.B. Shaw. Shaw was thin as a rail. He always wrote like a thin and acid man.

"Put an Irishman on the spit, and you can always get another Irishman to turn him." That is pure Shaw. It is accurate and it is unloving, and Dublin to a T. But it ignores so many other things, like the warmth of heart of the rural Irish. Wit and humor are both needed, but I feel more at home with humor.

Common Sense

The root and reason for my lifelong attachment to the mind and life of Oliver Wendell Holmes Jr. opened to me a couple of years back when I was talking with an old friend about books and writers and something called common sense.

We agreed that the greatest figure in French literature was Montaigne, a man whose stock in trade was common sense. Montaigne was a man, to use Terence's phrase, to whom nothing was foreign if it was common to mankind. The Frenchman knew if you said anything about one man, it had to be true about all men, or it was not worth writing or saying. Each man, he said, "bears the entire form of the human condition."

Montaigne urged man to come to terms with his frailty. "There is nothing so beautiful and legitimate," he said, "as to play the man well and properly, no knowledge so difficult as to know how to live this life well and naturally, and the most savage of our maladies is to despise our own being."

My friend agreed that if the English people had produced an equal of Montaigne, it had to be Samuel Johnson, whose forte was a towering common sense.

Johnson's own writing, excepting a loving biography of an aristocratic Bohemian bum named Richard Savage, was dense with Latinity and portent. His formal writing skids marvelously around his salient characteristic, his London street sagacity, the commonest kind of common sense.

"Why is it?" I asked, "that we in this country have produced no one like these men."

"How about the Junior Holmes?" my friend said.

Connections began to be made. My two favorite writers in the world, for reasons which I clearly understood, were of the precise school as the one American writer I found so much difficulty in placing. Yes, and indisputably, Holmes was a master of common sense, and worthy of a place among those great exemplars, Montaigne and Johnson.

And what, pray, is common sense? Descartes said it was the most universal of human qualities, since none would admit that he did not possess it, and mightily. Some have called it genius in homespun.

It is far easier to recognize than to define, like excellence in judging a ball in the outfield sky. Much common sense is found in the proverbs of a people; and yet there is hardly a proverb to

be found that does not have its equally pithy opposite.

What you recognize, when you are hit with a particularly deadly bit of common sense, is a falling of scales from the eyes. Common sense clears the mind of cant. Common sense, as I can best define it, is telling sense wrung from hard experience. The quality has the power to shake all kinds of nonsense out of perceived and received wisdom. As Sir Joshua Reynolds said of Dr. Johnson: "He cleared my mind of a great deal of rubbish."

It is that ventilating of the intellect that brings me back so often to Holmes and his writing. Of the practice of his own profession, so suffused with the dead hand of precedent, he could be devastating.

"It is revolting," he once said, "to have no better reason for a rule of law than that it was laid down at the time of Henry IV."

Nothing tells more about Holmes than his reaction to Lincoln, his Civil War commander-in-chief. He confessed that it took him 40 years to fully appreciate Lincoln's greatness. As he said to an elderly lady in 1909: "Few men in baggy trousers and bad hats are recognized as great men by those who see them."

Or Else

*I*t is not easy to love the world. It is just something that must be done. As the sporting lads say, it's the only world we got.

Consider the general terms of the deal. Except for nature itself, practically everything we live in and about is a pack of lies. These lies are usually called by rather grand names. The bigger the lie the grander the name, is the general rule. These lies are variously called theories, religions, unimpeachable facts, eternal verities; and, most outrageously of all, The Truth.

The lies are quite often high-blown ways by which man explains the spoiliation of nature—both within himself and in the world outside. Take our greatest current lie. It is called Progress. It begins with cutting down a tree. A tree is a living and lovely thing, vibrant in itself, nourishing the earth around. A tree is a fully justified creation.

And what does Progress make of trees? Dead houses chiefly, unconnected with any soil, which will be torn down before their time to provide for other dead houses which will once again be made from living trees with roots which assure the very growth of the soil. Is this to the good? Of course it is. We have the continuous assurances of the National Association of Real Estate Boards on this point.

And what of man's inner nature, that strength which can so easily be called violence? How do we handle it? With flags, and marching bands, and bitter tribal memories. We turn the strength against those brothers our patriots point fingers at. THEY oppose our interest, the patriots say, which means they oppose the patriots' interests. After thousands of years of the human experience we have not learned not to kill. We haven't even come close. There could hardly be a more signal failure for a species, one would think. When we walk, we walk with Cain and Abel still.

War and Progress are the worst of our lies. They are also, apart from birth and death, the prime data of our lives. They are cause enough for the deepest despair, in those who see their tragic mendacity. Yet the wisest and the best of men, while aware of the folly they inhabit, rejoice in life and approach its end with rue.

These people have literally seen through the lies of their life. They have learned to accept the world and their own nature. Acceptance is a word which has acid connotations in some

circles, especially revolutionary and young circles; but really, it IS all we've got. The finality of the rule was stated by H.G. Wells half a century ago. "Adapt or perish, now as ever, is nature's inevitable imperative."

"Neither dread your last day, nor long for it." Those are the words of the Latin poet, Martial. They express, as well as anything I've heard recently, the equilibrium that should be the lot of the happy man in his later years, after the long battle with illusion.

When all the grand illusions are explored, acted upon, or rejected—the decencies of our cradle, the various freedoms which have infatuated us, the creeds and fashions which seemed like final answers for a fleeting hour—we come to the knowledge that the whole of our life has been accepting ourselves as we are. That acceptance is well-named self-respect. This self-respect is the end of a long struggle which brings out the best in you, and the best in life. That, as they used to say, is the ticket!

To accept without fear whatever comes is another name for love. That self-respect which we grant ourselves late or soon, if we are lucky, goes out in waves to others. It is a circular thing. If you respect yourself as you would have others respect you, you will love others as they would be loved by you. That is the hope, and it is worth the try.

'My Trade and Art...'

\mathcal{M}ichel Eyquem de Montaigne, who was once mayor of the town of Bordeaux, was just about the smartest Frenchman who ever lived. Or, perhaps, the smartest one who recorded his life and thought for the world.

His philosophy was nebulous, his sense of duty was decidedly imperfect and his moral opinions were hang-out. He was fearless. He questioned everything. He had immense charm. He threw away remarks that contained more pith than many a respected classic.

He was original. He was original because he recognized fully that he was just like everyone else, a human being. It is characteristic of this profoundly skeptical man that he devoutly received the last offices of the Catholic church.

Montaigne defined himself and magnificently in the line: "My trade and art is to live."

There it is. How many of us, in this difficult and distracting world, have been able to achieve this insight? To live is more than to breathe, to earn a paycheck, to make love, and to prepare for death.

To prepare for death! That is perhaps the closest thing of all to living. To exist always under the aspect of eternity. To try to see that the books are balanced at the end. To be neither good nor bad, but each in such proportion as our nature and destiny finds meet.

You can of course define things by their opposites. Some things are clearly not living. Some things can be, in the telling phrase, a living death.

To be unable to love is to exist in this kind of limbo. To be able to love and to live with someone who is unable to love is an even worse thing. To suffer such a fate is to be a victim of the worst of human cripplings.

The same is true of your work. If you do not like your work, or your work does not like you, which too frequently happens, then you find yourself increasingly away from the trade and art of life.

Montaigne had a nature capable of embracing and realizing the largest experience of life. At the age of 38, in 1571, his two brothers died and he succeeded to the family estate. Until his death in 1592, he lived the life of a French country squire.

He did exactly what he wanted to do, which was to think, to

read, to travel and to write. He invented an art form called the essay in which he expressed all these things. His true home was his library, but he was far from being sedentary.

"Oh, what a tremendous advantage is opportunity!" he said. "Should anyone ask me what is the first advantage in love, I should reply that it is to be able to make one's opportunity; likewise the second and third thing as well. There you have the key to everything."

A poorly lived life is, among other things, a life of lost or neglected opportunities. To seize the hour requires intelligence and courage, courage sometimes to the point of recklessness.

I laugh at people who say they do not gamble. What greater gamble in life is there than to choose a woman to live with, under contract for the duration? Or to beget children by her? Or to walk through Golden Gate Park on a dulcet day?

The whole of life is a gamble with the odds slightly against. The only way the odds can be made more favorable for one is to learn the painful business of cutting your losses. If someone or something is bad for you, you will certainly know it sooner or later. The thing to do is to cut the person or thing out of your life as quickly as possible. This will often be painful, but painful and quick is better than painful and slow, or painful and forever.

Fight for what you want. When you have it, examine it and understand it, and you will love it. Love does not come first, but later, and you had better believe me. Montaigne also said "He who does not live in some degree for others, hardly lives for himself."

Sex and the Triple

\mathcal{M}y three favorite plays in baseball are the home run, the triple and the double play—in that order. The homer has, shall we say, a certain Homeric finality. With one stroke of the bat, the scorebook is altered instantly and forever.

There is no taking back a homer. The chap who hits it is not about to be left dolefully on base. The homer guarantees complete satisfaction for Our Heroes and their fans. It delivers an implacable abrupt trauma to the enemy.

And who among us has ever envied the hitter of the home run, provided he is on Our Side? He just fills us with wonder and delight. Altogether a most satisfactory maneuver, the homer.

The triple has much to be said for it, too. It is a mighty effort. There is a lot of drama in a man on third after this mighty clout. There's no drama at all about a homer per se. It's more of a *deus ex machina* than a dramatic build-up of suspense. It's all over too quickly with a homer. Nobody sits tensely on his seat after a homer is committed. The catharsis is complete.

But a triple? We have got to get Buster home.

The double-play is the other side of baseball—the grace and skill of fielding as opposed to the power of the bat. To see force put down by grace is a most satisfying thing. A powerful ground ball is scooped up at third, shot over to second and relayed quickly to catch the runner at first. Virtue has somehow triumphed. A good double play is a beautiful thing. I, for one, find it the one thing that can be done by the Hated Foe that I can condone and sometimes even approve.

But let us get back to the triple. I find that there are deep psychological facets to this bit of offensive strategy that I had never plumbed. Where did I get my new insights? From, of all people, a practicing major-league baseball player, George Foster. George has REALLY given some thought to the triple.

"I don't know why people like the home run so much," he said recently. "The triple is the most exciting play in the game. It's like sex. A home run is just slam, bam, thank you, ma'am. It's over as soon as it starts.

"But a triple is like meeting a woman who excites you, spending the evening talking and getting more excited, then taking her home. It drags on and you're never sure how it's gonna turn out until it happens."

Now there's a man who knows what he is talking about. His

words take me back to the days of my youth when I spent many a day marooned at third. So near and yet so far! as Romeo must have mused more than once in the presence of his beloved Juliet.

The triple as sexual foreplay is a brilliant conceit, for which I thank Brother Foster. You are almost home in the metaphorical sense, in the technical baseball sense, and in the sexual sense.

Every muscle within you strains, as you sneak as far away from third as prudence and the coaches will permit you. Your mind is home but your bod is anchored somewhere south of third. It's the Devil and the Deep, Scylla and Charybdis, nervous under the sword of Damocles.

There's nothing in baseball quite like being left at third after the final out. Your discipline forces you to continue to use your skills but a little something gnaws at your heart for at least an inning or two. The glittering prize has gone, and you have nobody to blame but your teammates. You did everything short of hitting a homer, and nobody would bring you home.

But the orgiastic delight of streaking over home plate after a clean hard single or a sound sacrifice fly! Ah, yes, Brother Foster, that's real sexy.

cA Bit of Sun

*I*t was one of the few fine days of our recent peculiar spring. This chap I knew decided to go down to Washington Square Park, and lie in the grass and take a little sun. This he did, a few yards from Mr. Franklin's monument.

He did not actually want to go to sleep, so he lay in comfort on his elbow. His comfort was soon disturbed. He watched a young man approaching him who was almost certainly bad news. "He'll put the arm on me for something," he thought.

He dropped his elbow and pretended to fall asleep.

This did not disturb his visitor at all. He just stood over the recumbent figure, a presence to be felt with increasing intensity and annoyance by that figure. After a while he opened his eyes, looked straight at the intruding figure and said, "What do you want?"

"Do you mind if I read you a poem?" asked the young man.

Things like that are always happening around North Beach, which is one of the reasons I like the place so much. To use one of our most durable cliches, the unexpected is the norm here.

The beach is, as I have often said, probably the most European place in America, even though there has been a recent heavy Oriental influx. Italian is still spoken nearly as much as English and the Italians have been more faithful to their city than the Irish, who have virtually abandoned the Mission, their traditional abode.

A great many Italian gentlemen here manage to be great adulterers and also great fathers and husbands. And at the same time they are deathbed Catholics but loyally support the demands of the two Catholic churches in the neighborhood, Sts. Peter and Paul and St. Francis of Assisi. That's the way it is in Italy, and that's the way it remains here.

And we have our beloved eccentrics, not necessarily Italian. There is a Scandinavian longshoreman called Sven. Sven drinks. He drinks a lot.

Once he had so much that he was taken in for public drunkenness, and had to go to trial. (Usually the cops just let the drinking fraternity dry out and then send them home.)

Came the day of the trial and Sven put on his best and only suit and appeared before The Law. The judge said not unkindly, "Mr. Soandso, I hear you drink quite a lot."

Sven drew himself to his full dignity, "Not by North Beach

standards," he said. He got off.

Another time, having exhausted all the saloons in the neighborhood on account it was 2 a.m., Sven went back to the flat which he shared with a lady. As usual, he lay back on his bed and turned on the tube. He could not drink because the lady would have none of the stuff in the house.

In the midst of one of those dreadful early morning movies, there came on the authoritative voice and message of the man from Raleigh Hills alkie reform school, who urges people just like Sven, and the rest of us, to avoid the Demon Rum.

When the vibrant message was finished, Sven turned to his friend and said, "Ask them if they deliver."

When the sun *does* come out the old Italian gentry move out of Capp's Corner and the Columbus Cafe like snakes who have been in the ground too long. Most of them are old sports and gamblers to whom Rocky Marciano is more important than the Pope.

They talk the morning line at the tracks as they mop up the sun. This is a racial memory. This is sunny Italy as their forebears knew it. This is where they want to go when they die.

cA Good cMan

There is an ancient academic wheeze to the effect that Henry James, the novelist, wrote like a philosopher, while his brother William was a philosopher who wrote like a novelist. All of which is true.

I was minded of all this the other day when I read what William James once said was the purpose of education. "Knowing a good man when you find him," he said.

Goodness, like quite a few things, is easier to recognize than to define. Webster is less than helpful: "Sufficient or satisfactory for its purpose."

I've known a fair share of good men and women in my time. It is not easy to state what the quiddity of their quality was.

A fair part of it, though, is that they were true to their own nature; and therefore, in the words of the Bard, not untrue to any man.

It is too harsh a thing to say that a man is not a good man if he is engaged in work, or lives in a personal relationship which is untrue to his nature. This is one of the things that is too close to the truth to stand much scrutiny.

You cannot fulfill yourself, and the good man is above all things the fulfilled man, if the main ingredients of your life are straining against your nature.

This almost amounts to saying that the good man is the happy man. I would not hesitate to go this far.

A good man is, among his other qualities, a person who treats others as if they were good. Goodness, more than almost any other quality, breeds itself. You treat a man, or a woman, as if they were a decent sort, and the battle is very nearly won.

"Treat people as if they were as good as you would want them to be," said Goethe. "It is the only way to make them so."

And I do not see how you can be good if you are not courageous. The saint who sits on the top of a pillar is not necessarily a good man. He may be in some contexts, a bad fellow indeed.

The good man is in the midst of life at all times. He has an interest in bettering the lot of other people, because he is one of them. He is involved, to use a word that is wretchedly thrown about these days.

Yet it must be admitted that a good man is a fellow who leads a lonely life.

Most of the rest of us groundlings prefer to hang around

with the wicked, with whom we feel at home. I like Mozart, but would prefer to hear funny stories. There are times in life when, for the extraordinarily lucky, you can do both at the same time.

I cannot say I am a good man, nor am I sure I would want to be one. There is something unnatural about the state of goodness. People were made to be human, not good.

If all of this seems a bit contradictory, lay it onto the fact that that's the way I happen to be feeling this particular morning.

I'm sure the world is that much the better for the existence of good men. I admire them. I root for them; but I really don't believe in them. The righteous keep saying warts and all. I insist this is simply a description of the species. Saints and criminals are aberrations, and therefore contrary to nature, and therefore bad. Next lesson. . . .

'Let's Go Outside'

I shall strike the elegiac note this morning. BOOOOOM: This is not because, like so many of my contemporaries, I find that the good old days exceed in every particular anything the '80s have to offer.

For instance, ladies look better to me every day, and great music is much easier to come by than in my youth—and a couple of thousand other things, like Perma-Press trousers.

There is one institution that flourished in my youth, and seems to be vanishing through simple desuetude. This is the fistfight. I realized the other day that it been years since I've seen one, and I do not lead all that sheltered a life. I asked a number of old boys. Their recollections were equally barren.

Like a lot of things, the fistfight can be best defined by saying what it is not. It is not throwing punches in a barroom because somebody has impugned the chastity of your companion, or the color of your eyes.

Throwing punches is mindless and settles nothing. It is an act of quick passion which is strictly quelled by annoyed neighbors, as perhaps was intended all along. Throwing punches can develop into a melee, and that, too, is what the fistfight is not.

The classic fistfight usually derives from something as simple as a slow burn. Some malign chemistry is set up between you and some other guy. He knows it too. Often a lot of people know about this building chemistry, and know a fight will come of it.

The salient thing is that there is nothing *sudden* about a fistfight. It's free-form antagonism, in that the fight is predictable but the circumstances leading to it are fluid. There is an issue, a point to be settled, and he who wins will be the best man. There is even a kind of primitive justice in it.

The time comes and you have had all you're going to take from this guy. "Let's go outside," you say. So you go out into the nearest alley, strip your coat off and either demonstrate your point or fail to. When it is over, you shake the guy's hand. Or, if you don't, the spectators do it for you.

The unlikely outcome of many a fistfight has become so boring as to make a cliche: The guy you fought becomes your friend, maybe one of your best friends. The young may not believe me, but that's the way it often worked out.

It is the measure of our times that fistfights do exist these

days, and the underlying causes and antipathies are still the same, but they are fought with switchblades and Saturday night specials. The fistfight nowadays is a criminal enterprise, and often an extremely complicated one. If anybody shakes hands with a guy who knifes him, I haven't heard of it yet.

All this is a loss. Hence the elegiac note. I suppose I have been in scores of fistfights, in the course of growing up in New York City. I usually lost them because I'm badly coordinated and can't see too well, but I never questioned their place in the scheme of things.

The fistfight was, in fact, our own irregular system of law and order. Even the cops recognized this, and seldom intervened in such an engagement until it got so big that it threatened street traffic.

Most of all, there was a "reason" for the fight. When it was over, and often before it began, people could say what the contest was "about." What it was about usually vanished in thin air when the bout was over.

This energy is still around, but what are its uses? Shooting old people you don't even know? Fights are now between criminals and victims. The fistfight was a rite of passage. It helped to make a man of you.

cA New Loneliness

Unless my perceptions are very wide of the mark, people in this country have changed since World War II. It has always been one of my deepest-held convictions that human nature changes very little through the centuries, that the Athenian and the New Yorker would react quite similarly to the same kind of stimuli.

It's hard to put a finger on what I mean by this outward change in the American character. I used to theorize solemnly that the change came from side-effects of our unleashing the atom and creating a weapon that could destroy us all. Now I'm not so sure.

There are doubtless a great many things that contribute to this change, and which really need a book to explore, but I increasingly focus on what television has done to the American character since it began to burgeon in the '50s.

A while back Los Angeles Times columnist Art Seidenbaum wrote a heart-felt piece about the fearful passivity induced in Americans by hours of prime time spent in "the sovereign state of catatonia.

"Prime time itself describes a universe of shut-ins. Prime time used to be when people quit the day's labors and went out among each other, to eat, drink or even serve good causes. Leisure was what a person wanted to do, not an exercise in being left alone with electronics.

"When television began mesmerizing Americans, we wondered whether it would stupefy children—encouraging them to be nonreaders and nonparticipants. We didn't wonder enough what it might do to insulate adults. I think television incites people to do nothing, meet no one and pass prime time in a pre-sleep condition."

I am by nature far too passive for my own taste. It is chiefly for that reason that I have declined to get hooked by the tube. I seldom look at anything save news at 7 a.m. and 6 p.m.

This creates a barrier between me and people who are hooked. I am aware of this when, of a morning, I find the conversation of adults is almost exclusively of what they have seen the night before.

A while back a pleasant young fellow came up to me in a restaurant and said he wanted to meet me because he was a "news groupie" and wanted to meet people who worked on news-

papers. It turned out he was a celebrity of the first water, Robert Walden, the hot-shot young reporter who appeared on the Lou Grant show.

I had never seen the show, and now, of course, never will. I am almost completely insulated from the television world, and trust it will stay that way. I prefer that to being insulated the other way.

There are drawbacks to this rigid stance, and I recognize them. Columnists are supposed to know and share the concerns of other people, and these days most of these concerns rise from the tube. Much rich material for satire and rough comment is missed by people who do not devote hours of their lives to what the tube says.

I don't want any part of this new loneliness that Seidenbaum described. It is an inhuman condition, a deliberate removal of self from the concerns that have always moved human beings. Worse, it is an abdication of self.

Even if television was good, it would be bad. If the commercials were not so appalling, if the meretricious appeals to the greed of children were not so blatant, if the taste of the sitcoms were not so appalling, the medium would still have the effect of turning people into robots.

Nothing Orwell invented for 1984 is quite as horrifying, viewed *sub specie aeternitatis,* than what television has done to the soul of man. And this was not done by some malevolent dictator. It was done willingly by people who designate their own species as sapient. The television tycoons merely found a need and filled it: the need for nescience.

Black and White

Can you honestly say that after your early formal education you have absorbed a single really important new idea that has changed your life? While I have no doubt a good many of us truly have, I fear that for most the answer would have to be a firm negative. What we have to act upon, for the most part, are our instincts and our schooled rationalizations of same.

How few of us, honestly, have been greatly influenced by the revolutionary ideas of even Darwin and Freud? These ideas have unquestionably affected the content of the intellectual air we breathe, and to that extent of course touch upon us; but have they really changed the way we look upon our fellow man, which is the thing that matters? Permissive sex in the '60s and '70s would have come about, I daresay, even if Freud had not opened the Pandora's box of the unconscious.

What gets me onto this is a sentence I read a long time ago, and which has stayed with me in a rather dismaying way since. It was an insight of the late Justice Oliver Wendell Holmes Jr.: "Every now and then a man's mind is stretched by a new idea and never shrinks back to its previous dimensions."

For a long time I had thought that I might be one of these favored, stretched-out souls. For the life of me, however, I could not put my finger on that single idea which may have opened my mind, may have widened my avenues of prejudice. It became a source of mild annoyance that I could not elect myself to Holmes and his goodly company.

The other day, between the coffee and the French roll, something came to me. It seemed clearly an answer to that large quest. I quickly grabbed a pencil and wrote it down:

"Men are not so far from animals, and are far closer to each other than they will grant."

This may not seem so remarkable to you. It might seem, in fact, a rather, banal derivation from Darwin's notions about the origin of species. But to me it has been, as I realize, an unformulated talisman during much of my grown life, a talisman which has changed utterly the quality of my early education.

Like most of us, I was brought up in a world of straight black and white. The world was made up of saints and sinners, whores and madonnas, creators and predators. I will never be able to extirpate from my system these absolute values, when I am judging other people. Everyone I like I cast far too near to

the pole of saintliness. Everyone I dislike is automatically pushed rigidly toward Satanism.

Yet my adult experience has been clear, and opposed to this. The color of gray is the dominant color of all people, including the saint and the sinner. Until you think gray, you are lying to yourself, and also doing an injustice to the one you are lying to yourself about. I hate to think of how many marriages could have been saved if the gray could have been used by each party in their coloration of their beloved, which is another way of lamenting how many marriages have been ruined by the growth and persistence of the notion of perfection on either side.

This is not to say that some people are not better than others, in that some conform more closely to the ideal generally accepted by our civilization—the person who follows the way of Christ. It is the corollary that is dangerous: That people who are more good than others are more good than others all the time. And that bad people are generally or continuously bad.

It is a terribly bad idea to operate on the principle that men and women, including and especially yourself, are good or bad, black or white. They are just damned people, just like yourself, and not very far from your dog and your horse. Just demented and bewildered children trying, in E. A. Robinson's telling phrase, "to spell God using the wrong blocks." Think black and white, and you're in the soup.

Lordly Utterances

"*L*ove," said the man, "is a venereal disease." And when you consider the subject in a certain light, it surely is.

The man continued, with considerable eloquence: "The contact, gestation, symptoms, suspicion, realization, involvement, prognosis and eventual partial cure physically and perhaps mentally. . ."

Apart from its considerable pith, this is what I call a lordly utterance. This is the kind of statement which has a majesty which transcends truth. The lordly statement is sweeping, general, and literally defies contradiction. Those who are hooked on this column are not unacquainted with them.

A splendid and long-remembered lordly utterance came some years ago from the finest actor in San Francisco, a man who has never professionally crossed a stage. This is attorney Bill Wallace. He is a great and amusing talker.

Bill and his wife, the actress Ina Claire, were once dining with his client, Louis Benoist, who produced wine under the Almaden label. The host offered the Wallaces some California champagne of which he had a pretty high opinion. Bill turned it down with a great circular wave of the hand.

"No, thank you," he said, "there is always about California champagne that whiff of the alfalfa."

A great one for lordly utterances was Evelyn Waugh, who regretted passionately that he had not been born a peer of the realm. This made him talk more like one to the manor born than the real thing. I've never doubted that one of the chief reasons he converted to Roman Catholicism was snobbery, since the grandest families of England are those who kept the faith through the rough days of the Reformation. Anyone who did not subscribe to Waugh's totally reactionary brand of Popery was dismissed as "a filthy atheist," even if he was a Popish man of the cloth.

Waugh's son Auberon, known to his friends as Bron, is cut off the same cloth. He is a brilliant young journalist, and a male chauvinist pig of the first water. A recent Bron Waugh utterance on the subject of women's liberation:

"I have never been able to understand the particular advantages and pleasures of a gang bang, especially from a male point of view. Some women may find it satisfactory, I suppose."

Most lordly utterances are intentional, but some are simply

statements of fact which have the same stunning effect. Such a one was heard many years ago in Paris by my former Wiltshire neighbor Victor Bruntisfield, who is in fact a peer of the realm.

Lord Bruntisfield was dining at the table of a legendary host, Arturo Lopez-Wilshaw. Lopez-Wilshaw was an immensely wealthy Argentinian emigre, who collected just about everything. Through the meal the Englishman observed with fascinated interest a pair of most beautiful cufflinks worn by Lopez-Wilshaw. When the men were alone over the port and cigars, Lord Bruntisfield looked at the cufflinks pointedly and asked:

"Faberge?"

"No," replied his host. "Benvenuto Cellini."

According to Hilary Belloc, son of the great Hilaire, his father claimed that the Salvation Army was a group which spied on the poor for the establishment. There's a beaut.

I leave you with a final lordly utterance. Last year the high spot of the opera season was the Beverly Sills' "Lucia." There is this guy who was invited to it with dinner before. After that lovely sextet was sung in the second act, this guy turned to his neighbor in the box, a former publisher from Monterey, and said, "After the sextet, it's all downhill." Ignoring the fabled mad scene, he marched down to the bar.

Throwing Port

This is a tale of throwing port and cooking sherry, or I like to think it is.

We all know what cooking sherry is. Throwing port is something I had not heard about until the other night, when its existence was made known to me by Mr. Hilary Belloc, a distinguished son of a remarkable father.

His father, the writer Hilaire Belloc, was that almost impossible combination, a French Englishman. He was said to be the best French writer who ever wrote in English and the best English writer who ever wrote in French. The son of a French barrister and an English wife, he was almost ruined by the combination.

In addition, Belloc was a red-hot Catholic, educated at the Oratory School in Birmingham under the great Cardinal John Henry Newman. Belloc wrote wonderful nonsensical verse for children. Just about the only book I ever read to my children was his marvelous "Cautionary Tales."

Belloc was a great friend of G. K. Chesterton, that gifted and word-besotted Catholic journalist, and of Maurice Baring, scion of a great Jewish financial and commercial house, also a distinguished writer. There is a wonderful picture extant of these three worthies by Sir James Gunn, which catches the good and convivial life as well as anything I've seen.

These three souls were the life of many a dinner party at the home of the Bellocs. Belloc and Chesterton were so close in most of their views that somebody, I think G. B. Shaw, coined the word Chesterbelloc to embrace them. They were also mightily contentious fellows.

When the post-dinner arguments began to get properly intense, and the angels who could fit on the head of a pin were being severely counted, Belloc would make a signal to the butler.

Then, according to his son, the butler would discreetly switch the port. The good port was exchanged for the throwing port. It was a certainty that before the night was over one of the disputants, usually Belloc, would fling a glass of the stuff at whoever was in opposition.

Some port may have been thrown by someone the first time Maurice Baring told a well remembered story. It was about two doctors, one a Roman Catholic and the other a renegade.

"I posit you this situation," said the Romish doctor. "We

have a husband and a wife, both of whom have congenital syphilis. Their first son was born blind, and lived only ten days. The wife is again pregnant. What would you do?"

The renegade doctor replied resolutely, "I would terminate the pregnancy."

"You have just killed Beethoven," said the Roman, who knew his facts.

I love to tell that story, being notoriously backward on the matters of population control, eugenics and all.

This is as good a time as any to put down another canard about Belloc. He was widely held to be anti-Semitic, which may or may not be so. He is also widely believed to the author of the lines: How odd of God, to choose the Jews.

This is not so. I once met the man who wrote the lines in the Fleet street pub called El Vino, usually called by its habitues El Vin's. He was a courtly old gentleman of 80 or so named Bill Ewer. He had been an editorial writer for The Daily Telegraph for as long as anybody, including Mr. Ewer, remembered.

He was aware of the attribution to Belloc and said, "It couldn't happen to a nicer man."

Ah, we were to say something of cooking sherry. Frankly, it isn't worth a mention.

'Senior Citizens'

*P*eople who are older than I may not mind, but I hope never to be called a "senior citizen." My hopes haven't much to ride on, since the expression has been practically riveted into our language by politicians and bureaucrats.

A "senior citizen" to these characters is an old goat and his wife who vote. It is a patronizing and dehumanizing expression. The "senior citizen" is catered to not because he has one foot on a banana peel, or because our culture respects the old; but because he has a vote, and can possibly influence one or two more.

This view of a human being is an insult. I daresay that the villain who invented the phrase thought he was taking the curse off "old people" or "aged folk" or something of the sort. Calling an old person a "senior citizen" is like calling a job office a "Department of Human Resources Development," a euphemism only a politician could think of.

Yet I have never been able to think of a decent substitute for the old. Other languages have expressions that connote both age and respect. When the Spaniard says *"Viejo"* it is a term so full of respect that it is often used for young persons whom one loves greatly.

The name of our chief law-making body comes from the Latin for old man, *"Senex."* Senate means "council of elders." It connotes respect and wisdom, as indeed it should. The best American English can seem to provide is "old man," which conveys neither. And the noxious locution at the head of this column.

The answer, the simple and perfect answer, to my quest came unexpectedly from E. Fritz Schmerl, M.D., a man whose job it is to work with old people.

He has the word. It is elder. Repeat, *elder.*

That Americans are afraid of old age is a cliche. That does not make it less true. We do not have a single convenient noun to designate an old person, though we are very good on the other age groups: embryo, fetus, newborn, infant, child, the adolescent and the adult.

Dr. Schmerl is engaged on a campaign to get the word elder used with the specificity and lack of denigration of those other words. I am back of him 100 percent. Elder is simple and sweet. It does the job. It sounds good to my ear. I like old people better when I write elder or when I say it.

Says Dr. Schmerl: "We are becoming more involved with

the phenomenon of respectability in old age, with creative performance, with its aspects of personal dignity and joy, with individualities and independence.

"Yet professional terminology still smacks of old stereotypes: the leveling term *older adult* refers to a certain type of adult, while, in reality, the variety among the elders is just as kaleidoscopic as among the middle-aged adults."

Elders are okay. Take the widely held idea that they are physically weak and generally suffer from poor health. Actually, the majority of elders are healthy and capable of usual physical activity, including climbing stairs, lifting normal size packages, and walking reasonable distances.

Only a small minority of elders (four per cent) require hospitalization or nursing home care. Only about 11 per cent are homebound. The remaining 85 per cent are in general good health.

Nobody is quite clear when one definitely becomes an elder. I should say when the fare on the Muni goes down to a nickel, which is at 65. I'm not quite there yet; but when I am, you may be certain I will stick my blackthorn stick in the chest of anyone who calls me a "senior citizen." "I'm an elder, goddamn it," I shall say. With pride.

'Pops' at the Vatican

Ernie Anderson, a gray-haired press agent who always wears blue-tinted shades, was for a long time media representative for the great Louis Armstrong, whom he called Pops, as did all of Louis' close friends. Ernie was traveling with The Master in Europe when he hit on one of his great ideas: How about getting Louis and the Pope together?

The Pope at the time was Pius XII, who as Eugenio Cardinal Pacelli had been Apostolic Delegate to the U.S. in the 1930s. He thus spoke fluent English. Pops was never sure that what he spoke was English; but he knew he could get dug in his way.

Ernie, with no little help from certain rich Americans who had bought their way into the papal aristocracy, managed to set up a date. He had not told Pops. When he did, the answer was No, for the reason Pops had never heard of the Pope, or what he represented. Ernie, a most plausible fellow, put it this way.

"Pops, you know this, don't you? There's only one Louis Armstrong in the world. Only one Louis. Right? Right? Same with this cat. There's only one Pope in the world. Only one. Right?"

Pops, who had an ego the size of an ice floe, was sold. Pops and the Pope were to meet, in a private audience at the Vatican in Rome.

When he really got the idea, Pops went to work. A papal guard, who was formerly an American Communist, was dispatched to teach him the drill. Pops got the striped pants, and the clawhammer coat. He rehearsed, like a good trouper. He even swallowed the bit about kissing the ring of Peter.

The great day came, with the news services and Osservatore Romano duly informed. The improbable summit meeting was a great success. The Pope knew about Armstrong, if Armstrong did not know much about the Pope. There were mentions of old Armstrong 78s, and of his immense contributions to popular culture. Pops, on his side, said the meaningless little amenities in which he had been skillfully coached.

The audience over, Mr. Anderson permitted himself a big fat sigh. Naturally, he wanted a few snappy quotes from The Master to feed the boys from the wires. As they left the Palace, somewhat later, the press agent asked Louis what he thought of his new friend.

"Man," he said, rolling those famous eyes, "dig those crazy

red shoes."

The reason why the pair didn't leave the Palace immediately was that Pops asked the papal guard, who had accompanied them, "Man, where's the can?" For The Master had had one of his unending series of calls of nature. He was led to the right bit of majestic plumbing, his need was satisfied, and the visit was at an end.

Pops lived by two things which were always in trouble; His lips and his bowels. There was always some new unguent or other he was discovering to keep his lips in shape, the better to play his recalcitrant old instrument.

The bowels were another matter. They were something of an obsession with him. He suffered from constipation, and spent literally hours each day on the old john. He had a theory he would live to age 150 if he could only keep the intestinal flow sweet and strong.

To this end, he would take in immense quantities of a product called Swiss-Kriss. The property of this straw-like stuff was that it bloated prodigiously when it came in contact with solid and liquid foods within the body. This, in theory, helped the old flow.

There was nothing on earth that could keep Pops' attention like word of some new laxative, like from the plains of Afghanistan. He was not anal-oriented, he was anal-centered. Lord knows what connection this had with his true splendor as a musician.

Once I asked Pops about marijuana, which he called tea or muggles. In those days, it was dread dope, leading to insane death and deflowering children. What I wanted to know: Was it addictive? Said Pops: "You crazy, man? I been using it for 30 years."

The Cats of Zanzibar

*I*t was the view of Mr. H.D. Thoreau that "It is not worth while to go round the world to count the cats in Zanzibar."

While this *sounds* charming, I am not altogether sure that I know what it means. Yet I am sufficiently aware of the general cant of the man's thinking, and of his views on travel in particular, to think that I do know what he means in the passage and that it is important to me.

In a famous passage on travel he also said: "I think I would rather watch the motions of these cows in their pasture for a day, which I now see all headed one way and advancing—watch them and project their course carefully on a chart, and report all their behavior faithfully—than wander to Europe or Asia and watch other motions there; for it is only ourselves that we report in either case, and perchance we shall report a more restless and worthless self in the latter case than in the former."

What we are being told by Mr. Thoreau, in any case, is that the real journey is within. The excitements of Tibet, and the cajoleries of Paris, and the lyric beauty of an Irish country-side, are as nothing to those discoveries, which almost always spring up unasked for and surprising, to make us know some little more about ourselves and our capacity to love.

While I think the journey is inside, I find that I can make this journey more usefully in foreign places than on my own turf. Had I the pond at Walden rather than the raucous charms of San Francisco, perhaps I would rather stay home and count my cows while trying, contrapuntally, to find out how the Lord had put me together, and how best to use what I found.

I travel, not to see the world, but to find myself. The stimulations of city life put a sensory burden on me that I find it impossible to digest. This is a weight which in due time becomes a form of stress.

The thing to do then is to get away, at least a thousand miles or so away, and lie in the sun or in a bare hotel room. Here, like some kind of giant serpent, you just lie down and digest that great mass of impressions you have been loaded with.

For the first few days I read nothing but light magazines and mystery stories. That, and walking and the fact of being inert, are immensely pleasing.

Then the funny thing happens. From nowhere at all come

little tags and sentences. They are sometimes so fragile that you must be sure to have some kind of small notebook along to record them. Your unconscious is talking back to you, at the end of the long digestive process, and what it is saying is stuff that you should measure and treasure.

These thoughts and scribblings are not something to be entered into Bartlett's Familiar Quotations; but they have the curious quality of illuminating large swatches of your experience. You find that people you thought you liked immensely really have no meaning for you at all. More important is vice versa—you see the value of people you had not valued sufficiently.

Meantime, the cats of Zanzibar, or the cats of whatever, are roaming without. You are just not paying any attention to them, even though your friendly travel agent has told you the purpose of the voyage was to see and study just these strange cats.

I have friends from California who go to the same town in Mexico that I do, and at the same time of year. They think it very odd of me, indeed, that I appear to actually be avoiding them. I cannot tell them that when I am traveling *they* are the cats of Zanzibar. I cannot tell them that the rapping between my inner self and my outer self is so much more exciting than anything else I know when abroad. It would be rude to tell them the real journey is within; but that is so.

No Room at the Inn

*B*ecause of those silly Roman laws, the couple, who were traveling to the husband's hometown, had to check in at an inn to comply with a census the Romans were taking.

They found there was no room for them, and their child was born in the nearest and warmest place they could find, which was a stable in the town of Bethlehem, Judea.

The boy, who was descended from David through his father's line, probably followed his father's trade and worked as a carpenter and a joiner.

His spiritual life really began when he was 30 or so, and was baptized by his cousin, a pretty revolutionary fellow called John the Baptist. John believed in repentance and forgiveness, and denounced Herod Antipas for divorcing his wife and taking a new one. The daughter of Herod's new wife, Salome, asked for John's head, and got it.

The young man, named Jesus, carried on the mission of John, and brought his teachings to their logical conclusion.

This fellow Jesus said things like this:

"Love your enemies." "Ye cannot serve God and Mammon." "Therefore all things whatsoever ye would that man should do to you, do you even so to them."

He was doing the most revolutionary of things, using love as a political weapon.

With Herod watching, he drove the money lenders from the temple, and performed miracles on the Sabbath, and hung around with a questionable crowd, which included publicans and sinners. His worst sin, in the eyes of the procurator of Judea, was the Sermon on the Mount. After that, a contract was out for Jesus.

After living in Tyre and Sidon, Jesus returned in triumph to Jerusalem during the week of the Passover. He had a meal with his 12 disciples, and was betrayed by one of them with a kiss.

The ruling clique, who knew they had to get rid of this strange and loving man, fixed it up so that he was condemned to death after a hurried trial. He was crucified and His followers deserted Him.

The cross upon which He died became the symbol of His teachings and remains so today.

No western man alive today, whatever his religious persuasion, or lack of it, can say that his life has not been affected, and

deeply, by Jesus Christ.

Christianity, as of today, is still but a promise, but how bleak our life would be without that promise!

We are too imperfect to love our neighbor just because we are told to do so, and just because we know we should. Yet we do know that we should, and in that sense Christianity has been a success, if not a triumph.

Christ still endangers the establishment. If all those oily-tongued preachers who exist by mouthing what they call the words of Christ were to be confronted by the serious implication of love, both politically and personally, they would be among the first to hit the border.

We are not ready, yet, for the teachings of Christ. It is my hope, and I trust it is not a deluded one, that we each day become more ready.

Perhaps the only way we will become Christians is by being frightened into it by that big dread bullet called the atom bomb.

However we makc it, there is something deep in our natures that deserves Christ and His teachings. If we have to be frightened into His arms, this too is an irony that Jesus of Nazareth would have appreciated.

'Who's Afraid . . .'

There was an interesting footnote to literary history in a recent issue of a weekly magazine. The new play of Edward Albee was being reviewed, and the failure of his talent since the 1962 opening of "Who's Afraid of Virginia Woolf."

A footnote said that in a Paris Review interview sometime back, Albee credited this arresting title to "a distinctly literary graffito inscribed in soap on the mirror of a Greenwich village bar."

I fear that is not the way it was, Brother Albee. The phrase is pure San Francisco-Berkeley, and originated here. Let me tell you why I think so.

In the late 1950s I lived on the rich side of Telegraph Hill, the side where Horace Stoneham of the Giants resided. Each day I used to talk down to Mission street, where the Chronicle was located, and on which I worked sporadically until 1959, when I took hold.

It was quite a marvelous walk. You went down Grant avenue all the way to Market, then up to Fifth and over one block to Mission. You passed through a fascinating congeries of cultures:

The Italian part of North Beach, passing a lot of street people and their friends, who later became The Beat Generation, and still later the Beatniks; the bustling culture of Chinatown, where the residents tended to walk four or five abreast, as they still do, and after California street the metropolitan culture of the downtown shopping and financial district.

At night-time, I spent a good deal of my time in the places in North Beach inhabited by the poets and poetasters, the painters and the daubers of the area. The two places I liked most were Vesuvio's on Columbus avenue, and Twelve Adler, in an alley across the street.

Twelve Adler was owned by Coke Infante, a man of prodigious talents, and Frank Guidera, a man of infinite charm. Eartha Kitt used to come in when in town. Among the regulars were various reporters from the Chronicle.

Vesuvio's in those days was owned by Henri Lenoir, who deserves a learned monograph in himself. Henri went to a posh British Catholic public school, Downside as I remember it. He spent much of his life in Paris as a tango dancing partner, sometimes called gigolo, with such other impoverished charmers as Prince Serge Obelensky.

Henri started his days here as a peddler of silk stockings to the Irish, German and Italian housewives of the avenues. He had taste and wit and a Bohemian bent. He wore a beret then and he wears it now. He is long out of the saloon biz.

Vesuvio's was fun. The window advertised "Booths for Psychiatrists." Henri had a passion for old postcards. He made a slide show of them which ran several times a week. His customers had a passion for writing funny, sacrilegious and obscene things on the walls of the john. These were called graffito, after the similar scribblings on the walls of ancient Roman bathrooms. They were a new thing then. They were done with a lot of style.

In those days I was also writing 1500-word causeries for the editorial page of the New York Herald Tribune. This page, under the editorship of Bill Miller, was a bright thing in literate daily journalism.

One of my pieces was about Vesuvio's, the Beat Scene, with emphasis on the graffito. It was headlined "Who's Afraid of Virginia Woolf" because that was clearly the best of the graffito quoted.

It is most unlikely that this graffito appeared on a Greenwich village wall or mirror, since the essence of the Bohemian bar graffito, like that of a quadruple murder, is that it is news. If it had been in the Trib, it was no longer news. Credit should be given where credit is due, and in this case it is due to the men's room of Henri Lenoir's old Vesuvio's.

Balanchine on Age

George Balanchine, the Russian choreographer, was asked how it happened that the great man seemed to grow in vigor as he grew older. Balanchine replied:

"Old people don't get tired—it's only the young who tire. Confusion exhausts them. I've got more energy now than when I was younger because I know exactly what I want to do."

This may seem like strange advice to most people of a certain age, who are physically decomposing before their very eyes, as it were, and experiencing great discomfort. It does not seem so strange to me, however.

I have spent a great deal of my life in a state of almost total confusion. It was not until I was well into my 40s that I found work that satisfied me. When I found that what I was doing was just about exactly what I wanted to do, both my physical and mental condition began to improve greatly.

The frustration, fatigue and exhaustion of the years before a benevolent editor decided that I should be a newspaper columnist, are hard for me to believe today. I was, as I now realize, a victim of what is called the biological stress syndrome. Damaging or unpleasant stress is called distress, in the vocabulary of Dr. Hans Selye, of the University of Montreal, the pioneer in this field of medicine.

Distress can make you damned sick. As Dr. Selye acknowledges, even the greatest experts in the field do not know why the stress of frustration rather than that of excessive muscular work is much more likely to produce disease such as peptic ulcers, migraine, high blood pressure or even a simple "pain in the neck."

"The best way to avoid harmful stress," says Dr. Selye, "is to select an environment (wife, boss, friends) which is in line with your innate preferences, and to find an activity you like and respect. Only thus can you eliminate the need for frustrating constant readaptation that is the major cause of distress."

That was just about the story of my younger days. I had the wrong wife, for me, the wrong bosses and the wrong friends. I defined myself as a tearing neurotic. I now realize that, while neurosis is decidedly a part of my personality, I was really a prime example of the distress syndrome.

In addition I had the wrong religion, which was none. I dropped away from Holy Mother Church at an early age,

through the influence of such writers as Ernst Haeckel, Joseph McCabe (no relation) and a lad named Voltaire.

As Dr. Freud has pointed out, the true believer is protected against certain types of neurosis. He accepts a universal neurosis and is thus spared the task of forming a personal neurosis. Most fanatics enjoy quite good emotional health.

I returned to the church in the mid-60's. Today I am a regular attendant at church and even an occasional communicant. I quite wallow in the universal neurosis, and feel infinitely more at peace with myself than I did as a young disbeliever.

While I doubtless lack the confidence of Mr. Balanchine, I more or less know exactly what I want to do for the rest of my life. I wish to do my work and keep out of trouble. Except for certain signs of age, such as a dicey memory, I can honestly say that I feel more vigorous and full of purpose than I did 20 or 30 years ago. And I feel even better having the corroboration of so distinguished a fellow as Mr. George Balanchine.

'Mere Buoys'

Largely because human life is so complex, and so beyond all reaching, I please myself with those facile and simple-minded generalizations that divide people into two classes: People who like tubs and people who like showers, day folk and night folk, bridge and poker players, bad men and good men, and like that.

This is all sort of comforting. It means, in a way, that you can put one crooked peg into two square holes. You get a specious kind of mastery over the most recalcitrant of materials. For a fleeting instant, you kid yourself that you have a handle on people.

A friend who knows my mild passion for these bifurcations has come up with a contribution from the Spanish philosopher Ortega y Gasset. It involves one of those sets of opposites that have deeply gripped me, each of them, at one time in my life. Says Ortega:

"There is no doubt that the most radical division of humanity it is possible to make is that which splits it into two classes: Those who make great demands on themselves, and those who demand nothing special of themselves, but for whom to live is to be every moment what they already are without imposing on themselves any effort toward perfection; mere buoys that float on the waves."

For quite a few years now, I have been a "mere buoy" and I have delighted in it. Before various fakirs made "go with the flow" a cliche, that is precisely what I was doing. I gave up, for reasons that were good and sufficient to me, the delusion that anything I could do would greatly influence human conduct, one way or another.

I do not know the exact hour that I gave up on perfection, but it was the best hour of my life. There comes a point when, if you have the luck and the wit, you realize that you are what you are. That, too, is a cliche, but when the truth of it comes to you with all its feral force, you know what life has in store for you.

That is: The chance to know yourself more fully, and nothing more. No writing of epics or constitutions, no leading of charges or landings on moons; nothing more than a protracted and in the end thrilling examination of conscience.

As I indicated, I was not always a "mere buoy." I belonged to the select and unhappy body called perfectionists. I thought that everybody I lived and worked with should be at least as compe-

tent and as prescient and as filled with wisdom as I was. And that I myself should pursue some not impossible He who represented perfection.

These impossible He's varied with great frequency, sometimes succeeding each other by the week. There was William Blake, there was Benjamin Franklin, there was old Plato, there was Alexander the Great, there was Jesus Christ.

Always there was the idea that I could move and shake. Most chances that were offered me in this direction I deemed unworthy of my attention. In those days I never wanted to be vice president of anything. In these days, I don't want to be president of anything.

To have gone from perfectionism to buoyhood seems to have been the most natural of progresses. There is nothing pleasanter than to float on the waves of life; but you must earn this pleasure. The way you earn it is to go through the frightful and, it must be repeated, unhappy novitiate of perfectionism.

You must put yourself through the turmoil that insists you can change the course of empire to win the serenity that comes from knowing that no one, not even such perfection-besotted heroes as Napoleon and Hitler, ever really does that. The Chinese, it is said, absorbed all their conquerors. Humanity does the same to its great heroes, and leaves its blessed fruit to the mere buoys.

The Broken Coin

*L*ove between man and woman casts out loneliness. That is perhaps the beginning and the end of it. I am thinking in terms of Plato's image of the broken coin. When the other half is missing, love is not there.

In our day and time, of course, it is quite easy to have a marriage based on strong sexual attraction and still be terribly lonely. Most of our marriages, after the first flush of sex, are like that, if we are to believe most of the polls on the subject. The divorce figures demonstrate amply that the institution of marriage today imperfectly fulfills our emotional needs, and specifically our need for that love which casts out loneliness.

The sexual attraction has for most of us little or nothing to do with love, at any age. If it could be thought of as something apart from love, or just usefully co-existing with it, there would be a lot less misery about.

The sexual attraction exists for one purpose. That is not the pleasure it gives us. It exists for peopling the world with our like. This is thought to be an ignoble motive in some quarters, where some people with quite a lot of money are being crowded by other people with much less money, and other differences, like color and religion. These people try to trade the joy of procreation for the pleasure of sex. Most of us find that a rotten bargain, in spite of those fake-joyous Zero Population Growth bumper stickers saying none is fun.

In its strong form, the sexual attraction exists for about half our life. This is the time of our youth and maturity, when nature requires us to create and rear families. The old are of no great concern to nature. To put it brutally, nature requires studs and mares. We forget this at our peril.

But before this period of productive usefulness, and during it, and after it, there is a positive need to share your life, both outer and inner. The inability or lack of opportunity to do this sharing is loneliness. Though some sturdy souls can abide it, loneliness is a most unnatural condition. In its prolonged and most acute form it is called desperation.

"I maintain, my brothers, that hell is the inability to love." Thus spake Dostoievsky, who knew a lot about the hell of loneliness. This is the particular hell of not being able to reach out, not being able to share, not wishing to enter the sanctuary of someone else.

Even the man who is hopelessly in love with an unattainable object is less than lonely, because he can people his life with dreams of possession. Dreams unfulfilled have more to recommend them than the achieved reality, as more than one wise man has told us. The green light at the end of the dock was more important to Jay Gatsby than life itself. He was a fool in luck.

The sad part about loneliness is not that it is unnatural, but that it has been forced on the lonely by some experience or experiences too terrible almost to be borne and certainly too terrible to look forward to again. The people who most need love, by one of nature's feral ironies, are nearly always the persons most often hurt by it.

To be forced into loneliness by neglect, or cruelty, or consuming love (or, as sometimes happens, all three together) is to suffer the fate of the walking damned. You are crippled in the worst way: You are unable to reach out. If the hurt has been great enough, you cannot even let your hurt be known. If it has been even greater, you turn the face of hate on the world. The coin will stay broken.

About sex and love, you might like something I heard the other night. "Think of all the lovers who are no longer friends. Think of all the lovers who are still friends. Think of all the friends who were never lovers."

&A Composed Life'

I fully go along with Socrates' idea of the examined life, and its difference from the life the ordinary man lives. I also esteem the way of life which includes the Christian examination of conscience. I usually do mine once a year and at sea.

But as a basic philosophy I value above everything I have encountered Montaigne's idea of the composed life. Here is how he describes it:

"If you have known how to compose your life, you have accomplished a great deal more than the man who knows how to compose a book. Have you been able to take your stride? You have done more than the man who has taken cities and empires.

"The great and glorious masterpiece of man is to live to the point. All other things—to reign, to hoard, to build—are, at most, but inconsiderable props and appendages.

"The truly wise man must be as intelligent and expert in the use of natural pleasures as in all the other functions of life. So the sages live, gently yielding to the laws of our human lot, to Venus and to Bacchus.

"Relaxation and versatility, it seems to me, go best with a strong and noble mind, and do it singular honor. There is nothing more notable in Socrates than that he found time, when he was an old man, to learn music and dancing, and thought it time well spent."

The point about Venus and Bacchus is well taken, for life is indeed a poor thing without the pleasures of the vine and the ways of women. There is something pathetic about a millionaire like Andrew Carnegie, with all his good works and his religiosity. Just as there is something robustly and completely alive about John P. Morgan the elder, who knew architecture, books and paintings as well as his vintages and his mistresses.

From time to time I do a thing I call editing my life. I go over what I think are my good and my bad qualities, and make several mild resolutions to improve the one and to mitigate the other.

Consistently, I fault myself on the pleasures in life available to me which I am too lazy or too ennuied to snatch. I love music and have not been to a concert hall in years, and go to the opera once a year when a friend provides Mozart. There are huge areas of popular music, starting with rock music, about which I know nothing and deliberately choose to know nothing.

This is what I take it Montaigne is referring to as "relax-

ation and versatility." To make money and to hoard it is indeed a small part of life, and I think I learned that lesson well when I was young. It is what to do with what money you have accumulated, by way of salary and investment, wherein I fell far short.

I have had the disadvantage of being very poor for a long time. The idea of paying six dollars or more for a movie or play strikes me as outrageous. I am stuck in the period when the movies cost less than a buck.

I know this is a perverse and disorderly reason for avoiding these pleasures. I tend to concentrate more and more on books (the prices of which outrage me too) and persuade myself, excessively, of the superiority of Jane Austen to a flick about space and what some Hollywood nitwits imagine happens there.

The cure is obvious. Open up the wallet a bit more, and let a little more life into my life. But not too much as to neglect my old friends, Venus and Bacchus.

It Floats

One of the few things in my lifetime that hasn't changed—save that it has become less heavy and more expensive—is good old Ivory soap. This is a gentle celebration of a wonderful thing.

I have known many glories and disasters in my time. There was the atom bomb and Babe Ruth. Lawyers selling apples in the streets in the 1930s and bizarre German-born secretaries of state in the '70s. The awful killing of the Lindbergh baby and the re-making of modern China. Lenin and de Valera. The strange death of President Harding and the even stranger fourth term of FDR.

And always there has been Ivory. Everything about this product is classic and correct. The white package, the chaste lettering, the classy blue wave at the bottom, are and have been for generations a beautiful creation.

The soap itself is white, the color of new snow. It has remained white in an age that has a deep prejudice against the color white, especially in soaps and toilet tissue. The soap looks clean; it smells marvelously clean; it *is* clean.

Even its ancient advertising slogans evoke the best of what Harding called the Era of Normalcy. "It floats," as indeed it does. "Ninety-nine and 44/100 per cent pure," as I am certain it is.

Ivory is a product of Procter and Gamble, whose chairman recently explained that he is not wholly sold on the idea that products have life cycles, and that Ivory is one of the chief reasons for this. The product has been on the market, virtually unchanged, for 97 years, and has remained a sales leader during that time.

"It isn't enough to invent a new product," he said. "The real payoff is to manage that brand with such loving care that it continues to thrive year after year in a changing marketplace."

A funny thing about Ivory is that its appeal as a product seems to lie with the down to earth classes—farmers, miners, ordinary folk—and with the absolute upper crust. The middle class, the supermarket buddies, like soap that is red or green or yellow, or something. Soaps that have a "life cycle."

The best hotels in the world, it seems to me, put out Ivory soap. Also the finest country houses, both here and in England, where the host is likely to offer either Ivory or the products of Floris of Jermyn street. In some fortunate premises, you can get both. Luxury cruise ships usually serve Ivory.

The places in California where you are most likely to encounter Ivory are places like Tiburon, Woodside, Santa Barbara and La Jolla—all spots where the living is easy. These are the places, too, where you are most likely to get white toilet tissue from the local markets.

Old money likes Ivory. You would do well not to underestimate old money when it comes to the simple niceties of life, such as soap and toilet tissue. Old money likes Tiffany lamps, homemade ice cream, and has a severe prejudice against frozen food. The long-time habit of spending forecloses on the shoddy.

It is a comfort to know that a thing as good as Ivory can survive in a marketplace of brutal vulgarity. It is a delight to see something plain white survive in a bazaar of kitschy pastels.

There are smells that bring back the pleasantest part of my childhood. They are both of soap—Ivory and Lifebuoy. One was clean and virginal; the other rough and medicinal. Ivory smells just the same today. The smell of Lifebuoy has long since been attenuated.

I now rise and approach my shower, with a small cake of Ivory in my hand. I will sniff it and think of my mother, of walks in Central Park, of the exploits of Nick Carter, of the Notre Dame footballers under Rockne, and other glorious things unspoiled in memory.

Looking and Seeing

To see is to have looked, surely; but to look is not to see. All of us look. So few of us see. When we do see, we are sometimes so struck by the strangeness of sight that we regard ourselves as a bit odd. We keep the experience to ourselves, thus lessening our capacity to repeat it. Seeing can be taught.

There seem to be two ways of seeing, apart from the natural gift which some people have. It can result from an act of will, as in the mystical experience; or it can result from a breaking down of inhibition, almost the opposite thing, through the use of hallucinogens. This can be from the use of mild alcohol to tremendously disturbing LSD.

Anyhow, once you have seen, you never forget it. Sometimes you never want to repeat it. Most people, though, would rather have seen and lost than never to have seen at all.

There are those who have the gift, unforced by either discipline or drug. I've just been reading the completely captivating "Self-Portrait" of Sir Kenneth Clark called "Another Part of the Wood." In this book Lord Clark tells of the youthful years he spent as assistant to that exotic figure, Bernard Berenson, the poor Boston Jewish boy who beame the great authority on Italian Renaissance painting.

Lord Clark, in retrospect, disliked the egocentric old boy considerably more than he liked him. When he first came to Berenson in Florence, Clark was in his early 20s. The great expert was in his early 60s. Clark never forgot his walks with Berenson through the hills behind Vincigliata.

"How he loved those walks," recalls Clark. "More, I believe, than any work of art. On my first visit there were usually more eminent people to accompany him, but whenever I did so I discovered a changed being."

"Gone were the vituperations of the all-powerful expert, and there reappeared the youthful aesthete who had tramped through the valleys of the Veneto. Every hundred yards he would stop in ecstasy, sometimes at a distant view, more often at a group of farmhouses, or the roots of an old olive tree, or at a cluster of autumnal leaves and seed pods. He would be completely absorbed in what he saw, speechless with delight."

I read that passage with envy. The subject of seeing fascinates me, largely because I feel I have done so little of it in my life, compared with a career that has been largely looking. Yet

I have at times experienced that ecstasy from the mere contemplation of natural things which seemed to come so easily to Berenson.

The nearest I came to seeing for any length of time was when I lived in England and walked daily on the Wiltshire downs. There was an especial ridge looking down on Shalborne valley that never failed to take my breath away. It was not so much the beauty of the place, which is transcendent; but the beauty of having been almost forced into seeing what was before my eyes.

That is the therapeutic value of placing yourself in situations of extraordinary beauty. You are *forced* to see and not merely to look. The things of man can be beautiful. There is nothing wrong with the Seagram's building in New York, or with the even more beautiful Racquet Club building across the street. But the things of nature, or of God if you will, are those which most readily drive you from merely looking to seeing.

"What thou seest, that thou beest," said Plato. You are the sum of what you have seen, far more than the product of what you have looked at. None of us has seen enough. Nearly all of us have just looked at far too much.

'Walden' Revisited

There are perils in re-reading books you have loved greatly.

This I discovered recently when I took on Thoreau's "Walden" after an absence of some 30 years. This famous celebration of nature and solitude on a New England pond is one of great products of the American genius. It also occupies a curious and neglected place in the history of World War II.

The number who were killed on strange Pacific islands and atolls with a paperback copy of "Walden" in the hip pocket of their battle dress was more than you might imagine. The Thoreauvians were the loners, the ones who had their own thoughts about the battles they had been impressed into fighting, their own vision of the world they wanted when it was all over.

In my experience Thoreauvians were especially to be found among kids from big cities, whose closest connection with nature in peacetime might have been the occasional nine innings of ball on a municipal park grass field. The world of "Walden" was very real to us, in the same way perhaps as the Holy Grail was.

For I was one of those loners, though I was not in combat. Wherever I went as a combat correspondent I carried "Walden" and a small pocketbook dictionary in my duffle bag. Like the rest of that curious crew who were hooked on Henry David, I knew that all men led lives of quiet desperation, that we were rich in proportion to what we could do without, and that the flouting of authority under the banner of our private truth was a signal and creative act.

We led tidy little private moral lives, flagged on by such sentences as: "The man who goes alone can start today; but he who travels with another must wait till that other is ready, and it may be a long time before they get off."

Thoreau never wrote a sentence that was not wholly his, a claim that his British contemporary Byron and not a hell of a lot of other people could also make. Henry David resolutely refused to be taken over by the merchant mentality of the Boston Common. He was his own man. This was what the World War II Thoreauvians identified with, in a world where the chicken colonel was king, and condoms were sold only for the prevention of disease.

But Thoreau was more than slightly dotty, too; a fact which passed me by in those earlier days. I picked up "Walden" again

the other night. The music and charm of the man's prose was still bewitching, as was his vision of a principled life.

I got to the well-known passage when the prophet wondered, by the side of his lonely pond, whether he had in solitude chosen the better path. "When, for an hour, I doubted if the near neighborhood of man was not essential to a serene and healthy life."

Then a gentle rain fell on his holy domain, and things were once again okay. The quiet and the creatures about "made the fancied advantages of human neighborhood insignificant, and I have never thought of them since."

It was the next sentence which stopped me dead. "Every little pine needle expanded and swelled with sympathy, and befriended me."

These words were sad. They told me how far I had come from the bright insolence of my youth. I had thought them brave and splendid once. Now they seemed like something a dotty and eccentric old man might mumble to himself, as he justified his misanthropy by a precious love of the primitive and untouched.

I thought again of how far away I was from the young fellow whose clothes had been sent back to his company—dirty green Marine fatigues and a blood-stained copy of "Walden," its feeble paper spine open and broken where he had been reading.

Hill People

I'm a great one for doing nothing whenever possible. In the donjon of my heart is graven Melbourne's motto: "When in doubt, don't." But you can flog a living virtue, as you can a dead horse.

In the roughest possible way, our world is divided into doers and thinkers. The complete doer and the completer thinker are monsters. The proportions should be more meet, like maybe four-fifths of one and one-fifth of the other.

Confucius spoke of water people and hill people. "The wise find pleasure in water; the virtuous find pleasure in hills," he said. "The wise are active; the virtuous tranquil. The wise are joyful; the virtuous are long-lived."

Water comforts me, especially when I live beside it, as I often have, and even when the water is angry and plangent. You know that whatever trouble lurks out there in the water, it is not the trouble which pursues you on land. The pull of water is often far too good for one. It may be the prescience of hindsight, but it seems that the poetry of Hart Crane foreshadowed his end—so mesmeric is the pull of his water images. He leaped to his death from a liner out of Vera Cruz.

But all this is nothing like the prospect of a distant, beckoning mountain. All mountains beckon to you if you are a hill person. The Sierra from Lone Pine on U.S. 395; the Tetons at twilight from Moose, Wyo.; the Connemara hills from anywhere in Galway, the Catskills from the Mohawk valley; Popocatepetl and Ixtaccihuatl from Cuernavaca—these are prospects to give a bit of life for.

Like crackling fireplaces, hills and especially high hills are begetters of dreams. They take us out of where we are, which is nearly always a good thing; but they have the corollary and not so good thing that they make us dissatisfied with what we are among. Between what the hills tell us about the far away and about the near at hand, there comes a point of stasis where hill people are bound like a Prometheus totally enfeebled. In this state, doing nothing is torture rather than tranquil.

The truth is, too many of the hill people live their lives thinking up reasons for not doing what they fear will turn out badly. This is a bad, bad state of affairs. It means nothing less than that they have given up on life, for a small or great period of time. They are in tune with infinity to the point where the finite

no longer exists. They have become, as I say, monstrous.

Doing nothing and doing something are both liberating forces. The one liberates from the other. The static state between the two is the true stagnant pool. I'm certain the water people fall into that happy pool quite as often as the hill folk.

If you believe with the conviction of the damned or the saved, and they can be the same thing in the same person, that whatever you do will turn out badly, you may be sure that you are not going to attempt much. There you are, fitting yourself for a shroud.

You begin to cut your moral losses, like a gambler who knows the jig is up. You fix it so that you will not be hurt by avoiding all occasions where you might be hurt, which are too frequently the great chances for happiness, or at least adventure. You pull in your horns, in the eloquent phrase.

This process was described with great insight by an expert, Dean Swift. He called it "the stoical scheme of supplying our wants by cutting off our desires." This is the limbo of the Do Nothing people, the wisest of us all in most respects. In due time, if all goes well, the unhealthy balance between the draw of the hill and the draw of the water is broken. We take to the hills again, wholly and joyfully, and peace is back.

Decline of Toothpicks

One of the ancient amenities I grieve for is that little bit of lumber called the toothpick. For those of you who, through the censorship of your parents or some other dire cause have never heard of this coarse instrument, a toothpick is a thing with which you clean your teeth and make your mouth comfortable after eating a solid meal. Its use causes the conjuring of some pretty terrible taboos among some people.

Toothpicks are much disliked by dentists because they do the work of the dentist so effectively and so quickly and with such a total lack of professional aplomb. In my indictment of all professions as conspiracies against mankind, I most certainly do not exclude the dentist.

Dental care, at least as advocated and practiced by dentists, is largely a scam. Americans indignantly reject people who use toothpicks, especially when they use them openly and publicly. Such people are considered savages. Yet these same Americans often remark, in envy, that savages do have such divine teeth, don't they? Maybe somebody is trying to tell them something, if they would but listen.

This is the only country I know of where, among respectable people, the use of a toothpick is a secret vice. There isn't a restaurant in France that doesn't have the wooden picks either on the table, or near the cash register or on demand. Ditto Germany, Italy, Spain—*tout le monde*—in fact. Even the best tables in Britain have these useful artifacts—for the men, anyhow.

The late Lucius Beebe, who made a career of being a continental swell, occasionally gave gold picks from Tiffany or Cartier to his friends, and often used one himself with considerable ostentation.

In Latin America they are called pallilos (in Spanish) or palitos (in Portuguese in Brazil). They are ubiquitous. You can't go into an eating place, even a hot dog stand, without being confronted with this wooden amenity. It is a part, and by no means the least satisfactory part, of a snack, or an ordinary meal, or a banquet *en fete* at the capital's Ritz. I recently heard a Brazilian quoted as saying that to finish a meal without the satisfying taste of a toothpick would be "like taking a bath without soap." My feeling exactly.

There is only one dentist I've ever paid the slightest attention to in my life. "Dear boy," he would say, to those who

would listen, "when the good Maker put you on this earth He so arranged it that if you lived an ordinary life eating dead vegetables and dead animals there would be set up within your mouth a desirable and maybe even ideal microbalance. Do nothing to your mouth, and you're ahead of the game. Use these damned dentifrices and medicinal washes and you kill precisely those germs that should NOT be killed. Mind what I say."

And I have minded. I am not one of your twice or thrice a day brushers. I use a toothbrush only when the stains of the dago red I consume regularly get so odious that I look more than usual like an ancient stallion. Then I use a British smokers toothpaste, or an Italian number called Il Capitaine, both of which have the effect of whitening the molars very quickly indeed.

To clean my teeth, I use the lowly toothpick, except when I run out or when the joint where I eat does not carry them, which is far too often. In that case, when I get home, out comes another toothpick or dental floss, which is just as good and maybe better. I may add that, with a few exceptions, I still have the set of teeth I was born with.

Not too far back toothpicks were not only essential, they were about the only form of dental care that existed in frontier and rural America. The only way I can explain the current prejudice against them is the exertions of the ad agencies which turned perfumed squishy chalk into some kind of sexual symbol as well as a toothpaste.

There is absolutely nothing vulgar, except vulgar in the good and best sense, about using a toothpick. It is cheap, it does the job, and it is about the only thing connected with the teeth which has any pleasure in it.

There are only two things vulgar about the use of the toothpick. One is that bit of doing it behind your half-clenched fist, the better the protect the delicate feelings of your fellow guests. That is proper vulgar. You should pick your teeth the way you shake hands, simply, openly, faithlessly.

Japing and Swiving

We are indebted to The New Yorker for reminding us, in a recent issue, of those two splendid Medieval verbs—to jape, and to swive. Both are explicit synonyms for the commonest way of saying sexual intercourse.

When England was a Catholic country, japers and swivers were all over the place. They were plainly and openly called such, and referred to as such in the books of the time. Those were the good old days. Then along came old Henry VIII, who rejected the Papacy for reasons not unconnected with his love life, and turned his country over the Church of England, and eventually those dear Puritans who dedicated their lives to the proposition that anything anybody else liked was a no-no.

High among the things that people liked were, of course, japing and swiving. The Puritans, in their power and glory, arranged that these words should become obsolete; as indeed they have, and unhappily. Japing vanished from the language for two centuries, until it was playfully revived by Charles Lamb in its secondary sense, meaning to play a joke. Swive seems to have been lost to us forever. It is perhaps time to form a Jape and Swive Society, with subscriptions, annual gourmet dinners, and all the other apparatus of clubmanship. Count me in.

Swive is a good one. Its definition, in the Oxford English Dictionary is "to copulate." It was used in this sense as late as 1898, in a cautionary maxim: "Don't bathe on a full stomach, nor swive." It was also fittingly employed in a pre-Burton 19th century version of the Arabian nights: "So he ate and drank and lay with her, and swived her." In the 15th century, the Scottish translation of the Book of Genesis was called The Buke of Swiving. There is, indeed, a good deal of japing and swiving in the first chapters of The Holy Book.

The history of jape in the OED is less picturesque, though there is a colorful entry dated 1530. "He japed my wife and made me cuckold."

How come, then, with this glorious history of plain speaking about the plainest of subjects, we are now so intimidated that we cannot use in print our most famous four-letter words? It is too easy to blame it all on the Protestants. Unfortunately, it's all too true, as well as being all too easy.

Those roundheads were profoundly convinced that japing and swiving were bad for the state, and therefore bad for the

individual. The Puritans refined the ancient thesis, held by certain stoics in all countries, that if a thing is distasteful it is good for you. The efficacy of a medicine is still often measured by its bitterness.

The converse proposition was equally true: If you liked anything it was bad for you. That is why the most enjoyable of human activities was most tabooed. The activity was only permitted at all so there could be more little Puritans to deplore it. Also to offer their bodies in the service of the Crown.

As brainwashers, the Puritans were right up there with the Jesuits and Josef Goebbels. The job they did on poor old sex was beautiful. Never has the apparatus of propaganda been more effectively leveled at a more harmless target.

Sex, qua sex, is about as harmful as breathing. But who among us is to say that there might not arise a new Martin Luther or John Calvin, who will found a faith on the proposition that breathing is INDEED harmful, and that the most obscene sound in the world is a snort. The population explosionists have, indeed, come close to this sort of reasoning.

Meantime, thanks for the blessings of verbal obsolescence. The next time I meet a truly attractive number, I know perfectly well that I can say to her, without the slightest fear of a slap in the face: "Shall we swive?"

In Defense of Aspirin

\mathcal{S}ometimes I think there is an active conspiracy against the greatest drug ever invented by man, aspirin. You never hear a good word about it. All you hear about are its side-effects, which are of course terrible. It causes, we are told, occult blood loss, nausea, vomiting, gastritis, ulcers and bleeding. I can only tell you that I have been using asprin all my life, and have never had any of these side-effects.

I heard a TV commercial the other day, and couldn't believe my ears. It was for Extra Strength Tylenol. The mellifluous lady doing the commercial announced proudly that Tylenol was "100 percent aspirin-free."

When being "aspirin-free" is a virtue, the world has come to a pretty pass.

And it was recently announced in Atlanta that federal health officials had warned parents and physicians that giving aspirin to children with chickenpox or influenza could increase the risk of Reye's syndrome, a sometimes deadly viral disease. It mentioned later down in the story that Reye's syndrome is "a relatively uncommon childhood disease." Which means almost nobody gets it.

Aspirin is the greatest pain-killing agent in the world, and it can be bought without a doc's prescription. It is useful to arthritis patients, gout patients and those with other inflammatory conditions.

The drug is one of medicine's greatest contributions to mankind; but because it is beyond the control of the practitioners, they seem to have mounted a campaign against it. I have heard nothing but bad-mouthing about this useful product in recent years.

I find it almost as useful as whiskey for the various ailments that affect the human soul and body. I find it quite effective as a sleeping pill, and often use it as such.

Aspirin is also disliked by the manufacturers of Empirin, Bufferin, Excedrin, Anacin, Aspergum, etc. etc.—all of which owe their pain-killing effect to aspirin.

I looked up the history of this much-maligned (at present) drug. "It is a safe drug, but some people are allergic to aspirin and may become quite ill if they use it," says my encyclopedia.

"Shortage of the drug quinine led chemists to search for other pain relievers in the 1800s. Charles Gerhardt, a German

chemist, discovered aspirin as a natural byproduct of coal tar in 1853. Its medicinal value was not recognized until 1899, when Heinrich Dreser, a German scientist, wrote about its effectiveness . . ."

I say "Howdy" to Dr. Dreser. He discovered a wonderful thing, and we should all be grateful to him for it. I have a son who suffered a severe back injury in a hockey game when he got hit on the spinal column with a stick. The pain flares up once and again. He often takes a dozen or so aspirin a day, after having been told to do so by a sensible doctor. The drug has made his life decidedly easier. Aspirin, unlike other painkillers, seems to keep its property longer.

Aspirin is the only thing that seems to cope with the common cold, the most exasperating of diseases. People sniff that it "only provides symptomatic relief." What are diseases if they are not symptoms of some disorder in the body, and what is useful save that thing that relieves symptoms until they go away?

I thank the Lord that I was born after 1899 (although some of my readers doubt this) and that I have been able to feel the analgesic effects of aspirin. I wish those spooks out there would lay off this dandy remedy for the very ailment of living.

Faking It

Robert Mitchum, the movie star, has remarked that "half the people in the world are faking it."

I believe the dear man, not so much because his remark has the immediacy and pungency of truth, as because Mr. Mitchum is a human being of rare presence. This I discovered in my one meeting with him at 12 Adler place, when that admirable premises was presided over by Messrs. Coke Infante and Frank Guidera. Mitchum isn't art nouveau, like so many of his colleageues. He is the real thing.

In his own case, the actor elaborated: "There are only two hard things about this business—wiping off the makeup at the end of the day and pulling off your boots while making a Western."

This sort of grave thinking puts me in mind of another chap I know, who takes the view that nobody working for the military-industrial complex that our country has become, puts in more than two hours a day at his job.

In many professions such laziness, and the faking which necessarily accompanies it, has become almost institutionalized. I am told that many a young newspaperman takes it in poor part if his editor interrupts the easy flow of his imaginings between two-alarm fires, to suggest that he do a little research on the obituary of some knave whom time has congealed into an elder statesman.

But the worst form of fakery, the one from which almost none of us is free, is this thing of masks. Masks have always been used. They have always been important, because there is nothing that gives so much confidence as a mask. The very word person comes from the Latin for the face mask that actors wore. Thus, a real person is no more or no less than a successful faker.

Yet how hard a thing to wear your mask successfully! What an enormous strain on all your inner resources to be continuously the guy who made Porcellian, or the guy who just didn't make it, and never got over it! How fatiguing to be continuously the rough diamond, the rock of Gibraltar, the charming irresponsible, or any of the hundreds of masks any of us can pick up.

It's bad enough when you more or less choose your own mask. But what of that army of sad sacks who have their masks

given to them by the media? And who engage in the desperate folly of trying to live up to them?

That cult hero of the young, Humphrey Bogart, was a perfect example of a guy who close to ruined himself as a human being by taking seriously the macho role a succession of directors imposed on him. He became a caricature of a caricature, and the gentle funny guy he had left behind in New York, where he came from, just disappeared.

Yet it still remains: We would be lost little whimpering souls, aimlessly gathering nuts and flowers, if it weren't for the assurance our masks give us.

The person who is to be pitied is not the one who wears his mask with ease; but the person who hasn't found the one which more or less fits. Which is the greater imposture: Not to have found the right mask, or to sit beamingly behind the one found? There are people in whom the identity crisis lasts for almost their entire life. There are those, and their souls are poor, indeed, who go to their end without ever having resolved the matter.

Chesterton assures us that you cannot unmask a mask, and that is too true. But the mask, if it is not an appropriate one, if it is not adjusted to the limitations of the wearer, can be as destructive as cyanide in a jewel. You can be torn apart in the role of Hail Fellow when you are more suited to mounting butterflies in total silence.

The lesson for today is, Don't let anybody else sell you a mask. Living up to your image can be a form of walking death. Do your own faking. It's the only sincere way.

Cheating the Worms

When I was younger, and my appetites were at their peak, I had a favored tavern toast. Raising a beaker, I would say, "Let's cheat the bloody worms."

Haven't said it for some time now, mostly because the motto fit best into another time and place. I think it often enough, though. Really should say it more often. It expresses an approach to life that is still most attractive to me.

What I mean by that harsh toast is hard to define exactly. In one sense, it was all there, in the words. Take life by the throat, and push it up against the wall. Work to beat the odds. Don't let the bastards grind you down. Don't give up the ship.

In fine, get more out of life than the presiding deities have decided is your share. In some quarters this quality is called zest, or gusto, or enthusiasm. Whatever the name, it's something which enriches the dullish adventure called life. As they say in the world of sport, it's the frosting on the cake.

The quality is a kind of blind exuberance, which has absolutely nothing to do with the life of reason. That great expert on the life of reason, George Santayana, was well aware of this when he said:

"Nature drives with a loose rein and vitality of any sort can blunder through many a predicament in which reason would despair."

Perhaps the reason I admire this headlong quality so immoderately is that I don't have enough of it. Not that I lack it. Most of the important decisions of my life have been made without any conspicuous deference to the life of reason. Where I have chosen to live, whom I have chosen to live with, these have nearly always been decided by caprice and passion—and accident, of course. The idea of sitting down and planning my life ahead for, say, five years is almost abhorrent to me. It seems presumptuous, taking on the privilege of the godhead.

Taking these headlong decisions has this disadvantage, in my case: For a long time you are almost drained of the power of decision. The deadly ennui sets in. You brood, and watch the rest of the world go by. You are doing your penance for having had the temerity to grab fate by the forelock.

Then you fall into man's most pitiful state. You elect to live far below your potential. You pull back your goals, truncate your ambitions. To protect an ego that has been badly bruised by

decision, you opt for a life with as little risk as possible. You approach the state of that Russian, Oblomov, who one day decided to take to his bed, and stayed there for the rest of his life, as I recall. In this state, you are only too willing to let the bloody worms have their way. You have temporarily retired from life.

It is when I'm going through these black periods that I envy that other part of me, so contemptuous of the worms, and so willing to do battle with "the fellow in the bright nightgown"—as W. C. Fields described death.

Somewhere in the works of that somber Danish theologian, Kierkegaard, there is a terrifying phrase about "the dreadful possibility of being able." This phrase does not come with any surprise from one who believed in the absolute moral isolation of the individual, and the necessity for really choosing Christ instead of just adhering to prescribed dogma and ritual.

When being able is a terror, when rising to the limit of your nature and capacity is a threat that cannot be met—this is the time you would not dare to cheat the worms. But nature is a great huge rubber band, thank God. Being unable is, in the end, foreign to nature. We snap back.

cAmbition cAs a Sin

There was a time in the history of Western attitudes, believe it or not, when the man who went out and deliberately sought power was judged unfit to wield it.

The thinking, in those unenlightened days, was that the will of the people could best be carried out by a man who was reluctant to the point of recalcitrance to accept public responsibility.

This thinking still has its pockets of acceptance in the discipline of certain religious orders. When a man begins to show too obvious a relish for authority, either before he is top dog or after, his sails are very deliberately trimmed. Ambition, in these orders, is thought to be a cardinal sin.

In the early Christian church ambition was universally suspect. A man named to be a bishop or cardinal was required to say: "I do not wish to be a bishop or cardinal." The rulers of Plato's "Republic" were to be granted power solely on the condition that they did not want it.

The arrogance that springs from the conscious enjoyment of power and its perks was the sin the Greeks hated most. The Greeks even had a name for it. *Hubris*, "wanton insolence or arrogance resulting from excessive pride or from passion." *Hubris* did not tend to fall on those who assumed power unwillingly.

One of the more penetrating of Oscar Wilde's wisecracks was, "Ambition is the last refuge of the failure." We have had in our time only too many puddings for this particular proof. Hitler, Lenin, Mussolini, etc. etc. Their lust for power came out of the stew of their frustrations.

These men, and others like them on a smaller scale, are precisely those least fitted to handle large affairs and large concerns. That is, if we take the Platonic view.

It is precisely the characteristics of the failed man that insure his misuse of power, if he gets it. And it is the measure of our corrupt modern system that great power is most readily available to misfits.

The thwarting of failure narrows a man's nature. This, in our times, is a decided asset in a power struggle. The ability to concentrate on a single issue, usually dwelling in the least admirable part of a nation's being, can grant great power to an orator or statesman.

We are too far into the ethos of ambition as virtue to switch our system around so that Nixons and Roosevelts can be barred

from the use of power. But what man has done, man can do.

Ideally, we should be able to walk into a polling booth, make a silent determination of which candidate we think least wants the job, and vote for him. Ideally, that choice would be available.

In fact, everybody runs for office these days, and in this country, because he thirsts for power—power which he would, of course, employ for "good."

Your choice, usually, is for the least noxious S.O.B.

When a man who wants power gets it on his terms, he becomes fearless, in the worst sense of the word. The mantle of the Messiah descends on him with the greatest ease. This man soon discovers that he does not have to explain himself to anyone, can order any act he pleases without offering any justification for it.

When he reaches this point, he has no need to fear anyone. Morality is impossible without fear of consequences, in government or anywhere else. That the good man would also be the fearful man, in terms of the consequences of his acts, was the fulcrum of the conviction of those older thinkers that a man sinned when he *sought* power.

The Astonished Self

You have been called a monster. If you are like most of us, there have been times when you have admitted it. Though you do not like to admit it, there is nothing you would not submit to, no violation of the spirit you would not accept, if the gun were cocked and backed by the strength of fear.

Virtue is a facade, as is self-conscious vice. We are all what we are, which is animals fighting the good fight against being animals. Some of the more civilized among us even wonder if the fight is not only not worth winning, but the wrong fight, in the first place, at the wrong time.

Perhaps when we were thrown out of Paradise along with Lucifer, for our pride, that pride consisted of the illusion that we were not animals, that we could accept and even glory in such values as good and evil, righteous and wicked.

These mildly melancholy reflections, which are none the less strongly held for being mildly melancholy, were bestirred in me while reading a review of a recent life of Balzac, that unremitting student of the human heart. "In my five feet three inches," the novelist said, "I contain every possible inconsistency and contrast. I am astonished by nothing more than myself."

If we are honest with ourselves, we can all make that boast, and in spades. If everyone told everyone else the baseness which his character has accommodated during the course of his lifetime, it is doubtful that anyone would ever speak to anyone else again. Or, a more healthy result, perhaps everybody would really begin to accept everybody else, and feel a decent charity when one of their fellows touched bottom. As we all do.

For myself, I should not care to catalogue the crimes which were committed by me, and undetected by the police. I have hurt people deeply, with the whips of devils I could not have believed existed within me. I now remember such things as one might remember the blizzard of '88, or some such. I would find it hard to do such deeds now, because the demons have been tamed a bit; but it cannot be doubted that the deed was done.

I hurt no one more deeply than myself by these deviltries. That is almost the name of the game. The punishment is built into the crime. The victim, O so often! turns out to be the aggressor, who turns out to be yourself. I used to call myself, with a kind of black humor, Death-Wish Charlie. That was far too

close to the knuckle. Over the years, I've done more to impede my cause, in more ways, than anyone I can readily think of.

Yes, I astonish myself, as Mr. Balzac and anybody who puts a mind to the matter is certain to admit. Yet is there anything to be ashamed of, or to be astonished about, in being a complete human being, warts and wounds and all? I think not.

I think more than that. I think a lot of bad health, both spiritual and mental, comes from taking the view that you are a good man, or a fine man, or a good woman nobly planned, or anything in fact other than an amorphous mass of living material made maybe in the image and likeness of God.

There are few of us, I believe, who have not done something as meaningless and evil as killing a man in cold blood. It may not have been precisely that act but nearly all of us have at some time inflicted mortal hurt, and without cause which could be called just, on one of our fellow creatures. It's terrible to say that such a thing is part of the price of being a human being; but I say it, and without hesitation.

There is the other side, too, the soaring side. Let us rejoice that it exists, and work hard that we may soar more. But it is the amalgam, the crazy mixture of the glorious and the gutterish, that is the signature of our species. We may well be astonished.

'Our Future Selves'

Psychiatrist Robert Butler, director of the National Institute on Aging in Bethesda, Md., is credited with coining the word *ageism*. It does seem a useful addition to the national vocabulary.

"Ageism," Dr. Butler says, "can be seen as a process of systematic stereotyping and discrimination against people because they are old, just as racism and sexism accomplish this with skin color and gender. . . Ageism allows the younger generations to see older people as different from themselves; thus they subtly cease to identify with their elders as human beings."

The NIA director holds that current policies in housing, pensions, health and social services and recreation for the aged are motivated by hostility and fear. He cautions that we seem to forget that these people we are tossing into a corner today are, in fact, "our future selves."

While all this has the ring of truth it is also accompanied by a real political phenomenon, sometimes called gray power. The number of people 55 years and older is projected to reach 57 million by the end of the century.

The elderly citizen is not a popular figure in our culture, and never has been. We are a people in a hurry, and anything that slows things down, or drags things out, is viewed as a block to our collective thrust.

Old men and old women are viewed as an outright embarrassment by many of the young. They would like to get the oldsters out of sight, like the daft or the physically deformed. Stick them in groups behind walls and forget them.

It is not because my age places me in the elderly group that I think this a wholly irrational view of things. Old age seems to me less a problem than an opportunity.

There are a lot of good things about age, and they ought to be recognized. Merely having lived over 55 years brings to most of us a hardy wisdom that can be imparted to the young. We know quite a bit about the gopher holes along the road of life, and there is no reason why there should not be a systematic spreading of that knowledge to those who are still sorting things out.

The way we cope with old age is, too, another part of our legacy to those who will some day become their "future selves."

The needs are interdependent. What older people need more than anything else these days are the tools to live productively and well and even inventively. These tools can only be

effectively produced by the citizenry at large, who are mostly not older folk.

Most of what conventional medicine knows about the old comes from the study of the *diseased* old. Recently there has been a tendency to study healthy old people. Dr. Butler has been in the forefront of this movement. With disease taken out of the picture, it appears that age itself does far less harm to a person than had been thought.

"A lot of what was attributed in the past to age," Butler says, "was clearly a function of a variety of different diseases, or social adversity or alcoholism or programmed obsolescence or lots of things that happen to the aged."

Yet the dark view of ageing persists. This view insists that memory loss, rigidity, dependence and even senility are inevitable accompaniments of old age. This popular attitude toward old age, Butler says, is in part just "stark terror. We base our feelings on primitive fears, prejudice and stereotypes rather than on knowledge and insight."

In the end whether most of us have a rewarding old age is, like most other things in life, a matter of luck. But that luck can be given a useful prod by looking for the useful rather than the merely annoying aspects of richness of years.

How to Be Solitary

One of the salient things about Dr. Samuel Johnson, who has been called and I think with justice, the greatest of Englishmen, is the amount of meaning he could pack into a single sentence.

His sententiousness is really extraordinary. You can pick up any standard dictionary of quotations and under the entry Johnson pick out three or four sentences of more pith, consequence and memorability than you will read in several novels or collections of essays. Sir Joshua Reynolds said, "He (Johnson) cleared my mind of a great deal of rubbish."

Item: "Gratitude is a fruit of great cultivation; you do not find it among gross people." Item: "Nothing is little to him that feels it with great sensibility." Item: "Dictionaries are like watches; the worst is better than none, and the best cannot be expected to go quite true."

And there is his classic formulation: "The law is the last result of human wisdom acting upon human experience for the benefit of the public."

The text for today is, however, a highly personal one. In a single sentence Johnson once laid down a rule of life that I have found extremely useful over many years. In a letter to Boswell, Johnson remarked:

"If you are idle, be not solitary; if you are solitary, be not idle."

The man who wrote those words, it is clear, knew a great deal about being alone and a great deal about being idle, and he figured out the uses to which their relationship could be put.

Though it may not seem like it to you, there are times when I am not producing a daily column. Sometimes these periods go for weeks at a time, thanks to holidays plus the accumulation of a backlog of pieces.

Whether these idle periods are a greater reward or threat to me I have never clearly ascertained. Everybody needs a rest, and that's for sure. Batteries must be recharged or the engine is likely to stall. Too-long-continued concentration on anything will make you stale.

That's the good part. The bad part is that you are suddenly rudderless. My practice, when I am first on the idle, is just to take to bed for a couple of days. I do this without one of my great supports, liquor, and with one of my great supports, a good or at least lively set of books.

That's where the first part of Johnson's apothegm beings to

work. If you are doing nothing, and all by yourself, you begin to feel not only an emptiness but an empty-headedness. Even if you are not a backslapper, and I am not, you begin to feel that you need human company or you will be forced to face that most desperate of prospects: The human condition. And that you wouldn't wish on a mongrel.

This is where it is good to hop into your little auto and get the hell away from the accustomed haunts and into some small town in the boonies where you will be compelled to relate to people you never saw in your life before. Then being idle can be almost fun, and sometimes even fun itself. Some people do it by going to Vegas. I'd as soon go to Rio Vista.

Comes the time when you have to get back to work, which in the case of people who write means being solitary. Being solitary even when you are in the midst of people, which is one of the things that makes writers seem rather odd fish to those not of their persuasion.

I return to work with more relief than I give up work. When you are idle you have to see people to justify yourself spiritually. This is dicey work, people being what they are—you might end up on a hospital ship or in the middle of a barroom brawl.

When you are working you justify your pleasures and your excursions into society by getting what you consider an honest piece of work done first. This done, the conscience assuaged, it is possible to find happiness even among bridge players.

The Look of Success

The next time you luck out and get invited for lunch at the prestigious Pacific Union club, just take a long, hard look at the members. You will find that they all look alike, in a curious way.

You will not have been the first person to make this discovery. Perhaps the greatest student of success in modern times was a Scottish author and social reformer named Samuel Smiles, 1812-1904.

Smiles' famous book "Self-Help" was published in 1857. It was the Victorian school prize usually given to bright students. Smiles is the author of the useful injunction, "A place for everything and everything in its place."

It was also his contention that success makes everybody look pretty much the same, even when they are essentially as unlike as, say, Gerald Ford and the late T.S. Eliot.

There is a kind of seal-like sleekness about those who have made it. The consciousness that you have cut the mustard can work wonders with your chemistry. There are women who go for men not because of their accomplisments, or the amount of loot they have in the bank, but simply because they are successful in the eyes of other men.

We have only to remind ourselves of the immortal words of Henry Kissinger to the effect that power is the ultimate, the greatest, aphrodisiac.

A cat may look at a king. In fact, it is just about impossible to stop cats from looking at kings, and damned critically, too. Success has gotten a bad name, largely from those of us who have not been embraced by it. It is almost a mark of the intellectual these days to point out that the successful person is almost invariably desperately unhappy and shrink-ridden.

That cool old codger, Mr. Willie Maugham, was not so deceived. He said: "The common idea that success spoils people by making them vain, egotistical, and self-complacent is erroneous; on the contrary it makes them, for the most part, humble, tolerant, and kind. Failure makes people bitter and cruel."

If successful men look the same, au fond, then successful women are even more to the point. By a successful woman I mean something as simple and as old-fashioned as those who have married well, and produced good issue.

There is an air about such women that is almost palpable. Life has given them as much as it can give anyone, and it shows.

By George, how it shows!

There is a kind of serenity that comes from just having been around the track. The woman who has experienced a full life, with its goods and its bads, seems to acquire a sort of special pride. This pride says, "I've been there and I liked it."

If you know you're good, man or woman, it shows in your stride, in the way you cup your fingers, in the brightness of your glance, even in the way you kneel to pray.

The successful are a kind of special confraternity, and we would be wise to admit the fact, and then to enjoy it. A great tennis player and a fellow who is clever at putting companies together have something in common. It is easy to call this arrogance; but that is a cheap shot. There's more to it than that.

To use a phrase I once found repellent, but no longer do, these people are the favored few. They do one or more things superlatively well. The gods smile on them. Inside of them something grows which is almost impossible to define.

They develop an aura. They are apart from the rest of us, in ways both good and bad. They have a way of staying at the top of their form. They do, to be sure, tend to forget the dreadful injustices of this world; but they do get that sleek, seal-like look.

Last Day of Your Life

*A*mong the odd birds with whom I associate is one who sends me by post arcane wisdom, often of the Ancient East. The other day he sent me what he described as a Zen story.

My dictionary has this to say of Zen: "An antirational Buddhist sect developed in India and now widespread in Japan: It differs from other Buddhist sects in seeking the truth through introspection and intuition rather than in Pali scripture."

The story is rather fetching: "A man traveling across a field encountered a tiger. He fled, the tiger after him. Coming to a precipice, he caught hold of the root of a wild vine and swung himself down over the edge. The tiger sniffed at him from above.

"Trembling, the man looked down to where, far below, another tiger was waiting to eat him. Only the vine sustained him. Two mice, one white and one black, little by little, started to gnaw away the vine. The man saw a luscious strawberry near him. Grasping the vine with one hand, he plucked the strawberry with the other.

"How sweet it tasted!"

The message is clear, even to a resolutely occidental intelligence. It is like, and yet unlike, that fashionable cliche of a couple of years back: Today is the first day of the rest of your life. This message is more filled with meaning. Today is the last day of your life.

What a pleasant business it would be, for each of us individually, and for people at large, if we could transport ourselves into a state wherein we felt that we had but 12 hours or so to live!

What delicious penances would be paid! How our feelings toward other people would focus! How we would edit our lives, bringing back from the bank of memory that which we really wished to remember, those quick moments which seemed to define the good, that strange thing which we all know exists, but which still seems somehow incredible.

I was once asked by a chap on a television show what I thought was the worst thing about my fellowmen. I saw the show a few days later. My answer surprised me greatly. I had responded, with evident sincerity:

"What saddens me most is that people don't know how good they are."

I could never have predicted that response. It came from some part of me so deep that I had not really met it before. I

doubt not that the remark applied more to myself than it did to those millions of people who surround me.

I have never thought of myself as a particularly good man. Each person has something he is especially gifted at, whether it is the identification of birds and flowers, or the ability to remember everything that happened to him, or a capacity to excel at games.

If I were to say what I am best at, I would reply like a lot of other people who were brought up on the streets of a big city: The ability to survive. If gutter wisdom means any one thing, it means the capacity to perceive danger, and to dodge it.

That sort of urchin cant does not promote in your character the view that your fellowman is good, or that you are. The slum city kid perceives everybody as his enemy. His life is all tactics and strategy. The end is to get home at the end of the day in one piece.

Yet, when I try to transport myself into that state where I can feel that I am mortal, and by a short margin, everything that I learned on the streets is somehow negated. Perhaps because I know I cannot be destroyed, because the end is already at hand, I lose that sense of fear which is so completely the enemy of good.

Kindness and love, and sorrow that I did not know these things well enough when they happened to me, are the feelings I get as I in imagination approach the end of my life. I hope that is the way I feel when the real end approaches. I would like to go remembering, intensely, that strawberry.